FIRST AVENUE

MINNESOTA'S MAINROOM

CHRIS RIEMENSCHNEIDER

MINNESOTA
HISTORICAL
SOCIETY PRESS

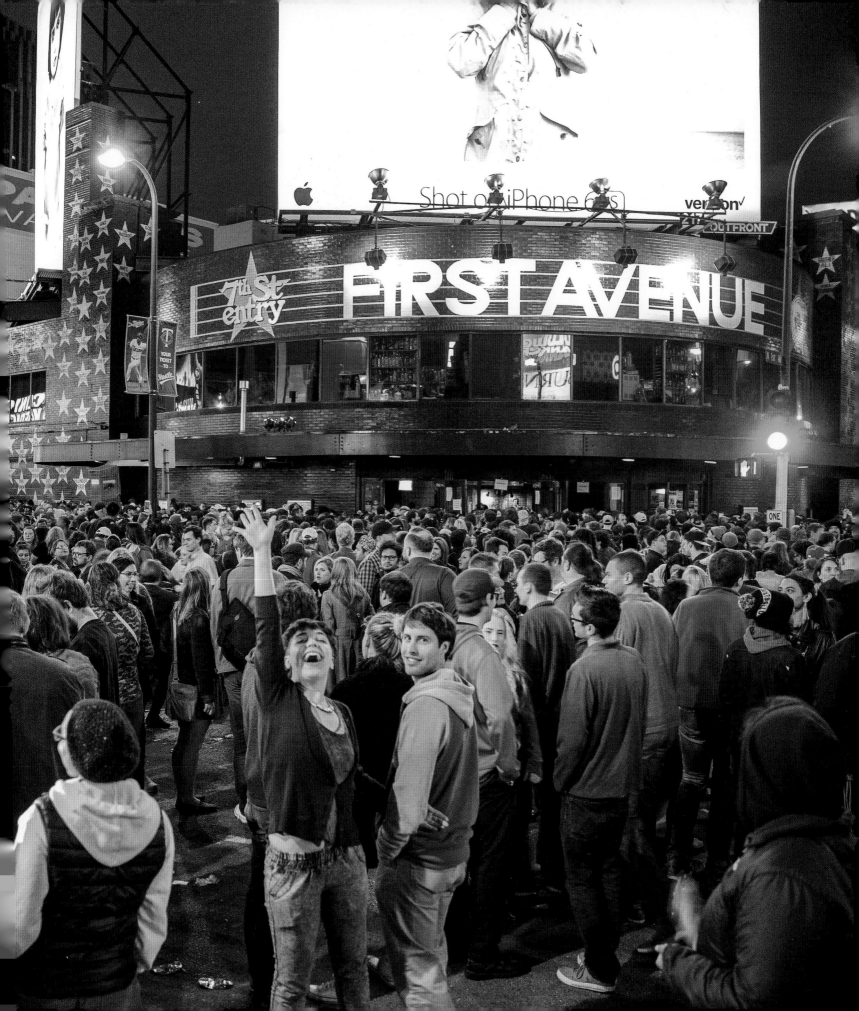

ATMOSPHERE

COWS

HÜSKER DÜ

7th St. ENTRY

BABES IN TOYLAND

IN THE ENTRY
7/16/2013

MUNQS
CARIELLE
BEARS & COMPANY
THE SET

FIRST AVENUE

$5.00 / 8:00PM / 18+
PURCHASE FIRST AVENUE TICKETS ONLINE AT
WWW.FIRST-AVENUE.COM

POSTER PRINTING PROVIDED BY

Phillips

THE REPLACEMENTS

MIKE WATT

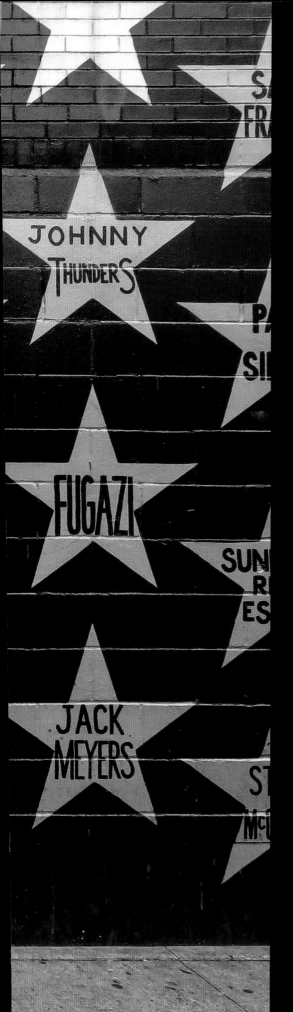

CONTENTS

PREFACE

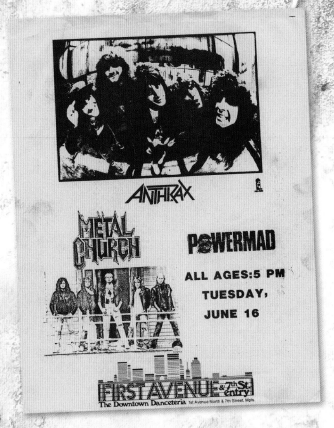

The author's first experience at the legendary Minneapolis rock club featured head-banging sets from Anthrax and Metal Church. *Minnesota Historical Society Collections*

My first time through the curved entryway nearly ended with my buddy suffering a concussion. I made my virgin trip to First Avenue to see Anthrax and Metal Church in June 1986, at the ripe metalhead age of fourteen. Heading over from east St. Paul with my friend since birth, Mark Dueffert—who still often goes to shows with me despite having to get up early to deliver mail—was scary and exhilarating. The club's all-black interior was especially dark and grimy in those days, or maybe it just seemed that way. Mark and I got right up front and sat on ledges that, at the time, were attached to the stage. We sang into Joey Belladonna's microphone when Anthrax encored with "Anarchy in the U.K." At the end of Metal Church's set, Duke Erickson unstrapped his bass and started swinging it around wildly, striking Mark in the head. Like Beavis to Butt-head, I guffawed as my friend fought off tears from the pain. I thought I had just witnessed one of the coolest things of my life.

Mark turned out fine, but I've never been the same. I'd been to many concerts before that, but never one where you could get close enough to sing into the microphone or get whacked in the head by a guitar. We quickly graduated from metal to punk and went to First Ave every month or two after that, since all-ages shows were commonplace at the time. We saw G.B.H., the Circle Jerks, 7 Seconds, and D.I., my first show at the 7th Street Entry. We caught Soul Asylum when they returned home for Thanksgiving on the *Hang Time* tour. We had plans to hear our favorite locals, Hüsker Dü, in December 1987, but one of us had to work his crappy dishwasher job the night of the all-ages show. We figured we'd catch them the next time. Of course, there wasn't a next time.

Like most First Ave regulars, my experiences at the club after that read like signposts of my personal life: The first time I brought my Texan girlfriend home from college to meet my family, I took her to the club to see Babes in Toyland; Kat Bjelland's shrieking was perfectly emblematic of my future wife's impressions of the cold (and maybe the family, too). The week I flew up to Minneapolis from Austin, Texas, to interview for a job with the *Star Tribune* in April 2001, my future coworker Jon Bream took me there to introduce me to the young hip-hop sensations that would dominate my beat for the next decade: Atmosphere, Eyedea & Abilities, and their Rhymesayers crew. The day I arrived in town permanently at the end of June 2001, Wilco was at the club with the *I Am Trying to Break Your Heart* documentary film crew in tow. The

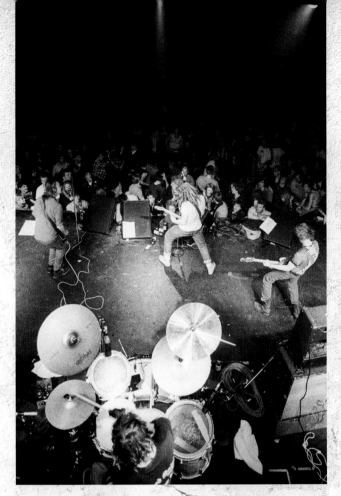

Soul Asylum is one of countless Twin Cities bands that came of age at First Avenue and 7th Street Entry. They were packing the Mainroom as far back as this show from November 1986. *Photo by Daniel Corrigan*

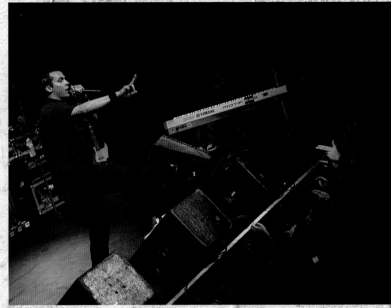

Following in the footsteps of punk and indie-rock bands of earlier decades, hip-hop artists like Slug of Atmosphere helped to build First Avenue's reputation as a premier venue for a wide range of musical acts. *Photo by Steven Cohen*

Whether one joins the club officially as a member or simply attends the occasional concert, First Avenue and 7th Street Entry has been an integral part of many people's lives. *Minnesota Historical Society Collections*

first time I saw Lizzo wow a packed house there, opening for Har Mar Superstar in September 2013, the night ended with me rushing to St. John's Hospital—my mom had suffered a fatal heart attack. By the time you read this, I'm hoping I'll have taken the older of my two daughters to her first show there. I'm pushing hard for Anthrax.

It's not hyperbole for the most fanatical music lovers to say First Ave has changed our lives. For us, there's extra comfort in its longevity, in how little the place has changed. Rock 'n' roll's deepest appreciators are often loners and misfits by nature. First Ave's regular patrons throughout its five decades usually fit that stereotype. Many of the thousands of employees over the years have been outcasts by nature, too. From Steve McClellan on down to the tall kid hired last week to carry that box of beer on his head through a packed Mainroom dance floor, they all deserve our thanks for their often thankless and rarely well-paying job keeping the place running like it's the Old Ironsides of rock 'n' roll. For us diehard rock 'n' roll bleeders, having First Ave in our lives for so long has only deepened our connection to the music and the lifestyle. It really is like home to us. ∎

▥INTRODUCTION▥

The quick thinkers crammed inside the curved offices overlooking Seventh Street and First Avenue North in downtown Minneapolis had never faced a more logistically and emotionally challenging day than April 21, 2016. And that's saying something. Even for a rock club—one of the most legendary and longevous rock clubs in America—the venue had seen an unusual amount of calamity in its prior forty-six years. There was the scary ceiling collapse the previous summer that shut it down for sixteen days (and could've been a lot worse). There was the bankruptcy court battle between two lifelong friends in 2004 that shuttered it for three weeks (and could've been the end). The place actually closed for an entire year from the summer of '71 until the summer of '72: Apparently, even acts like Joe Cocker, Ike & Tina Turner, B. B. King, Frank Zappa, Iggy

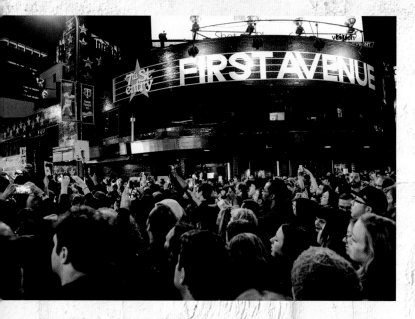

& the Stooges, John Lee Hooker, and Alice Cooper somehow couldn't keep it out of debt. Then it survived for seven years on disco records. Welcome to the club business.

When the former Greyhound Bus depot finally took on the First Avenue name, along with a renewed purpose, in 1982, the biggest reason it didn't go under again was the little guy from north Minneapolis. Prince never had anything to do with owning or running the venue. He didn't even perform there much for a local kid; just nine full concerts. What he did inside those thick black walls from 1981 to 1987, though, changed Minneapolis and rock 'n' roll forever. In many ways, that gritty, oddly shaped, poorly ventilated venue also changed him. He repaid it by turning it into an international landmark.

Worldwide attention returned to First Avenue the day Prince died. News organizations from all over flashed images of ten thousand people dancing, singing, hugging, and weeping at a memorial organized on the fly outside the club that night; inside, the club hosted the first of three emotionally bipolar all-night dance parties. "Fans remember Prince at iconic club," CNN's headline read. Those moments of musical mourning turned into one of the saddest and proudest events in Minneapolis history, and it happened because of something called the Prince Permit. Hashed out in 2007 by then-mayor R. T. Rybak, the Minneapolis Police Department, and club management, the special pre-approved documentation allowed one of the most historic rock clubs in the country

In April 2016, First Avenue was a gathering place for mourning and celebration in the days following the death of Prince, a treasured local and international artist who had a long history with the club. *Photo by Steven Cohen*

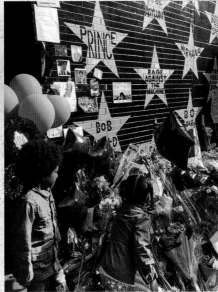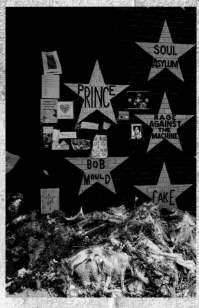

Within hours of Prince's death, the first flowers were laid beneath his star on the First Avenue wall. The pile grew quickly. Within two weeks, the star was painted gold, in what photographer Daniel Corrigan called a "guerilla paint job." *Photos by Nicolette Shegstad, Tina Morgan, and Kelly Ward, Minnesota Historical Society Collections*

to stay open past curfew should one of the greatest musicians ever to walk the planet come walking through the back door again. Prince had been given his own license to groove. It applied only to him. It could be used only at First Avenue.

The rock 'n' roll permission slip was a byproduct of the hometown hero's frenetic but frustrating 7/7/07 concert, his first time playing the club in twenty years. It turned out to be his last, too. After he opened Paisley Park in 1987, the studio complex in suburban Chanhassen replaced the downtown nightclub as his own late-night party pad. Paisley Park was cool in an inner-circle, pre-internet word-of-mouth sort of way, but it wasn't First Avenue. It wasn't where Prince "found his audience," one of the many things said about his debut at the club on March 9, 1981, when it was still named Sam's. Paisley wasn't where Prince premiered and recorded his most sacred song, "Purple Rain," on a sweaty August night in 1983. It wasn't where he filmed some of the greatest rock 'n' roll performance scenes in cinema history during a frigid December, also in 1983. First Avenue was where bands ranging from Ween to Lauryn Hill to TV on the Radio to the Drive-by Truckers added Prince songs to their set list over the decades just because they were playing *that* venue, one they all returned to even after they outgrew it. Prince kept returning, too: He would sneak into the private booth above the soundboard to either scoff at or crib from other performers, even up until a couple months before his death.

I happened to be in that private viewing area during the 7/7/07 concert, standing next to First Ave's owner, Byron Frank, when a staffer rushed in to tell him the bad news. "The cops want to shut it down," Frank yelled into our ears over the petulant funk. No one was surprised. Prince didn't take the stage until 2:45 AM, late even for him. He did have the excuse of already playing two other gigs the previous day, including a full-scale concert at the basketball arena across the street that generated tens of thousands in tax dollars. And yet, excessive overtime pay for the dozen or so police officers stuck waiting outside First Ave at 3:45 AM was cited as reason enough to cut Prince off after seventy minutes, just as his old friend Sheila E. had joined him onstage.

Still, the 7/7/07 debacle turned out to be a triumph

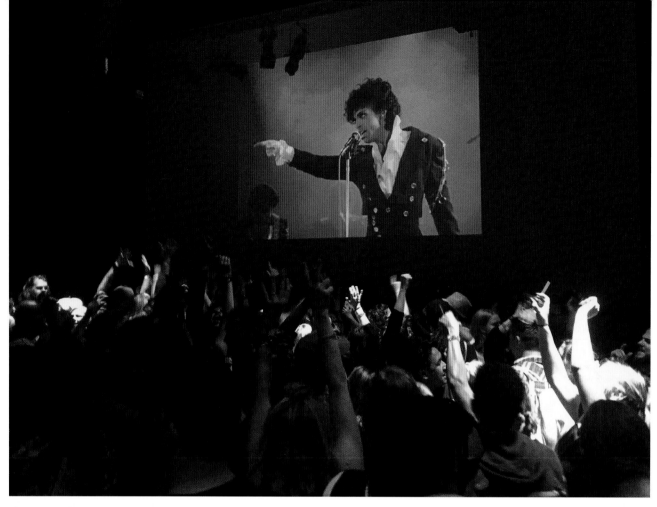

The Prince dance parties went all night long, and lines to get in the door extended around the block late into the night and on into early morning. *Photo by Julie Wells, Minnesota Historical Society Collections*

on two fronts. Thanks to the deal hashed out afterward, the staff at First Avenue on April 21, 2016, had to wade through only their emotions and not any red tape to organize the street festival and all-night dance parties that signaled to the rest of the world how the joy in Prince's music would outlive the trauma and sordidness of his sudden death. Byron Frank's daughter, Dayna Frank—who took over the club in 2009—recounted of those few chaotic hours: "After the initial shock and grief of his death, the first thing we said was, 'We gotta pull the Prince Permit!' And the city, to its credit, complied right away. For nobody else but Prince could this happen." It's hard to imagine it happening for any other club, too.

The other victory out of Prince's abbreviated '07 performance was the way it signaled the end of the long battle over the future of First Avenue. An accountant for the venue since opening day 1970, Byron Frank went to court with his longtime friend and former Hebrew-school pal Allan Fingerhut over ownership of the building and its assets in 2004. Fingerhut was the guy who put up about $150,000 of his family's catalog fortune to open the venue as the Depot in 1970, but Frank was the guy with the money and vision to keep First Ave afloat in 2004. The bankruptcy judge agreed.

If Prince was cool with the outcome, so should everyone else be. And you better believe he was worried. "I remember him asking about it, being really concerned," said Jellybean Johnson, drummer for the Time and an early cohort. "That was our playground, you know? Nobody wanted to see it go." Even the not-so-easily riled Paul Westerberg—whose band the Replacements also used First Avenue as a workout room in the 1980s—expressed his concern when the club's longtime managers, Steve McClellan and Jack Meyers, got caught up in and

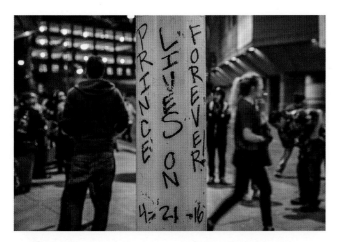

Graffiti written on a lamppost outside First Avenue proclaimed, "Prince Lives on Forever!" Let's hope the same can be said about the club he helped to make famous. *Photo by Michael Iverson, Minnesota Historical Society Collections*

Photo by Steven Cohen

fired during the legal fracas. "They were the guys that supported bands like mine when we still sucked," Westerberg said as the battle ensued.

If 2004 had been the end, the venue still would've outlasted most of the big rock halls of the late '60s hippie era, the glitzy disco clubs of the mid-'70s, and the grimy punk and new wave incubators of the late '70s and early '80s—all incarnations that First Avenue had lived through since its opening in 1970 as the Depot. Hey, what a run, right? Thankfully, there's a lot more to the story than that already-incredible accomplishment.

"First Avenue: a line in the sand," read the headline for a column I wrote for the *Star Tribune* when the venue was about to reopen three weeks after the bankruptcy closing in November 2004. As the reporter for Minneapolis's daily newspaper assigned to cover the court proceedings, I couldn't choose sides in the battle. To this day, I can see both sides, and I have, I hope, represented them fairly in this book, along with the other viewpoints, many opposing, on the club's business matters. But as a music critic whose opinions are meant to bolster a city's cultural wealth, I could at least choose sides between a Minneapolis with and without First Avenue. "Having lived in another city, I can say with a bit more authority that First Avenue is something special," I wrote in that column. "Its longevity and history are as impressive as its sound and sightlines. Few other cities have a club that's such an all-out hub."

Instead of an epitaph, here I am thirteen years later writing a book on First Avenue as the club steams along full-speed ahead to its fiftieth anniversary in 2020. This book is a little early for the occasion, but then again, it's long overdue. There have been at least eight books written on CBGB, and five on the Fillmore East or West. Those fabled New York and L.A. clubs didn't last nearly as long as First Ave. They never meant as much to their cities as First Ave does, *and* they never had Prince hump their stage. First Avenue played host to one of the greatest rock 'n' roll movies of all time. It birthed some of the most influential bands in underground rock and, later, underground hip-hop. It has changed tens of thousands of people's lives.

One of those people—and one of the hundred-plus musicians interviewed for this book—is Atmosphere rapper Sean "Slug" Daley. He advised holding off on writing the First Avenue story. "Wait 'til it closes," he told me, knowing from eighteen years of touring that most rock clubs indeed don't last. "More people will read the book after it's gone." Slug is probably right, but I hope to never find out for sure. ∎

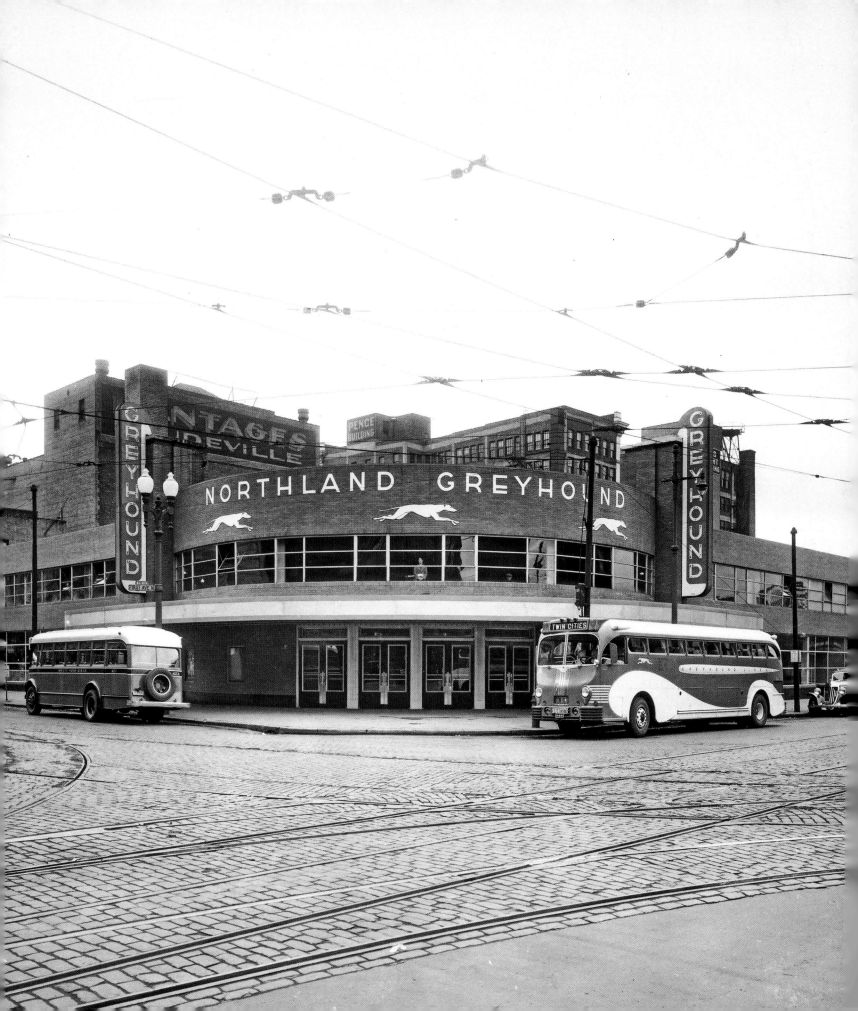

FILLING A VOID

FIRST AVENUE'S PREHISTORY

Allan Fingerhut's crash course in the rock 'n' roll business came on April 3, 1970, at the ripe but emboldened age of twenty-six. Nearly five decades later, the story almost seems scripted for dramatic (or comedic) effect. The Depot's opening night headliner, Joe Cocker, had a freakishly large entourage of forty-some people that needed to be taken care of, including future stars Leon Russell, Rita Coolidge, and Bobby Keys, several children, and a dog. Then someone in Cocker's management threatened that their star wouldn't play that night's second set unless the singer got paid more. Fans were already lined up around the block. And when Cocker did finally go on again, the most basic mistake a bar owner can make added to Fingerhut's woes: The club ran out of booze.

Amid all that, when he finally got free to sit and watch the concert and enjoy the fruits of his labor—and his initial personal investment of more than $150,000— Fingerhut got to the table where his name was written on a reservation card only to find a guy already sitting in his seat. "Who are you?" the newbie club owner asked the imposing patron. "I'm Allan Fingerhut," the man flatly responded.

(Opposite) Long before it housed a music venue, the curved-front building at the corner of First Avenue and Seventh Street in downtown Minneapolis served as the Northland Greyhound bus depot. *Minnesota Historical Society Collections.* *(Right)* Allan Fingerhut and his first wife, Sharon, in the Depot, circa 1970. *Courtesy of Sharon Fingerhut*

So it has gone for Fingerhut.

Around the time of the Depot's opening, *Minneapolis Star* columnist Jim Klobuchar (father of future U.S. Senator Amy Klobuchar) described Allan Fingerhut this way: "a boy impresario [who is] squat, mod-groomed, flawlessly mustached and agreeably lathered with suntan oil from widow's peak to jawbone. Mr. Fingerhut is

a cordial sort who smiles often although nervously, as if the next hand he shakes is almost certain to contain a subpoena."

Allan was the second of three children born to Manny and Rose Fingerhut in 1944. Like a lot of Jewish families who prospered in the postwar economic boom, the Fingerhuts eventually moved from north Minneapolis to the first-ring suburb of St. Louis Park, also home to Allan's former schoolmate, future accountant, and successor as club owner, Byron Frank.

In 1948, not long after Allan was born, Manny and his brother William started the namesake company that would make them into one of Minneapolis's wealthiest families. The Fingerhut Corp. was built on, of all things, plastic car seat covers. It wasn't so much the product that made the company prosperous. It was the way they sold it: by mail order and on credit, giving customers a thirty-day grace period and opportunity for monthly payments. That became the basis for the Fingerhut catalog, which grew to include a wide array of car accessories and household items. Manny's and William's company was also a pioneer in the "as seen on TV" advertising and robocall telemarketing realms. Manny Fingerhut stepped down as chairman of Fingerhut Corp. in 1978 and had divested most of his interest in it before his death in 1995.

Back in the mid-1960s, a teenaged Allan showed little interest in the family business. Instead, his budding passion for photography and fashion led him to enroll at the New York School of Design after graduating from St. Louis Park High School. He and every able-bodied young man in America had extra incentive to enroll somewhere after high school.

"Vietnam was starting to really escalate," Fingerhut recalled. "I thought I would be safe being in school, but I was wrong. They drafted me anyway." He got one thing right, though: He self-enlisted in the army and chose his own military path to become a truck driver. "Trucks didn't do too well in the jungles of Vietnam, so I never got sent."

Not long after his two-year stint in the army, Fingerhut broached the idea of using some of the money his father gave him to open a nightclub. Allan was still very much living in his father's long shadow. The Depot became the first of his several attempts, with varying degrees of success, to live up to the Fingerhut name's entrepreneurial reputation, which later included several art galleries and an art publishing business.

Allan's younger brother Ron remembers, "My parents were supportive of all of us following our own paths." Speaking in 2015, Allan said he didn't remember the idea being a big deal: "My parents didn't care what I did as long as I was happy. I wanted to [open a club] for a long time, and when I got back from the military I pursued it."

Among the disputed details of the club's opening, this much is certain: Fingerhut was the guy with the money, and Danny Stevens was the one with the rock 'n' roll connections and—maybe even more valuable in those days—the liquor license.

Danny was Minnesota's original teen idol and has been called Minnesota's king of rock 'n' roll. Or at least that's what it says on his website. With his band, Danny's Reasons, Stevens played colleges all around the country and was the local opening act for Jimi Hendrix, Janis

"My parents didn't care what I did as long as I was happy. I wanted to [open a club] for a long time, and when I got back from the military I pursued it."

—Allan Fingerhut

Joplin, and Ike & Tina Turner. In the late '60s and early '70s he received multiple Connie Awards, instituted in 1967 to honor the Twin Cities music scene. Later, he served as regional promotional director for Polygram Records, working for the Rolling Stones, Rush, Kiss, Bon Jovi, and John Mellencamp. He was also known for star-studded parties at his mansion on Minneapolis's elite Mount Curve Avenue.

More than anything else, though, Stevens's greatest contribution to the music scene was his role in opening the club that would become First Avenue. As his website tells it: "in 1970, he leased the former Greyhound bus station and transformed it into a popular nightclub. Simply called 'The Depot,' the club was the creative result of Danny, his brother Mickey, and Skip Goucher."

Conspicuously omitted from Stevens's version of the history is Allan Fingerhut. The two men are as different physically as are their accounts of the club's founding. Stevens loomed a foot taller than Fingerhut and had an athlete's physique, piercing blue eyes, and thick, wavy, sandy blond hair worn in a dramatic comb-over that he still sports to this day. He still carries grudges from back then, too. Stevens feels he was cut out of the club without receiving his due share. Even in 2016, during the writing of this book, he was exploring a lawsuit based on the idea that his name was unjustly removed from the club's liquor license at some point in its first four decades. Stevens has not been involved in the club's operations since its earliest years, however.

Danny and his tambourine-shaking, aviator-attired showman brother Mickey started knocking around bands together while at West High School in Minneapolis in the early '60s. The brothers fell hard for the British Invasion bands, and in 1967 they landed a local hit as Danny's Reasons on Twin Cities radio station WDGY, covering the Rolling Stones' "Under My Thumb." That got them to New York and an appearance on *The Mike Douglas Show*. From there, they went on national tours and, for a while, were managed by Bob Dylan's brother, David Zimmerman. One of the Twin Cities' top booking agents, Marsh Edelstein, represented them.

"Everybody knew Danny Stevens back then, and not

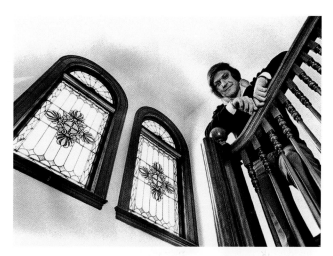

Depot cofounder Danny Stevens at his twenty-room mansion in Minneapolis. *Photo by Richard Olsenius, Star Tribune*

just among the music community," Edelstein said. "People would follow him around; he was sort of a ringleader."

Even during his band's heyday, Stevens branched out into other business ventures. One was booking at a former vaudeville club called Diamond Lil's, housed in the Normandy Hotel at Eighth Street and Fourth Avenue South in downtown Minneapolis. In the mid-'60s, Diamond Lil's became a well-known live music venue thanks to a residency by the Dave Rooney Trio, one of the Twin Cities' preeminent jazz bands at the time. When Stevens got involved, the club's name changed to Times Square and its format turned toward rock. He booked Danny's Reasons to perform in the four-hundred-person-capacity club after big concerts at the nearby Minneapolis Auditorium or Minneapolis Armory; sometimes Danny's Reasons was the opening act at those larger venues and then hosted the unofficial after party at Times Square. Among the big-time acts who did double-duty at the armory and Times Square were Janis Joplin and Johnny and Edgar Winter.

The armory regularly hosted concerts in those days, a sign of the dearth of midsize venues in the Twin Cities to host the growing number of in-demand touring rock bands. In 1970, Minneapolis had only two other concert halls comparable in size to the Depot: the Guthrie Theater and the Labor Temple; one a fondly remembered landmark, the other something of a forgotten footnote.

The Labor Temple was the site of some major rock concerts in the late 1960s. This poster for a Grateful Dead show in February 1969 was designed by artist George Ostroushko.

Opened in 1963 next to the Walker Art Center, the original Guthrie was an anti-Broadway theater boldly envisioned by British actor Sir Tyrone Guthrie. His theater company immediately caused a stir nationwide, but the Guthrie also proved a groundbreaking music venue almost from the start. It hosted the first-ever recording by New Orleans's Preservation Hall Jazz Band in 1964 and mid-'60s appearances by Miles Davis and Charles Mingus. By the time the Depot opened in 1970, the Guthrie was hosting rock legends such as the Who, Led Zeppelin, the Grateful Dead, and Elton John. But there were obvious downsides to the Guthrie as a rock venue. Concerts

had to be booked around the theater company's productions. And, a real bummer to the hippies of the day, it was a seated venue with little to no room for dancing.

The Labor Temple, conversely, became a frequent site for rock concerts in the late '60s, if for no other reason than it was there and available and had plenty of room for dancing. It was a rather nondescript space with room for about fifteen hundred, on the third floor of a 1920s-era Masonic Temple, across the river from downtown Minneapolis on the corner of Central Avenue and Fourth Street Southeast. Scott Greenblatt, a University of Minnesota student who would later attend many of the Depot's earliest concerts, remembered the Labor Temple as "pretty much a dump, with terrible sound." It catered to African American crowds in the 1950s with concerts by the likes of Dinah Washington and Percy Mayfield. In the late '60s, the Grateful Dead, the Byrds, and Grand Funk Railroad played there, as did several acts that later ended up at the Depot: Alice Cooper, the Faces, Jethro Tull, and Procol Harum.

Danny Stevens recognized the need for a rock venue sized between a typical nightclub and the dated, dingy armory and auditoriums. Times Square's tenure as a rock club would be short-lived, though. The owner, a prominent Minneapolis businessman named Jack Dow, wanted to sell the club and the hotel that housed it. Stevens said Dow didn't want rock 'n' roll riffraff or the African American groups and their audiences bringing down the property's value. So Dow offered Stevens the chance to open a new club elsewhere using the liquor license from another of his downtown properties, the Hotel Hastings, which was about to be torn down.

"Jack Dow essentially wanted to wash his hands of us, so he bought me out by offering me the Hotel Hastings's Class A liquor license," Stevens remembers. "That's very important: Those liquor licenses were very hard to get, and they don't really have them anymore. You could do any kind of entertainment you wanted with those licenses: girls, dancing, comedy, whatever."

As vital as the liquor license was, it did Stevens no good without an address or start-up money. Skip Goucher may have been the one to come up with the location. A

fledgling Minneapolis concert promoter who grew up in neighboring Robbinsdale, Goucher would be around for only the first few months of the Depot before he and Fingerhut got into a dispute. Goucher's son said his dad, who died in September 2015, always claimed credit for dreaming up the club, but newspaper articles published at the time of the Depot's opening don't mention his name.

"There was no Fingerhut at that point," Stevens insisted. "I didn't even know who the kid was." Instead, Stevens said he initially found support from a member of an even more prominent and wealthy Minneapolis family, Elizabeth Heffelfinger, part of the Peavey mill-operating clan. Heffelfinger, then in her sixties, had sold Stevens the party mansion on Mount Curve Avenue. Her granddaughter, Kate Heffelfinger, wouldn't put it past her grandmother to have been involved in the club's birth. "That would be cool to think she might've, because she was that kind of a lady," Kate said. "She made a lot of random investments." However, Kate did not remember hearing any talk of either the Depot/First Avenue or Stevens being among Elizabeth's business ventures.

As Stevens remembered it: "I sat down with her, and she said, 'God, Danny, I know Jack Dow, too. Let's put something together.' Jack was contacted by Mrs. Heffelfinger, and she told him she was going to be my partner and we had special plans. About the time we were talking to Ted and Marvin Mann [owners of Minneapolis's vacant bus depot building], Mrs. Heffelfinger started getting sick. She said, 'I'll be your partner. We'll get the doors open and whatnot. But if you find somebody else, fine.' I wanted to make sure I found a partner who didn't interrupt my ideas. Some real—I'm not sure the right word to use—some real questionable people came to me and said, 'We know somebody with a lot of money.'"

That somebody was Allan Fingerhut, who disputed Stevens's story. "What would sweet, old Mrs. Heffelfinger want to do with Danny Stevens?" he said. Rather, Fingerhut claimed he first talked to Skip Goucher about the idea, and Skip then brought Danny to his attention because of the liquor license.

"In one of the meetings we were told it would cost about $10,000 to buy a liquor license, so we went looking around for one," Fingerhut said. "Skip Goucher had the original idea. Others will say they had it before him. Other people came and went in our early meetings. Danny was the one able to get us a liquor license."

Even before the current structure was built in 1937, buses lined up at the original depot located at First and Seventh. *Minnesota Historical Society Collections*

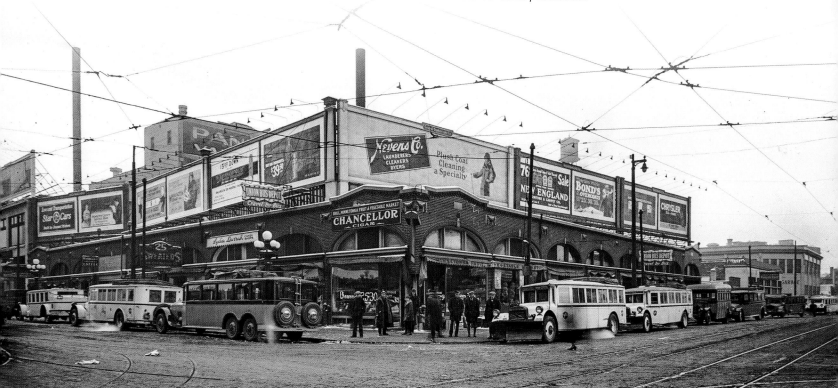

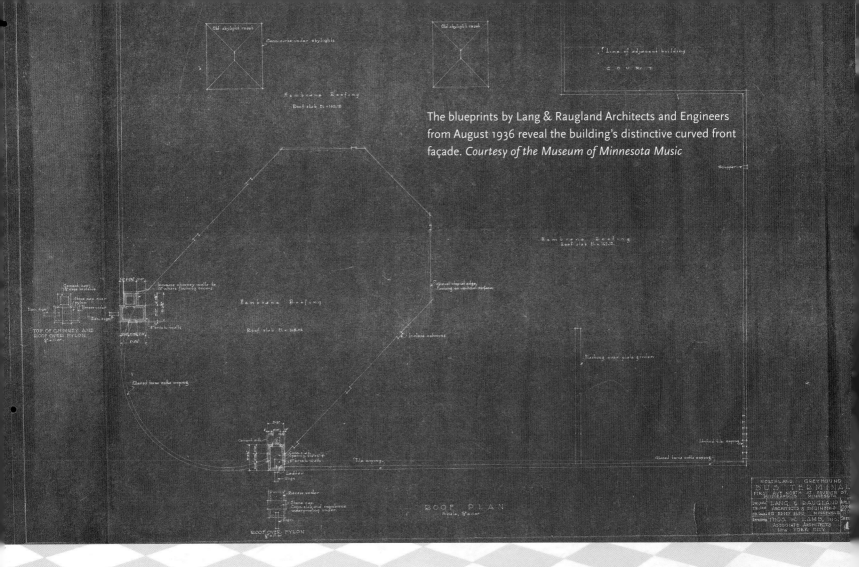

The blueprints by Lang & Raugland Architects and Engineers from August 1936 reveal the building's distinctive curved front façade. *Courtesy of the Museum of Minnesota Music*

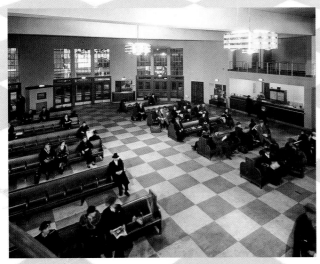

After three decades as a bus depot and nearly half a century as a rock venue, the building's distinctive black-and-white tile floor has seen a lot of action since the building opened in 1937. *Minnesota Historical Society Collections*

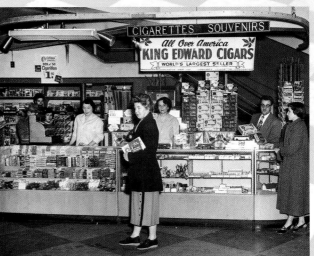

A newsstand offered newspapers, magazines, candy, cigars, cigarettes, and souvenirs for travelers at the bus depot. *Minnesota Historical Society Collections*

There's something cool and symbolic and even Minnesotan about First Avenue being housed in a former Greyhound bus depot. The national bus company is a coincidental crossroads in state history: The builder of Minnesota's most famous music venue was founded up north in Hibbing, a mining town also known as the birthplace of the state's most famous musical son, Robert Zimmerman. The quirkier child of Abe and Betty Zimmerman occasionally hung out at the club in the '70s and '80s, long after he became Bob Dylan. As of this writing, though, he has yet to perform there, despite many attempts to lure him.

Booking agent Marsh Edelstein said certain facets of both Stevens's and Fingerhut's stories check out, and both young men had the drive and ego to pull off opening the rock club. "Danny would get into meetings, and I don't know how he did it, but he would get things going and get it moving," Edelstein said. "Allan had a big name, too, the Fingerhut name, and Allan could back up his ideas financially. Between the two of them, that was a good combo. If either of them had found another partner, I don't know if it would've worked."

One thing the pair did agree on, and still do: They found the perfect location. "It really looked like it was meant to be a rock club when we went in there," Fingerhut recalled.

The unusually shaped two-story building on the corner of Seventh Street and First Avenue North in downtown Minneapolis had been vacant for a couple of years when Fingerhut and Stevens came up with the right idea of what to do with it. Opened in February 1937, the Northland Greyhound Bus Depot was both regal and popular, and a source of pride for Minneapolitans. Homegrown architects Oscar Lang and Arnold Raugland and their namesake firm designed the twenty-two-thousand-square-foot facility with art deco flourishes.

At the depot's ribbon-cutting ceremony, an orchestra called the Gopher Melody Men became technically the

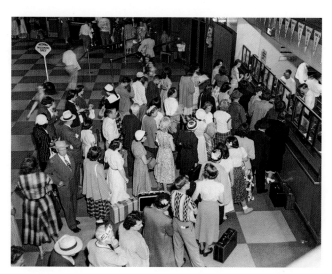

The ticket counters at the bus depot were located in the back right area of the building, near the rear doors that led to the garage. A bar and band merchandise tables now occupy the space where the counters were. *Minnesota Historical Society Collections*

Large windows allowed plenty of sunlight into the café at the Northland Greyhound depot—a stark contrast to the distinctly dark and windowless 7th Street Entry currently occupying this space. *Minnesota Historical Society Collections*

first band to play the hallowed musical ground. Passengers entered the depot through four doors that curved along the corner of Seventh Street and First Avenue. This entrance looks relatively unchanged today aside from the bluish gray paint that is now all black and, of course, the addition of "Butthole Surfers," "Gwar," and other bands' names in painted stars on the exterior walls. Back then, long rows of windows on each side of the doors (gasp!) let in sunshine; the curved outlines of the windows can be seen today amid the varying brick patterns.

Once inside, bus patrons would walk to the right to buy their tickets at gated counters in the back corner, the area that now houses a bar, coat check, and bands' merch tables. Benches were lined up under large chrome-trimmed chandeliers in the main waiting area, which is now the dance floor in front of the stage—with the same black-and-white checkered terrazzo floor that has proven unimaginably resilient since 1937—and then exit through another set of doors in the back to board the buses in the garage. Upstairs were restrooms, showers, and snack and general store counters. To the left of the front entrance, a café was located in the room that's now 7th Street Entry.

When it came time to board buses, the riders would walk through doorways along what's now the wall behind the big stage. That area is still used as a garage to this day, although it wasn't until the late 2000s that modern tour buses could enter, thanks to an expanded entryway off First Avenue. The garage doors along Seventh Street are now the front walls of the club's restaurant, the Depot Tavern, which opened in 2009.

The two guys who would tangle in court over ownership of the building decades later, Allan Fingerhut and Byron Frank, found the original bus depot a nice place to hang out when they were growing up. "We would go in there and play pinball all day together as kids, until they'd come along and kick us out," Frank remembered.

The Northland Greyhound depot shut down in 1968 when bus operations moved to a new, larger facility a few blocks away. Minneapolis theater maven Ted Mann wound up owning the vacant depot. Along with his brother Marvin, Ted ran the Pantages, State, and Orpheum

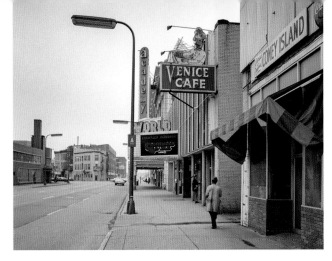

When the Depot music venue opened in 1970, the World Theatre was located across the street and housed the offices of the Mann movie theater family. *Photo by Mike Evangelist*

theaters on Hennepin Avenue, just around the corner from the depot, plus many other movie houses in town. Ted's nephew Steve Mann, who now helms the family's chain of nine theaters in Minnesota, said no one in the family or company remembers exactly how Ted came to own the depot property, except that it might have been "some kind of block deal."

The Manns worked out of offices above one of their theaters, the World, across Seventh Street from the depot on the notorious Block E. Allan Fingerhut remembered calling to ask where their offices were located. "We're on the second floor of the World," Ted's assistant replied, prompting a bemused Fingerhut to use it as a name for the Depot's upstairs bar: Second Floor of the World.

Fingerhut believed the initial rent deal he struck with Mann was for about $3,500 a month. "That was pretty cheap for a property that size," he said. One reason it was relatively affordable was because a lot of work had to be done to remold the space into something new. Construction took about six months, he recalled.

"It was a mess," he said. "In order to make it work, we had to take out the [ticket] cages. When you go in now and go to the right, it's all wide open now. That had all the ticket booths on that wall. It was pretty much straight down from the walkway up above where the bathrooms are. First thing we did was take a big mallet and make a big puncture in that wall and tore it down.

"After that, though, it was just so perfect. We knew exactly where to put the stage."

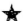

"The sign of good things to come," read an ad with the Depot logo in *Connie's Insider*, one of several publications to run promos in the months leading up to the April 3, 1970, opening.

The Depot name wasn't settled on until shortly before those ads ran. Fingerhut says they came close to calling it the Electric Hound, a more psychedelic-sounding nod to the building's Greyhound past. Stevens's memory of the naming was more surprising and, if true, noteworthy in the annals of national rock-venue history: He said it nearly become the Fillmore Midwest, an offshoot of pioneering rock promoter Bill Graham's famed San Francisco and New York clubs.

"I knew Bill Graham through Timothy D. Kehr," Stevens recounted, referring to the late Twin Cities record producer of the Castaways' "Liar, Liar" notoriety, who at the time worked with Graham's associate Clive Davis at Columbia Records. Said Stevens, "I said I want it to be the Fillmore Midwest. I worked out a deal with Bill where, any time an act was passing from the East Coast to West Coast, or vice-versa, they'd let us know if they came into our area. It was a good deal, because it would make it cheaper for all of us. Bands back then still didn't fly much."

Fingerhut recalled having only one conversation with Graham, but, however serious the idea was for Fillmore Midwest, it didn't last.

"Rock-band Night Club to Open in Bus Depot," read a headline in the *Minneapolis Star* on February 24, 1970, five weeks before the opening concert. "The waiting-room area is being redecorated in a mod atmosphere for the club owner, a new corporation called The Committee. Allan Fingerhut is chairman of the board, and Danny Stevens, of the Danny's Reasons rock band, president. Facilities will include four bars, a record shop, a novelty store and two mod clothing shops. Acts lined up for April include the Joe Cocker Band, Vanilla Fudge, Canned Heat and the Bangor Flying Circus. Fingerhut said acoustics in the hall are 'perfect.'"

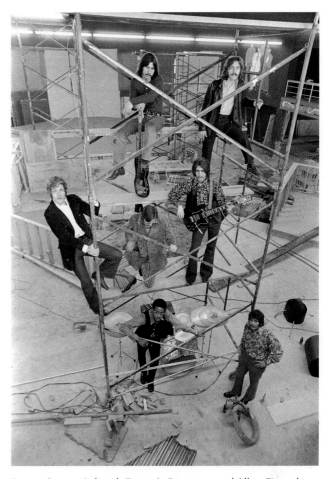

Danny Stevens's band, Danny's Reasons, and Allan Fingerhut posed on construction scaffolding for a promo article about the venue's impending opening: (top, left to right) Keith Krupp and Chuck Edwards; (middle) Danny Stevens, Mickey Stevens, and Tom Hopps; (bottom) Jimmy Lawrence and Allan Fingerhut. *Photo by Mike Zerby, Minneapolis Tribune; Minneapolis, St. Paul, and Edina newspaper photographs collection, Minnesota Historical Society*

The week before the opening, the *Minneapolis Tribune* ran a large centerpiece photo on the front page with the headline, "A Short Wait at the Depot." In the photo, Stevens and the rest of Danny's Reasons are standing under and on scaffolding that was still being used inside the club a week before the opening. The copy with the photo teased to Joe Cocker and the Grease Band playing the following weekend. ∎

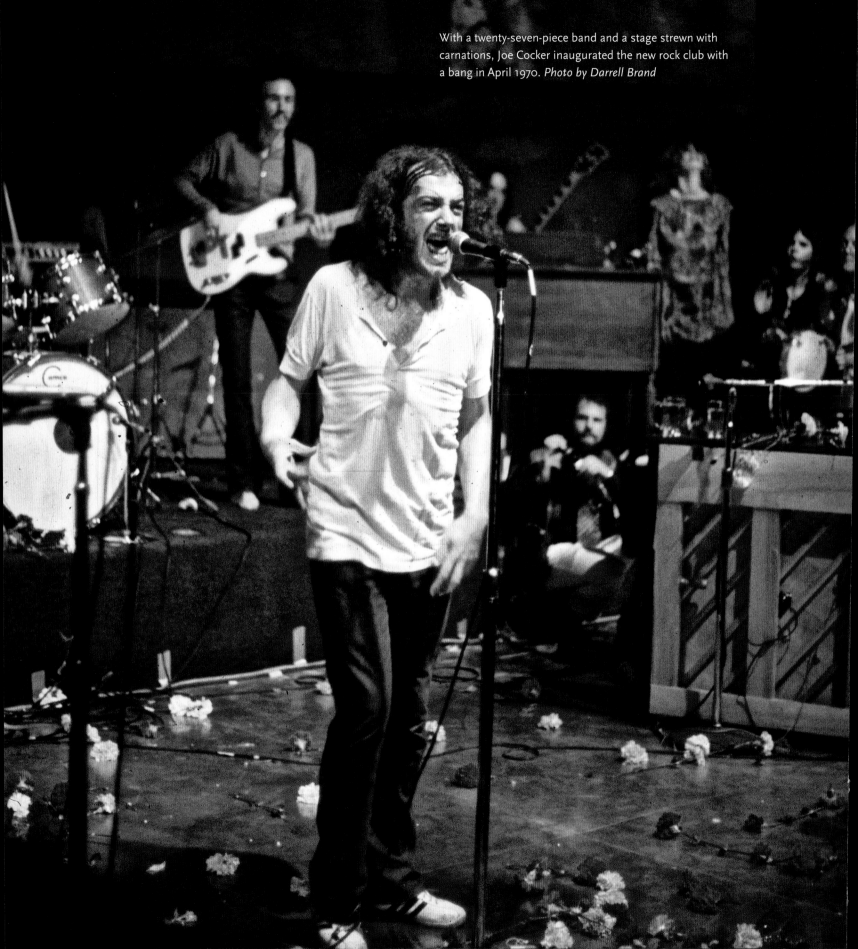

With a twenty-seven-piece band and a stage strewn with carnations, Joe Cocker inaugurated the new rock club with a bang in April 1970. *Photo by Darrell Brand*

GETTING ROLLING WITH THE DEPOT

1970–1971

"Not since the truck drivers' strike of 1934 is it likely that there has been such excitement, such chaos, such congestion, such noise just off Hennepin Av. as there was Friday night."

—ALLAN HOLBERT, *MINNEAPOLIS TRIBUNE*, APRIL 4, 1970

A prophetic sign of how up-close and personal fans would get with their rock 'n' roll heroes over the next five decades at the converted bus depot, Scott Greenblatt had his first encounter with Joe Cocker even before the first notes rang out on the Depot's opening night, April 3, 1970. It happened at the urinal trough. The club's lack of a bathroom in the backstage dressing room was one of many peculiarities that immediately set it apart, a structural shortcoming that would become an odd part of the venue's lore well into its First Avenue years. On opening night, Cocker had to fight through the crowd and use the second-floor rest rooms, just like your average Joe.

"I didn't say anything to him and didn't know what to say, I was so dumbfounded," said Greenblatt, a University of Minnesota student at the time who, like so many other Twin Cities music fans, would enjoy some of the best concert experiences of his life at the Depot over the next fifteen months. But the first was his most unforgettable, for more reasons than the brief relief encounter. "Here was a nineteen-year-old kid standing next to a rock icon

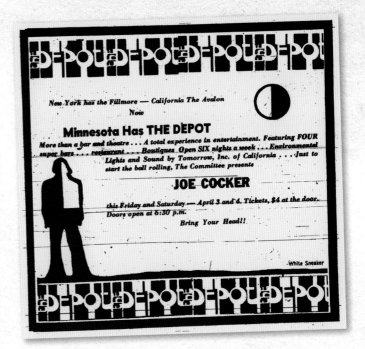

"More than a bar and theatre," proclaimed this early advertisement, the Depot was "a total experience in entertainment" with "FOUR super bars." *Courtesy of Robb Henry*

taking a piss. I just remember thinking, 'Wow, they really don't have a bathroom anywhere backstage for the performers?!'".

Cocker, then twenty-five, was actually a backup choice for opening night. Allan Fingerhut and Danny Stevens got help from Bill Graham in San Francisco in lining up another young star to inaugurate their new venue: Carlos Santana and his namesake band. Santana cancelled a few months out, though, for reasons not quite clear. At least one of the club's cofounders was none too excited about the replacement offered. "I told [Cocker's agent] I had just played with Joe Cocker and the Grease Band a few months earlier, and it wasn't that spectacular," Danny Stevens recalled. His band, Danny's Reasons, opened for Cocker during an earlier tour in December 1969 at a teen club dubiously named the Prison, attached to Burnsville Bowl in suburban Minneapolis. "They told me, 'No, no. He's got a new band this time.'"

Stevens found out just how different Cocker's band was when he went out to the airport to greet the singer and his entourage upon their arrival in Minneapolis on that frigid April 3. They had a private plane for the tour, with "Cocker Power" emblazoned on the side. "They opened the door to the prop plane, and even a hundred yards away we could've gotten high off the smoke that came out," remembered Stevens. That wasn't the surprising part, though. "People just kept coming off the plane," he added. "There were so many of them."

The Englishman put together the oversized band for his *Mad Dogs & Englishmen* tour on the fly and under the gun. The group's enormity—forty-some members, including twenty-seven musicians, three preschoolers, and a dog—was a sign of the freewheeling attitude of the day. It was also something of a spiteful move by Cocker against his manager, Dee Anthony, and the team at Bandana Management. They had seen a breakthrough opportunity in the wake of the documentary film about the Woodstock Festival and its accompanying soundtrack, in which Cocker had prominent roles, and rushed to put together a U.S. tour; Cocker found out about it less than two weeks before its March 20 kick-off in Detroit. They also hired a film crew to make a subsequent movie

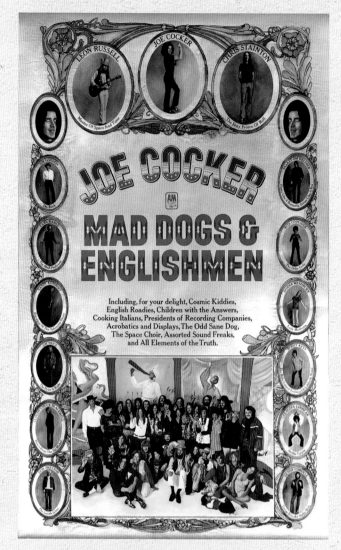

Hot on the heels of a triumphant performance at the Woodstock Festival and its follow-up film, Joe Cocker took off on a major U.S. tour in the spring of 1970. Cocker and his massive entourage came to the Depot in Minneapolis just two weeks into the tour.

focused on Cocker. They told him if he didn't go through with the tour, he could lose his U.S. working papers and would have to go back to England. Everything was taken care of for the tour except for hiring the band. That was left up to Joe.

Newly ensconced in Los Angeles, the Sheffield native turned to his chum Leon Russell as bandleader. Russell had coproduced Cocker's eponymous 1969 album and

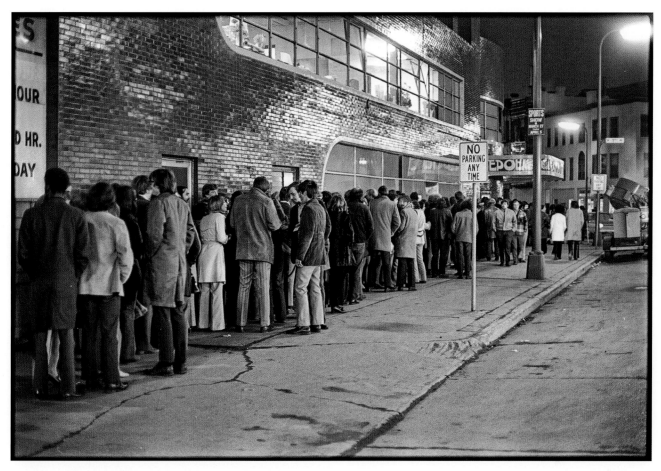

The front page of the *Minneapolis Tribune* on the morning of April 4, 1970, featured this photo of eager fans lining up for the inaugural concert at Minneapolis's new rock venue. *Photo by Skip Krueger, Minneapolis Tribune; Minneapolis, St. Paul, and Edina newspaper photographs collection, Minnesota Historical Society*

wrote his second U.K. hit, "Delta Lady." By then, the piano plunker from Tulsa was a well-established Los Angeles session player and part of the fabled Wrecking Crew of studio musicians. Russell also worked with the folk-rock duo Delaney & Bonnie; he cherry-picked the backing band from their just-completed tour with Blind Faith for Cocker's hastily arranged tour. Among the recruits: backup singer Rita Coolidge, who in the coming years scored her own hits and toured with husband Kris Kristofferson; saxophonist Bobby Keys, who spent the next four decades touring with the Rolling Stones; bassist Carl Radle, who went on to be one of Eric Clapton's longest-tenured sidemen; drummer Jim Gordon, soon to join Clapton in Derek & the Dominos; and another drummer, Jim

Keltner, who became a top-tier session player for John Lennon, George Harrison, and others. Additional noteworthy members among the twenty-seven musicians included Cocker's longtime keyboardist/producer Chris Stainton and backup singer Claudia Lennear, later immortalized by the Stones' "Brown Sugar" and in the 2013 documentary *20 Feet from Stardom*.

Cocker's gargantuan ensemble rehearsed in L.A. over four twelve-hour days, then hit the road, playing forty-eight cities in fifty-two days. One week into the tour, they recorded the landmark *Mad Dogs & Englishmen* live double album at the Fillmore East in New York. The format of those New York shows—four sets over two nights—would be repeated a week later at the Depot in

Minneapolis. Despite tickets going for what was then a rather steep ten dollars for reserved seats and four dollars for general admission, each set was sold out. About two thousand fans crammed inside the converted bus station for the shows. The capacity would later be set between twelve and fifteen hundred people, after many fire-code upgrades.

Members of Cocker's entourage had no idea they were there to inaugurate a new venue. Forty-five years later, they were surprised to learn that the Depot still exists as the now-legendary First Avenue. Cocker admitted he didn't remember the Minneapolis date on the *Mad Dogs* tour, even after he returned to the venue in 1994. "The Depot? It doesn't ring a bell at all to me," he said in a *Star Tribune* interview.

Some tour members did vividly recall the gigs, in part because the Depot was the smallest site on the tour, otherwise mostly made up of auditoriums. "That night definitely stood out from all the rest, just because the venue was so different—and so packed," recalled Linda Wolf, who, at age nineteen, was hired to be a photographer for the tour. "It really was like joining the circus," Wolf noted, pointing to the young children of musicians who were part of the caravan and to the tour's mascot, Canina, a fox terrier. "It was total mayhem, but there was a lot of sweetness and love involved, too."

Fingerhut would later complain to the press that the terrier did her business on the floor of the club. However, Canina's owner, Pamela Polland, has fond memories of those shows. "I always thought of the Depot as the only true club date we did on the tour," said Polland, who was part of the so-called Space Choir, Cocker's large team of backup vocalists. "The Depot was packed to the rafters, and that was a *great* gig—as is evidenced in the video footage," she said.

The footage Polland referred to is Cocker's performance of "The Letter" in the *Mad Dogs & Englishmen* concert film, which was shot by director Pierre Adidge at the Depot. The film shows a shaggy, shaky Cocker dressed in a white, tunic-like shirt performing in front of a curved white screen, part of a psychedelic lighting backdrop featured in all the early Depot concerts. At the

end of the scene, the camera pans around for audience reaction. Any First Ave regular will recognize the club's two-story layout, with the wraparound balcony and back bar. It looks virtually the same as it does today (aside from two side staircases later added). A noticeable difference in the *Mad Dogs* scene: Daylight pours in from the front of the club, which confirms that performance as the early evening set—and demonstrates how bright it could get before the windows alongside the front entrance were bricked up. In the final seconds of the scene, Cocker walks offstage toward the doorway that now leads to 7th Street Entry, then a storage space.

While audience members always seem to mention Polland's dog, the detail that members of Cocker's tour usually bring up first in remembering those nights are the carnations. Allan Fingerhut had ordered two thousand of the fragrant flowers for his club's opening. "Just to brighten things up," he said. The flowers were eventually tossed around all over the room, including onto the stage. "Carnations up the wazoo!" recalled Polland, who we see in the movie draping a lei-like necklace of carnations over Cocker's head. "He wore it for part of the set, but took it off after a while because it was too cumbersome," the backup singer remembered. The film also shows a red carnation conspicuously sticking out of Bobby Keys's saxophone.

Musical highlights included the two hits off Cocker's 1969 album, "Feelin' Alright" and "Delta Lady," plus artfully rearranged versions of the Stones' "Honky Tonk Women," Leonard Cohen's "Bird on a Wire," and two recently issued Beatles tunes, "She Came in Through the Bathroom Window" and "Something." Coolidge and Lennear each got a turn to shine out front, singing "Superstar" and "Let It Be," respectively. The sets ended with another Beatles cover, the one Cocker also sang on-screen in *Woodstock*. Darrell Brand, a photographer who covered the concerts for Minneapolis's music tabloid *Connie's Insider*, said, "I do remember when he got to 'With a Little Help from My Friends.' That really was *the song*. It felt like the show's big moment."

Several hometown photographers were there to document one of the most historic nights in Minnesota

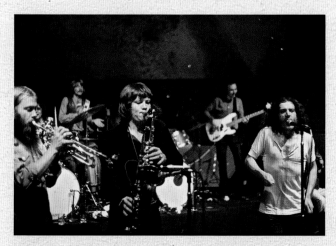

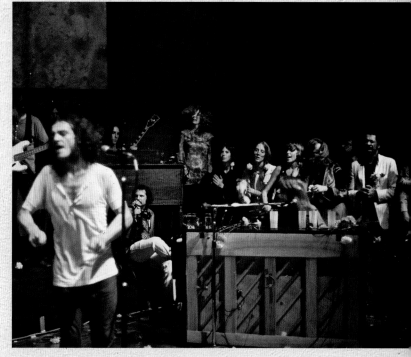

(Above) Trumpet player Jim Price and saxophonist Bobby Keys were prominent session musicians brought on board for the *Mad Dogs & Englishmen* tour. Both toured extensively with the Rolling Stones, and both were plucked from Delaney & Bonnie's backing band. *(Right)* A large troupe of backup singers accompanied Cocker on tour and at the Depot. *Photos by Darrell Brand*

music history. Mike Barich's portrait of the singer, taken off to the side of the stage, later appeared on the cover of the August 1970 issue of *Circus* magazine. "Joe Cocker needs time to think," the headline declared, a reflection of the singer's ragged state as the *Mad Dogs* tour came to a close. The backdrop of the club was edited out, but the image shows Cocker wearing the same white garb as seen in the movie, and he's holding a yellow carnation. "Joe was pretty cool about doing it," remembered Barich, who went on to shoot many more concerts during the Depot era. Cocker "was certainly the most exciting thing they ever had there," he said. "That night it seemed intimate, even though the place was packed."

"It was a great way to start," agreed Fingerhut. "I couldn't have been more proud in the end. The band was just so terrific. [It's] one of the best tours in the history of rock, and we had it for our opener."

In a sharp contrast to the flowery and familial vibe onstage, however, a bona-fide shakedown took place behind the scenes in the office upstairs. Someone representing the singer demanded more money from the untested club owners after the band's rapturously received first set. If more money wasn't handed over, there'd be no second set. Tour photographer Linda Wolf was not surprised to hear about the incident decades later. "There was a lot of shady stuff going on that Joe didn't know about," she said. "He really wasn't happy with the way things were being handled."

Both Stevens and Byron Frank—then Fingerhut's accountant—agreed that Cocker likely was unaware of the shakedown. Stevens remembered, "The manager came up to the office after the first show and said, 'I want more money.' He said, 'You didn't tell us you were going to have this kind of crowd.' They saw the lines. We said, 'You said a contract for X amount of money.'" Cocker's initial agreed-to fee was around $15,000. Frank thought the shakedown was for several thousand dollars more—big money in 1970, even to a catalog fortune heir. "I said to Allan, 'What do you want to do?'" Frank recalled. "He said, 'Count it out.' Our thought was that Cocker probably never even saw that money. That money probably stayed with that manager. Why would he insist on cash?"

Fingerhut downplays the incident now. "The tour was so big, I'm sure they needed the money," he said. "We

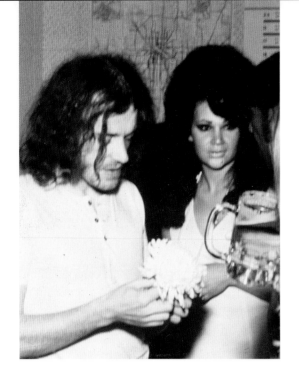

booked them months ahead of time, and I don't think they expected *Woodstock* to be as big a success as it was. They wanted it, and I paid it." The true debacle from his first weekend as a club owner was the fact that the purple shag carpet did not show up on time. You read that right: purple shag carpet. It was intended to match the new paint on the interior walls. Yes, the walls were purple, too—quite a contrast to the all-black transformation twelve years later, when the venue became First Avenue. In 1970, Fingerhut chose purple in homage to the Minnesota Vikings. "I was so mad about the carpet," he said, and it was evident he was still fuming forty-five years later. It arrived a week or two after the opening and would be the source of much ridicule in the years to come.

(Above) The scene offstage appears amicable enough in this photo, showing Joe Cocker and Sharon Fingerhut on opening weekend in April 1970, but Cocker's people were putting the squeeze on Allan Fingerhut for more money. *Courtesy of Sharon Fingerhut.* *(Below)* The view from the second level reveals a stage packed with musicians for the inaugural Depot concert. Chaser lights highlight the bar on the main floor. *Photo by Darrell Brand.* *(Below inset)* Mike Barich's photo of Joe Cocker taken during the Depot show later appeared on the cover of *Circus* magazine, which asks "Will Cocker Crumble?" following the exhausting *Mad Dogs* tour.

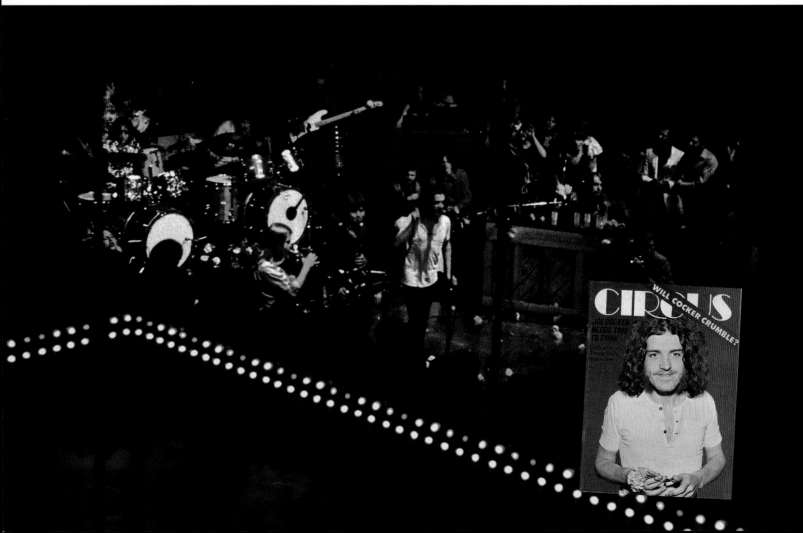

A few other visual traits of the club that would out-live even the disco era were also in place on opening night. White screens around the stage used for lighting effects during Cocker's performances also showed *Road-runner* cartoons and 1940s newsreels, in much the same way as the wrestling matches and music videos projected onto the giant screen in the decades to come. The chase lighting panels hovering over the three bars on the main floor were also in place on opening night. Fingerhut liked the look of the overhead lights outlining the shape of the bars, but it was also a shrewd way to highlight where the money was made. "As soon as the bands would finish," Fingerhut said, "we would shut off all the lights and just have the chasers above the bar."

On opening night, the bars were sufficiently lit up, but not, unfortunately, sufficiently stocked. With a sold-out crowd patiently awaiting Cocker's arrival since doors opened at 6:30 PM, the bars started running out of supply even before the first set, about two hours later. Fingerhut blames the shortfall on the liquor-license holder, Stevens. "I was running around taking care of everything else. That wasn't my responsibility," Finger-hut said. "Opening night, you didn't want to overbuy, but we had no idea what was going to happen or how many people were going to show."

> "The club didn't make any money from the start."
> —Byron Frank

Between the unexpected spike in the talent fee and the loss in potential alcohol sales, Fingerhut's accountant offered this simple assessment: "The club didn't make any money from the start," Frank said.

For the local press, the Depot's opening was a major news story. However, most of the newspapermen (yes, all men) also treated the ambitious rock club with derision. The *Minneapolis Tribune* ran the story the next morning

as its front-page centerpiece, with a large photo showing fans lined up under the Depot marquee. "Not since the truck drivers' strike of 1934 is it likely that there has been such excitement, such chaos, such congestion, such noise just off Hennepin Av. as there was Friday night," wrote lifestyle reporter Allan Holbert, who made note of Fingerhut's anger over the missing carpeting and the booze shortage. He also showed an unusually high amount of snark for the front page. "The beautiful people in their bell bottoms, furs and long hair stood or sat patiently," one paragraph read. "Then along came Joe Cocker in his long hair, skivy shirt and blue jeans. He worked hard, singing like a black man, which he isn't, and doing his dancing stuff like a spastic, which he isn't either."

"Beautiful people" also showed up in a five-page spread in the *Twin Citian*, the metro area's first magazine: "Beautiful people jammed the table area, most of them with resplendent sun tans and $250 hippie outfits. A lot of people came stoned, which helped them endure standing in the line that extended four abreast from the entrance all the way down to Hennepin Avenue." The story went on to describe Cocker's 11:30 set as the wilder of the two, as the stylish, well-heeled hippie hipsters left and "the hard core rock freaks moved in on the privileged table area," writer Tony Swan recounted. "And girls—adult, grown-up girls—began saying things like, 'My God, he's beautiful, he's just beautiful!'"

The *Minneapolis Star* was even more disdainful. "The thought of having rock concerts at the old Greyhound bus depot was one that could have blossomed into a good thing," read a review the following Monday, "[but] the new club's directors, who call themselves the Committee, have managed to cast a pall on the whole concept." The writer, Marshall Fine, went on to complain that "the remodeling was unfinished" and "the seating was inadequate" (which sounds funny nowadays, when there are hardly any chairs in the club). Fine also bemoaned "the inane idea of making the whole place a mammoth bar, as if the entertainment were incidental" (a complaint that also sounds laughably outdated today).

Venerable *Tribune* columnist Jim Klobuchar had some of the best lines. In a write-up that doubled as

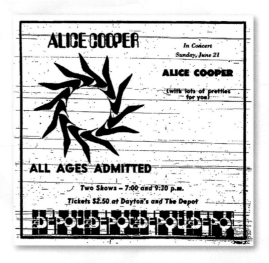

While some journalists bemoaned the lack of seating on opening night, tables and chairs filled what in later years would become an open dance floor with little or no seating. *Courtesy of Sharon Fingerhut*

The Alice Cooper concerts on June 21, 1970, were Sunday-night, all-ages sets, which meant strong ticket sales but weak booze sales. *Courtesy of Robb Henry*

a lament for the old bus depot and old days in general, he wrote that the Depot "now gives asylum against the Golden Strings culture of Minneapolis," a reference to the city's popular milquetoast supper-club orchestra of the '60s. "There is no question that Allan Fingerhut's music asylum plays to some of the biggest and most tumultuous crowds in the Twin Cities. When the joint is moving full-stride, with all mufflers removed, Williams Arena [the University of Minnesota basketball arena] mid-tournament is a confessional booth by comparison."

Still, the old-guard press contingent recognized the generational shift inherent in the Depot's opening. Supper clubs with waiters and seated music theaters with a bar out in the lobby were giving way to large, general-admission venues with bars on all sides. Fans didn't mind standing in long lines outside—or waiting through long set breaks inside—so long as they got a loud, in-your-face rock 'n' roll show, with easy access to liquor.

Younger music fans took to the Depot immediately. Students from the University of Minnesota and the Twin Cities' many smaller colleges were the biggest customer base. Stories abound of men hanging out at the club either before or after they were sent off to serve in the Vietnam

War, a sign of its audience's youthfulness as well as a reminder of the tumultuous era it opened in. The drinking age was twenty-one, but fake IDs were in plentiful supply. High schoolers could go to the club legally on Sundays, because liquor laws at the time prohibited alcohol sales there. No booze meant no age limits. Fingerhut, Stevens, and the Depot team made a boneheaded decision to book many of the biggest concerts on Sundays—including the Faces, Frank Zappa, and Alice Cooper—knowing they could sell more tickets with all-ages crowds. The shows were packed, sure, but the club saw much slimmer profits with the younger, non-drinking crowds.

The kids had been waiting for a place like this. Richfield High School student Peter Dzubay, a budding guitarist who took in the Faces and Alice Cooper at the Depot, remembered the stark contrast to the Doors show he saw a year earlier at Minneapolis Auditorium. "Everybody had to stay in their seat the whole time the Doors played. The Depot seemed so cool because you could go wherever you wanted, and you could get down front if you got there early." Photographer and U of M student Darrell Brand said, "There wasn't any other music venue like it in town. From the start it felt like it was *our* place." As

fellow cameraman Mike Barich put it: "The club really was a big deal. The feeling was: Everybody's going to go there. So everybody went there."

Mike's brother Steve Barich was hired to help stage the Depot's ambitious lighting show, work he had also done at a Chicago club called the Kinetic Playground. The visual gimmickry, designed by a Chicago company called Tomorrow Inc., involved slide images and liquid-light effects that moved to the music. "The whole production side was way ahead of anything else Minneapolis had to offer," Mike Barich said. "It was another reason people really wanted to go there and check the place out."

There was a dip in attendance for the second weekend's headlining act, Chicago blues revivalists the Paul Butterfield Blues Band. A review of the show in the University of Minnesota newspaper, the *Minnesota Daily*, raved about Butterfield's remade lineup and paid as much attention to the venue as it did to the performance. "[It] was a much nicer place to be this week than last," wrote Jim Gillespie. "If you wanted a table you could have one. The price of mixed drinks had been lowered.... The place definitely seems to be improving, and if they continue to bring in acts of Butterfield's caliber—next week Poco is coming for only $1.50 per ticket—it's certainly worth a visit."

The buzz caught on by the third weekend with Poco, the pioneering country-rock band featuring Buffalo Springfield's Richie Furay and Jim Messina. "They were a really hot band at the time, so it was a full house," remembered Tom Husting, a guitarist in Crockett, the local band that opened for Poco. Steve Barich said, "Poco was really enjoyable. Just a very tight band, and everyone in the crowd was into what they were doing."

The calendar really got interesting in May and June. Delaney & Bonnie canceled a pair of shows on Sunday, May 17, which left the duo's scheduled opener, Mitch Ryder, as the headliner. In turn, the Detroit-bred "Devil in a Blue Dress" hitmaker had Mojo Buford, Minneapolis's adopted blues hero, as his opening act. Buford had moved to town in 1963 after a gig at the Loon nightclub in south Minneapolis as the harmonica player in Muddy Waters's band, a role he would keep off and on into the '70s. The teenage guitarist in Buford's band, Robb Henry, remembered of Ryder, "He was great, but I spent most of the night watching his guitar player." That guitarist, Steve Howard, would join Lou Reed's band a few years later and be cemented in rock history trading licks on "Sweet Jane" for Reed's live album *Rock 'n' Roll Animal*.

A new level of prestige came the Depot's way when the owners brought in one of the original British Invasion bands. The Kinks were booked for Friday and Saturday, May 22 and 23, two sets per night. They were the kick-off dates to the band's U.S. summer tour and fell at a particularly pivotal time in Kinks history. Just a few weeks earlier, the band finished recording their album *Lola Versus Powerman and the Money-Go-Round*, which would be their first major U.S. hit since the mid '60s. Each of the four sets at the Depot, however, largely comprised songs from 1969's esoteric concept album, *Arthur (Or the Decline and Fall of the British Empire)*. That material fell flat with the Minnesota crowd, according to the *Minnesota Daily*'s Ray Olson: "The audience remained largely intransigent"—except during "You Really Got Me" and "All Day and All Night"—"and the night was pretty disappointing," he wrote of the Friday sets.

Olson also expressed surprise in his *Daily* review that neither of the Kinks' nights sold out. He blamed a big antiwar rally at the U of M campus that weekend, which included a free concert by Phil Ochs. On Saturday, Olson sat with Ray Davies in the Depot's upstairs office for a short interview, where the singer

Courtesy of Mark Freiseis

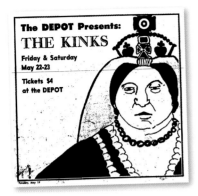

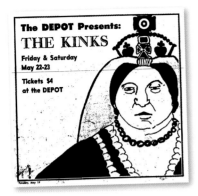

Just a few weeks before the release of their mega-hit "Lola," the Kinks kicked off their U.S. tour with two nights at the Depot. Neither show sold out. *Courtesy of Robb Henry*

observed, "It's a strange audience. I understand that a lot of students can't [be here] because of what's going on on campus." Those goings-on included a set by Danny Stevens's band Danny's Reasons. Stevens remembered taking the Kinks—or at least Ray and Dave Davies—along. "They asked if they could come with and play," Stevens said. He ended his show with the Country Joe & the Fish song "The 'Fish' Cheer/I-Feel-Like-I'm-Fixin'-to-Die Rag." "Then I asked the crowd if they wanted to hear some rock 'n' roll. I told everyone, 'They're performing later at the Depot! The Kinks!' The whole crowd surged over Washington Avenue toward the stage."

A weekend after the Kinks, Jethro Tull arrived for two all-ages sets on Sunday, May 31. Ian Anderson's flute-tooting prog-rock troupe would release *Aqualung* a year later and were still playing songs from their 1969 debut, such as "Fat Man" and "Nothing Is Easy." Then came the unlikeliest of the acts to enjoy a breakout from the *Woodstock* movie: '50s greaser revivalists Sha-Na-Na, who reportedly drew a packed house for another all-ages show on Sunday, June 7.

A whole other kind of weirdness showed up for two all-ages sets on June 21: Alice Cooper. Depot regular Peter Dzubay recalls it being a last-minute booking, so there was a barrage of ads on KQRS-FM the week of the show with the hook, "Alice Cooper: four guys and a girl from Phoenix. Or is it four girls and a guy?" There was still a buzz in the air—and maybe a few feathers, too—from Cooper's two opening gigs over the year prior with Frank Zappa at the Guthrie Theater and the Faces at the Labor Temple; all those acts would play the Depot by year's end. Cooper blew chicken feathers on the crowd at both shows, annoying unaware fans of the headlining acts.

By the time of the Depot show, Cooper had a coffin and guillotine for stage props. Fingerhut said he booked Cooper because both were fans of horror films; after talking to the performer before the show, the club owner also became a big fan of the shock rocker. Cooper proved congenial and talkative, and the real-life Vincent Furnier spilled some of his grand ideas on the young club owner that night. "He wanted to put the whole group in a weather balloon," Fingerhut recalled. "He also wanted to put fake money into balloons with helium and float them over the room, and then take out a BB gun and shoot them all and watch the money float down. He was just a really funny and charming guy."

Beyond those notable acts from the first few months, the club also showed a knack for bringing in diverse performers beyond the realm of white rock dudes. The first such headliner was Ramsey Lewis, who played a two-night weekend stand, May 8–9, 1970. An innovative jazz pianist from Chicago, Lewis was popular with both black and white audiences. He landed on the pop charts in the mid '60s with jazz rewrites of "The In Crowd" and "Hang on Sloopy." Besides being the first jazz artist to play the Depot, he was the first act of any genre to record a live album there. With Curtis Mayfield sideman Phil Upchurch on guitar, Lewis debuted new interpretations of George Harrison's "Something," the gospel standard "Oh Happy Day," and five other tunes that wound up on his next LP for the Cadet label, *Them Changes*.

A month after Lewis came another act out of Chicago: Rotary Connection, a psychedelic soul and R&B band featuring future "Lovin' You" singer Minnie Riperton on vocals. The group was then best known as the backing band on Muddy Waters's revered 1968 album *Electric Mud*.

Except for Waters, there was no bluesman more famous at the time (or any time, really) than B. B. King, who played two Sunday all-ages shows on June 28—among the most fondly remembered appearances of the Depot era. The Mississippi legend, then forty-five, had crossed over

A LUSTY ONE-NIGHTER
WITH AL JARREAU

Most Minnesotans don't know that scatting legend and all-time great jazz singer Al Jarreau, who passed away in 2017 at the age of seventy-six, lived in Minneapolis for a spell. "I had kind of a lusty one-nighter with Minneapolis," is how Jarreau described it in a 2016 interview. Originally from Milwaukee and a star athlete at nearby Ripon College, Jarreau left Wisconsin for Los Angeles looking for a record deal in the mid-'60s, to no avail. He made headway in New York in 1968, playing at comedy venues such as the Improv and Dangerfield's and even landing on *The Tonight Show* with Johnny Carson, but he still couldn't find a decent recording contract.

Jarreau's manager at the time was Sheldon Jacobs, a Minneapolis native who later launched the Shelly's Woodroast restaurant chain. Jarreau and Jacobs planned to drive cross-country back to L.A. to give it another try in 1970, but Jacobs suggested they stop in Minneapolis and stay at his mom's house. "We were just going to stay for a little while to catch our breath," Jarreau said, "but we wound up staying for a little over a year."

Jacobs contacted his childhood friend Allan Fingerhut about giving Jarreau a gig at Fingerhut's new club, and soon got it. Jarreau put together a rock-flavored band to suit the Depot's aesthetic. The versatile and quite stellar group included bassist Dik Hedlund, who later toured with Bonnie Raitt, and teenage keyboardist Rich Dworsky, who became the longtime bandleader of Garrison Keillor's internationally renowned public radio show, *A Prairie Home Companion*.

Performing under the name Jarreau, the band pulled off several well-remembered shows at the Depot, including one on September 27, 1970, opening for Long Island psychedelic rock quintet the Illusion, who had cracked the Top 40 a year earlier with "Did You See Her Eyes?" Jarreau later admitted, "What we were doing was a little against the grain, but the audience at the Depot was open to it. It was a young, hip audience that was open to new sounds. The entire city at the time really had it going on, with the university there and a lot of different cultures crossing. It was kind of a revolutionary time, and the Depot was at the center of it."

Jarreau also befriended Fingerhut during his Minneapolis stayover. "He looked like he was still about twelve years old, and here he was running this big club," the singer remembered. "I thought, 'What courage. What balls it takes to be doing this at his age.' He was really ambitious and wanted to be like Bill Graham out in San Francisco." For his part, Fingerhut gave Jarreau more than gigs. "He still owes me some money," Allan claimed with a laugh in 2015. "He was broke at the time, and he was still talking about whether or not he wanted to be a professional baseball player or a professional singer. So I loaned him some money to keep working as a singer. I'm sure he's forgotten about it, though. I'm just glad it did work out for him."

Decades later, Jarreau credited Fingerhut and the Depot for giving him a break at a pivotal time, and sparking a new artistic spirit in him. "I did some of my first writing when I was there. It's a very important era in my career, the start of the Yellow Brick Road for me. It was only a few steps, but they felt like some big steps." In fact, since Jarreau was locally based at the time, he qualifies as the most successful homegrown artist to use the Depot as a launch pad—the biggest name born out of that club until Prince showed up a decade later. ∎

Al Jarreau signed an autograph for Sharon "Mama" Fingerhut during his time in Minneapolis.
Courtesy of Sharon Fingerhut

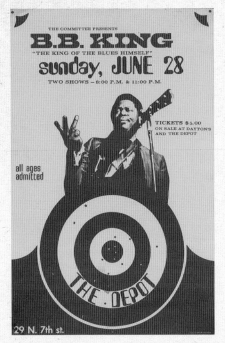
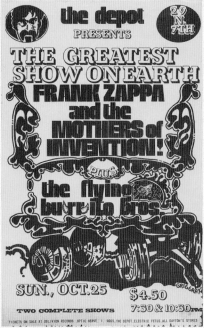
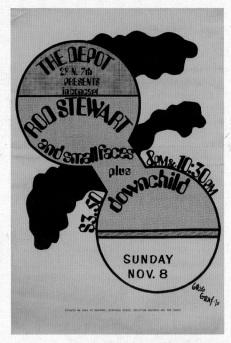

(Above left) "The King of the Blues Himself," B. B. King was another big star to grace the club's stage during its brief life as the Depot. Tickets for the all-ages show cost five bucks in 1970. *(Above middle)* Frank Zappa's so-called "Greatest Show on Earth" didn't quite live up to expectations from longtime fans, but the opening act, the Flying Burrito Brothers, was a big hit. *(Above right)* Many of the Depot concert posters from 1970 were designed by artist Greg Gray. This one for Rod Stewart and the Small Faces (soon to be officially known as, simply, the Faces) is a memento from a memorable show late that year. *Posters courtesy of Mark Freiseis*

into rock stardom and won his first Grammy Award earlier that year with "The Thrill Is Gone." His near-capacity crowd at the Depot included a lot of thrilled young fans, as did his opening band.

Mojo Buford had hired some young hotshots for his Minneapolis band, including seventeen-year-old guitarist Robb Henry, who was about to start his senior year of high school. Henry was set to have his graduation portrait taken the same week he opened for one of his heroes, and his parents pestered him to cut his hair. He cut a deal with them: Buy him that new Fender Twin Reverb amp he had his eyes on, and he'd let the barber get the hair out of his eyes. "So I played that show with a brand new amp *and* a new haircut," Henry mused. He also remembered hanging out with King and his entourage in an upstairs enclave past the restrooms, which later became the VIP Room and Record Room but back then sometimes doubled as a green room. "B. B. sat and talked to us, and was

a really nice guy," Henry said. Another of Buford's band members, Will Agar, recalled that for payment, King got a briefcase filled with cash from the five-dollar tickets that night—the old-school bluesman still doing business the old-fashioned way.

The club rolled on strong into the fall of 1970 as college kids returned to campus. Frank Zappa and his Mothers of Invention made their one and only trip to the venue on October 25, and if that weren't momentous enough, they brought along Gram Parsons and the Flying Burrito Brothers as openers. Zappa's two sets that day aren't so fondly remembered, though. It was his first tour with former Turtles members Flo and Eddie, and the "Happy Together" co-vocalists added a harmonious quality to the Zappa record issued a week earlier, *Chunga's Revenge*, which Zappa diehards weren't too crazy about. Zappa also made a bad impression offstage with Allan Fingerhut. He said a fan presented Zappa with

a painting she made of him, "and as soon as she walked away he threw it aside. I asked him what he thought of the club, and he said [in a snide voice], 'I haven't played it yet.' I just walked away. He was a real jerk."

The Burrito Brothers, however, earned raves. "They had the matching nudie suits, and Sneaky Pete on pedal-steel was just amazing," recalled Tom Husting of Crockett, who later played in a Gram Parsons tribute band. "I don't think a lot of people knew them yet, and the crowd for them was only moderate in size." It was likely the Burrito Brothers' presence that brought out a VIP guest that night: Bob Dylan. It's the first trace of the Minnesota expat showing up at the club. Dylan wasn't touring in the early '70s and was known to pop in to the Twin Cities to visit his parents and brother, David, who had been managing Depot cofounder Danny Stevens's band. Bob reportedly hung out with the Burrito Brothers after the show. One of the club's employees recalls having to ask a seated Dylan to get up off the bumper of his Jeep in the garage so he could leave.

Arguably the most legendary performer of the era besides Cocker, the Faces rolled in for an all-ages double-header on November 8—or "crawled" in, according to Stevens and other witnesses. The British quintet was still billed as "Rod Stewart & the Small Faces" in America, same as on its debut album *First Step*, issued the prior March. Stewart and guitarist Ron Wood had split from the Jeff Beck Group and teamed up with the three remaining members of the Small Faces following the departure of their frontman, Steve Marriott. Their final band name wasn't yet in place, but their reputation as a hard-drinking unit was. "Part of their contract was they *each* had to have a bottle of Jack Daniel's," Stevens recalled. "Ronnie Wood was so drunk, he crawled onstage." Peter Dzubay remembered Kenny Jones kicking a hole in his bass drum about three or four songs into the first set. "Rod said, 'Aw fuck it, then, let's just play country covers,'" recalled Dzubay. They got the drum kit fixed after a song or two, but the mayhem continued. "Every one of them had a bottle readily at hand," according to Dzubay.

Stories abound about how rock 'n' roll changes people's lives, but Mike Guion's experience the night the Faces played the Depot was literally life-altering. Eighteen years old and fresh out of St. Paul Central High School, Guion and six friends crammed into his 1965 Chevy Malibu and drove through a torrential downpour to take in the Faces' second set that night. The 7:30 PM show started unusually late, so the 10:00 PM show started even later. As Guion and his crew stood outside in the rain until 11:30 PM waiting to get into the club, they could feel vibrations from the music on the brick walls, amplifying their excitement. However, Guion said, "My mind wasn't entirely on the show." He was scheduled for his first U.S. Army physical exam the following morning at 6:00 AM. He had drawn number 121 in the lottery, which "almost assured that I would be drafted, and most likely shipped off to Vietnam," he recalled.

But first things first. Finally inside, Guion and his friends found a spot in the Depot's balcony and waited until almost two in the morning for the Faces to take the stage. The band finally emerged from the upstairs green room and walked through the crowd to the stage, cheered on like boxing champions. Guion yelled a request for "Street Fighting Man" at Rod Stewart as he passed by—he had covered the Stones classic on his debut solo record the previous year—and the singer cocked his head and yelled back, "Yeah!" (It was already in most sets that tour.)

What ensued was one of the best rock concerts of Guion's life, going back to the Beatles at Met Stadium in 1965. "From start to finish, this was as loud as any show I have ever attended. They were a great live band—so much energy, Rod in constant motion, his voice at full rock 'n' roll power, Woody, Ronnie Lane, Ian, and Kenny blasting away, until it ended." Guion remembers spilling out into the empty streets of Minneapolis with his friends around four in the morning, "barely able to hear our own voices." He was due back downtown just two hours later.

Guion drove his friends home to St. Paul, swung back to his house and didn't bother to shower or even change his rain-and-sweat-soaked clothes. Instead, he just sat on his bed and thought about facing "a process that might end with me in a foreign land shooting at someone, or being shot." That never happened, though. He failed his

"C. C. Rider" singer Wayne Cochran delivered one of the wilder performances at the Depot on November 29, 1970, at one point throwing empty liquor bottles against the wall. *Courtesy of Sharon Fingerhut*

Sha-Na-Na was the rare touring act to make the trip to Minneapolis in the depths of winter in '71. They played two sets on January 31 with local openers Chesterfield Gathering. *Courtesy of Mark Freiseis*

physical that morning: "They said I had high blood pressure." He's all but certain it was caused by the double whammy of staying up all night and being bowled over by the Faces. A decade and a half later, when Ron Wood was back in Minneapolis to promote a show of his photos and artwork, the guitarist did an on-air interview with WCCO Radio's Ruth Kozlack. Guion called in and told his story of the 1970 concert to an amused Wood. "I thanked him for saving my life," Guion said.

The last big touring band to play the Depot in its inaugural year was the James Gang, fronted by future Eagles member Joe Walsh. Despite falling on a Tuesday night, December 8, the two-set appearance was "another one packed to the rafters, and louder than hell," remembered Tom Husting of Crockett, once again the local opening

band. Walsh's power trio had just put out its second album, and both "Funk #49" and the seven-minute "The Bomber" earned heavy airplay locally on KQRS. Walsh was already something of a cult hero, too. "Every guitar player in town wanted to emulate his sound," said Peter Dzubay, who was again in the crowd that night and later played guitar with Denny Craswell of the Castaways. "We used to call what Joe did a train wreck, it was so overpowering and off the rails, and it was especially true that night."

Then things went quiet at the Depot for a couple months. And so it would go at the club for the decades to come: Out-of-town bands refrained from booking dates in Minneapolis from December to February, for obvious reasons. Sly & the Family Stone had been confirmed for a show on February 19, 1971, but apparently got scared off and cancelled. Thaws in the winter months came in the form of two acts that enjoyed a breakout from the previous year's *Woodstock* movie. Sha-Na-Na made a return appearance following their gig the previous June, with local band Chesterfield Gathering opening the all-ages show on Sunday, January 31. On February 21, Richie Havens gave a performance that Allan Fingerhut ranks as one of his all-time favorites. Exactly a month later, on March 21, came a show that remains one of his least.

"Ike Turner was just a pain," Fingerhut said simply, remembering the man who would be heralded as a rock 'n' roll originator but ultimately decried for abusing his wife. Danny Stevens had opened for the Ike & Tina

Minneapolis talent booker Marsh Edelstein—who brought Ike & Tina Turner, Cain, and many other bands to the Depot and Uncle Sam's—poses with Allan Fingerhut at the club. *Courtesy of Sharon Fingerhut*

Turner Revue at the Minneapolis Armory in 1967 and remembers it being a predominantly African American crowd. "They were a little taken aback by us," Stevens said, recalling how his brother and bandmate Mickey Stevens used to light his helmet on fire, among other stage antics. By 1970, Ike and Tina were at their peak of popularity among mainstream rock fans. They had toured with the Rolling Stones in 1969 and landed a No. 4 hit and a 1970 Grammy Award with their remake of Creedence Clearwater Revival's "Proud Mary." Ike's drug problems were in full force by then, too.

The Turner entourage showed up late to the Depot, where time was already tight because two sets were booked, one starting at 7:30. The bus didn't roll up until about 8:30, according to an account by Bob Protzman in the *St. Paul Pioneer Press.* "It rained on hundreds of people who had waited in line up to 4½ hours," Protzman

wrote, describing a dreary scene inside, too: "There were too many people in the place, and hundreds more were begging and conniving to get in. The place was stifling and smoke-filled." The *Minneapolis Tribune* later described the unhappy crowd reaching "riot-like conditions." It got so bad, Fingerhut made a quick call to comedian Ron Douglas to come down and lighten things up. Douglas wound up performing for more than an hour. "Even Jack Benny would have trouble entertaining a crowd that long," Protzman wrote.

Having already caused turmoil with the band's tardiness, Ike made more trouble upon arrival. He demanded to get paid in full before taking the stage. He also insisted on delivering one performance, not two. Standard procedure was for bands to get paid half of their guarantee before hitting town, and then the other half once their job was complete. The contract also clearly

stipulated it would be a two-set appearance. It was a rare show booked with an outside promoter, the prominent local power broker Marsh Edelstein, who years later didn't recall Ike's demands but said that Tina Turner was also causing trouble and "being a diva." Said Edelstein, "I remember her and Allan going at it and arguing about going on so late, and I said, 'Allan, you can't do that. Just let her be. It's part of the game.'"

Unlike the situation with Joe Cocker's handlers a year earlier, Fingerhut was not so easy to push around this time. He didn't confirm it, but other accounts from that night have the club owner threatening to call in local Teamsters, who were close business associates of his dad, Manny Fingerhut. Ike was purportedly told that the Teamsters would "guard" all of his band's equipment until the contract was fulfilled. Whether or not that happened, Fingerhut did confirm that he asked for the change drawers in all of the club's cash registers to be emptied out at the end of the night. All of those coins were put toward the Turners' final payment. Edelstein marveled at the memory. "I swear to you, it was mostly pennies. I don't know how he did it, but he came up with tons and tons of change. That sounds just like the Fingerhut family, too: millions of pennies lying around."

In the end, Ike and Tina performed the two sets. The second didn't start until after midnight but reportedly was as electrifying as the first.

Despite winning the battle of wills with the Turners, Fingerhut told the *Pioneer Press* he feared he "lost a lot of people who had come here for the first time. One woman told me she'd never darken the Depot's door again." He would be haunted by the show, and pointed to it in the ensuing months as the moment that the club's honeymoon period wore off.

The Depot hosted two more touring shows that carry more weight with fans today than they did in 1971. First came an April 18 double bill with another storied Mississippi bluesman and another *Woodstock* standout: John Lee Hooker and Canned Heat. The Los Angeles blues-rock band was only seven months out from losing its harp-blowing, depression-battling coleader Alan White to a drug overdose. A month before his death,

(*Above left*) Blues-infused rockers Canned Heat shared a Depot bill with blues icon John Lee Hooker, a pairing that would soon produce the double-album *Hooker 'n Heat*. (*Above right*) Foreshadowing the club's later affection for punk, Iggy Pop brought his lively act to the Depot's carpeted stage in May 1971. *Posters courtesy of Mark Freiseis*

they paired up with one of their heroes in the studio for the loose but cult-loved double-LP *Hooker 'n Heat*, which came out that January. The acts went out on tour together, and although accounts of the Minneapolis show are scarce, the Carnegie Hall performance three days earlier was released as the live album *Carnegie Hall 1971*.

Blues music never played as prominent a role in the club's history as it did in its first year and a half. On May 9, 1971, the venue got its first taste of a genre that would have a central role there beginning at the end of the decade: punk rock. Little Richard was originally booked for that night but cancelled a few weeks out, the nearest he ever came to playing the venue. How Iggy & the Stooges came to be the replacement is as perplexing as the fact that their Minneapolis debut was covered in the *Tribune* by Michael Anthony, who later became the paper's esteemed classical music critic.

"Iggy's act makes Mick Jagger look like Rudy Vallee," Anthony wrote, Vallee being a sort of 1970 equivalent of Michael Bublé. "He minces, prances, crawls on the floor, and turns his long, pouty lips to the audience. He works mainly in the audience, falling, jumping, shoving,

jumping on to the back bar and up to the balcony and occasionally singing." Anthony wasn't impressed with the antics and wrote that the set only lasted about forty-five minutes before the other Stooges walked offstage "looking mighty bored." Fans recount Iggy smearing peanut butter all over himself and smashing and throwing bread. Another dismissive recap appeared in the Macalester College newspaper, written by future Orchestra Hall marketing and events manager Reid McLean (using the alias D. Kniel). McLean described the crowd as mostly "15-year-old speed freaks and tripping regulars," and Iggy as "naked except for low-slung jeans and shoes. His chest, face and hair were streaked with silver paint or dye." The Detroit-bred punk icon apparently took umbrage with Fingerhut's decor, too. In what might be deemed the first warning shot in the battle to make the club the gritty, black-painted punk-rock haven it would become a decade later, according to McLean, Iggy launched the set by yelling, "I can't stand this goddamn carpet!"

Touring acts got the bulk of the attention, but local bands did find a foothold during the Depot era. It quickly became a place many Twin Cities rock musicians clamored to play. If they weren't nabbing an opening slot, locals were often brought in on alcohol-free Sunday nights to play to the teen crowds, or on Monday or Wednesday nights when the club offered drink specials and other promotions. The musician who eventually performed in the former bus depot more than any other, local legend Curtiss A (Curt Almsted), remembered auditioning for Depot gigs even before the club was open. Auditions took place at George's in the Park, a venue where Danny Stevens's band frequently performed. Stevens also recruited a staffer from George's, Abby Rosenthal, to be the Depot's first general manager.

"It was all the buzz among people in the know that Danny was opening this club with Allan Fingerhut, so we auditioned for him," recalled Almsted. "I put 'audition' in quotes. I didn't blow him, if that's what you're thinking. He was trying to find talent, and I felt like he wanted to get behind me. Well, that doesn't sound right, either." Almsted's band Wire (not to be confused with the British punk band of the same name) got to play a weeknight not long after the Depot opened. Apparently, though, they were still in the audition phase, unbeknownst to Almsted. This led to an incident that became club lore.

"Our manager at the time basically gave the impression I was going to get some money for this gig, but it was more of a showcase," Almsted recounted. When they didn't get paid, the man who would later be dubbed the "Dean of Scream" went straight up to the office and did what any hotheaded, indignant rock 'n' roller would do to a club owner known to come from family money: He spit on Allan Fingerhut.

"It was really weird, because I went in the next day to apologize, and the tall guy and the beefy guy from the 5th Dimension were sitting on the couch," Almsted remembered in rather vivid detail. "To this day, I have no idea why they were there, because they never played there. I had to be contrite to Allan while my audience was those two guys. That oughta be in my memoir, just a bizarre moment. And then Allan got them involved, saying things like, 'They're not here to get money.' Allan was really nice about it, though. I mean, look how many times I played there even after spitting on the guy. So that tells you something." Almsted and Wire even got one of the more prominent opening slots of the club's first year, as the supporting act on November 15 for Country Joe McDonald, performing without his band the Fish and apparently a bit out of sorts that night. Almsted claimed that McDonald told him after the show, "I should've opened for you."

Crockett was one of the most frequently called local bands to fill opening slots at the Depot. The first time, it was by fluke. The bluesy, psychedelic rock quartet wasn't even a band yet when its members were invited to open for Poco on the club's third weekend in business. Bassist Larry Hofmann and drummer Dan Burneice were part of the construction crew that converted the bus depot into the rock club. They were still doing sporadic work there when Poco's scheduled opener backed out at the last minute. Hofmann and Burneice seized the opportunity, even

In October 1970, the Depot hosted a stellar lineup of Twin Cities blues acts. In addition to renowned bluesman Willie Murphy, the concert featured three bands that would return the following year to record the live album *A Gathering at the Depot*: Pepper Fog, Chesterfield Gathering, and Kiwani. *Courtesy of Robb Henry*

though they didn't have an active band. "Allan Fingerhut or one of the people there knew Dan and Larry played music," recalled guitarist Tom Husting. "They asked if they could get some kind of music up there for a short set. They looked around, and I was there. So we decided to do a little jam, see what comes out. We got up there and played two sets, and it went fairly well."

Well enough for Crockett to play many times after that, once they added fourth member George Miller and settled on a band name. Husting remembered not only opening for the Kinks but joining them for a fifteen-minute jam in a true encore. "For some reason, the crowd was still hanging around, so it was a case of, 'Well, let's get up and do something.' It turned out really great, though. We were all pretty star struck."

By the time the Depot came along, the celebrated Twin Cities garage-rock scene of the 1960s had splintered. The Trashmen of "Surfin' Bird" fame had mostly called it quits, and two of Minnesota's other noteworthy bands from the mid-'60s, the Underbeats and the Castaways, had broken up. Nevertheless, their members wound up playing the Depot on occasion with their newer, heavier, hazier groups, Gypsy and Crow.

The Litter was the one well-known '60s group that hung on long enough to play the venue with more frequency. Like the Castaways' "Liar, Liar," the Litter's bombastic fuzz-rock single "Action Woman" became a classic years later via the influential box set *Nuggets*. Anybody who knows the song knows the Litter was the perfect local band to open for Iggy & the Stooges. Several who attended that show even say the Litter was the better and more powerful band that night in May 1971. Some of the Litter's members also played there frequently in the subsequent band White Lightning, including guitarist Zippy Caplan. "In the '60s, it was like a big family, all the groups in town knew each other and all hung out with each other," remembered Caplan. "If I was playing at Mr. Lucky's [in south Minneapolis] with the Litter, most of the Accents would be there hanging out, or the Underbeats. That carried over to the Depot. A lot of us would go and meet up for drinks there, especially if one of the local bands was playing."

The apex of the Depot's tenure as a hub for the local music scene came on September 13, 1970, when eleven bands converged on a Sunday afternoon to record a compilation album, *A Gathering at the Depot*. One of the talent agencies in town that wielded a lot of influence over the clubs, Ralph Ortiz's Alpha Productions, hired a recording crew from Minneapolis's famed Sound 80 studio (where Bob Dylan would eventually record *Blood on the Tracks* and Lipps Inc. their "Funkytown" single). Each band played three or four songs, one of which ended up on the resulting LP. The record sold modestly well in local department stores and earned some of the bands their only radio airplay.

Some of the band names and song titles on *Gathering at the Depot* speak to the hippie-dippie-ism of the era: Free and Easy, an oversized groove-rock ensemble whose harmonious split track "It's For You / Wake Up Sunshine" evokes memories of the Brady Bunch's "Sunshine Day"; Thundertree, who played a psychedelic, bluesy cover of Tennessee Ernie Ford's "16 Tons"; and Chesterfield Gathering, whose "Take Me to the Sunrise" meanders through a series of jammy time changes and guitar solos. But much of the record holds up well. One highlight is Pepper

THE DEPOT & ALPHA PRODUCTIONS

present

A GATHERING

FEATURING TEN GROUPS

SUNDAY
SEPT. 13
1p.m.—Midnite

Pepper Fog
Litter
Danny's Reasons
White Lightning
Dave Mark Syndicate
Grizzly
Cricket
Lemon Pepper
and more

All Ages Admitted

THE DEPOT
29 N. 7th

Tickets $2.00

On Sale at DAYTONS/ELECTRIC
FETUS/OPTIC NERVE/I ROSS/
OBLIVION RECORDS

A Gathering at the Depot was recorded live on September 13, 1970. Tickets cost a mere two dollars for the multi-band, eleven-hour showcase. *Courtesy of Mark Freiseis*

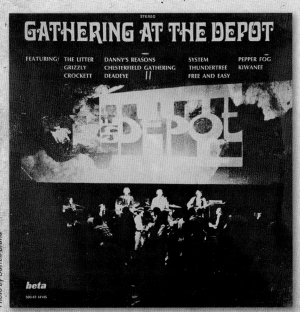

STEREO

GATHERING AT THE DEPOT

FEATURING: THE LITTER DANNY'S REASONS SYSTEM PEPPER FOG
GRIZZLY CHESTERFIELD GATHERING THUNDERTREE KIWANEE
CROCKETT DEADEYE FREE AND EASY

DEPOT

beta

580 47 14145

Photo by Darrell Brand

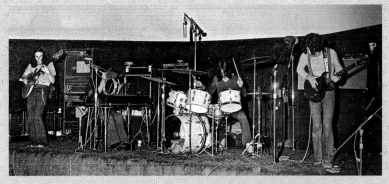

Ron Merchant, Gregg Inhofer, Bob Strength, and Dale Strength had been playing together since the late '60s, first as Rubberband and then Flight before becoming Pepper Fog. By 1971 they were well-enough established to get a spot on the *Gathering at the Depot* recording. *Photo by Darrell Brand*

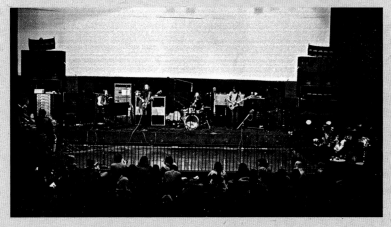

The first live recording of an album at the venue that would become First Avenue was a seated affair for the audience. Onstage in this shot is Crockett—George Miller, Larry Hofmann, Dan Burneice, and Tom "Foot" Husting—who opened for various touring acts during the Depot era. *Photo by Darrell Brand*

Recording engineers from Minneapolis's Sound 80 studio captured it all from the side of the stage. *Photo by Darrell Brand*

Fog, a band of south Minneapolis rockers who opened for the Velvet Underground a year earlier at the Labor Temple and would warm up for Chicago folk-rockers Mason Profitt at the Depot that January. Pepper Fog included future *Blood on the Tracks* session player Gregg Inhofer, whose rollicking organ is all over "Celebration," a riveting, Jefferson Airplane–meets–*Revolver* track. The Litter's hard-blasting contribution "Ungrateful Peg" might qualify them as the first punk band to play the venue. Crockett reinvented Bob Dylan's "Dear Landlord" into an ascendant, Allman Brothers–like rocker. Danny's Reasons also, predictably, made the record, featured at their most hazy and heady in the 5th Dimension–like "With One Eye Closed." Other bands on the LP include Kiwani, Grizzly, Deadeye, and the System.

Paul Strickland, a music fanatic who became a writer for the alt-weeklies *Connie's Insider* and *Sweet Potato*, characterized the *Gathering at the Depot* participants as "Underrated and barely remembered bands of that era." "It was a daylong event. I seem to remember everything ran behind, and I had to leave before the Litter performed." Zippy Caplan recalled, "That was just a really big party. It was a great night." Crockett's Tom Husting agreed: "It was mostly bands that already played the room a lot, so everyone kind of felt at home. Us especially. I think the record is a very good snapshot of the era."

Despite its popularity among musicians and young audiences, the Depot was in trouble by the summer of 1971—double trouble, really, since both local law enforcement and the bottom line were calling for a reality check. Unruly crowds were a problem, especially on the Monday Beer and Wine Nights, when five dollars would get you all you could drink. Danny Stevens claimed he got the idea for the weekly guzzle fest from Eddie Phillips of local distributor Phillips Liquors: "Eddie said, 'I got a wine.' It was Bali Hai, cheaper than shit. People would drink it, though. The gimmick was we didn't fill the bars with bartenders. We only had one or two working each bar, so people had to wait." That did little to temper the chaos, though.

After too many fights and arrests on Beer and Wine Night, the Minneapolis Police Department made an unprecedented move. Plain-clothes, off-duty cops had been the club's main security force since it opened. It was a good way for police officers to supplement a modest income. But the unruliness got to be too much even for Minneapolis's finest. In early 1971, they began working at the club in uniform in order to be taken more seriously, but by the beginning of May, the department passed a directive prohibiting its officers from working at the Depot, the only bar in town deemed off-limits. Deputy Chief Gordon Johnson told the *Minneapolis Tribune*, "I think their Beer and Wine Night is getting out of hand. You've got people going there getting blasted on wine, and you know how silly some guys get on wine." Fingerhut, however, contended that the police were discriminating against the club because of its counterculture clientele. "As soon as a cop sees a kid with long hair, there's hatred," he told the *Tribune*.

Fingerhut also seemed to be growing weary of the young, free-thinking rock 'n' rollers, who chafed at rising ticket prices, even though their heroes were the ones driving up costs. On May 23—just a couple weeks after the police directive, and a month and a half after the tumult of the Ike and Tina show—an interview with Fingerhut and his San Francisco counterpart Bill Graham quoted them complaining about bands and their handlers turning greedy. Graham had just announced plans to shut the doors on both Fillmore East and Fillmore West. Fingerhut was trying to avoid the same outcome at the Depot. Graham said in the article, "In the last five years the performers' prices have gone up as much as six hundred percent, while my own prices have increased twenty percent. In place of musicians, we're now dealing with officials and stockholders of large corporations, only they happen to have long hair and play guitars."

For his part, Fingerhut said that he was "tired of being called a capitalist pig" by his customers. He declared he would end the Depot's "rock-only policy and start catering to an older and 'straighter' crowd." He named the Platters, the Four Seasons, and Pat Paulsen as the type of acts he'd like to bring in, as well as country and big-band

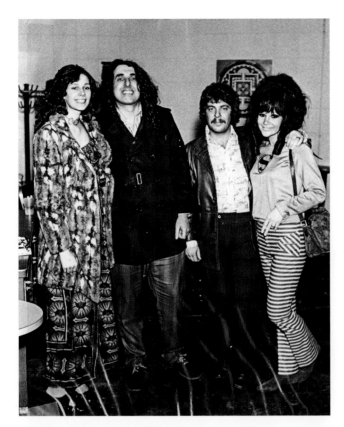

As owner of the Depot, Allan Fingerhut got to hang with some big celebrities of the day, but the concert business was wearing on him by the end of 1971. Here he and his wife, Sharon, posed with Tiny Tim and "Miss Vicki" Budinger, whom the crooner had famously married on *The Tonight Show* two years earlier. The "Tiptoe Through the Tulips" singer later married Twin Cities native Susan Gardner and moved to Minneapolis a few years before his death in 1996. *Courtesy of Sharon Fingerhut*

acts. He pointed to a booking for the next month as an indicator of what was to come: a June 25 date with 1950s big-band mainstays the Stan Kenton Orchestra. That certainly fit the bill of "straighter."

In the end, the Kenton Orchestra was not eligible for a star on the wall of the club. The Depot closed before the date came around. After a disappointing turnout of some 450 fans on June 6 for Edgar Winter (who hit it big with "Free Ride" and "Frankenstein" two years later), Fingerhut announced to staff that he had to shut the place down. He had gone through all $280,000 of his personal fortune, he told the press. He had to empty out

every cash register and safe in the club just to pay Winter his guarantee that night. Winter's tour manager even gave back some of the money because things were obviously so bleak, according to Fingerhut's comments in a June 10 column by Will Jones in the *Tribune* about the impending closing. Remarkably, though, many of the Depot's fifty or so employees agreed to stay on and work without a paycheck through the weekend, when the Allman Brothers Band was due to play. A hot show like that could've been a real godsend. That the staff was willing to work for free is a good indicator of how much emotional attachment the Depot had already engendered in its short existence. "Maybe it will work," Fingerhut told Jones. "Even if it doesn't, it's so beautiful that they tried that. I don't think the kids should go unrecognized."

Alas, the Depot's woes did not go unnoticed by the Allman Brothers' management. The band's handlers in New York got wind of the club's financial troubles and were less forgiving than Winter's team. They demanded their guaranteed payment up front by that Friday (for a Sunday gig). Fingerhut claimed to the *Tribune* he actually came up with the funds in time: "I got it together and called the next day, and they said they had already gotten another booking." So much for the Allman Brothers getting a star on the building.

Less than fifteen months after Joe Cocker roared onto the stage, the Depot era ended with a whimper. Funky local party band Big Island, which had become another regular midweek act, had played a couple free shows earlier that month to try to right the club's downward spiral. It agreed to play one last night, June 14, 1971. Word spread via KQRS it would be the club's last show. A capacity crowd showed up, but it was too little too late. Fingerhut told the *Tribune* he was $35,000 in debt but hoped to "get some money together" and reopen the club under new auspices. "Once you start you just can't walk away from this business," he said.

It would be a full year before the venue opened again, with new financial backers. Not only would Fingerhut's new partners give the Depot a different name, they also had a completely different idea of what the club should be. ■

Disco dancing was alive and well at Uncle
Sam's in Minneapolis during much of the '70s.
Photo by Steven Laboe

DISCO AND DECADENCE AT UNCLE SAM'S

1972–1979

"Dancing to records backed by the live drummer is the whole lure. Each Uncle Sam's has a large dance area averaging about 60 by 12 feet. A computerized chase-rotate-and-flash electric circuit matches the 40-foot wall of lights and multi-colored lighting under the foot-high transparent plexiglass dance floor with the rhythm of the record played. Overhead six strobe lights are calibrated to match the rhythm. There are stationary black lights and several bubble machines in the dance area."

—"6 Uncle Sam's Discos Stimulate Dancers," *Billboard* magazine, December 21, 1974

It's easy to blame the out-of-town proprietors for ushering in the uncoolest era of Minneapolis's legendary rock club, but to give them a little credit, they were actually ahead of the curve. American Scene (later known as American Events) had already opened several disco clubs by the summer of 1972, when the logo for their Uncle Sam's franchise went up on the marquee of the former Minneapolis bus depot. It would be another five years before disco hit its commercial peak in the bright, starchy form of John Travolta's white polyester suit in 1977's *Saturday Night Fever*. The first big wave of hits didn't even come until two years later in 1974, when Carl Douglas's "Kung Fu Fighting," the Hues Corporation's "Don't Rock the Boat," ABBA's "Waterloo," George McCrae's "Rock Your Baby," and Gloria Gaynor's "Never Can Say Goodbye" set the craze in motion. All those songs would be in steady rotation at the Uncle Sam's on Seventh Street and First Avenue.

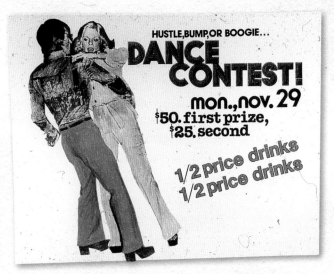

It was all about the dancing when Uncle Sam's took over the space at the corner of First Avenue and Seventh Street. *Courtesy of the Museum of Minnesota Music*

"Never Can Say Goodbye" was No. 1 on *Billboard*'s Hot Dance Club Play tally when the magazine unveiled the new chart on October 26, 1974. It was a way for the industry trade magazine to reflect and fuel the burgeoning disco movement. To hype Hot Dance Club Play, *Billboard* ran an article two months later spotlighting the Uncle Sam's club chain and its growing influence in the recording industry. The franchise of dance clubs, including its year-old Minneapolis location, played a big role in breaking some of these new singles, according to *Billboard*'s report.

The company behind the Uncle Sam's franchise, American Scene, was not some slick operation out of New York or Los Angeles. It was a family business based in Cincinnati. Entrepreneur brothers Don, Jim, and Dick Fraser opened their first club there in the mid-1960s, and by the time they got to Minneapolis in the summer of 1972, American Scene included the flagship Uncle Sam's dance club in Buffalo, NY, and a newer Uncle Sam's in Cincinnati, set in a mammoth twelve-thousand-square-foot space.

The brothers had their eyes on other midsized blue-collar markets. When *Billboard* profiled the company in 1974, the chain extended to Houston, Syracuse, and Detroit, and the Frasers claimed to be serving more than twenty thousand customers weekly across the six clubs, all called Uncle Sam's. They told *Billboard* they had six more clubs in the works for 1975, including a Lincoln, Nebraska, site set to open a month later. Iowa would soon be in the mix, too, with clubs located in Des Moines and Davenport. Dance fever had found a foothold in Middle America.

Allan Fingerhut didn't remember how or when American Scene first approached him about taking over the Depot, but he knew he didn't turn up his nose at the idea. He had more in common with the well-dressed socialites and suburban youths who would soon flock to Uncle Sam's than he did the long-haired hippie kids typical of the Depot's crowd. "I loved to dance, it was as simple as that," he said. His accountant Byron Frank, however, said the conversion to Uncle Sam's was a simple choice for another reason: It offered a way for Fingerhut to finally make some money on his investment. Frank believed Fingerhut bought up the liquor license from Danny Stevens even before the Depot closed. "Keep in mind: After the first six months, they were broke," he said. "Danny probably saw a way to get some money out of it, and I bet Allan paid him like $15,000 or so for his part." Stevens, however, has claimed all along he was never bought out.

What's certain is that no one was making money while the club sat empty after the last Depot shows in June 1971. That was incentive enough to take the Cincinnati investors seriously. "I don't remember what the thinking was on what to do with the place all that time," Frank said, "but then American Scene came along and said they would like to lease it and use Allan's liquor license. So they became the managers. They ran it all after that." Frank believes Fingerhut made about $100,000 out of the gate, thanks to some shrewd accounting work and the fact that American Scene invested a lot of money to make over the venue. With help from federal investment tax credit laws, the club owner would benefit from everything the Cincinnati investors put into the place.

"All the equipment [American Scene] put in, Allan got paid for it. He got the credit, write-offs, everything," Frank said. "After I did that deal, I walked out of that meeting and immediately went to a phone and called Allan and said, 'Listen, I just did this deal for you, and you will not believe it. Don't say anything about it. *Don't fuck it up!*'" The deal was that American Scene would keep ninety-five percent of the revenue to manage the place, and Allan was going to get five percent for essentially doing nothing. "They ran it five or six years with that deal," Frank said.

American Scene came in with plans to mold the club to their vision, which included a large dance floor of multicolored plexiglass. It was sort of a low-rent version of the iconic dance floor that would later appear in *Saturday Night Fever*, with long, striped panels instead of squares. The dancing platform was built about a foot off the ground, with lights underneath to create a rainbow effect. Taller wooden platforms of varying heights were also built and moved around the periphery of the dance floor, for those who fancied themselves worthy of *Soul Train*–like dance showcases in a spotlight.

(Above) The illuminated, multicolor dance floor was the centerpiece during the Uncle Sam's era. *Photos by Steven Laboe*

(Above left) The Uncle Sam's mascot (Stanley Himes) worked hard to keep the dance party going. *Photo by Steven Laboe.* (Above) The infamous Firecracker cocktail. *Photo by Steven Laboe.* (Left) DJs, not live bands, were the main stage attraction during the peak years of disco at Uncle Sam's. *Courtesy of the Museum of Minnesota Music*

The club's new operators also brought in pinball, foosball, pool tables, and eventually arcade games, which were placed in the stage-left back corner area. Wooden cocktail tables and chairs filled in around the dance floor and game area, and most of the upstairs balcony area, too. Glassware with the Uncle Sam's logo included special tall red glasses for the house drink: a sugary, Fourth of July–themed, candy-red vodka concoction called the Firecracker. American Scene even sent along a corny, oversized, red-white-and-blue Uncle Sam costume for an outgoing (and surely underpaid) employee to wear around the club, equal parts host and mascot. "That poor guy," laughed Fingerhut, who mostly only came to the club to dance. "I wouldn't go anywhere near him, because I don't think they ever washed that costume. He would have to sweat in it night after night."

Solitary DJs held court on the same stage that Cocker and his twenty-seven-member band had crammed onto in inaugurating the club a couple years earlier, a striking visual contrast. The DJs were a sharp financial contrast, too: A one-man entertainment system required a much smaller talent fee than a rock band that rolled in from out of town with a crew. That formula didn't die with the disco era, either. Even as the club turned to punk, metal, and rap acts in the 1980s, it continued to rely on dance nights to balance the bills. During the Uncle Sam's years, though, nearly every night was a dance night. Live music performances were rare.

"When it changed from the Depot to Uncle Sam's, it went from this hippie club to this red, white, and blue patriotic disco club," recalled Bobby Z, the future Prince & the Revolution drummer who was just then coming of club-admission age. "They had the rainbow-colored plexiglass dance floor. It became this *Urban Cowboy*-meets–disco kind of club. I really didn't get it." A doorman at the time, Richard Luka, may have summed up the

club's Uncle Sam's years best: "It was Studio 54 for the discriminating K-Mart shopper."

In keeping with its patriotic name and concept, the Minneapolis branch of Uncle Sam's opened just before the Fourth of July, 1972. It was swarming with people by the following weekend, as is evident from a photo that appeared in the July 9 *Minneapolis Tribune*. A blurb about the club's makeover ran underneath: "The discotheque, formerly the Depot, opened last week featuring computarized [*sic*] top-40 music with dancing on the plexiglass floor installed over neon lights." Another *Tribune* blurb a week later reported sold-out crowds on weekends and said the newly reborn club was doing "better than expected, and weeknights are good, too."

The *Tribune*'s July 16 write-up also saw the first mention of one of the more nefarious traits of the Uncle Sam's era: "The new operators started with a policy of no blue

Richard Luka (aka Dix Steele) was a formidable bouncer at the club during the Uncle Sam's years and beyond. The large sign to the left of the ticket window reminded patrons of the strict dress code. *Photo by Steven Laboe*

jeans and no headwear, then relented to 'proper attire,' [in] an attempt to 'keep out undesirables,'" the newspaper reported. Implemented by the home office in Cincinnati, the dress-code policies would be an issue for several years. In hindsight, those rules deepen the contrast between the club's 1972–79 era and the Prince-led 1980s, when First Avenue gained a reputation for its multiracial crowds. Most photos from the Uncle Sam's era show crowds whiter than a Donald Trump political rally. In addition to banning hats, the Uncle Sam's brass instituted a "no canes" policy at one point. "It was pretty clearly a policy of not-so-veiled discrimination," said David Vieths, a manager at the club during the mid-'70s.

Vieths started out as a bartender in 1972 and was managing the club within a year (later, he would become a booking agent with Marsh Edelstein's company). The bosses in Cincinnati sent him around to the other clubs in their chain to indoctrinate him in the disco format, which was new not only to him but to most of Minneapolis. "There was nobody else in town doing recorded dance music like that then, at least not with the lighted dance floor and DJ like that," Vieths recalled. "American Scene was hell-bent on expanding into smaller or midsize markets and into the Midwest with this disco concept," he continued. "They knew their dance clubs. The club in Buffalo was especially happening: This huge place that was open 'til like four AM."

While the executives in Cincinnati had anticipated the disco mania, they could not have foreseen the major boost they would receive from the Minnesota Legislature. In 1973, the state rolled back its minimum age for buying alcohol from twenty-one to eighteen. As the club's new operators turned toward the harder-drinking and more youthful Top 40 dance crowds, the change in the law was like a spark to a powder keg. "The place just went nuts right away after that," Vieths remembered. Fingerhut recalled: "The drinking law change helped out a lot. And then when they went back to the twenty-one drinking age [in 1986], it hurt us a lot. But it was the right thing to do. The law never should've been eighteen."

Remember, during the Depot era, Sunday night all-ages shows were often the most well attended. The

club never profited from those shows, though, because alcohol sales didn't rise with the attendance. Thanks to the change in state law, suddenly every night was teen night at Uncle Sam's. The kids came to party, and many of them had money to spare, too. The crowds were no longer made up of hippies, but more suburban kids and underclassmen from the U of M. They wore fancier attire, including silk dresses and, yes, polyester suits. Even as early as 1974, Vieths said, "Uncle Sam's was really looked at as not a very cool place to be. That pretty much lasted up until Steve McClellan took over the booking."

Somewhere in the wild swirl and mall-bought swank of this era, a less-than-swanky University of Minnesota student came to Uncle Sam's looking for a job as a bartender.

Steve McClellan graduated in 1968 from Minneapolis's DeLaSalle High School on Nicollet Island, not far from the nightclub. He continued to gravitate in and around downtown after graduation, living in a flophouse above a bar in the Seven Corners area. His dad, Robert, was a marine and World War II fighter pilot who won a Distinguished Flying Cross and Gold Star. He went on to be a pilot for Northwest Airlines and married Betty Brancheau in 1948. Betty was also quite the warrior, giving birth to eleven kids. Stephen, the second oldest, pointed to this big Catholic family to explain at least one of the traits he would become known for as the ringleader of First Avenue. "It was a loud family," McClellan confirmed. "If you got eleven kids, and you want the best piece of chicken, you had to yell the loudest."

He's fond of a story involving his DeLaSalle classmate Jack Meyers, who comanaged the club with him for twenty-five years: One afternoon, one of McClellan's brothers came walking into the club's office, followed by another brother. Meyers hightailed it out of there. "Whenever there's more than two McClellans in a room, I can't do it," Meyers huffed. "It's too loud."

Steve wasn't asserting himself at the U of M, though. Unlike Meyers—who was studying computers at the university and had also enlisted in the air force—McClellan

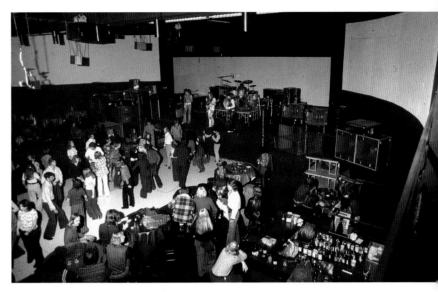

Uncle Sam's manager Steve McClellan all decked out in a beige tuxedo for a New Year's Eve party at the club. *Photo by Steven Laboe*

Live music was a relatively rare occurrence during the Uncle Sam's years, but rock bands occasionally took the stage above the dance floor. *Photo by Steven Laboe*

was dawdling his way toward a liberal arts degree and didn't have a career plan. He heard the pay was decent at Uncle Sam's and figured it'd be a good way to meet girls and have some fun while he figured out what to do with his life. He wasn't even that big of a music nut at the time and hadn't gone to many concerts at the Depot. Turns out, though, he was a good bartender, and his loud and animated personality made an impression on both customers and management. "I still have people come up to me who remember me from when I was a bartender at Uncle Sam's, and not from my thirty years as a manager at First Avenue," McClellan said. "That blows my mind."

Like David Vieths, who quickly became the club's second-in-command, McClellan found himself being courted by the bosses in Cincinnati for a managerial position after only a year or two of bartending. They flew him out to American Scene's home offices and then to the Uncle Sam's clubs in other cities. "It had a good-ol'-boy feeling to it," McClellan recalled of the management network. "I met all the top brass in Cincinnati a couple times. They flew me out. I think I wrote their first waitress manual or operations manual of some sort, and that might've impressed them. I went through their training system for management. I went to Des Moines and Lincoln, and within eleven months they sent me back up here to manage this club."

Returning to his hometown Uncle Sam's, now in a management role, McClellan saw just how much of an impact the change in Minnesota's liquor laws had on the club. "The police made twenty-three arrests in one night at the club shortly after I came back," he said. "Monday nights had become drink-and-drown nights, with ten-cent drinks. So the police would come in just about every week. I remember that one night specifically. I kind of wondered what I'd gotten myself into."

While DJs spinning disco records dominated the schedule through most of the Uncle Sam's era, the club did sporadically welcome bands for live music. Vieths said the dance club concept didn't fully catch on during the first couple years, which aligns with the fact that disco didn't become a national craze until later in 1974. To help bring in crowds and mix things up, rock acts came back to the old depot again in 1973.

Drumming to the Disco Beat

Drumming along to the tunes being spun by the DJ was a peculiar tradition at Uncle Sam's clubs during the disco era. *Photos by Steven Laboe*

Bobby Z had a prime view of many of First Avenue's biggest moments, and made his mark there with one of the world's most dynamic live musicians as a member of Prince's Revolution. His introduction to the club, however, was anything but historic. "I was caught in the middle," recalled the real-life Bobby Rivkin with a laugh. "By the time I was old enough to get through the doors, it wasn't that cool of a place anymore."

Raised in the first-ring suburb of St. Louis Park, Bobby was only fourteen or fifteen when the Depot's legendary concerts went down, but he heard about the goings-on from his older brothers, David and Stephen, who would grow up to be a successful record producer and movie editor, respectively.

By the time he graduated from high school in 1974, Bobby had become a "jobber," a drummer-for-hire through the Twin Cities Musicians Union. He filled in for everything from polka to country to Top-40 cover bands, playing weddings around the state and strip-mall bars around suburbia. Looking for something cooler and more permanent, he answered a call at Uncle Sam's. He would play to crowds more his own age, eighteen or nineteen, and get free drinks while he worked. He also got to play closer to the front of the stage, because he was the only musician: The job was drumming along to recorded disco music being spun by DJs. As a *Billboard* article about the Uncle Sam's chain of clubs noted, "Dancing to records backed by the live drummer is the whole lure."

Bobby wasn't the only notable Minnesota musician lured into this peculiar gig: Denny Craswell of '60s garage-rock darlings the Castaways and Depot-era psychedelic band Crow also took the job—and he took it farther than expected, too. Craswell created a sort of George of the Jungle–style stage setup with drums built into fake logs and Amazonian props. A lot of people remember him as "the ape-man drummer." Denny,

Bobby, and the other drummers usually performed off to the side of the stage where the DJs did their thing. Shifts often lasted four hours or more.

"The room still had a mystique to it, in my mind, because of the shows my brothers saw there," Bobby said, remembering how enthused he was over the new gig. That didn't last long, though. "It was kind of a horrifying job. Especially with free drinks on break. The lights would be flashing nonstop, this sort of multicolored barrage of lights, and you would have your headphones on with this delay between what you're hearing and what the audience is hearing. The [DJ] is making hand motions at you. It felt like a government mind-trip bender kind of thing, where you just kind of felt like, 'Wow, where am I?' It was very disorienting."

Club owner Allan Fingerhut thought the live disco drummers were "a great gimmick," one that "the kids really seemed to like." But Bobby countered: "If it had been a great idea it would probably still be continuing somewhere." ∎

"We did it much to the dismay of American Scene—and sometimes without them really even knowing—because I think they just wanted it to always stay a disco club," said Vieths. Wednesday nights became designated live music nights for several years in the mid-'70s. Major national touring acts like Cocker and the Faces were out of the picture, though. "It was mostly local bands," Vieths noted, "a lot from the Marsh Edelstein stable: Cain, Fairchild, Sterling, a band called Straight Up, Jesse Brady. . . . A lot of them did fairly well pulling people in, playing a lot of covers." Booking concerts at Uncle Sam's made for an "odd transition, going between the people who only wanted to go there to dance," he noted, adding that "it was a good wave for a while, but then it kind of fizzled because a lot of the local acts themselves kind of fizzled."

Edelstein relished the opportunity to bring his bountiful crop of bands into the club. But, he noted, they "had to be of a certain level to play there." He even started hosting auditions there during the day. "The bands would get excited, 'Oh, we get to audition at Uncle Sam's!' It was a big deal," Edelstein said. "Some of them would get scared. They were so young, and it was such a big room. I liked to use a club that had a name, because it was a good test for the bands."

Cain was probably the biggest Minnesota band to play the club in the mid-'70s. One of Edelstein's prized acts, the semi-psychedelic hard-rock band became a regional favorite but never quite garnered a national buzz. Their 1975 debut album for ASI Records, *A Pound of Flesh*, has a cult following among old-school metalheads, and the release show in the summer of that year was one of the more notable events at Uncle Sam's.

For live shows, "it was still the premier room in town," said Cain frontman Jiggs Lee, who would go on to be a successful commercial sound designer and maker of

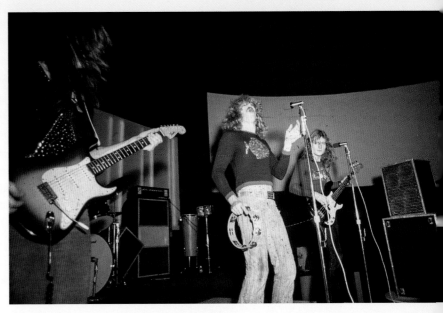

Cain was a top local rock act of the mid-1970s, making multiple appearances at Uncle Sam's, including this set in November 1972. *Courtesy of the Museum of Minnesota Music*

fishing jigs. "A lot of people still went there, and bands still wanted to play there."

But the changeover to disco had disadvantages for concerts. For starters, the club did not have a sound system suitable for live rock 'n' roll. "The roadies all hated it there because the bands would have to haul in their own sound equipment," Lee said. And even with the most hi-fi system around, there was still a certain glitch in the sound. Lee recalled how "that damn translucent dance floor drove guitar players crazy, because the lights under it made the amps buzz. You'd have these giant Marshall stacks all buzzing because of those stupid lights."

Despite those handicaps, Cain pulled out all the stops for its record release party, with showman Edelstein leading the charge offstage. Memories of the concert

"It was still the premier room in town. A lot of people still went there, and bands still wanted to play there."

—Cain frontman Jiggs Lee

make it sound like something straight out of *Spinal Tap*. Lee remembered, "Marsh had the upstairs area set aside as a VIP thing, and he had us working the room: 'Shake this guy's hand, shake that guy's hand.'" The event decor was themed around the LP cover, which showed raw cuts of meat—"pounds of flesh," per the album title. "They had these soup cans set up all over the club with labels on them: 'eight prime cuts' [the LP had eight lengthy tracks] and a picture of the band on it. They had stacks of the cans, and displays all over the club with cuts of meat. It was supposed to be a shock kind of gimmick, but I think it mostly just kind of grossed people out."

A more unintentional shock occurred onstage as the band launched into "The Minstrel Song," which Lee calls "this moody acoustic guitar intro thing." The band had hired a Milwaukee company to concoct a fog machine: Water in two fifty-gallon barrels was heated with coils inside; then dry ice was dropped in. Lee recalled that with the lights down, an "ethereal" fog was supposed to creep onstage from pipes under the drum riser. But on this occasion, the band told roadie Mark Gregory "Red" White (who later was involved in building Prince's Paisley Park) to double the dry ice. "Hey, it was a big night!" Lee recalled with a laugh. Instead of a creeping fog, "I look behind me, and [White] is sitting on the barrel because it's just exploding . . . shooting these jets of fog. People had to move out of the way."

Cain played the room on a few other, less eventful occasions in the Uncle Sam's era. At one show, in the winter of 1975 or 1976, Bobby Z—one of the club's disco drummers—was finally going to play the stage with a real band, as the drummer for the Robert Moore Group, Cain's opening act, led by the sax-blowing frontman for the popular Skogie & the Flaming Pachucos. But fate stepped in, the way it often does in Minnesota in winter: "It was one of those cataclysmic snowstorms," Bobby recalled. "I think we sound checked and were ready to go, and then they cancelled. . . . I don't think my heart has ever been more broken over a gig."

While Uncle Sam's didn't host many national acts, it did draw Cheap Trick on its first-ever tour. The pride of Rockford, Illinois, had formed in early 1973 after guitarist Rick Nielsen and bassist Tom Petersson returned from a lengthy stay in England studying the music scene there. They quickly worked their way around Wisconsin and pushed into Minnesota by summer. When they pulled up to the former Minneapolis bus depot, it was a year into its rebirth as a dance club.

"We were a total glam band at the time," recalled Cheap Trick's first singer, Randall "Xeno" Hogan. They were mostly a cover band, too, playing songs that Nielsen and Petersson picked up in England. Playing a room as big as Uncle Sam's was exciting to them, Hogan said, never mind the disco. "It was still the great room it is today, just with the dance floor and whatnot. We had a pretty big and receptive crowd turn up. I was only twenty years old at the time and had really never been anywhere, so I fell in love with the city immediately."

In fact, he soon quit Cheap Trick and moved to Minneapolis, after the band returned for another Uncle Sam's gig a couple months later. The singer was greeted by members of the aspiring, Alice Cooper–style

Cheap Trick first played Uncle Sam's on its inaugural national tour in 1973 and returned to the club many times in the ensuing decades. During the second night of a three-night stand in November 1998, the band was joined onstage by fellow future Rock and Roll Hall of Famers Aerosmith. *Photo by Jay Smiley; ticket courtesy of Michael Reiter*

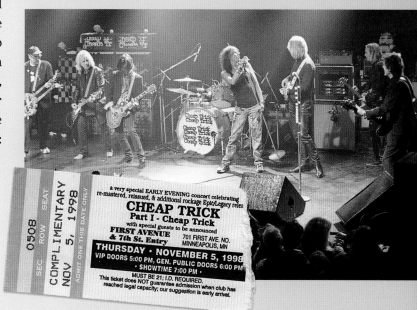

theatrical rock band Straight Up, who pulled up in their trademark white limo and asked him to join their act.

In the book *Reputation Is a Fragile Thing: The Story of Cheap Trick*, Nielsen confirmed, "Xeno left voluntarily. He got an opportunity to play with a band making two hundred and fifty bucks a week, and we were never near there." The Trick went on to headline arenas, but they didn't return to the venue until a decade and a half later, after that status had faded. They also made a three-night stand in 1998, performing their first three albums in full to satisfy the diehard fan base they've maintained even in down years, and gaining mention by longtime patrons as a standout run in the club's more recent decades.

As for Hogan, he played Uncle Sam's frequently over the next decade with Straight Up and, later, with one of the town's most prominent hair-metal bands, Dare Force. Straight Up also featured on keyboards future new-age music superstar Yanni, who had moved to town to attend the University of Minnesota. The glammed-up quintet was captured (pre-Yanni) in a television segment that aired in 1976. Introduced by Dave Moore, a straitlaced veteran with local CBS affiliate WCCO, the band covers "Wild Thing" on the (still carpeted) stage, backed by more exploding pyro than would ever be allowed today. There are also scenes of Xeno and his bandmates in their limo, bragging about their action-packed live show. Guitarist Mark Lundeen proclaims: "We're into more of an electric, explosive type thing, where we want to create a spontaneous 'poof!'" So it went in an era of widespread "poof" at Uncle Sam's.

Although live music persisted at Uncle Sam's, disco dominated more than ever as the craze peaked in 1977. Many local bands had either faded, hit the road, or called it a day amid the dance fever. Meanwhile, a burgeoning new crop of edgier acts was picking up steam just a few blocks away—but seemingly worlds apart—from Uncle Sam's.

Jay Berine started booking bands at Jay's Longhorn, a dive bar on Fifth Street just off Hennepin Avenue, in the summer of 1977. Over a short three-year stretch, the

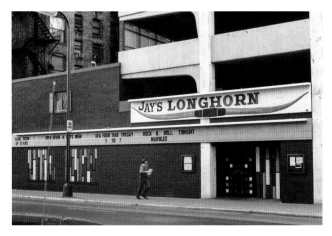

The emerging punk and indie-rock music of the mid-'70s inspired an alternative scene a few blocks away from Uncle Sam's, at Jay's Longhorn bar on Fifth Street. *Photo by Steven Laboe*

Longhorn became a punk and new wave hotbed. Local bands that played there included the Suicide Commandos, the Suburbs, Flamingo, Curtiss A's Thumbs Up, and the Hypstrz. The Replacements and Hüsker Dü played their first bar gigs there in 1979. Among touring acts, Iggy Pop likely was the only one to perform at the Longhorn *after* the converted bus depot. Other notables who rolled into town for Longhorn gigs included the Police, Talking Heads, Elvis Costello, Blondie, Buzzcocks, and Gang of Four.

"Uncle Sam's just wasn't on our radar at all for those of us over at the Longhorn," remembered Suicide Commandos guitarist Chris Osgood, who did visit the disco once, at the suggestion of a woman with whom he had been set up on a date. "I gave it a good try and danced for maybe forty-five minutes, but finally I just told the girl, 'I don't think this is going to work,' and left. I just couldn't do it anymore, couldn't be in that place. And she was a really nice-looking girl, too."

Perhaps fittingly, it was two club DJs—not musicians—who helped bridge the gap between the dive bar and the disco club: Roy Freedom and Kevin Cole. Freedom, née Roy Freid, was one of the first two DJs hired by Berine at the Longhorn, the other being future Twin/Tone Records cofounder and Replacements manager Peter Jesperson. The DJs blended the underground rock

Roy Freid, aka Roy Freedom (right), was an innovative DJ who helped bring a new mix of sounds to Uncle Sam's in the late 1970s. *Photo by Steven Laboe*

records of the day with a wide variety of R&B, funk, new wave, and dance singles coming out of Europe. Unlike Jesperson and Cole—both record-store clerks—Freid was an experienced club DJ, used to playing the more mainstream tunes that got people moving on the dance floor. He was intrigued when McClellan approached him in 1978 about moving over to Uncle Sam's, to bring a little of the punk bar's aesthetic to the disco club.

"Steve was specifically looking to change the club," recalled Freid, "but he didn't have the people he wanted." (Freid later added calendars and marketing to his duties and became the longest-tenured employee at First Avenue—thirty-nine years and counting!) McClellan first approached a friend of Freid, who declined the job but said, "Well, I know a guy that knows how to play rock 'n' roll, and a little bit of both." Freid said, "So I came here on those premises."

Kevin Cole had just been hired, too. "The first time me and Kevin Cole met, we were both kind of leery of each other," Freid recalled. "And we just started asking group names, and I think Devo was like the second one. And we were like: 'Okay, we're good!'"

Cole had zero club DJ experience when he first came to Uncle Sam's in 1978. He had run the student radio station at Gustavus Adolphus College in St. Joseph, Minnesota; then interned at Georgetown University's station when it debuted the Sex Pistols and Roxy Music on Washington, D.C.'s airwaves. Upon his return to Minnesota, he said, "I got a crappy job while trying to figure out what I wanted to do next. I went to the Longhorn all the time. I was just super intense into music." But he had never set foot in Uncle Sam's until he heard they were looking for a DJ.

"I wasn't a 'disco sucks' guy; I just wasn't really into it," Cole explained. "So I had a crash course in it." His education included visits to the Saloon, a landmark gay club on Hennepin Avenue a couple of blocks from Uncle Sam's. "A guy named Jerry Bonham was DJing at the time. He was incredible, really popular and really the most progressive dance DJ in town. He'd mix Giorgio Moroder and Kraftwerk and hold that mix for like two minutes long. I saw myself as a mix of what Jerry was doing at the Saloon and what Peter Jesperson did at the Longhorn. Peter would go all over the place, from the Sex Pistols

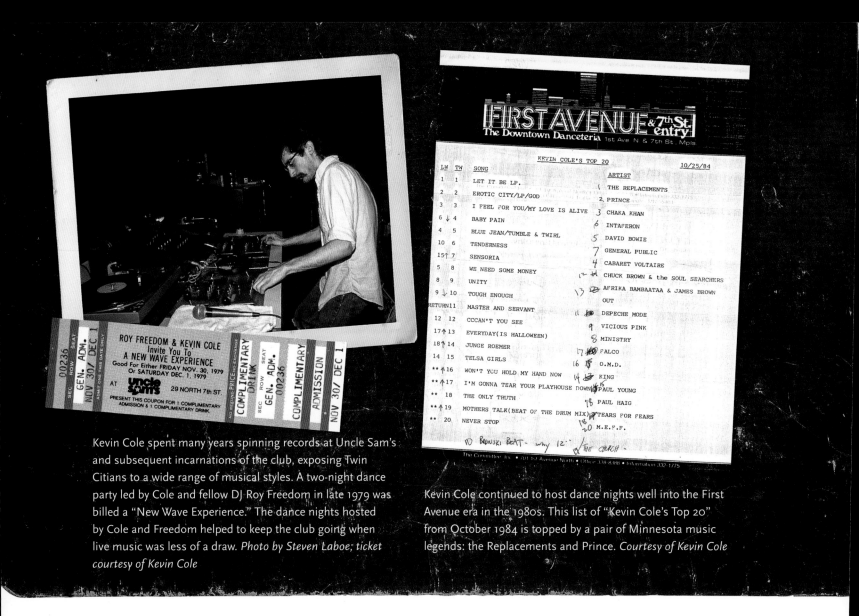

Kevin Cole spent many years spinning records at Uncle Sam's and subsequent incarnations of the club, exposing Twin Citians to a wide range of musical styles. A two-night dance party led by Cole and fellow DJ Roy Freedom in late 1979 was billed a "New Wave Experience." The dance nights hosted by Cole and Freedom helped to keep the club going when live music was less of a draw. *Photo by Steven Laboe; ticket courtesy of Kevin Cole*

Kevin Cole continued to host dance nights well into the First Avenue era in the 1980s. This list of "Kevin Cole's Top 20" from October 1984 is topped by a pair of Minnesota music legends: the Replacements and Prince. *Courtesy of Kevin Cole*

to Elvis to Donna Summer." Like Freid, Cole bought into McClellan's ideas for allowing Uncle Sam's to phase out of the disco era. "Steve knew there was a change happening, a transition in music," Cole said, "and I guess he saw me as part of it."

Roy and Kevin weren't the only two musicheads bouncing between the Longhorn and Uncle Sam's. Babes in Toyland cofounder and drummer Lori Barbero had what might seem like an unusual introduction to the club during its disco days. "I was a money-making disco dancer," confessed Barbero. She bartended and waitressed at the Longhorn and had something of a side profession going at Uncle Sam's, sneaking there on off nights or after a shift at the Longhorn.

"I used to hide it," Barbero said, "but I will tell you,

I used to win competitions at Uncle Sam's. I would go back and forth between those clubs every single night. Myself and a gentleman, Andy Nordberg, who was my best friend Mary Belle's brother. He taught me to disco dance. And they would have competitions at Sam's.... It was like the disco dance floor in *Saturday Night Fever*. It really was like disco people. I mean, I had the Danskin wrap skirts and all of that stuff."

If the thought of punk queen Lori Barbero rocking a Danskin skirt isn't a shocking enough revelation, then how about Steve McClellan in a tan polyester tuxedo with bowtie and ruffles as Uncle Sam's lead manager? "I'm sure I was told to wear it [by American Events]; they were very particular about the kind of image we projected," said McClellan, cringing. Bartender Steven Laboe noted

The club staff was a tight-knit crew throughout the transition from Uncle Sam's to Sam's to First Avenue. Here employees are enjoying the game room at an after-hours staff party at the club. *Photo by Steven Laboe*

a "common denominator" between Uncle Sam's and Studio 54 in New York: "Bouncers at both locations were constantly confronted with the same exact phrase: 'I'm a friend of Steve the manager; I'm on the list, aren't I?'" (The legendary New York club's cofounder was Steve Rubell.)

Laboe captured much of the disco-infused atmosphere with his camera, and his memories and photos also show a staff that partied together after hours and spent time together outside of the club. Among the staff was doorman Richard Luka, aka Dix Steele, who later designed the skyline logo for First Avenue. "The entire staff plus management maybe numbered thirty, thirty-five people," Luka said. "It was a very close-knit—and at times

very dysfunctional—family unit." McClellan, presiding over that family, would soon have to test its closeness and dedication to the club.

McClellan had spent enough time with the bosses in Cincinnati to know that something was up. As disco waned in 1978–79, so did American Events' interest in its Minneapolis franchise. "They wanted to get out of the hard-drinking, blue-collar disco crowd at the time everyone was saying, 'Disco is dying,'" McClellan remembered. "I believe they started pulling out in 1978, if not officially on paper. They were opening up these grand discos in places like Long Island. It was a huge club, the kind you couldn't have in Manhattan. They started trying these more expensive, grand clubs called Park Avenue in Orlando, Houston, Milwaukee. They were giving up on the blue-collar disco crowd and going more upscale."

Thankfully, the gritty old bus depot on a beat-up corner of downtown Minneapolis did not fit the Park Avenue vision. American Events opted to cut and run. McClellan's high school classmate Jack Meyers, who was by then helping with some of the club's accounting, recalled American Events going from ten clubs to four in 1979. "We were one of the six they lost," said Meyers, who never had much good to say about the company that ran the club for almost seven years. "American Events was successful, I think, but I don't think much of the money ever made it to the bank. When they closed, the landlord was mad because they hadn't paid the water bill. And they stiffed a lot of their staff, too."

McClellan was left in the position of having to look out for the staff, which by then included a lot of his good friends. Even though he was management and served as American Events' go-between at the club, he acted more like one of the staff and was having as much fun as everyone else working there. When the parent company started indicating its intentions to pull out, McClellan started scheming—not just to keep the club open but to make it more vital, returning it to its roots as a live music venue. He eventually took his ideas to Allan Fingerhut, who had largely been out of the picture but still held the club's lease and liquor license. McClellan didn't want the party to end. ∎

"It was a very close-knit—
and at times very
dysfunctional—family unit."
 —Richard Luka, doorman,
 on Uncle Sam's staff

NEW NAME, NEW ATTITUDE

4

1980–1981

There are four nights in First Avenue history that stand above all the rest in capturing the club's story. Joe Cocker's *Mad Dogs & Englishmen* army cramming into the new club in 1970 was its momentous starting point. That sweltering night in 1983 when Prince debuted and recorded *Purple Rain* was the venue's defining moment. The day the doors reopened after the 2004 bankruptcy battle was its crucial rebound. One more pivotal turning point came on November 28, 1979, when four black-leathered punk rockers from Queens, NY, broke through the red-white-and-blue sheen of Uncle Sam's and destroyed the disco era at the club. Or at least their fans did.

Legend has it that certain audience members made a point of busting up sections of the plexiglass dance floor the night the Ramones debuted at the old Minneapolis bus depot. If true, a Hollywood scriptwriter couldn't have come up with better symbolism. Musicians from some of Minneapolis's most celebrated rock bands were part of the rancorous Uncle Sam's crowd that night, including

The Ramones helped to kick down the disco door at Uncle Sam's and usher in an era of punk rock and live rock 'n' roll. Just six months after their first appearance there, the Ramones returned to the club in May 1980, by which time it was known as Sam's. *Photo by Michael Reiter*

(Opposite) For two years, the club went simply by the name Sam's as it transitioned out of the American Events–led Uncle Sam's. *Photo by Steven Laboe*

members of the newly formed Hüsker Dü. Billy Batson, frontman of that night's opening band the Hypstrz, has a vivid memory of the Hüsker dudes because they were standing in front of the stage yelling at him, "Hey, you fat fucks! Get off the stage!"

Steve McClellan gave the Ramones' coveted warm-up slot to the '60s-flavored garage-rockers because the Hypstrz had been brave enough to play his so-called "cameo sets." One of many schemes McClellan came up with during the period from 1978 to 1981 to ensure Uncle Sam's survival beyond the disco era, these ten-minute mini-performances forced live rock 'n' roll on unsuspecting dance crowds. Bands set up their gear behind the screen separating the stage from the dance party; then, without warning, the screen would be lifted to reveal a real live rock 'n' roll band. The groups would bash through three or four songs, cut out, and attempt the same surprise attack an hour or so later. Another young local rock band, the Replacements, also did a few cameo sets around that time. McClellan thought he could introduce the swinging disco audience to the joys of live music. Most of the patrons hated it, however. "A lot of people would literally run for the doors," Batson remembered.

The Ramones audience dug the Hypstrz just fine; it simply grew impatient. McClellan wanted his newly re-born but struggling club to make the most money it could off the rare sold-out rock crowd—around two thousand people, five hundred more than the room's legal capacity today—so he hired only one opening band. He then told the band it had to play two sets. The longer the Hypstrz performed, McClellan reckoned, the more booze would be sold. Batson remembers telling McClellan, "No way! The crowd will tear us up." He and his guitarist brother, Ernie Batson, compromised and agreed to play one long set, which was still too much. "They loved us for the first hour," Billy recalled, "but after that, it got ugly. People were throwing shit at us. And the Hüsker Dü guys were down in the front row yelling at us."

Bob Mould figures he and his bandmates had another reason to be nuisances: "We were probably jealous we didn't get the gig," said the Hüsker Dü coleader, who

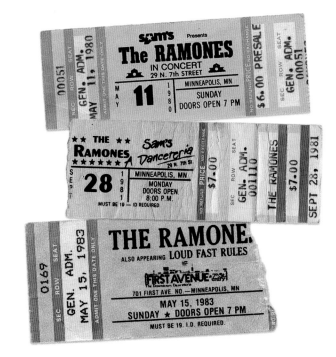

During the Ramones' multiple visits in the early '80s, some up-and-coming local bands opened for the punk icons, including the Replacements (September 1981) and Loud Fast Rules, soon to be known as Soul Asylum (May 1983). *Courtesy of Michael Reiter*

didn't know Billy Batson at the time but would later hire him as a tour sound man. "I'm lucky I don't have a dent in my forehead from Batson's mic stand that night," he concluded. Mould pointed to that show as "probably the first time a lot of us went into that place," while Batson, a future 7th Street Entry/First Ave sound man and ring-leader of the Entry's groundbreaking New Band Nights, called the first Ramones show "a threshold moment for the club."

Everyone agrees the Ramones were downright devastating that night, playing a little over an hour with

"It was really insanely loud, beyond what others were doing."

—DJ Kevin Cole

new drummer Marky Ramone and with a new theme song from the just-completed movie *Rock 'n' Roll High School*. McClellan had hired local sound company Southern Thunder to bring in a better P.A. system than the one used on disco nights. They might've overdone it. The sound limits in the room were tested that night as much as the human occupancy load was. "It was really insanely loud, beyond what others were doing," recalled the club's resident DJ, Kevin Cole. In addition to the special wardrobe case backstage for the Ramones' black leather jackets, Ernie Batson vividly remembers the cranked-up monitors: "I could hear myself breathing when I was almost a foot from the mike."

The 1979 Uncle Sam's show wasn't the New York punk legends' first time in town, but "it was the first one where they really seemed to fit the room," said guitarist Chris Osgood. Osgood's Suicide Commandos opened for and helped book the Ramones' first Twin Cities appearances, at the nondescript, blue-collar St. Paul watering hole Kelly's Pub on July 1 and 2, 1977. "We were just looking for somewhere, anywhere to bring the band to town for a show," he remembered. Jay's Longhorn bar began its three-year run as the Twin Cities' preeminent punk-rock venue that same summer, but the Ramones' stature jumped enough with *Rocket to Russia* that, when they returned less than seven months later, they needed a larger venue. They played Minneapolis's State Theatre on January 21, 1978—with the Runaways as the openers—a show stymied by the stiff, seated configuration. Then the quartet opened for the smooth-rocking Foreigner at St. Paul Civic Center on November 18, 1978. They got booed by the feathered-hair majority at that arena gig, but a small army of Ramones fans did turn out. Those fans needed the future First Ave as much as the club needed them.

Cole considers the Ramones' 1979 Uncle Sam's show the big-bang moment for the club's post-disco existence, even if its impact wasn't immediate. "That first time truly was amazing," Cole said. "It was just a classic Ramones show with raw energy, but it meant a lot. To have them in our venue was remarkable, and it sold out! That really made it seem like we were onto something."

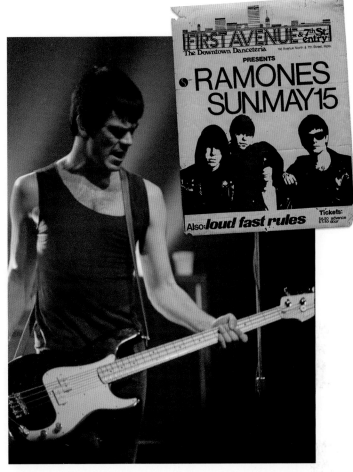

First Ave's Mainroom stage was familiar territory for guitarist Dee Dee Ramone and the rest of the Ramones by the time of this May 1983 gig. *Photo by Tommy Smith III; flyer courtesy of Dale T. Nelson*

"Back then there was very much an us-versus-them mentality among the people who were into underground music," he continued. "We really identified with the music and the scene, and with being outside the mainstream. You couldn't hear this music on the radio, couldn't buy it in most record stores. It became part of our identity, and eventually it became part of the club's identity." Working at First Ave, Cole said he and his co-workers "felt like we were making the world a better place. So when the Ramones played, I really thought we were changing the world."

If nothing else, the Ramones gig at the end of 1979 marked a changing of the guard. Someone else was now running the club that would soon become First Avenue.

Even though Byron Frank would invest a lot of his own money into the club after he became its principal owner twenty-five years later, in 1979 Allan Fingerhut's accountant advised his client to wash his hands of the place. Any decent accountant would have made the same recommendation. Fingerhut earned a steady income from Uncle Sam's for almost seven years, simply for letting American Events use the lease and liquor license. Once American Events pulled out, the catalog heir again faced the prospect of investing his own time and money into the venue—one with musty, worn purple carpeting and a similarly faded reputation. Not to mention the economy was in a nationwide slump, and that part of downtown Minneapolis in particular was looking quite grim. Future Lollapalooza cofounder Stuart Ross remembers coming to Uncle Sam's as a tour manager with Brian Auger's Oblivion Express in 1978—one of McClellan's first efforts as a rock booker—and being told by staff not to wander far from the club for dinner. "They were like, 'Well, it's getting kind of dark, so you don't want to walk in this direction, or in that direction,'" Ross recalled.

Beyond the dire economics, Fingerhut admitted, "I was burnt out on the club business and had moved on to other interests." Having already opened a gallery in the Minneapolis suburb of Edina, he would make the art business his primary focus for the next three decades. Allan was still fond of the old depot, though. In particular, he was fond of the guy who had become the club's primary caretaker after American Events backed out on its commitments. "I really liked Stephen [McClellan] and trusted him," Fingerhut recalled. "I thought he knew what he was doing, and he made a good pitch."

That pitch came in the spring or early summer of 1979. McClellan went over to the club owner's new house overlooking Lake of the Isles, in one of the toniest neighborhoods in Minneapolis. Clearly, the personal wealth that Fingerhut had lost on the Depot from 1970 to 1971 had been replenished in the subsequent years. In his proposal to convert the dying disco club to a more progressive live music venue, McClellan knew he had to promise

Fingerhut he wouldn't lose any more. "We won't ask you for any money, and we'll continue to pay you out," McClellan recalls telling him. "We'll take a half cut in pay, and we'll make it work."

To McClellan's surprise, the personal appeal paid off. Fingerhut bought into his plan. "I knew not to go through Byron," McClellan said. "I knew there was a lot of opposition to the idea. Byron wanted nothing to do with keeping the club open. I don't think the [Fingerhut] family wanted him to keep it. But Allan, to his credit, seemed to believe in us." The primary "us" was McClellan and Jack Meyers. The former schoolmates had become roommates after Meyers's service in the air force ended abruptly; he didn't pass the stringent physical required to become a fighter pilot. "He was a broken man," McClellan said. Meyers started bartending at Uncle Sam's to get by, but as American Events became less and less involved, a bigger opportunity opened for McClellan's friend. As Meyers remembers it, "One of the things American Events provided was the back-room accounting, all the numbers stuff. When they pulled out, somebody had to oversee that part of the business. Steve looked at me and said, 'Aren't you an accountant?' I said, 'No, I'm a math major.' He said, 'Close enough!'"

Meyers and McClellan formed a new company to manage the club: 2M, a play off their last names and local manufacturing giant 3M. They operated in a sizable financial hole from the very beginning. "American Events knew they were going to close, so the last six weeks they didn't pay any of the bills," Meyers recalled. "They said, 'Allan, here. These are yours.' And business wasn't so bad that they couldn't have paid them. Steve didn't know the bills hadn't been paid." At one point the founder of Kuether Distributing Co., one of Minneapolis's biggest beer suppliers, came to the club in person to collect: "Old man Kuether himself came in and said, 'Where's my money? You haven't paid us in two months.' He was a tough, old-school beer distributorship guy, and he's pissed. So I learned right away: When you owe somebody like that money, you call him right away. Even if you can't pay—or especially if you can't—you call. And he actually became one of our most loyal vendors. The [liquor] vendors on

the whole kept this place open. They stayed loyal to us when we couldn't pay. They had a good reason, too, because our volume was so high. It's not like I was just ordering two cases of beer from them. I was ordering fifty. But without their support and trust, this place probably wouldn't have lasted another year."

McClellan thinks the debt was around $60,000 from the start. True to his word to Fingerhut, he and Meyers worked for peanuts in order to avoid a financial burden on the owner. Said McClellan, "I figure I was making less than the starting wage at the club, when you consider I was working at least eighty hours a week."

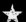

Despite many proclamations of the death of disco at Uncle Sam's—and the symbolic changeover with the Ramones show—the end was more of a trickle than a crash.

(Top) Dance nights were still a big draw even after American Events left the scene and Steve McClellan and Jack Meyers took over operations at the rechristened Sam's. *(Above)* Bands became more regular as the club looked to transition from disco DJs to live music. The funk/R&B act Phantasy played the main room twice during the month of July 1981. *Photos by Steven Laboe*

Uncle Sam's had already ridden the disco wave longer than most other venues around the country, going back to 1972, and as the new operators simply tried to keep it afloat, the club's look and formula remained relatively unchanged through the end of 1979. The signature Firecracker cocktail was still a bestseller. Dance nights were still the main draw, although they were becoming less Top 40 and more diverse and edgy.

"There was a period where I played a half hour of disco, and then I would go into a rock set and would completely lose the floor," Kevin Cole remembered of the Uncle Sam's–to–Sam's transition. "But then a new set of people would get on the floor. It was interesting to work that crowd, and work it to the point where nobody left and people didn't care if it was rock or dance or funk or whatever, it was just great music. That 1979–80 era might be Sister Sledge and the Sugar Hill Gang into the Clash, Devo, Gary Numan, or, for that matter, Lipps Inc. and eventually Prince. We were trying to get to the point where people just liked music and had a level of trust in the DJ." Billy Batson said of Cole and Freedom, "They led the crowds by the nose from crap to anything that mattered."

Many live acts were brought in for the first few months of Wednesday night concerts, and they were still mostly locals. Among them: hair-metal pioneers Dare Force (with ex–Cheap Trick singer Randy "Xeno" Hogan); popular hippie folk-rockers Sussman Lawrence (led by future Grammy-nominated singer/songwriter Peter Himmelman); and Cain, holdovers from the mid-'70s who had graduated from low-rent fog machines to laser-light shows. Other names on the calendar those first few months under the McClellan-Meyers leadership included a surprising number of acts that still regularly perform around Twin Cities clubs into the 2010s: country-rockers the Daisy Dillman Band; jazz groups Rio Ndio and the Wolverines; veteran supper club singers Mary Jane Alm and Johnny Holm; and the ever-reliable Curtiss A, then performing with a group called Yipes!

"There was a pretty big explosion of new bands at that time, but a lot of them were playing over at the Longhorn," remembered Curt Almsted, one of the few acts playing both the Longhorn and Uncle Sam's/Sam's. "Most of the whole new wave thing was born at the Longhorn, but nobody liked [late-era Longhorn owner] Hartley Frank, so it was a relief to have somewhere else to play."

It was through Curtiss A that Sam's hired the first of many women who would play a pivotal role in making First Avenue cool. And man, was she cool herself. Chrissie Dunlap had three young children at home by 1979, but she still made it out often to see and support gigs by her husband, Bob Dunlap, then Curtiss A's sideman and later a Replacements guitarist. An avid music lover, Chrissie somehow got turned onto blues and R&B growing up in St. Louis Park. At fourteen, she forged a note from her mother to attend a concert by blues master Jimmy Reed at the Marigold Ballroom. She met Bob at a show by his early band, Mrs. Frubbs, in 1971. By 1979, Bob had put in a few years in several of Curtiss A's bands, one of which, Thumbs Up, Chrissie held up as "the best band in town at the time, and one of the few that dared to play original music."

Bob Dunlap was often the one to collect payment after gigs with Almsted. It was during those "settle" sessions that Chrissie first stepped into the office where she would spend the next nine years of her life. "Bob is a yapper, and Steve [McClellan] is a yapper, so the getting-paid

Chrissie Dunlap not only brought order to the office when she started working at the club in 1979, she played a big role in turning First Avenue into a premier venue that attracted elite touring and local acts. *Photo by Allison Cumming*

thing would usually take until two or three AM," Chrissie said with a laugh. "I would look at Steve's desk and be amazed at the amount of crap on it, and I asked, 'How do you get anything done?' The man is really, really messy and unorganized. I told him, 'What if I just came in one afternoon and made some organized piles for you and prioritize them?' I offered as a friend, not as a job. I wasn't even thinking of working then; I was a full-time mom. So I was basically hired as Steve's desk organizer. Somebody had to do it. I just came in one day and made piles and left. I guess I was effective, because he did hire me."

Dunlap's arrival near the end of 1979 was perfectly timed, since the club was starting to book more and more live music. Just having someone in the office during the daytime—the only time Dunlap could work—proved to be an asset. "Those guys were working until four in the morning and then partying or whatever," Dunlap recounted. "Steve did not show up at the office until about four in the afternoon. Well, the phone starts ringing at nine AM with agents and radio stations. I just started dealing with all of them. All that stuff on Steve's desk was promo material, contracts, riders, that kind of stuff. Agents would call and ask, 'Where's our deposit? If we don't get it today, you aren't getting the show.' I quickly figured out how to do a wire transfer, how to do a rider or sign a contract, and what are we going to [pay] the band. Instead of filing the files, I started dealing with what's in the files."

The concert business was relatively new to McClellan, too. When American Events was still in charge in 1978, he had booked that Brian Auger show and two other tour dates with acts he thought would be sure things because they had hit songs on the radio: Vancouver glam-pop rocker Nick Gilder of "Hot Child in the City" fame, and disco-y Atlanta band Starbuck, which scored a No. 3 single with the breezy "Moonlight Feels Right." The club lost money on both shows. "They did okay, but I just didn't really know what I was doing and paid too much for them," McClellan said. Over the next two decades, the club's leader would pay a lot less attention to record sales and radio play when it came to booking acts—sometimes

to a fault. But even he was surprised at the turnout for that first Ramones show in '79, for a band that "had never gotten a lick of radio play," he said. "How did so many people know about this band? It was really an eye-opener to me."

McClellan had another sellout show the night after the New York punks' appearance, but in this case radio support definitely played a role. Pat Benatar made her Minnesota debut at Uncle Sam's on November 29, 1979, a few months after her first hit, "Heartbreaker," broke wide and set her on her way to becoming one of rock's biggest-selling female artists of the '80s. Tickets were only $1.92, a "low-dough show" promoted by rising FM rock station KQRS (92.5 FM). Curtiss A opened, but he

The back-to-back Ramones and Pat Benatar concerts—with locals the Hypstrz and Curtiss A, respectively, as the openers—in November 1979 helped put the club on the path to becoming a relevant concert venue again. *Ad courtesy of John Haga; ticket courtesy of Errol Joki*

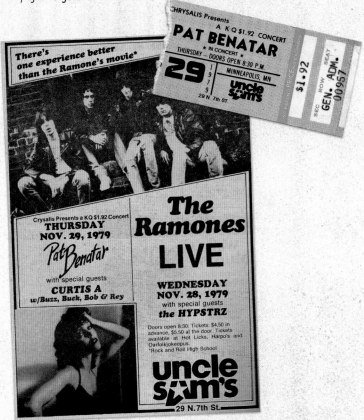

doesn't remember much about it. "Lots of jean jackets and suburban mullets," is how it was remembered by future Jayhawks manager PD Larson, then a writer for the alt-weekly *Sweet Potato*, which became *City Pages* a year later. "I'm guessing for many attendees, it was their first and last trip to First Ave," Larson added.

It was no coincidence the Ramones and Benatar were on back-to-back nights. They were a twofer package offered by Jorge Quevedo, an agent with the Premiere Talent Agency in New York, who gambled on McClellan and the transforming Minneapolis nightclub. "[Quevedo] took a liking to me and booked both shows with me at a time no other major agency would have anything to do with Uncle Sam's," McClellan recalled. The risk paid off and would lead to a fruitful relationship for both.

As the '70s came to an end, though, a disconnect persisted between the transformative disco club and the underground/punk/new wave/whatever music freaks who would become its mainstay audience in the coming decade. Pat Benatar wasn't the answer, and the Ramones show alone wasn't enough to turn the tide. Fortunately, by the end of 1979, McClellan and his team had something else in the works that would bridge the gap and make Sam's relevant, especially to the local music scene. Hypstrz singer Billy Batson believes that the night of the Ramones show was when McClellan pulled him aside and asked him to go look at the dark, musty room that had mostly served as a coat check space. "I remember him telling me it used to be the short-order restaurant for the bus depot," Batson recounted. "He said, 'What do you think? We're thinking of putting a club in here.'"

The club's part-time coat-check room/storage space/merchandise shop would soon be put to better use as a second performance space. In this 1978 photo, behind the merch table is Jody Penhollow, whom Steve McClellan described as "one of the sweetest people I have ever known." *Photo by Steven Laboe*

The idea for 7th Street Entry is mostly credited to Danny Flies, a staffer involved in booking and promotion for Uncle Sam's. Although he would be fired a short while later, Flies proved integral in the meantime. "He was one of the go-getter kids who knew a lot more about the music than I did at the time," McClellan said. "We were trying to figure out what to do with that room. It was a game room for a while, but American Events found out most people didn't go in there—and people would break into the games, because no one was in there to see them. So that stopped. It was used as a storage area off and on. We used it as a coat check on the real busy nights. But it seemed kind of like wasted space."

Now out of the music business and living in Peoria, Arizona, Flies recalled McClellan being equally

"It was a dingy, dark, ugly, filthy room. Steve [McClellan] came in and said, 'I wanna put a stage here, a bar over here.'"

—Danny Flies, booking and promotion, Uncle Sam's

responsible for the vision behind the small room. "It was a dingy, dark, ugly, filthy room," Flies recalled. "Steve came in and said, 'I wanna put a stage here, a bar over here.' I remember distinctly us wondering what to call it. He came up with calling it The Tangent. I was like, 'What the fuck is that?' In a moment of brilliance, though, he looked at the door and said, '7th Street Entry.'"

Flies, Dunlap, Cole, Freedom, and eventually McClellan all recognized that something special was going on in the Twin Cities music scene. The crowds a few blocks away at Jay's Longhorn bar hinted at a bigger, broader movement of punk and new wave bands playing original music. The Suicide Commandos were ahead of the punk curve starting in 1975 and had already signed to Mercury Records in 1977. By 1979, Chris Osgood and bandmates Dave Ahl and Steve Almaas had inspired an untold number of local musicians to start bands, including the Replacements, the Suburbs, and Hüsker Dü. Even before the Commandos and the Longhorn, local audiences got a taste for punk with that 1971 Iggy & the Stooges show at the Depot and especially with a now-legendary appearance by the New York Dolls at the Minnesota State Fair in 1974.

In September 1979, Walker Art Center staged what's seen as the Woodstock of the Twin Cities punk scene. The event's full grandiose title was "Marathon '80: A New-No-Now Wave Festival," but locals remember it simply as M-80. Over two days at the University of Minnesota Field House, bands including Devo, Suicide, the Joan Jett Band, the Feelies, Television's Richard Lloyd, and future First Ave regulars the Fleshtones and the dB's performed along with local acts the Suburbs, NNB, Flamingo, and Osgood's all-star Minneapolis Rockestra. The show was one of the many big ideas pulled off by Tim Carr, a Hopkins native and one-time *Minneapolis Tribune* rock critic who would later help the Beastie Boys and Babes in Toyland land their record deals.

It's no coincidence that the idea for the Entry was launched in the aftermath of M-80. Most of those edgy, left-of-center new bands were gaining traction but weren't big enough to play the main room at Sam's. Some local bands of that ilk—namely the Suburbs, whose great Twin/Tone Records debut *In Combo* arrived at the start

The Marathon '80: New-No-Now Wave Festival, better known as M-80, shined a spotlight on the Twin Cities' growing punk and new wave scene. *Courtesy of Dick Champ*

of 1980—were getting big enough to regularly pack the four-hundred-capacity Longhorn bar. While that venue was still thriving in March 1980, when 7th Street Entry opened its door, Jay Berine's run as manager/owner and bands' interest in playing there were both wavering by 1981. Berine's less-well-liked cousin Hartley Frank took over and converted the Longhorn into a pizza joint called Zoogie's by 1982.

Danny Flies remembered, "Some of the bands were reluctant to play [the Entry] at first because Hartley Frank didn't want them to play anywhere else but the Longhorn. Osgood, Suburbs, the Flaming Oh's all didn't

The floor plan for a redesigned Sam's shows a small stage set-up in the former coat-check room. *Courtesy of the Museum of Minnesota Music*

play there early on because Hartley essentially wouldn't let them."

Hüsker Dü never really earned a strong reception at the Longhorn, so Bob Mould remembers taking a liking to the Entry right away. "To watch another room come to life like that was exciting," he said. "It was good timing, too, because the Longhorn was becoming Zoogie's. There was also Duffy's [later Norma Jean's, a south Minneapolis bar], which was . . . well, it was Duffy's, just different. And other than that, there were not many other places to play."

An unofficial ringleader and perhaps gatekeeper for the vibrant new underground scene, Peter Jesperson remembers McClellan calling him up at Oar Folkjoke-opus to petition his support for the Entry. Jesperson still managed the famed record store (later Treehouse Records, on Lyndale Avenue and Twenty-sixth Street) while also DJing at the Longhorn and cohelming the new Twin/Tone Records label. Oh, and he also had just started managing a new band called the Replacements. "I didn't know [McClellan] then, but he said they're opening this new room," Jesperson recalled. "He said they're not trying to do anything up against the Longhorn. They

wanted to live in harmony with the Longhorn and have a sort of connection and synergy between the two clubs. He asked me to come down and look at it. He gave me a tour, and I met Danny Flies, who was on board to book. [McClellan] and I hit it off and clicked immediately."

The conversion of the coat room into 7th Street Entry began in January of 1980. Suicide Commandos drummer Dave Ahl and Steve's brother Kevin McClellan were part of the construction crew. Tearing out a wall, they found menus for the old bus depot café offering a five-cent cup of coffee. Elsewhere, somebody found a science-experiment-worthy jar of pickles that dated back at least fifteen years, if not fifty. "There was even a walk-in cooler back there, which we later used as storage," McClellan recalled. Mostly, though, the refurbishment was bare bones and a bit out of sorts: The Entry stage was originally erected in the corner where the bar currently sits, and the bar was where the sound booth is now. That lasted only about two years, so you know someone's old school when they tell you they remember when the stage was over in the corner.

"We had it all set up wrong, with the stage where it was," McClellan said, confessing to several questionable tactics used to open the 250-capacity room. "We did it for like $1,500 total. We used card tables, and ice buckets for

The bar (for lack of a better term) at the newly opened 7th Street Entry was originally set in the corner where the sound booth is now located. Michael Pittman served as the bartender in those early days. *Photo by Steven Laboe*

beer at first. There was no plumbing back there. We didn't have the city managers come in and inspect the place. We would've never got it open if they came and looked at it. I don't think anybody at the city was really aware we had it in there for years—probably not until two years later, when we remodeled it. And by then, it was doing well."

The Entry opened on such a shoestring budget, even Jack Meyers came out from behind the club's pile of overdue bills to get involved with the sound system. Meyers had bought himself a small collection of relatively high-end Bose home stereo equipment at low cost while stationed overseas with the air force. "The speakers that opened the Entry were my home speakers," Meyers marveled. He summed up the rest of the low-budget approach well: "The general idea was it was fashionable to have a club that was incredibly ugly. Just like CBGB and the Mudd Club in Manhattan. We didn't do any painting, no carpet. It was just bare minimum. I brought in my old couch, too." The couch was used in the downstairs green room, where it remained for many years, soaking up god knows what.

While Meyers's speakers were great for a living room, they did not work so well as the club's stage monitors, used by performers to hear themselves. Curtiss A, who would play the Entry probably more than anyone over the next few years, certainly wasn't impressed. "He hated them so much, he would grab them and tear them down" from their hanging positions, Meyers remembered. "He must've done that at least four times. I would get so mad whenever he did it, because I was the one who would always have to hang them back up. I would yell at Steve to tell him to stop doing it, and Steve said, 'Well, you can't really get mad at him. They are terrible monitors.'"

Curtiss A served as 7th Street Entry's opening-night headliner on Friday, March 21, 1980. With him on guitar was Bob Dunlap, who thus beat his future Replacements bandmates to the stage by a few months. The warm-up act—and thus the first band to officially play the room—was Wilma & the Wilburs, one of the first local punk bands fronted by a woman, Cathy Mason. At first, many of the bands who played the Entry would settle in for

Steve McClellan's letter to "Media Folks" in May 1980 explained the dissolution of the club's partnership with American Events and outlined the opening of 7th Street Entry and upgrades to the main room. "We are an urban club," McClellan wrote, "and the bottom line is music." They hadn't yet gotten new stationery, however, so McClellan crossed out the word "Uncle" on the old stationery to indicate the club's new moniker. *Courtesy of the Museum of Minnesota Music*

two-night stands. Hüsker Dü may have been the first to double up with two midweek gigs that March 26 and 27, with Wilma & the Wilburs opening for them both nights. A flyer for their shows, decorated with cutout photos of binoculars, advertised the venue as "7th Street Entry under Uncle Sam's," and promised two-for-one drinks on the first night.

The first mention of 7th Street Entry in *Sweet Potato* came in early April. Music editor Martin Keller botched the new venue's name in his gossipy column, the Martian Chronicles: "Meanwhile, back at the latest New York City styled (dump) club, the 7th Street Entrance," he wrote, "the latest joint to feature all the likely ambience of dives like CBGBs, the patrons were mixing it up in the coziest kind of way. Martian spied all sorts of local rock stars, groupies, strangers he'd never seen before and a bevy of local critics taken to a small corner to casually dismember the latest album or group they love to hate."

7th ST. ENTRY
SAM'S 29 N. 7th St. Downtown Mpls. 338-8388

May 2-3 Curtiss A and the Buckrakers 2 for 1 until 10:00	May 5-6 PSYCHENAUTS Mon.: 2 for 1 all night Tues.: 50¢ Draft and Bar Drinks	May 7-8 THE WARHEADS Mon.: 2 for 1 all night Thurs.: 2 for 1 until 10:00
May 9-10 Surfin' with the Overtones 2 for 1 until 10:00	May 11 Ramones with Overtones and Wilma & the Wilburs Sam's Main Room	May 12-13 Wilma and the Wilburs Mon.: 2 for 1 all night Tues.: 50¢ Draft and Bar Drinks
May 15 FINE ART 2 for 1 until 10:00	May 16-17 The Wallets 2 for 1 until 10:00	May 19-20 Nicks Mon.: 2 for 1 all night Tues.: 50¢ Draft and Bar Drinks
May 21-22 the Overtones Wed.: 2 for 1 all night Thurs.: 2 for 1 until 10:00	May 23-24 Curtiss A and the Buckrakers 2 for 1 until 10:00	May 26-27 The Wallets Mon.: 2 for 1 all night Tues.: 50¢ Draft and Bar Drinks

Coming May 30 and 31

NNB

Mark Freeman, Richard Champ, Cindy Blum, Chuck Hultquist.

(Above left) Hüsker Dü was an early headliner at 7th Street Entry, doing a two-night stand in March 1980 with Wilma & the Wilburs. *Minnesota Historical Society Collections.* (Above right) The May 1980 calendar featured several bands that would become Entry staples, including Curtiss A, the Warheads, Wilma & the Wilburs, and the Wallets. That same month, on May 11, the Ramones made their second main room appearance in six months. *Courtesy of Dick Champ*

The first "Sam's 7th Street Entry" ad in the back of *Sweet Potato* ran in April 1980. Bands on the calendar included Escape, Wilma & the Wilburs, Yipes!, Chris Osgood 55401, and the ever-present Curtiss A. The next month's listings featured most of those acts as well as the Warheads and the Wallets, who would also become Entry staples during the Sam's era. By the end of summer, the calendar also regularly highlighted Safety Last, a rockabilly band that later featured future Jayhawks coleader Gary Louris, as well as NNB, one of the artier, Television-channeling bands that appeared at the M-80

festival. "It was the same set of bands for a while—maybe a dozen or so—all just kind of alternating nights," Mc-Clellan remembered.

Under a headline declaring it "The Avant-Garage," the Entry got a full-page write-up in the May 30 issue of the *Minnesota Daily*, the first coverage to recognize the small club's big potential. U of M student Eric Lindbom wrote, "The Entry's size restricts it to presentation of bands without mass appeal, so experimentalists are welcome and they're not expected to have played bars before. The importance of the Entry for the development of young bands in Minneapolis can't be overestimated.... While Duffy's has always seemed like Uncle Ed's ornate Minnetonka billiard room, the Entry looks like a rock room should. It looks lived-in, puked-in and treehouse-like." Lindbom detailed the graffiti left over from when the space was used as a game room, including "Gene Vincent is God," "X-Ray Specs," and "I Love You Riff Randle." He described nights with two other bands who would become Entry regulars: Fine Art, a new-wavey funk band with two women singers, Kay Maxwell and Terri Paul; and eclectic, accordion-fueled funk-pop greats the Wallets, who purportedly "broke the box office record" at the club the week before and would be one of the first acts to successfully graduate from the Entry to the bigger room next door once it became First Avenue.

"The Wallets may sum up what can be done in a bar like the Entry," Lindbom wrote. "They've played together months, not years, and the lineup of musicians is as stable as the U.S. economy. The concept is a poor man's version of Dylan's Rolling Thunder Revue: Whoever is available chips in and plays under the direction of Steve

"This is what a rock 'n' roll bar should be. It's giving people incentive to start bands."

—NNB singer/guitarist Mark Freeman, on 7th Street Entry

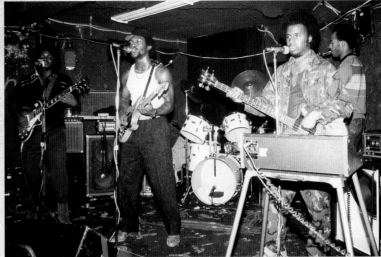

(Above left) The Entry attracted a diverse array of innovative acts in its early years. Here members of the Warheads, including Jay Smiley on bass, Tim Holmes on guitar, and Grant Hart on drums, perform on what Smiley describes as "Torture Clowns" night. *(Above right)* For many local funk and R&B acts in the early 1980s, gigs were easier to come by in the Entry than in the Main-room. The Family (not to be confused with the Prince-produced version later in the decade) played the smaller room in 1981. *Photos by Steven Laboe*

Kramer." That concept would be tested a month later when David Byrne—whom Kramer befriended while living in New York—became the first bona fide rock star to step on the Entry stage. In town to take part in the New America Music Fest at Walker Art Center with Laurie Anderson, the Talking Heads frontman joined the Wallets for two cover songs, "Crimson & Clover" and Van Morrison's "Stop Drinking."

The Entry was more about inventing rock stars than inviting them onstage, a fact the *Minnesota Daily* caught right away. As Flies told the student newspaper, "There's new blood in the Minneapolis music scene, and we're nurturing it." Mark Freeman, singer/guitarist in NNB, said in the same article, "This is what a rock 'n' roll bar should be. It's giving people incentive to start bands. I know a lot of people with good musical ideas, but why should they bother if they're going to be stuck playing a Tiger Night [a showcase for new bands] somewhere?" More in touch with the numbers up in the office than with what was going on down below, Jack Meyers confirmed three decades later, "The Entry did well almost right away. People really came out and supported the

local bands that played there. We had more trouble getting people in the bigger room."

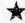

As the Entry quickly turned into a bustling hub for local bands, the main room remained more of a void. Touring concerts were still rare as McClellan struggled to get booking agents to gamble on his big club in a midsized city. Ads in the back of *Sweet Potato* in early 1980 list only one or two concerts per month in the main room. That doesn't mean things weren't interesting inside the old depot space, though.

Desperate to fill the main room during the week—weekend dance nights with DJs Kevin Cole and Roy Freedom were solid draws—McClellan and his crew got creative over the summer of 1980 and through the end of 1981. This period has been held up by some eyewitnesses as McClellan's P. T. Barnum era. "If you didn't have live entertainment, it was slim pickings on Mondays, Tuesdays, Wednesdays," recalled bartender/photographer Steven Laboe. "They were kind of desperate." Laboe remembers

(Above left) Sam's All-Male Revue—yep, male strippers at the now-legendary rock 'n' roll club. Photo by Steven Laboe. (Above right) One of the less risqué promotions initiated during the Sam's era was air-guitar, lip-synch contests at which participants performed as their favorite bands to compete for cash prizes. It was a tradition that continued well into the First Avenue years as the Great Pretenders series. The Great Pretenders VII finals were held on July 14, 1983. Photo by Steven Laboe; flyer courtesy of the Museum of Minnesota Music

hitting the town with a group of guys from the club one Monday night to go check out the competition. The group included McClellan, Meyers, and Dan Lessard, the last of whom had signed on as manager in charge of bar staff and some of the promotion. "We all piled in my car," Laboe said. "We started driving around, checking out what other clubs were doing. We ended up over at Norma Jean's and a few others. They were looking for something that would, you know, start generating some more traction down there [at Sam's]."

Among the ideas McClellan's team came up with to bring in weeknight crowds: Tuesdays became Ladies Night, with the so-called Sam's All-Male Revue. Yep, strippers. Thursdays featured the amateur talent contest "Everybody's a Star" and, later, a lip-synch competition called "the Great Pretenders," both of which proved unusually popular and lasted into the First Avenue era. And in one of its less progressive moments, Sam's also regularly hosted wet T-shirt contests or mud wrestling, the latter set up right in the middle of the dance floor.

"Those of us who hung out in the Entry early on didn't go in the main room unless you had to use the bathroom and wanted the slightly nicer can, because the main room was not cool," Chrissie Dunlap explained.

"The mud wrestling was just—ewww. It was just gross in so many ways, so sexist, but also just literally dirty. It was such a mess to maintain that stupid mud-wrestling pond." Dunlap was in charge of booking the male dancers, "which was also gross in a different way, but at least it didn't involve mud," she said. "They kept the male dancers around a while. It was pretty popular."

Matt Wilson, who later formed the beloved '80s band Trip Shakespeare, remembers playing a couple cameo sets with his earlier group, the Panic, on the night of the all-male revue. A weird gig for any rock band, the strip-night cameos were especially odd for Wilson and his bandmates since they were still in high school at the time. "There'd be these male strippers out there doing these really pretty amazing stripper things, and then all of a sudden here comes a band of goofy high school kids playing these new wave kind of songs," Wilson marveled. Still, those gigs weren't without merit. "We got to really know Steve McClellan through those, and I think we earned his respect," Wilson added. This would pay off in April of 1981, when the Panic landed one of the most coveted warm-up gigs of the Sam's era, opening for a young band from Ireland called U2.

The high-water mark for McClellan's non-musical

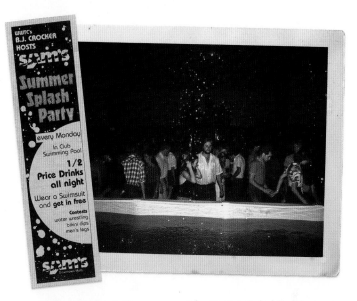

Every Monday in the summer of 1981, Sam's held a "Summer Splash Party" to promote the new swimming pool. Apparently the concept of pairing half-priced drinks with "water wrestling" didn't give anybody pause. Although there are no swimsuits in this photo, club-goers danced the night away behind the above-ground pool. *Photo by Steven Laboe; ad courtesy of Dean Vaccaro*

inventiveness came over the summer of 1981 when he had an above-ground swimming pool erected on the dance floor, where the soundboard usually is nowadays. One can't help but wonder how many liquor laws, city codes, and common-sense sanitary rules were broken by today's standards. "I remember drinking after hours one night, and I almost dove into the damn thing," said former marketing staffer LeeAnn Weimar. "It would've been all over for me."

"Wear a swimsuit and get in free," read an ad for the "Summer Splash Party," hosted every Monday by WWTC's B. J. Crocker. Activities included a "bikini dip," "water wrestling," and a "men's leg contest." A later ad promotes "Aqua Dance Night" on Wednesdays, also offering free entry with a swimsuit. Even Allan Fingerhut—who took some credit for bringing in amateur wrestling and the air-guitar and lip-synch contests—was quick to pass the buck on the pool: "That was Steve's deal," asserted the former owner. "I walked into the club one night. There it was: a swimming pool right in the middle of the floor. I said, 'Steve, what the hell are you doing?' He said, 'A lot of people like to jump in a swimming pool.' I didn't

want to know how much the swimming pool cost, or how they got the water in there."

McClellan said he got the idea from a salesman who sold the club a new lighting system around that time— "one he didn't actually own, it turned out"—and who also happened to have a toe dipped in the swimming-pool business. As if the pool wasn't enough, piles of sand were brought it to make a "beach" (albeit a booze-soaked one with zero sunlight and heavy cigarette smoke). "You have no idea how many inspired belly flops occurred at closing time for this promotion," said longtime doorman Richard Luka.

Nevertheless, the pool itself was mostly a flop, and many staffers hated it from the outset. Kevin Cole thought it was great "until the pool leaked and soaked all the records stored under the stage." Three decades later, though, having taken the plunge in the First Ave pool provides an unusual bragging right, one claimed by Paul Barber, a Southwest High School grad who's now a web developer for Wells Fargo: "I was a city lifeguard, and we'd come down after work in our uniforms, complete with whistles," he recalled. "I won the under-water kissing contest once."

As desperate as these schemes might seem, they are the reasons why Luka believes the Sam's era was the most fun time to work at the club. "Nobody knew what they were doing; no one knew what direction we were headed in. Lots of times we didn't know if the payroll would be met," he said. "But was it ever exciting! We got to see bands and listen to music no one else had heard in these parts. It was total chaos at times, and I wouldn't have traded anything in my life for the amount of fun we all had then. It was like the wild west at times, lots of fights, lots of parties, and lots of mayhem."

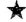

Concerts in the main room remained sporadic and elusive, but McClellan and his team did manage to bring in some big names. In April 1980, the Pretenders and the Joe Perry Project performed on consecutive nights. The Pretenders' April 23 show came one month into the first

the legendary
BO DIDDLEY
accompanied by
Curtiss A
**Wednesday
April 16**
2 for 1
DRINKS
Tickets $3.50
at the door
sam's
Downtown, Mpls.

MP MPPRT PRETENDERS
PRT EVENT
 APRIL 23,1980
STP VALID FOR DOORS OPEN AT 8:00PM
GA ADULT SAMS
SEC ADMISSION
CHA IF ATTACHED FORMERLY UNCLE SAMS
GEN 4.00 PRESENTED BY COMPANY 7
ROW PRICE A 1538 GEN ADM STP A ADULT
 TAX
ADM 04/03 GA GEN ADM s 4.00
SEAT SEC ROW/BOX SEAT TAX INCLUDED

(Left) Chrissie Hynde and the Pretenders were fresh off their hit "Brass in Pocket," released in November 1979, when they took the Sam's main stage in April 1980. *Photo by Michael Reiter; ticket courtesy of Michael Reiter.* **(Above)** Bo Diddley was one of the biggest stars during the Sam's era—and you could catch him, along with local opener Curtiss A, for $3.50 *and* two-for-one drinks. He returned to the club several times in the First Avenue era as well, as seen in this 1985 photo. *Flyer courtesy of Chrissie Dunlap; photo by Tommy Smith III*

U.S. tour for the Akron-reared Chrissie Hynde and her London-based band. With their debut album released just four months earlier, they were already big enough to pack the club. They opened with two of the heavier songs from the record, "The Wait" and "Precious," delivered the hit single "Brass in Pocket" midway through, and ended with their soon-to-chart cover of the Kinks' "Stop Your Sobbing."

Twin Cities metal vet Bill Lindsey, who would found the pioneering gore-rock band Impaler a few years later, remembers the following night's Joe Perry Project show well because it was his first visit to the club, and because he ran into the guitar legend on Hennepin Avenue that afternoon and got his autograph. "The stage was just a stripped-down rock 'n' roll presentation with simple drum kit, amp stacks, and a bunch of Stratocasters and B. C. Riches on guitar stands," Lindsey recalled. At the time, Perry had parted ways with Aerosmith, and he and frontman Steven Tyler weren't even speaking to each other. So, the guitarist came to town with his own band; he introduced the Aerosmith song "Bone to Bone" as "a song I recorded with some friends."

Another big April show was the first of what would become a trademark under McClellan's reign, especially when Chrissie Dunlap was working with him: booking older R&B and rock pioneers alongside the punks and hipsters. They brought in Bo Diddley, a music legend they thought belonged in a gritty rock club instead of a stuffy supper club or outdated prom center. Diddley would return to the venue twice more over the next few years, including one date with a pickup band led by Chris Osgood of the Suicide Commandos. Osgood's cohorts the Ramones also came back and played Sam's on May 11, a sign of how well the show six months earlier did. This time, McClellan splurged and booked two openers: Entry mainstays Wilma & the Wilburs and Twin Cities surf-rockers the Overtones.

Through the latter half of 1980, however, the Sam's calendar was conspicuously sparse and far from trendy. The only bands listed for the big venue that June were "TBA" and Trillion, the latter a Styx-flavored Chicago band led by future Toto singer and Twin Cities resident Fergie Frederickson. John Mellencamp, then still known as John Cougar, was booked for October 16 but cancelled (McClellan believed an outside promoter moved Cougar to a bigger room). Ronnie Montrose, Sammy Hagar's former Montrose bandmate, played the main room with his new band Gamma on November 13. In the same vein of hair-band precursors, Australian hard-rockers the Angels arrived December 14, billed as Angel City in America. Sam's was still far from hip and happening, at least not consistently so.

Luckily for the new managers, the weekend dance parties led by DJs Cole and Freedom were still bringing in crowds and profits. Ads touted these nights as a "Danceteria," which Freedom said was "definitely ripped off from the Danceteria in New York. The first year they had that New Music Seminar [1980], me and Steve went out there. 'I like that name,' Steve said. 'We'll put that on our night as Danceteria.'" It carried extra meaning in the minds of the DJs, who saw their mix as being like a

cafeteria. "We're going to play everything," Freedom recalled. "We're going to play hip-hop, we're going to play rock, we're going to play Madonna, we're going to play you know, the top tunes, whatever."

Up in the office, Chrissie Dunlap and Jack Meyers noted that the dance nights did so well, booking live music on those nights seemed almost self-defeatist. "Back then, we were so packed on weekends, why give away the store and book live bands?" Dunlap remarked. Of course, she and McClellan still had their hearts set on live music. They began booking live shows more and more, relying on the dance nights to pay the bills. This would stay the case off and on until the late '90s. "The money that came in on the weekend allowed Steve to book those unknown bands in the Entry," Dunlap said. "You look at the calendar from any given month in those days and see so many amazing bands playing the Entry. That's because the weekends were paying for them."

By the autumn of 1980, more touring punk bands were popping up at 7th Street Entry, breaking up the rotations of local groups. Among them: New York art-punks Bush Tetras for two nights in September; San Francisco's all-female punk trio the Contractions on consecutive nights in late October; the Skunks of Austin, Texas, on November 4 and 5; and Boston's influential trio Mission of Burma for two nights, November 22—with their future SST labelmates Hüsker Dü opening—and 24. The

By November 1980, the Entry was booking touring punk acts like the Skunks and Mission of Burma while cultivating emerging hometown stars like Hüsker Dü and the Replacements. *Courtesy of the Museum of Minnesota Music*

JOHN LENNON TRIBUTES

urt Almsted and Bob "Slim" Dunlap weren't even speaking to each other the night they kicked off the longest-running event in First Avenue history. They didn't really need to communicate, though. It was on Tuesday, December 9, 1980, and everyone was numb from the news the night before: John Lennon had been gunned down outside his apartment in New York City. ABC-TV sports legend Howard Cosell broke the news to much of the country with only three seconds left in the *Monday Night Football* game.

When Chrissie Dunlap got to the First Avenue office the next morning, she made a spur-of-the-moment decision. Hard-swinging rockabilly band Safety Last was scheduled to play 7th Street Entry that night. Chrissie's husband, Bob, was serving as the band's fill-in guitarist at that point. "I thought we had to do *something*," Chrissie recalled. "Curt was the obvious choice."

A Minneapolis native with a troubled upbringing and one of the most realistic alien abduction stories you'll ever hear, Almsted had been kicking around city and outstate bars with various bands since the late '60s. He was known to nail Beatles tunes as well as older rock and blues classics that influenced the Fab Four. In the spring of 1980, though, he set himself apart from his cover-band past by releasing *Courtesy*, his debut album as Curtiss A for Twin/Tone Records, which earned a five-star review from *Rolling Stone* and featured Bob Dunlap on guitar. Soon after its release, though, the two bandmates got into an argument that lingered hardheadedly into December.

"Chrissie called up and asked if I would do it," Almsted recalled of the aftermath of Lennon's death. "I said yeah, '[Bob] and I don't have to talk. We can just play.' We both compromised. I wasn't in the mood to be mad at anyone, and I think he felt the same." Bob Dunlap sounded a little more apprehensive when he recounted that night in a *Star Tribune* article in 2000: "I was going, 'I don't know, I don't know.' But I figured

By the thirtieth Lennon Tribute in 2010, a full stage of local musicians joined Curtiss A year after year. *Photo by Steven Cohen*

Curtiss A's Lennon Tribute has been growing in popularity since its inception in 1980, the night after John Lennon's assassination. Here Curtiss A enjoys the moment during the tenth annual concert in 1990. *Photo by Jay Smiley*. Ticket stub from the seventh annual John Lennon tribute, December 8, 1986. *Courtesy of Errol Joki*

Curtiss A, a longtime Twin Cities music icon, enjoyed a quiet moment in the green room of 7th Street Entry during his sixtieth birthday on January 29, 2011. *Photo by Jay Smiley*

that after what had happened, Curt could probably also use the company, because that was a mighty sad night for people of my age group."

There was no rehearsal, or even a set list, as Almsted recalled. He took a city bus down to the club and didn't bother bringing his own guitar. He showed up in the Entry while Safety Last played one of its regular sets to kick off the night. After the break, they got serious. By then, word had gotten out on what was going down that night, so the club was nearly packed. "The first song we played was 'I'll Cry Instead,' and we just went from there," said Almsted. "I think we played about an hour, just one set. It was all the songs we could play off the top of our heads."

"It was a solemn affair," Almsted continued. "My one memory of it is at the very end, it was kind of cathartic, but instead of being a nice guy, I just walked offstage and went to get a bus. I didn't talk to anybody. That wasn't because I was mad at Slim. I just didn't feel like I had anything to say."

Curt helmed a Lennon tribute with his own band the following year at Goofy's Upper Deck, a popular early-'80s punk bar above a strip club on Second Avenue North in Minneapolis. In 1982 he brought the show back to 7th Street Entry and in 1983 it landed in the First Avenue Mainroom. According to Almsted, that's the year it took hold as an annual tradition. The 1983 lineup included two future Replacements replacements: drummer Steve Foley and Dunlap—the two friends had reconciled by then. Almsted had a distinct memory from that year: "The song that killed me the most was 'I Am the Walrus,' because Slim was so great. We did it as a four piece. I don't know how."

From then on, every December 8 has been Curtiss A's Lennon Tribute night at First Ave. The band has grown over the years to something of a mini-orchestra, with mainstay members including late guitarist Vik Johnson, Safety Last bassist Rusty Jones, drummers Steven "Tilly" Thielges and "Bongo" John Haga, Phones/Suburbs guitarist Steve Brantseg, and, in later years, bassist Dik Shopteau and *Blood on the Tracks* session keyboardist Gregg Inhofer. Dunlap was a regular early on, and often showed up for at least a few songs until his stroke in 2012. Many of those nights, the music has gone more than four hours, with about seventy-five songs on average. "It turned into a beautiful thing," said Almsted. "I'm still happy to play *any* of these songs." ∎

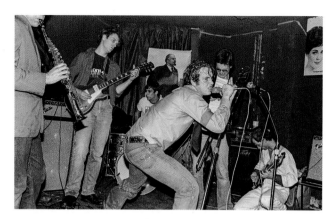

Behind frontman "Don the Baptist" Holzschuh, the Warheads could be counted on for an exciting show, especially in the close confines of 7th Street Entry. *Photo © Kathy Chapman*

Replacements also became Entry regulars that fall, as did another wild-eyed but artier punk band, the Warheads.

A reputable visual artist, frontman Don Holzschuh regularly turned Warheads shows into spectacles that often included a lot of nudity. "That's one guy you do not want to see naked," remarked Soul Asylum's Dan Murphy, who otherwise remembered Warheads gigs fondly. Many people recall an apparently inebriated Holzschuh taking his microphone all the way out the door during one Entry gig. Working sound that night, Roy Freedom confirmed, "He was out in the middle of Seventh Street with the microphone, singing away!"

The punk-rock spirit bursting out of the Entry spilled over into the Sam's main room a couple more times in 1980. Poet-turned-rocker Jim Carroll showed up with his band on December 4. In his *Sweet Potato* write-up, Martin Keller called Carroll's gig "a heavily papered event, the bulk of the audience being music industry folks, local journalists and many who attended Carroll's Walker Art Center reading back in October." Keller praised the "note-for-note reading" of Lou Reed's "Sweet Jane," saved for the encore. Carroll also performed his own anthem, "People Who Died," which would be covered in the venue for decades to come, including by the Drive-by Truckers.

Maybe the most legendary Sam's concert of 1980 took place in midsummer. Punk heroes Johnny Thunders of the New York Dolls and Wayne Kramer of the

MC5 had paired up after splitting with their prior bands to form the group Gang War. The band was booked in the main room on Wednesday, July 30, and it tacked on a warm-up show in the Entry a night earlier. Kevin Cole had also lined up the band for an in-store appearance at Hot Licks record store one of those afternoons. As is well known, though, Thunders was pretty deep into his struggles with heroin addiction at that point.

Cole remembered that Thunders turned up at the record store two or three hours late. "When he finally showed up, he wouldn't come in," Cole recalled. "There were people still inside waiting. He wouldn't come in until somebody scored him some drugs." Fans had to wait on Thunders at both concerts, too. According to Jack Meyers, "He was out on Hennepin Avenue trying to score when he was supposed to be onstage." The drugs apparently didn't dampen the shows, though. "His sound was so intense, and such a raw, spontaneous style," remembered Cole, who mixed sound for the Gang War show in the Entry. "He had monitors up all the way—they could not get any louder—but between every song he would yell, 'Turn up the monitors!'"

Michael Reiter, who played with the Mighty Mofos and various other bands over the years, was on hand for

The punk supergroup Gang War, featuring Johnny Thunders and Wayne Kramer, played its second night of a two-night stand in the Sam's main room on July 30, 1980. *Courtesy of Michael Reiter*

U2

"We're from Dublin. We're called U2. It's a long way, but I'm glad you've made it worthwhile."

Bono waited through five songs before introducing his band to Minnesota on April 9, 1981. The show fell on an especially dreary and cold night, which didn't seem to faze the four young Irishmen. Nor did the modest turnout of maybe five hundred, the oft-heard estimate. Near the end of the set the twenty-year-old singer promised they would be back, and when the quartet did return the following February it packed the club. By the end of the decade, they were filling stadiums.

That 1981 debut is held up as a pivotal night in the club's history, but not just because of the band's eventual enormity. For one thing, Minneapolis's future indie-rock heroes were out in force, including Bob Mould and Paul Westerberg. The latter famously wrote the Replacements' anthem "Kids Don't Follow" in response to U2's "I Will Follow," played twice because the band didn't have enough material for an encore.

Also, the concert fell during a transitional era, when Sam's was still trying to become a rock club that mattered. Landing one of the biggest buzz bands of the moment certainly mattered—especially just a month after Sam's hosted its equally buzzing hometown star, Prince—and U2 came through with a stellar performance. A bootleg audio recording offers up a confident young band that had polished and tightened a forty-minute set into a compact blast of perfection after a month of playing everywhere from Albany, New York, to Lubbock, Texas. The recording doesn't, however, include the fog machines that were working full-tilt throughout the performance, as was Bono. The singer ran, jumped, and climbed all over the stage, according to attendees, who paid four dollars per ticket. Near the end of the regular set, the singer told the crowd, "We were told to expect a very conservative-type audience when we came to your country. No. This is good."

Reviewing the show for *Sweet Potato*—before the band members' nicknames were official—PD Larson praised the club's acoustics and made the crowd sound bigger than everyone else remembered: "Bono Hewson put on an energetic show and seemed genuinely awestruck by the huge audience and their near-maniacal reaction. . . . But the real star of the show was guitarist David Howel Evans, better known as The Edge. Near the end of the show, Bono gushed, 'This is great.

When U2 first played Minneapolis at Sam's in April 1981, they were not widely known among Twin Cities music fans. Within a few years, they'd be selling out arenas. *Flyers courtesy of Kevin Cole; ticket courtesy of Don Hughes*

We'll definitely be back.'" The band played nine songs off of its six-month-old debut album *Boy*, plus the B-sides "Boy-Girl" and "Things to Make and Do," the never-released "The Cry," and the non-LP single "11 O'Clock Tick Tock," which was also repeated in the encore, as was "The Ocean."

While Larson reviewed the show, Martin Keller caught up with the band for a *Sweet Potato* feature that would run a few weeks later. "They were just a bunch of green kids," recalled Keller, who interviewed the nineteen- and twenty-year-olds at the Normandy Hotel that morning. "Bono did most of the talking, even back then. He talked about their Catholic upbringing a lot, and they really kind of came off like good Christian boys." Keller and photographer Greg Helgeson then accompanied the band members to sound check, where Helgeson shot a portrait of them in the southeast corner of the club, looking coolly aloof yet earnest. Their leather jackets and jeans evoked the Ramones, but Bono and bassist Adam Clayton both sported poufy hairdos that gave away their new wave influence, too.

Working behind the counter at Hot Licks record store that afternoon, Kevin Cole snuck over to the club to take in the sound check. Little did he know it would last almost three hours. "I was already a big fan," Cole said. "Hot Licks sold a lot of imports and carried all the U2 singles early on, and then the first album. So I ran over there, and I hung out while they essentially rehearsed all day. That was remarkable." Keller, who had stuck around for the sound check, said, "We had no idea they were essentially writing part of the next album."

That rehearsal and the show that followed seem to have footnote significance in the band's lore, too. Bono had apparently lost a notebook full of lyrics earlier in the tour, and that afternoon the band tried to revive the song ideas. Out of that effort came at least two songs that made their sophomore album, released later that year: "I Threw a Brick Through a Window" and "Stranger in a Strange Land." Cole remembered, "When they came back [to First Avenue] after *October*

came out, [Bono] referenced that and told about how much they liked the space." Bono even referred to the Sam's sessions seventeen years later: When the gargantuan PopMart Tour came to the Metrodome, he mentioned writing the two *October* songs at the venue on the other side of downtown.

The Irish lads were a long way from the excessiveness of PopMart in 1981. As Roy Freedom later recounted to *City Pages*, "They asked me and [Kevin] to come back to the dressing room, because they hadn't met any American kids on their tour. I think they thought this was going to be their only shot in America. We smoked pot with 'em and talked about music and had a good time." The "good Christian boys" did, however, decline the beer offered to them before the show. They gave it to the members of the opening act, the Panic—who were still high schoolers.

"That was huge to us, getting free beer," laughed Matt Wilson, who was the Panic's drummer before he launched Trip Shakespeare. He remains impressed by how unpretentious and down-to-earth the future megastars were. "They really couldn't have been any nicer to us," Wilson said. "We were young, but so were they. They were only a few years older than us. We were very wide-eyed, and amazed to be a part of the show. We had opened for the Replacements and Hüsker Dü a couple times [in the Entry], but this was different. We went out and bought *Boy* after we found out we had the gig, and thought it was amazing." He recalled the Panic playing unusually fast and feisty that night, trying to impress the hot band from Ireland: "We got super sweaty, and at the end we just dramatically dropped all of our stuff. The whole time we were thinking, 'U2 must be watching us in awe.' Just as the screen came down, though, we saw U2 walk in the side door."

Chan Poling remembers U2 walking into his apartment near Twenty-sixth Street and Nicollet Avenue after the show. "I was twenty or so at the time and had a very cool bachelor pad in a funky old building, so I kind of became the after-party guy for a while," said the Suburbs frontman. "I'll never forget the Edge

U2 returned to the club, now known as First Avenue, in February 1982, shortly after the release of their second album, *October*, and with a larger crowd on hand. *Photo by Steven Laboe*

sitting there in my living room with me. All the guys in the band came, and all the local music scene people, too. We had a beautiful little party, a lot of good conversation. And then they became 'U2' and we never met again."

For its second and final appearance at the club, on February 21, 1982, U2 had well over an hour's worth of material for the thirteen hundred fans who came out. It was a bigger show, but maybe not as big a deal. The *Star Tribune*'s Jon Bream was tepid in a later review, saying the Edge's guitar work "sounded like sonic experiments" and Bono "was intriguing but not commanding" ("OK, I've been wrong before," he admitted in a 2009 recap of that review), but Martin Keller raved in *City Pages*, calling it "perhaps one of the most jubilant concerts ever in Minneapolis." The band opened with "Gloria," the lead track on the new album, and saved "I Will Follow" for the finale—without playing it twice.

The encore kicked off with a memorable moment as the band tried to wing it through a version of Neil Young's "Southern Man" in honor of its sound man's birthday. Bono, unsure of the lyrics, asked for help from the crowd. Keller's recap describes "one older rock fan . . . looking like a businessman in a suit (no tie) [who] obliged and belted out a grand verse." That was Bruce Brabec from Hopkins, wearing what he called "a brown leisure suit—god knows why." He counted that moment as a highlight of his life. "I was twenty-four years old and was like, 'Hell, I don't care, I'll do it,'" he recalled. "I was pretty damn buzzed, too." He did know and love the song, though, and has reprised it at his own wedding and his daughter's. He also listens to his original now and again on a harder-to-find U2 bootleg. "I was a little off-key, but I think I did okay."

Even had he not joined the band onstage, Brabec—who also attended the Sam's show in '81—said he would still remember those nights well. "U2 became one of my all-time favorite bands," he said, and believes that was the case for a lot of people that night. "And First Avenue is still a part of my life, still a place I like to go to. So to get to see that band at that place was really something special." ∎

British pop rockers Squeeze played Sam's just a few months after the release of their hit record *Argybargy*. *Photo by Steve Madore; ticket courtesy of Errol Joki*

both the Entry and main room shows. "Being a big New York Dolls fan and an MC5 fan, the pairing of Johnny and Wayne seemed like a good mix," Reiter recalled. "It was disappointing to see Johnny in such bad shape, even though we knew he was an addict. We kind of laughed it off at the time. But Wayne looked embarrassed."

On the night of the main room show, Cole had to go to retrieve Thunders at the band's hotel and found him lying on the bed, seemingly unaware what time it was. Finally roused, Thunders made the audience wait a few minutes longer: "He called his wife before leaving the room and wanted to talk to his kids," Cole recalled. "It was weirdly sweet."

By the spring of 1981, Sam's was starting to resemble the First Avenue we've come to know and love, although the name change wouldn't come until the following winter. The disco dance floor was finally out, and some bold new

bands were coming in. First and foremost, the venue got its first taste of Prince on March 9, 1981. Print ads for that show also noted, "Coming April 9: U2." As Steve McClellan put it: "It felt like we finally started rolling."

While not as significant as Prince or U2, many other artists who performed in the main room during 1981 signify a noticeable shift to more alternative or underground or eclectic shows. New York no wave band DNA, who appeared on Brian Eno's influential *No New York* compilation, played March 8 with Hüsker Dü opening, perhaps the local trio's first main-room set. Public Image Ltd guitarist Martin Atkins came in under his solo moniker Brian Brain on March 18. The summer and fall saw numerous underground bands from England play the big room, including the Stranglers, Squeeze, Siouxsie & the Banshees, and the Psychedelic Furs. Billy Batson of the Hypstrz, who opened for Hugh Cornwell's Stranglers on May 18, said, "They were just scary."

Squeeze's July 23 gig is still fondly remembered decades later. "Pulling Mussels (From the Shell)" and other

The October 1981 calendar boasted a virtual who's-who of the early '80s Twin Cities music scene, with everyone from the Suburbs and the Replacements to the Time—a sign o' the times to come. *Courtesy of the Museum of Minnesota Music*

This flyer for the Canadian punk band D.O.A.—playing the Entry on their appropriately named "Destroy Tradition" tour—heralded a new attitude at the former discotheque. *Courtesy of Mark Dueffert*

songs from their breakout 1980 album *Argybargy* filled the set list, which stretched into three encores in front of what reviewer Martin Keller described as a "frenzied audience." An enduring band that would continue to fill First Ave into the next century, the Psychedelic Furs made their Minnesota debut at Sam's during their second U.S. tour on July 19, just a month after the release of their seminal record, *Talk Talk Talk*. Siouxsie & the Banshees made it there on their first U.S. trek in November, touting their fourth album *Juju* and ending their taut thirteen-song set with that record's key tracks "Head Cut" and "Spellbound."

These ultra-cool, record-store-clerk-approved concerts were finally taking hold as the place transitioned to First Avenue in both name and spirit. Having 7th Street Entry as a breeding ground during the club's two years as Sam's certainly helped. Chrissie Dunlap summed it up well: "The main room was not cool even after the first couple years. It was still mostly known for the cheesy promotional nights like Ladies Night, and a lot of sleazy people would come in. All the cool people were over in the Entry, and they were packed in there, which was an indicator of what's to come. There were so many great bands, and all the bands would bring out friends, then all those friends of bands became friends with other bands' friends. It was really like a social club. The Longhorn [bar] was the new wave and birth of this era, bringing the original music, but to me those Entry years were really the more vital years. All those Entry bands would move on to the main room."

Uber-scenester and future Babes in Toyland drummer Lori Barbero remembered one Entry band in particular that seemed to set the place apart during 1980–81: Flyte Tyme, the R&B/funk group that featured another of McClellan's trusted record-store clerks, Jimmy Harris, and most of his future bandmates in the Time. "That was really wild because you really didn't find any black people over in 7th Street Entry once it opened," Barbero said. "They were all dancing in the main room, [but] there really weren't any local black musicians that played the [rock club] circuit."

At least one wunderkind African American musician from Minneapolis had taken note of the transformation at Sam's and its kid-sister club by that point, and would play a pivotal role in the transition to First Avenue. ∎

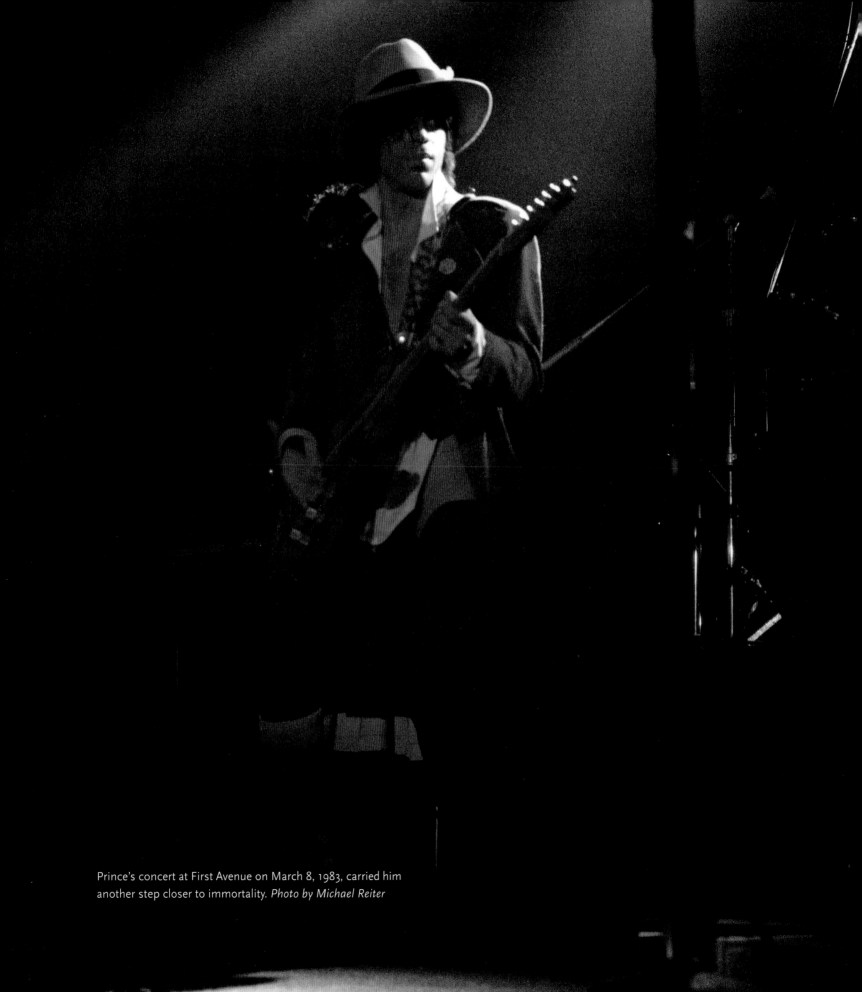

Prince's concert at First Avenue on March 8, 1983, carried him
another step closer to immortality. *Photo by Michael Reiter*

PRINCE'S REIGN, PART 1

1981–1983

"Minneapolis finally has its own bona fide rock star. Born, bred and based right here in the Twin Towns. His name is Prince. That's his real name. He doesn't use a surname and it really doesn't matter. Last night at Sam's, Prince showed his hometown crowd why he's royalty."

—Jon Bream, *Minneapolis Star*, March 10, 1981

He liked it because it didn't have seats but still felt big and theatrical. He liked it because it was an edgy rock club but didn't just book white male rock acts. He liked it because of its downtown location, where African American audiences had not been welcome at night even up through the prior decade, and where Minneapolis's north and south sides—where the city's black population was concentrated—literally and figuratively meet. He liked it because the staff would let him show up anytime he wanted, even—or especially—to play a surprise gig with only a day's notice. And he liked it for the same reason so many other musicians do: It's just a great live-music room.

First Avenue is also where Minneapolis's rock icon, Prince, truly came to life, and the curvy, gritty, black-painted club remains the living, breathing, thriving testament to his legacy in Minnesota. "Playing there was always important," said Revolution drummer Bobby Z. "It became his marquee, and it still is today." Prince's early bassist and childhood friend André Cymone added, "First Avenue was a game-changer to his whole reality." And Prince was a game-changer to the whole reality of First Avenue.

The man who first booked Prince at the club, Steve McClellan, held up Prince's legacy at First Ave as something more significant than just keeping the lights on, which was no small feat in itself for the struggling club. "It was so exciting in the early '80s to see Prince mix the audiences, the racial diversity he brought" into the club, McClellan said. "I had never seen that before to that level."

Even with his outsized impact on the club, Prince didn't perform there as often as one might think. In all, he delivered only nine full-fledged concerts there, plus a handful of short jams and guest appearances, including a couple stints in the 7th Street Entry—and all but one

"First Avenue was a game-changer to [Prince's] whole reality."

—Revolution bassist André Cymone

Prince didn't perform very often at the club, but any time his name appeared on the calendar—or, just as likely, on the grapevine—the crowd was assured of a memorable night. This March 1981 calendar for Sam's advertises his first appearance at the club. *Courtesy of Kevin Cole*

Even with all those momentous nights, perhaps the deepest connection between Prince and First Ave lies in the casual, everyday relationship he had with the club, even after his career had hit the stratosphere. He went there a lot to watch other bands or just to hang out. "There were several years there where he would come in by himself, no bodyguard, and just quietly keep to himself," McClellan said. Staffers remember their local megastar bringing in Madonna one night in 1986 when they were both at their peak of fame, as if to let her in on his secret little hideaway. That didn't turn out so well, but most nights he came and went unbothered. And he never really stopped going. His last time at the club—to watch a set by King, the synth-fueled women's R&B trio, two months before his death—was low-key enough that most of the crowd didn't even know he was there.

In the '80s, one of Prince's favorite things to do was bring in a test pressing of a new single for DJs Kevin Cole or Roy Freedom to try out on a dance night. "I think he felt a certain validation and pride from the club, even after he stopped playing there," the Revolution's scrubs-wearing keyboardist Matt Fink (aka Dr. Fink) theorized. And that is a pretty amazing theory: Prince thought highly enough of First Ave that he sought its approval, even after he became a worldwide legend. More than anything else in the club's five-decade history, that might be the ultimate testament to its greatness as a rock venue. One undisputable fact, though, is that First Avenue is the first place where Prince's hometown audience felt the full impact of his greatness—although the club wasn't even called First Avenue yet.

Some of the people who were at Sam's on March 9, 1981, swear to this day that the first time was the best. It was certainly the perfect time to catch Prince as an artist on the verge. His third album in as many years, *Dirty Mind*, had been issued in the autumn of 1980 to strong reviews. He had toured as "Superfreak" hitmaker Rick James's opening act the previous spring and played his first round of headlining dates that December. Then he kicked off 1981

of them came between 1981 and 1987. Then there was a twenty-year gap until the 7/7/07 show, the one that didn't start until almost three hours into July 8 and was unplugged by Minneapolis police.

Of course, quality takes precedent over quantity in Prince's case. Each of those main nine concerts was distinct from the others, and most hold a significant place in both Prince's story and the history of the club. In almost all cases, the First Ave performances differed greatly from the shows he was playing elsewhere around the world at the time. The professional recording of one of them—the dance-company benefit at which he premiered the *Purple Rain* songs on August 3, 1983—might qualify as the most sought-after unreleased live album in all of rock 'n' roll. Other appearances are important for different reasons, including the testing of new material, the debut of a new band lineup, or just the chance for the little giant to get back to commanding a smaller room.

with his trench-coated performance of "Partyup" for a couple million *Saturday Night Live* viewers on February 21. That was just two weeks before the Sam's gig. Bobby Z sees meaning in the close timing of the two career milestones. "Something about Minneapolis, if you go away and come back, you're appreciated more," the drummer said. "It's just kind of this—not a snobbiness—but we're definitely impressed if you make it and come back."

Even though he already had three albums to his name going back to his 1978 debut, *For You*, Prince had performed surprisingly few times in his hometown once he got his record deal with Warner Bros. He cut his teeth around Minneapolis in his midteens playing black clubs such as the Riverview Supper Club and Cozy Bar with Grand Central, the band that also featured his close childhood friend André Cymone and, on drums, future Time frontman Morris Day. But Prince didn't step out as a solo act until January 1979, with a pair of shows at the tiny Capri Theater, near where he grew up in north Minneapolis. Intended as a showcase for Warner Bros. executives—who flew in during a snowstorm to see their young star come out as a live act—the Capri sets didn't

Grand Central—featuring Prince on keyboards, André Cymone on guitar, and Morris Day on drums—played regularly at the Riverview Supper Club in south Minneapolis and other African American nightclubs in the mid-1970s, occasionally backing events like fashion shows, as here. *Photo by Charles Chamblis, Minnesota Historical Society Collections*

go so well. The execs told him to hold off on touring and continue rehearsing and writing. He quickly issued his second record, *Prince*, in October 1979. He played fewer than a dozen dates in 1979, none at home.

His first big hometown show, on February 9, 1980, was big only in terms of the venue, not attendance. He drew fewer than a thousand people to the Orpheum, a theater with a twenty-seven-hundred-person capacity on Hennepin Avenue, a few blocks from Sam's. Besides being too big, the theater proved ill fitting because its permanent seats left little room for dancing. "He needed that movement in the room, that kind of energy, we found out," Dr. Fink recounted.

Still, modest local hype set in for the rising star after that Orpheum show. "What we've got here is a phenom in the making, a hometown kid brewing a delicious batch of rock and soul music," music scribe Martin Keller raved in a full-page spread in the *Sweet Potato* alt-weekly newspaper. Kevin Cole had to man the counter at Hot Licks record store a few blocks up Hennepin from the Orpheum, but he heard a gushing report afterward from the store's co-owner Richard Elioff. "Richard came back and said, 'I just saw the best rock show I ever seen in my life. Imagine Tommy Bolan meets Bowie meets Sly meets Hendrix,'" Cole remembered. He started regularly spinning Prince during his Sam's sets around that time, particularly "I Wanna Be Your Lover" and "Why You Wanna Treat Me So Bad?" He also passed along the high praise to McClellan, who thought a Prince show at the club would be a gamble—"*Every* show was a big gamble back then," the club manager reiterated—but one worth taking. Prince wouldn't be available for another year, though, as he hit the road as the opening act on Rick James's forty-city "Fire It Up" tour. That, combined with the release of the *Dirty Mind* album in October 1980, sparked a national buzz in the meantime.

At the same time, a buzz had set in back home for the newly rechristened Sam's nightclub among Prince's friends and fellow musicians. After hosting the likes of Ike & Tina Turner, B. B. King, and John Lee Hooker in its relatively diverse Depot days, the club had been largely closed off to African American crowds during its

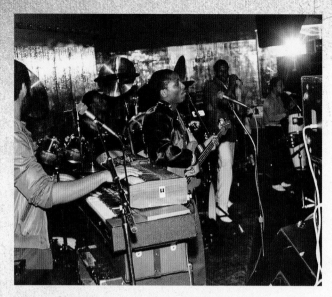

Flyte Tyme, at the Fox Trap Club in Minneapolis, circa 1980.
Photo by Charles Chamblis, Minnesota Historical Society Collections

corporatized Uncle Sam's disco era, both through its own policies (e.g., the dress codes, the suburbanite-baiting playlists) and the general hostility toward black nightlife all around downtown Minneapolis at the time (the popular nightclub King Solomon's Mines in the Foshay Tower was targeted by city officials and shut down by 1970). That started to change near the end of the '70s, when Steve McClellan booked several local black R&B acts. Among them: Mind & Matter, an eleven-piece, Earth, Wind & Fire–flavored dance band led by Prince's junior high schoolmate Jimmy Harris, aka Jimmy Jam. In an archival video clip of a Sunday night show, a shirtless, eighteen-year-old Harris rocks a keytar onstage while four gentlemen in tuxes work the rainbow-lit dance floor in Temptations-style unison. Flash forward two or three years, and Jam's group Flyte Tyme became one of the first black groups to perform in the 7th Street Entry.

Prince's childhood friend and bassist at the time, André Cymone—whose mom took in a teenaged Prince after his parents split up—remembers the club coming on their radar about 1980 once it became Sam's and 7th Street Entry opened. "Everybody was talking about it," Cymone said. "It had a buzz. It was an edgy venue. We

wanted to be edgy, and we considered ourselves at the time to be getting edgier and pushing the envelope a little bit." Cymone remembered them being inspired by British new wave groups such as Adam and the Ants and Bow Wow Wow (both of whom would play the club over the next two years). Cymone and company saw Sam's and the Entry as being of the same urban, new wave mold. The bassist had even taken a liking to the Replacements and some of the punk bands performing in the Entry.

Another inspiration for Prince and his band was their own video for "Uptown," which they shot in Los Angeles with a hired studio audience. The clip resembles that first Sam's performance in a lot of ways, Cymone said. "It had that same vibe. The people in L.A. really didn't know all that much about us. But when they saw us doing this performance, they were like: 'Where are you guys from?' I remember it was really effective. When you realize something is effective as an entertainer, something that works, you want to keep bringing it, trying it out. And no better place to do it than in your hometown."

Bobby Z, Prince's drummer since 1979, remembers playing venues that had an aesthetic similar to First Ave on the band's first tour in late '79 and early '80. "We played the Paradise [in Boston], Bogart's in Cincinnati, and in Europe they gave us the Lyceum [in London]," he recounted. "These were First Avenue–type places that really had an open feel—gutted theaters, churches, really cool spaces that really, really opened up. So it was just a natural. There couldn't be any two more perfect collisions than Prince going out, seeing the world, experiencing these other venues, and then coming back and finding that we had one right here in Minneapolis."

The timing was perfect, too. Prince and the Minneapolis club were on a parallel trajectory when he finally booked a show there. The concert sold out relatively quickly and had a buzz well before the budding hometown star took the stage. In the two weeks between the *SNL* appearance and the Sam's debut, Prince and his bandmates were spotted at the club for the first-ever performance by Lipps Inc. The group that went to No. 1 with "Funkytown" in 1980 was born only a year before that as a studio project helmed by Minneapolis producer

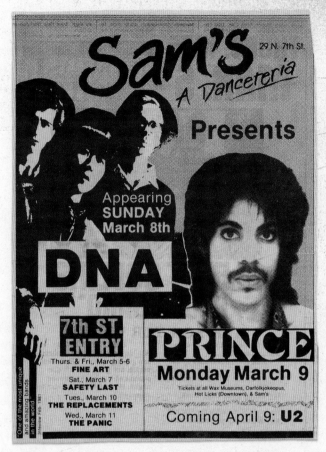

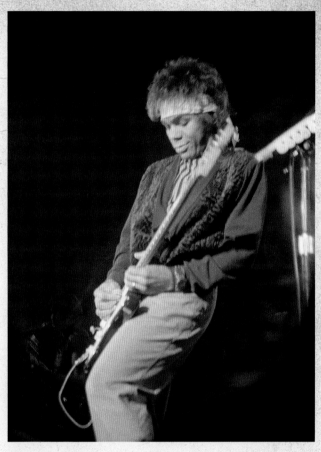

Prince's debut concert at Sam's on March 9, 1981, didn't warrant much more attention in the local papers than the previous night's DNA concert. (It did, however, garner significantly more ink than the March 10 concert in the Entry by another future local legend, the Replacements.) *Courtesy of Kevin Cole*

Dez Dickerson played alongside Prince during their formative years, including at the Sam's show in 1981. Dickerson broke off on his own before his former colleague hit the stratosphere. *Photo by Steve Madore*

Steve Greenberg, with Flyte Tyme alum Cynthia Johnson on vocals, plus Bobby Z's brother, David Z, on guitar. No doubt Prince was genuinely interested in seeing the performance by his friends and Minneapolis's hottest music act of the moment (for at least another week or two), but you have to suspect he was also there to study the room, where live music continued to be the exception.

Dance nights on Fridays and Saturdays still paid the bills, so Prince and company were relegated to a Monday night. But it didn't matter. "We created a pretty good buzz about the show," remembered Kevin Cole, who touted it from behind the DJ booth at Sam's and the counter at Hot Licks. Ads for the concert were all over the daily and alt-weekly papers, where Prince had equal billing with DNA, a little-remembered experimental New York band that played the night before.

Prince endlessly, tirelessly rehearsed with his band in the months before the concert. "He really wanted to make a strong impression this time out, and we were all very hungry about performing," recalled Fink. He and fellow keyboardist Lisa Coleman helped cultivate Prince's vision of synthesizers replicating horn parts, which had been the backbone of the so-called Minneapolis Sound. Both Fink and Coleman, along with Bobby Z, would stay on through the heyday of the Revolution. The other band members who played the first Sam's show,

Cymone and guitarist Dez Dickerson, would each be pursuing their own frontman dreams by 1983.

In fact, that 1981 show was Cymone's only time performing at the club with his childhood friend. "One of the things I remember is Sue Ann Carwell [a Prince-affiliated singer] telling me there was this guy in town that looked just like me," he recalled thirty-five years later. "I was pretty cocky back then. I thought, 'There's nobody that looks like me!' And I remember going out there, and I looked in the crowd and I saw the guy she's talking about: It was Jesse Johnson." New in town from St. Louis, Johnson would soon be the guitarist in the Time, the Prince-curated band that formed later that summer.

Without the Time or other protégé acts to open for him yet, Prince went with the flow of Sam's and 7th Street Entry and enlisted Curtiss A, one of the venue's flagship acts. Curt Almsted first encountered the young headliner while on an afternoon walk around Minneapolis's Lake Calhoun with Allen Beaulieu, a mutual friend and the photographer of the *For You* album cover. "Prince comes rolling up in his roller blades, in a cute little get-up," Almsted recalled more than three decades later, laughing at his own audacity that day. "I pitched him some of my songs [to record]. Little did I know." Although Chrissie Dunlap, wife of Almsted's guitarist Bob Dunlap, was well involved in booking at the club by then, Almsted insisted that Prince picked his band himself, an anecdote that now falls among the many Curtiss A Conspiracy Theories© well known within the Twin Cities music scene.

He took it as a compliment at the time. "I don't want to think the worst of every situation, but I'm not naïve," he said. "Beforehand, I thought, 'What a great opportunity! How nice of Prince to give me a shot to open for him.'

Curtiss A earned the opening gig for Prince's debut at Sam's in March 1981. It was a memorable, if humbling, experience for the Twin Cities rock vet. *Courtesy of Don Hughes*

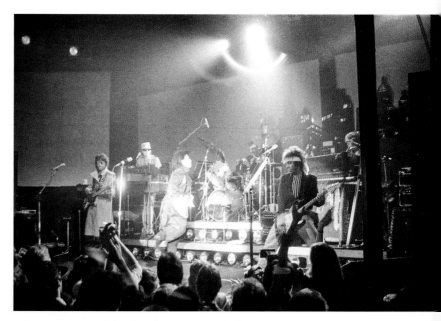

(Above) Prince and his band tore the roof off the club during his inaugural performance there. *Photo by Steve Madore* *(Opposite)* The twenty-one-year-old Prince demonstrated a newfound confidence and his ability to work a crowd during his 1981 Sam's performance. *Photo by Duane Braley, Star Tribune*

But really, I think he got me up there to crush me. It was kind of like, 'Really? This is who you all like?' I only came to that conclusion in later years. I laugh about it now. He wanted to show me up, especially at that club. Which of course is exactly what he did."

Before the music kicked in, Prince walked out onstage dressed in a khaki trench coat, thigh-high black stockings, and a sparkly bodysuit. He greeted the excited and slightly stunned crowd by channeling fellow Minnesota native Judy Garland, uttering three times in a soft voice, "There's no place like home." He and the band then launched into "Do It All Night," the first of all eight tracks from the *Dirty Mind* album played during the ninety-five-minute set. They saved the title track for the finale, before the first of three encores. The set list also included the unreleased "Broken," the B-side "Gotta Stop (Messin' About)," the *For You* nugget "Crazy You," and several tracks from his 1979 eponymous LP, including "Sexy Dancer," "I Wanna Be Your Lover," and "Why

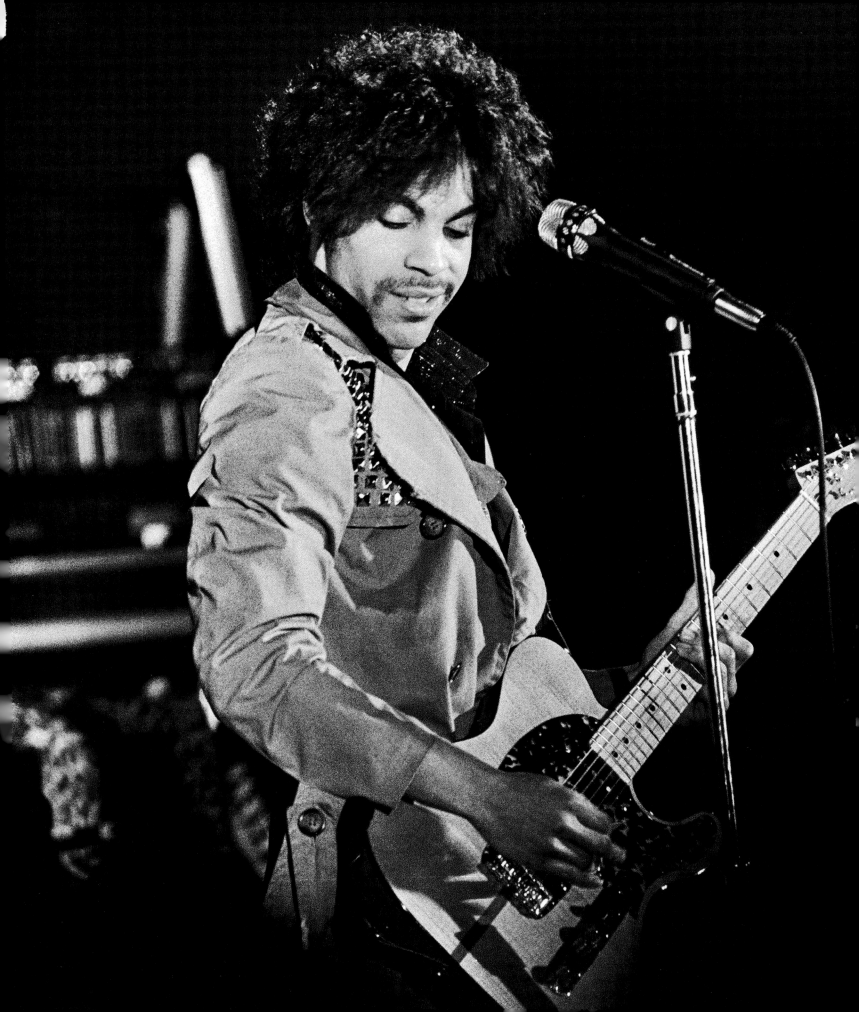

You Wanna Treat Me So Bad?" The encores kicked off with a lengthy funk jam known in collectors' quarters as "Everybody Dance" and ended with the hardest-rocking song of the night, "Bambi."

Under the headline "Prince gives city claim to a star" in the next day's *Minneapolis Star*, Jon Bream perfectly captured the moment in a review that, in retrospect, recalls Robert Sheldon's famed 1961 *New York Times* write-up of Bob Dylan in Greenwich Village, tying the critic and subject together for years afterward and capturing the artist on the precipice of stardom. Bream had interviewed Prince as early as 1978 and covered his Capri and Orpheum theater shows. But he had yet to rave about him like this: "Onstage, the twenty-one-year-old star—who had only limited performing experience in his midteens—has grown confident as well as coy. He knew how to work the jam-packed Sam's, where people were sitting on the bars and hanging from the balcony railings."

The review singled out Prince's falsetto and guitar playing as strong suits, and pointed out what's now obvious to Prince fans: "The raw-edged tunes on *Dirty Mind* have more bite than his older, more pop-flavored material." As for the budding stage presence that would become Prince's ultimate weapon, Bream wrote, "He knew when to dance with his hand in his coat pocket, just when to show a little leg, when to strip down to his briefs and when to strut his stuff . . . when to dance in unison with Cymone and Dickerson, when to shake his shag and coyly glance over his shoulder." Bream concluded by referencing Prince's own conclusion to the show, "a modest, almost reticent 'thank you' after the final song and the nervous smile that comes when you recognize too many hometown faces who finally know who you are."

In *Sweet Potato*, writer Randy Anderson declared, "Prince and his band of urban renegades take over the stage like pirates storming a Spanish galleon. They know they're fantastic and they flaunt it. But just as you feel this aggressive approach along with the heavy metal posturings and the song topics (oral sex, incest, anarchy) . . . Prince flutters his Bambi lashes and opens his mouth. Out comes a teensy-weensy, baby-cakes falsetto that

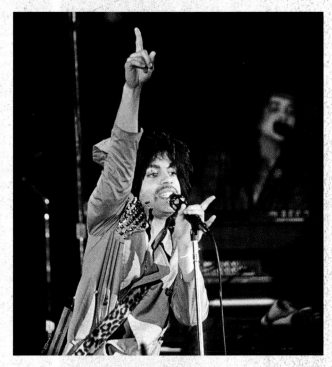

As Jon Bream wrote in his *Minneapolis Star* review, Prince "knew when to dance with his hand in his coat pocket, just when to show a little leg, when to strip down to his briefs and when to strut his stuff . . . when to dance in unison with Cymone and Dickerson, when to shake his shag and coyly glance over his shoulder." *Photo by Duane Braley, Star Tribune*

floats above the occasionally heavy thunder of the band. This is the stuff of breakthroughs."

Others still talk about the performance like an epiphany. "It was one of those moments," said Kevin Cole, who remains deeply entrenched in the music industry thirty-five years later as the director at Seattle's trendsetting KEXP-FM. "It was easily one of greatest shows I'd ever seen—not just great musically but great that way you could see Prince connecting with the audience. You could see it in their eyes, the way he captivated them. It felt like the first time he really connected with his hometown audience, sort of a mutual acceptance. From his end, it was like, 'Wow, these are my people.' But you could also see him accepting his own confidence, owning up to what he can do as a performer."

Realizing he had been out-rock-starred, opening act Curtiss A said he wanted to hate the "spunky young

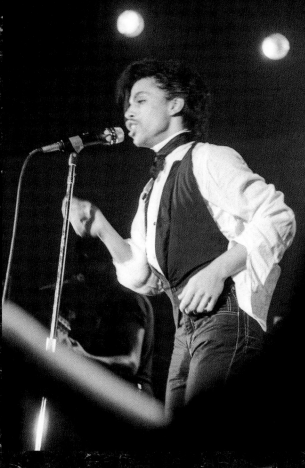

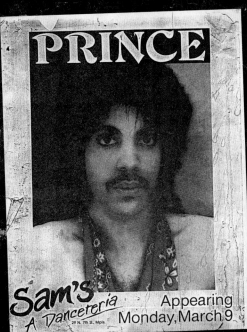

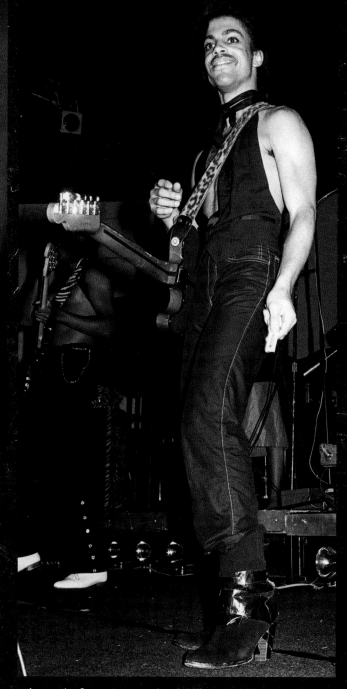

(Above) The first concert at the club that would become First Ave helped to cement Prince's connection with his audiences and with his hometown. *Photo courtesy of Chrissie Dunlap.*
(Above left) *Photo by Steve Madore.* (Left) Prince's gigs at Sam's or First Avenue were not always announced and promoted with flyers like this one. *Courtesy of the Museum of Minnesota Music*

PRINCE

Sam's
A Danceteria
29 N. 7th St., Mpls.
Appearing
Monday, March 9

thing," especially in his flashy attire. But he couldn't. "He had the trench coat, the panties, these little go-go boot things," Almsted said. "But really, he was so fucking good. I vividly remember watching him just thinking, 'Oh my god. This guy is crushing it.'" Chrissie Dunlap was instantly smitten, too. "I saw James Brown twice in the '60s, and I would rank Prince right up there with that," she said. "I went really, really ga-ga for him." Chrissie and Bob Dunlap accompanied Almsted to the after party at Beaulieu's photography studio. Almsted's memory of that shindig unintentionally invokes *The Godfather*'s meet-the-new-boss closing scene. "I remember he was kind of holding court," he said. "It was worked out beforehand: If you wanted to talk to him, you had to sort of bend down like, 'Oh, my Lord.' I said to Chrissie and Bob, 'I'm going to go say something to him.' Bob said, 'I'm not gonna go kneel and kiss his ring.' I went up to him, though, and this is all he said to me: 'I remember you.'"

Prince's second performance at the club was announced in the same manner as most of his subsequent gigs there: It wasn't. After that initial sellout, not to mention "Uptown" and "Dirty Mind" climbing Billboard's R&B and dance singles charts, it was clear he wouldn't have any trouble packing the place. The club's main-room calendar was spotty enough in those days that there were always open nights available any given week. Bobby Z remembers those surprise shows becoming an essential part of Prince's process. He would play unannounced even more often after he built Paisley Park in 1987, and right up until the end. His last Twin Cities performances were a trio of surprise gigs at Paisley in January 2016 before he launched his "Piano & a Microphone" tour, and he had played eight unannounced Paisley concerts in 2015. But First Ave—then still called Sam's—is where the fun began.

"We started to play these unbelievably magical shows that were [usually about] trying out new material," Bobby Z said. "Back then, there was no internet. Just the way word of mouth went back then, [there'd be] a line around the bar." Bobby recalls one especially last-minute decision: "He literally decided like at four [in the afternoon]. We were done with rehearsal. He said, 'That sounds great! Let's go down and play.' And I don't know if they were bumping acts or what we were doing, the chaos of it. But it was just very empowering and very thrilling to kind of use it as a dress rehearsal place."

For the night of October 5, 1981—once again, a Monday night—the club's calendar listed a band called Controversy. For those paying attention (a lot of people by then), "Controversy" was the provocative single Prince released a month earlier as well as the title to his new album dropping two weeks later. Fans were lined up around the block by the time doors opened, and no one balked at paying the three-dollar cover solely on the rumor that Prince might play that night. They certainly got their money's worth.

As with other surprise shows to come, this one wasn't just for fun; it served a clear purpose. Not only did Prince have fifty-plus dates on his *Controversy* tour to prepare for—playing city coliseums and large theaters from New York to Los Angeles, and Macon, Georgia, to Monroe, Louisiana—he also had a new bassist, Mark Brown (aka Brownmark), to break in and new songs from the *Controversy* album to test drive. Beyond all that, what was probably top of mind were the two biggest shows of his career, coming up just four days later. Bill Graham Presents booked him as one of four opening acts for the Rolling Stones' shows on October 9 and 11 at the mammoth Los Angeles Memorial Coliseum. These would be legendary gigs in Prince lore, but not for good reason. Stones fans threw cups at Prince and the band and booed them off the stage the first night, which left Prince so shaken he flew home right afterward. Purportedly both Mick Jagger and Bill Graham called to talk him into flying back out for the second show. "I'm sure he freaked some people out with his effeminate appearance," Matt Fink said, "but more than anything I think it was just racism. It was that kind of crowd."

The Sam's crowd four nights earlier must've seemed like a godsend in comparison. And perhaps the surprise gig reassured him he was on to something great with *Controversy*. Martin Keller wrote afterward in his Martian Chronicles column for *Sweet Potato*, "What was supposed to be a secret dress rehearsal for Prince and band

at Sam's Monday night turned into a blockbuster sell-out—and maybe the best live club gig this year. . . . Looking like Edgar Allan Poe in Civil War clothing, Prince pirated about the stage, throwing suggestive looks at an adoring audience."

Like all the subsequent *Controversy* tour dates, the set opened with an unreleased two-minute a cappella piece called "The Second Coming," which introduced the love-one-another messages ("You've got to love your brother if you want to free your soul") sprinkled among all the between-the-sheets lyrics on the new album. Then the ten-song show kicked into gear with the live debut of "Sexuality," which gave newcomer Mark Brown the chance to strut his thump. Four more tunes from *Controversy* were tested that night: "Jack U Off," "Annie Christian," "Let's Work," and the title track—essentially the bulk of the album, save for the epic slow-jam "Do Me, Baby," which would be played later throughout the tour. "Head," "Dirty Mind," and "Why You Wanna Treat Me So Bad?" rounded out the October 5 set list. In the encore, he dramatically spiked "Controversy" with a recitation of the Lord's Prayer and then ended with another older crowd pleaser, "Partyup." Perhaps the ultimate only-at-Sam's moment came when he sheepishly refrained from introducing the title of "Jack U Off," noting, "'Cuz my dad's here." Yep, there's no place like home.

Prince returned to Sam's just two nights later, and two nights before the debacle in Los Angeles. This time it was for an advertised show he was heavily involved in, though he never took the stage. Rather, he watched from the soundboard as a new band under his tutelage, the Time, made its live debut. Working under a clause in his Warner Bros. contract that allowed him to sign and produce other acts for the label, Prince had his hands all over the Time's self-titled debut album, issued that July. The electro-funk group grew out of Jimmy Harris's band with Terry Lewis, Flyte Tyme, and featured former Grand Central drummer Morris Day's untested but unmistakable skills as a frontman. As Prince's fame

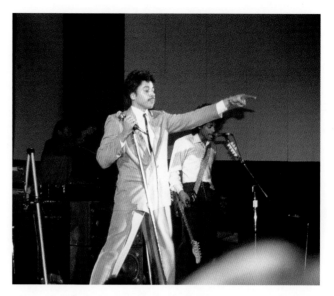

Morris Day & the Time were far from simply Prince sidekicks but could pack the Mainroom in their own right. *Photo by Steven Laboe*

rocketed in 1981, the Time rode with him. Their singles "Get It Up" and "Cool" had already hit the Top 10 on Billboard's R&B chart even before that first gig. Given the band members' prior experience in clubs, though, it was no surprise that they pulled it off as smoothly as Morris pulling out his famous pocket comb.

It surely helped that it was the same venue where they played a private showcase for Warner Bros. executives that August, amid intensive preparations. "We had been rehearsing eight days a week, which is how it always was in Prince's camp—like boot camp, really," recalled Garry "Jellybean" Johnson, an early cohort of Prince's and still the drummer in the band now known as Morris Day & the Time. Johnson noted that he and his bandmates "mostly grew up playing soul and R&B clubs, so being in a rock club was still kind of new to us. But that was Prince's influence. Prince was all about the rock, so playing there meant a lot to him. It's how he saw things back then. He had this vision of creating a diverse audience." Another original member still on the road with Morris Day & the Time, keyboardist Monte Moir said Prince worked closely with them to sculpt the band's act in the months leading up to the debut gig. "He would go

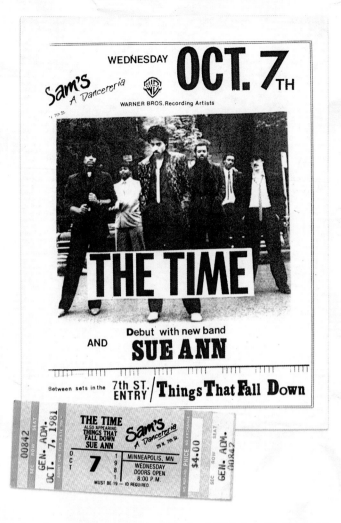

(Left) The Time secured their first Mainroom show in October 1981, and they soon took off on a wild ride with Prince. *Flyer courtesy of the Museum of Minnesota Music; ticket courtesy of Errol Joki.* (Above) New York's Defunkt and their opening band, local R&B act Phantasy, had to move their scheduled March 8, 1982, gig earlier in the evening to make time for an unannounced performer later that night. *Courtesy of the Museum of Minnesota Music*

just beyond the sound and the look," Moir said. "He held space for the biggest possibility to happen all the time. Even down to the smallest keyboard part, he would try to find a way to make it better."

There was still some room for improvement, according to reviews in *Sweet Potato* and the *Minneapolis Star*, but the seven-song, forty-minute set on October 7, 1981, earned raves nonetheless. "The group's five [instrumentalists] were a solid ensemble, equally adept at soul, rock and ballads," Jon Bream wrote for the *Star*. "The keyboard work of Jimmy Jam and Monte Moir was especially impressive, and Jesse Johnson contributed some tasty guitar licks. Lead singer-songwriter Morris Day, who resembles a youthful Little Richard, came across as a natural showman."

Out of the chute, the Time was ready to hit the road, and it did so soon thereafter as the *Controversy* tour rolled along almost nonstop, from its Pittsburgh kickoff

on November 20 through early March 1982. On March 7, Prince hired a recording truck to capture the show at the Met Center in Bloomington, just south of Minneapolis. Turned out, though, the more memorable gig took place the following night at the club that had been rechristened First Avenue at the start of the year.

Prince, of course, wasn't scheduled to perform. The jazz/rock hybrid group Defunkt made its first trek from New York to headline the Mainroom that night. Upon arriving, the band was asked to start its set an hour or two earlier to make room for an unannounced special guest. Defunkt leader Joseph Bowie recounted to the *Jazz Times* in 2016, "We commenced to laying out a New York brand of rock/punk/funk that went over very well with the

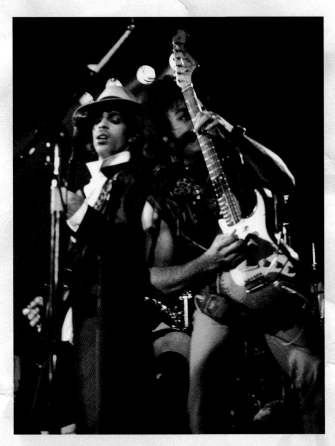

Prince and fellow guitarist Dez Dickerson put on an explosive performance during the surprise Mainroom concert on March 8, 1982. *Photo by Michael Reiter*

crowd. And we kicked ass. When Prince took the stage, the first thing he said was, 'Jazz is dead,' which I kind of took offense at. I saw it at first as a dismissal of the New York punk-funk sound. But I kind of see it a little differently now."

Prince also sternly declared at the start of what would be his loosest and most comedic performance in the Mainroom, "This is not a concert; this is a dance. The only reason we're here is because you people had no place to go." A sold-out crowd paid the four-dollar cover based on the rumor that the local hotshot would play, a rumor spread by word of mouth and a little exposure on the community station KMOJ. "If anything, we usually had to worry about word getting out too fast and too many people showing up," Steve McClellan remembered

about the unannounced Prince concerts. "After the first couple, we wouldn't even tell the staff until last minute. All it took was one of them telling somebody else, and within an hour it would be all over town. The old dial phones worked as well as cell phones when it came to this: 'Did you hear Prince is playing tonight?!'"

The crowd that waited in line on March 8 was rewarded with a short set by the Time, followed by a ten-song, ninety-minute Prince performance. It kicked off with an especially loud, maniacal "Bambi," which—like all the songs except one ("When U Were Mine")—hadn't been played at the arena show the previous night. Another bold and experimental number followed, "All the Critics Love U in New York," a live debut and still a bit of a work in progress; Prince coached Lisa Coleman on her vocal parts and seemed to be clueing in the whole band on his intention to play a long guitar solo when he declared, "Excuse me while I masturbate." Before "Still Waiting," he called for another of his protégés, Sue Ann Carwell, to join him. "I saw her in my dressing room trying to steal my coat," he cracked. That was just a hint of the attitude he copped once Morris Day joined him onstage for a lengthy encore, following a lengthy funk jam through "Head" and "Sexuality." Here's a play-by-play of the back-and-forth that followed:

> Prince: Is Morris Day out there? [*Cheers, and a long pause.*] Their managers, who are our managers, said they wanted to play. Y'all can play, but let me tell you something: This is my stage tonight.
>
> Morris: Fuck that.
>
> Prince: This is my stage, man. If y'all wanna play, you gotta play some of that rock 'n' roll. Don't come up here playing that old you-know-what.
>
> Morris: Say, you could use my comb.
>
> Morris [*after a pause while the rest of the Time settled in*]: We're gonna do some rock 'n' roll, and show him how it's done.

The band breezed through "Dance to the Beat," an unreleased track played at a few other shows around that time. After the song, Prince retorted, "I didn't like that. Play something you know how to play." So the Time launched into "The Stick," a playful romp from their first album, written by Prince and Lisa Coleman.

As the Time's other members left the stage following "The Stick," Prince taunted Morris with, "Do you still know how to play the drums, or are you too cute now?... Take your coat off. I don't want you to get all sweaty.... Where's my band at? I'm gonna wear them out.... The police are going to be here any minute.... Look at him [Morris, behind the kit]. Don't he look cute? Can you still play them drums, boy? That's right, I said boy, not Roy."

The show ended with Prince and his crew (sans Bobby Z) tearing through "Partyup" as if to test Morris's resilience. He held up all right, and so do the fond memories of that night and the many others, as Prince and the Time became regular road companions during 1982 and 1983. "We did that in a lot of other cities, getting up and playing with him like that," Jellybean Johnson recalled. "We had a lot of fun in those early days. It was a lot of work and a lot of fun. But it wouldn't last."

The Time never again performed at First Ave with its original lineup. Prince fired Jimmy Jam and Terry Lewis the following March, when they missed a gig due to a blizzard while working on the side with the SOS Band (the start of the duo's rich career as producers and writers for the likes of Janet Jackson, Mariah Carey, and Usher). A new lineup debuted at First Ave on October 3, 1983;

(Left) Prince's penchant for provocative costuming was evident early on in his career. *(Below)* Prince engaged in playful banter with his friend and sometimes rival Morris Day at the March 8 concert. *Photos by Michael Reiter*

replacing Jimmy Jam was Paul Peterson, later coleader of another Prince-produced act, the Family. That night, "The Bird" was recorded at the club and would be used for what was still a fairly well-kept secret: a film loosely based on Prince's life in Minneapolis and its music scene. First, though, the star of the movie had to craft his own music for the project.

When Prince took the First Ave stage on August 3, 1983, everybody recognized the petite figure in the bright spotlight even if they couldn't see his face. The giant white light shrouded him from behind and partially blinded the packed and sweaty audience. Simultaneously, a single organ note straight out of a cathedral church service flooded the room with the same flat, direct, overpowering effect as the light. Then came his voice, also flat but emphatic, talking instead of singing: "Dearly beloved, we are gathered here today to get through this thing called life."

Millions of people would be grabbed by the same opening montage the following summer, when *Purple Rain* stormed movie theaters. One can imagine how riveting that moment was for the 1,566 ticketed attendees who got to experience it for the first time in person. "Let's Go Crazy" was the first of five new songs and one of the many dazzling displays of showmanship that were first tested on that seemingly random night in that unflashy club for one of the greatest rock 'n' roll movies ever made.

It seemed like a well-intentioned but inconsequential night going in, the kind of gig that most acts at Prince's level of fame might've phoned in. Advertised two weeks ahead of time, the show was billed as a benefit for the Minnesota Dance Theatre. The fundraising effort was legitimate, too. Prince had taken dance classes at the company's studio as a grade-school kid. In preparation for the movie they were about to make, Prince and his Revolution bandmates returned to the dance studio during the summer of 1983, along with members of the Time and Vanity 6 (soon to be remade as Apollonia 6) to sharpen their stage movement and work up some choreography.

The ticket for the "Special Benefit for the Minnesota Dance Theatre" on August 8, 1983, gave little indication of exactly how special it would be. *Courtesy of Patrick Garrity*

"Minnesota Dance Theatre essentially gave us free rein of their facility," Matt Fink remembered, "so Prince wanted to pay 'em back." Still in business today, the dance company was in danger of shutting down at the time. Prince went all out, charging twenty-five dollars per ticket for the First Ave show, compared to three or four dollars for his prior gigs at the club and ten dollars for his Met Center concert the previous year. Of course, it still sold out fast. After expenses, the event raised $23,000 for the dance theater. (This was not the last time Prince supported a dance company. After his death, it was revealed that he had funded a year's operational costs at Harlem's Uptown Dance Academy in 2011, to the tune of $250,000.)

Of course, the whole world would soon reap the benefits of what went down that August night at First Ave. Now housed at the Minnesota Historical Society, the club's file folder from the benefit includes a lot of paperwork not seen in the files for other concert bookings, including a thirty-five-dollar permit from the city of Minneapolis to block off metered parking spots outside the club. Those spaces would be used to park a semitruck equipped with a mobile recording studio, which Prince had hired from the Record Plant in New York (sister studio to the Record Plant in Sausalito, where he made his 1978 debut album). Even with the recording truck outside, though, Prince's bandmates still didn't know what his exact intentions were that night. "He was always recording shows, so we didn't think much of it," Fink said. "I think maybe we found out the day of the show. Maybe he didn't tell us because he didn't want us to be nervous about it."

Bobby Z got clued into Prince's recording plans when he learned his older brother had been hired to

A "Street Use Application" form submitted to the city requested that a portion of the street outside the club be blocked off "for filming purposes" on August 9, 1983. *Minnesota Historical Society Collections*

man the mobile studio that night. David Z (Rivkin) had engineered many of Prince's recordings, going back to his earliest solo demos. "I was working on and off with him all along," said the elder Rivkin, who claims he, too, did not know how the benefit recording was going to be used. "I wasn't privy to the movie. I thought it was going to be a live album. I really didn't know." David had done his fair of share of mobile recording jobs, including the Police's local debut at Jay's Longhorn bar in 1979 and a monthly concert series for KQRS-FM. The truck and the setup at First Ave that night, however, "went above and beyond the norm," he said. "We covered the whole place. I had microphones on the ceiling, hanging off the balcony, audience mics. It was pretty elaborate."

Among the two-hundred-plus names on the guest list for the show were the usual local VIPs and media reps, plus a couple of noteworthy out-of-towners: Al Magnoli,

who by then had been hired as the director and cowriter for the unpublicized movie project; and Peter Buck, guitarist of R.E.M., who was in town hanging out with the Replacements and would be recruited to lay down the guitar solo on "I Will Dare" for the Replacements' seminal album, *Let It Be,* recorded that week. "I just happened to be in town, and it seemed like a typical when-in-Rome kind of thing to do in Minneapolis: Prince is playing First Avenue," Buck recounted twenty years later. "But it obviously wasn't a typical show, not even for Prince. I didn't know exactly what he was up to, but clearly something special was going on."

Five of the songs that would be used for the *Purple Rain* movie and album debuted during that hot August night at First Ave: "Let's Go Crazy," the dramatic concert opener, plus "Computer Blue," "I Would Die 4 U," "Baby I'm a Star," and the iconic title track. The basic tracks captured by the mobile-studio truck for "I Would Die 4 U," "Baby I'm a Star," and "Purple Rain" wound up on the album and in the movie, with audience noise later stripped out and a few overdubs made in a real recording studio. The eleven-minute performance of "Purple Rain" was edited down to eight minutes and forty-five seconds on the record, and to four minutes for the radio single version.

The full concert was videotaped by First Avenue's own in-house production company, AVE Productions, which used three cameras to capture the concert as a rough sketch for the movie's performance scenes. Decades later, a well-informed bootlegger of that video posted the full eleven-minute rendition of "Purple Rain" online with annotated factoids and captions pinpointing exactly where certain parts of the song were cut out for the album. The annotator even highlighted the moment an audience member let out a loud "owww" that can be heard faintly on the album version. Throughout the full concert video, a bootleg version of which also exists, you can see a lot of the same stage tricks, dance steps, and rock-starry movement that would later appear in the movie—everything from the hand gestures in "I Would Die 4 U" to the kiss Prince plants on guitarist Wendy Melvoin's cheek just before "Purple Rain" crescendos into its glorious finale.

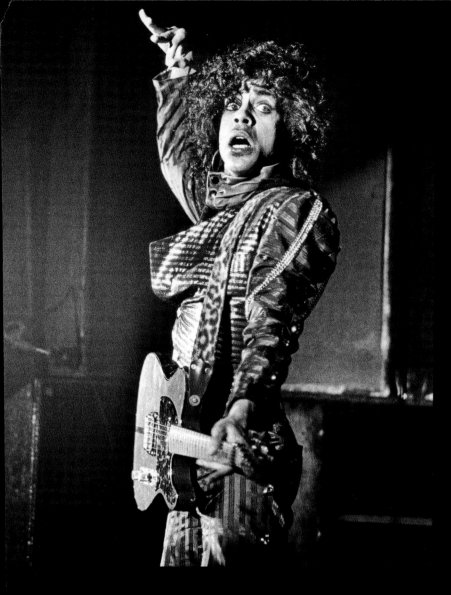

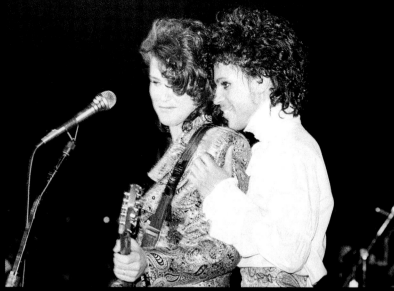

(Left) Prince was especially animated during the performance of "Computer Blue," one of three songs featured on the *Purple Rain* album just as they were recorded that hot August night in 1983. *Photo by David Brewster, Star Tribune. (Above)* Guitarist Wendy Melvoin with Prince at the 1984 Jammi Awards. *Photo by Daniel Corrigan*

Melvoin's presence is another dramatic storyline from the 1983 concert. Only nineteen years old and newly dropped in Middle America, the Los Angeles native was being tested in her very first performance with Prince & the Revolution on what happened to be one of the most vital nights of his career. When she returned to First Avenue for the Revolution's emotional tributes to Prince in September 2016, the guitarist recounted her conversation with Prince in the First Ave dressing room that night. "He took me aside and asked me if I was nervous," Melvoin said. After she responded, "Hell yeah," Prince talked about how her heart rate will naturally start pumping faster onstage. Instead of counting the songs' rhythm in usual one-two-three-four time, he told her to count them in half time "to get behind the rhythm." Said Melvoin, "It's the best advice I've ever gotten to

this day." More lightheartedly, her new boss offered additional counsel before taking the stage: "If you make a mistake, make it twice."

Melvoin emphasized her youthfulness that night by wearing tomboyish, white high-top sneakers with a more adult (and Princely) see-through lace skirt and low-cut T-shirt. After the all-eyes-on-Prince opening number "Let's Go Crazy," she landed in the spotlight for the second song, an especially feisty, almost punky "When You Were Mine." She and the frontman did their first synchronized moves together, dancing and strutting with her new purple Rickenbacker swaying alongside his light-brown Telecaster with the purple leopard print pick guard. After Prince's captivating solo turn on "A Case of You"—a Joni Mitchell cover that revealed one of the sources of his tenderness—Melvoin again made a big impression in "Computer Blue." She knelt down in front of the bandleader at crotch level as he laid down the guitar solo. The opening monologue that appears on the

album ("Wendy? Yes, Lisa. Is the water warm?") was not included that night, however.

After a nod to that year's breakout album *1999* by playing "Delirious," Prince sat at the electric piano for a new song that did not make the cut for the movie: "Electric Intercourse" was a sexy, innuendo-filled ballad that climaxed with writhing vocals and Prince sensually running his hands through his hair. After a grinding "Automatic," the band nailed its back-to-back performances of "I Would Die 4 U" and "Baby I'm a Star," both coming off remarkably similar to how they would on-screen.

After a finale of "Little Red Corvette," Minnesota Dance Theatre's founder Loyce Houlton appeared onstage to thank Prince. Handing him a rose, she declared into the microphone, "We don't have a prince in Minnesota. We have a king." Members of her dance company had performed a specially choreographed routine earlier in the night set to the *1999* classic cut "D.S.M.R.," which would also be Prince's final song of the night in the encore. In between, though, came Melvoin's and the concert's biggest moment.

With a darkened stage and no Prince in sight, the new guitarist stood alone in a spotlight strumming a slow but not so simple four-chord intro for nearly a minute, which must've felt like an hour to her. She nervously bit her lip at one point before Prince finally emerged from the stage-right stairs and walked behind her, only to let her be for a few bars longer. He chimed in with a few fluttery fills on his guitar, then harnessed the Tele behind his back in his soon-to-become-signature manner. He stepped up to the microphone, then dramatically stepped back as if to say, "I need a moment. This is too much." Then he stepped back up, wrapped his hands around the microphone, and held on tight like a pole vaulter going over the top.

In the ensuing years, people everywhere would come to recognize what came next: "I never meant to cause you any sorrow / I never meant to cause you any pain." After going through the now-familiar verses and choruses and an extra verse that didn't make the record (with oddly spiteful lines: "Honey I don't want your money / I don't think I even want your love"), Prince kicked

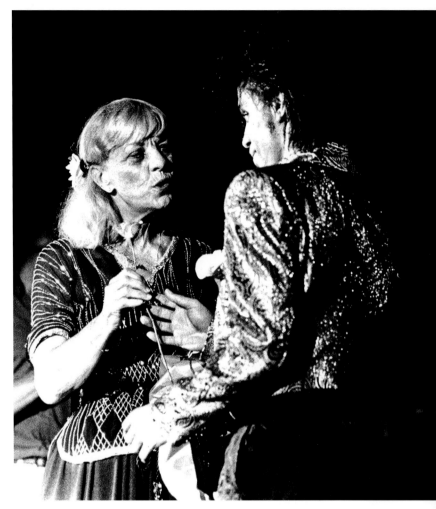

In addition to offering an opportunity to try out some new tunes for Prince's next major undertaking, the August 3 concert also raised considerable funds to support the Minnesota Dance Theatre, something for which the theater's founder, Loyce Houlton, showed her appreciation onstage. *Photo by David Brewster, Star Tribune*

into his guitar solo. It's a couple minutes longer in the bootleg clip than what was included in the final version, but it is unmistakably *that* guitar solo, the one you've heard twenty-five thousand times on the record and the radio, and you can see he was in a zone that only the best of the best have entered.

Those who were there in person all agree they knew Prince was onto something special that night. "I remembered him playing the song 'Purple Rain' for sure; you

just knew it was going to be a hit," said Allan Fingerhut. "It was kind of weird to hear so many new songs in one show, but obviously they were great songs," remembered Jon Copeland, a KFAI-FM show host who would become a lifelong Prince fan and regular patron of the club. Heidi Vader, then nineteen years old and soon one of Minneapolis's most passionate Prince fans, recognized five of the songs when *Purple Rain* hit theaters the following summer, but she didn't recognize the audience in the movie. "It wasn't the really cool, stylish hair-and-makeup crowd you see in the movie," Vader said, pointing out that future *St. Paul Pioneer Press* and *City Pages* music critic Jim Walsh can be seen in front of the stage in the bootleg video. "It was mostly the average hardcore musicheads, the people who are so into music they rushed out to get tickets and didn't mind paying twenty-five dollars, which was a lot in those days."

Bobby Z looks back on that night as the highest of high points in the room. "When I hear the record, I can put myself back into that moment, on that stage, that smell, in that heat, in that summer—that whole journey of what First Avenue is about," Bobby said. "That was just, you know, [the band] clicking with the bandleader— the most incredible bandleader! We know that now. History tells us that: the greatest coach, general, bandleader. Everything you wanted, he had. And he hits those guitar solos on 'Purple Rain.' They were real, and they're captured for real! Nobody ever did anything like that before. So when you're behind that, you're inspired to rise up to a kind of a superhuman level that only Prince can give you. Because he's the closest thing to supernatural I've ever seen."

On a more down-to-earth level, the drummer also came close to heat exhaustion that night. It finally subsided when he got out of the club to visit his brother David Z in the mobile recording studio after the set ended. "I remember opening the door of the truck and feeling the air conditioning," Bobby said with a laugh, recalling being a little jealous of his brother's cozy setup and feeling proud when David looked at him and declared, "You guys were great!" David noted another reason to envy his recording job inside the truck: meeting Sheila E. "Prince

Refreshments and catering for the August 3, 1983, concert at First Ave: $475.10. Advertising and miscellaneous expenses: $463.00. Club total production costs: $3,559. Having Prince play a concert that would evolve into a legendary album and rock film: priceless. *Minnesota Historical Society Collections*

brought her into the truck and said, 'Can she sit in here with you?'" he recalled. David also remembered that, during and after the concert, "Everyone in the truck was just cheering, saying how great it all sounded."

While he was known to tirelessly comb over recordings late into the night, Prince apparently rested on his laurels after this one. As David remembered, "I walked out of the truck and Prince pulled up in his black BMW, rolled down the window, and said, 'How'd it go?' I went, 'It sounded great!' And just then, a girl stepped off the curb with a trench coat and opened it up, and she was naked underneath. Prince goes, 'No, no. Don't do that!' And he rolled up his window and drove away! So that was really our conversation after the concert. He didn't listen back that night. Maybe he knew he nailed it." ■

BECOMING FIRST AVENUE

1982-1990

"The rumor mill has turned out some pretty amazing bits and pieces this year—for instance, the one about Sam's beloved little backroom, the 7th St. Entry, going down the tubes. Highly unlikely. The only changes coming to the hallowed corner of creative cacophony, hardcore ingenuity and knee-jerkin' rock 'n' roll will be taking place with the big bar, Sam's. They're changing their moniker to First Avenue on New Year's Eve."

—Martin Keller, Martian Chronicles column, *City Pages*, December 23, 1981

Just a month before Sam's officially became First Avenue, a band that would be one of America's biggest rock acts by the end of the decade learned just how large a leap it was between the club's two rooms. R.E.M. was originally booked to headline 7th Street Entry on Thanksgiving night, November 26, 1981. A band nobody remembers cancelled in the main room, perhaps due to the blizzard that hit that day, so Steve McClellan moved the young quartet from Athens, Georgia, to the larger venue. His ambitious goals were starting to pan out after two years of making the shift from the Uncle Sam's disco era, but he got ahead of himself on R.E.M. "They were kind of nervous and pissed about it, and I don't blame them," the club's general manager said. "Nobody showed up."

Guitarist Peter Buck later claimed only twenty people were there for that gig, R.E.M.'s fourth outside of the Eastern time zone, though the club's records indicate eighty-eight attendees. Those who did attend offered

hints of what was to come. As R.E.M.'s longtime manager Jefferson Holt told Twin Cities writer Michaelangelo Matos for a 2016 article in *Pitchfork*, "Bands don't like playing to that emptiness. But because of the enthusiasm of the people that came out, it was one of the best shows that they ever did." The eager musicheads in attendance included many musicians, club staffers, and writers, including Jon Bream, who later wrote of the singer, "Michael Stipe has captivated me ever since." Also in the crowd that night were fourteen-year-old bassist Tommy Stinson and Replacements manager Peter Jesperson, who had championed R.E.M. from behind the counter at Oar Folkjokeopus record store. "We probably sold hundreds of copies of the Hib-Tone single at Oar Folk," Jesperson said, referring to the band's first seven-inch, "Radio Free Europe," released by the Atlanta-based Hib-Tone label. The song wouldn't make it onto a full-length LP for another year and a half, with the release of their debut album, *Murmur*.

"Tommy and I went to see Curt [Almsted] at Goofy's [Upper Deck] first, and then went over," Jesperson recalled. "They even exceeded my expectations. I was a huge Velvet Underground fan, and in those days you

(Opposite) Posters like this one helped promote the club's transition from Sam's to First Avenue at the start of 1982. *Courtesy of the Museum of Minnesota Music*

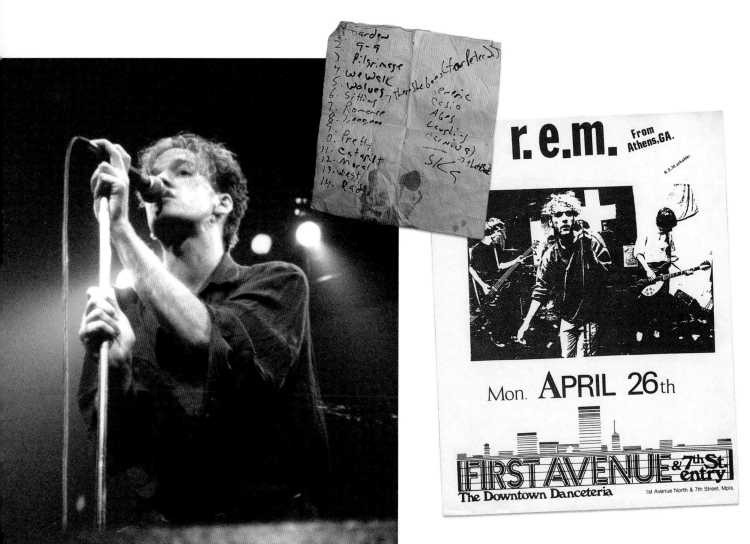

R.E.M.'s first trip to Minnesota turned into a surprise main room gig on Thanksgiving Day, 1981. The set list, sketched out on a napkin, includes many songs fans today will recognize. It also shows a note for a request of the Velvet Underground's "There She Goes Again" by Twin/Tone cofounder and Replacements manager Peter Jesperson. R.E.M. returned just five months later and still hadn't released an album. *Photo by Lori Barbero; napkin courtesy of Peter Jesperson; flyer courtesy of the Museum of Minnesota Music*

didn't hear a lot of people playing that kind of guitar work that Peter Buck played." Jesperson was so smitten, he saved a napkin with the set list scrawled onto it. Among the songs were VU's "There She Goes Again"; "Radio Free Europe" and the other track from the 7-inch single, "Sitting Still"; three from the not-yet-recorded *Chronic Town* EP; "Pretty Persuasion," which wasn't recorded until the band's second LP, 1984's *Reckoning*; and several more that would appear as B-sides ("Windout," "Ages of You"), plus "Skank," a reggae-flavored show-closing jam.

"A short, quickly paced set fueled by a lot of bluster, booze, and probably some cheap trucker speed" is how it's remembered by PD Larson, then a *Sweet Potato* writer and later a friend of the band. Decades later, he

still marveled over the chance to see one of his all-time favorite acts not once but three times at First Ave (they returned twice more in 1982), before they even put out an album—"something fairly uncommon before the indie-rock paradigm was fully in place," Larson said. "It's a pretty significant event in both the history of R.E.M. and the history of First Ave," said Jesperson of that first

(*Left*) In December 1981—the club's last month as Sam's—there were only two live concerts scheduled in the main room. *Courtesy of the Museum of Minnesota Music.* (*Above*) The calendar for January 1982 did not feature the club's new moniker, but Brian Brain was scheduled for a Mainroom concert on January 6. *Courtesy of Richard Luka*

Posters announcing the birth of First Avenue. *Courtesy of the Museum of Minnesota Music*

THE LOGO

(Top) Richard Luka's original logo design, from the first stat sheets—when the city skyline was less developed. *Courtesy of Richard Luka.* **(Above)** Sketches of possible updates to and variations on the iconic logo. *Courtesy of the Museum of Minnesota Music*

O nce Allan Fingerhut, Steve McClellan, and Jack Meyers settled on First Avenue as the club's name, McClellan recruited doorman Richard Luka, aka Dix Steele, to design a new logo. "Steve insisted on something that said 'Minneapolis' and 'music,'" recalled Luka. He took his inspiration from another club, however, lifting the skyline idea off a T-shirt from an American Events–run dance club called Boston Boston. The typeface for the name—a Letraset press type called "neon tubing"—was selected from another promotional T-shirt that McClellan had for a "Monday Nights at the Orpheum" music series. "I was leaving town, moving to Milwaukee at the time, and I suggested [Warheads frontman] Don Holzschuh do the artwork, as he was doing a series of pen and ink cartoons at the time," Luka recalled. "It was a good match." Of course, the city view from the original 1982 logo—with the IDS Center the only true skyscraper and the Foshay Tower in plain view—would soon be out of date, but Luka's skyline-atop-a-music-bar design has proven to be as resilient as the club. ■

show. "You can debate whether or not it was the right move for Steve to move them into the main room that night, but I think it showed foresight."

McClellan's vision was slowly coming to fruition. The club's manager now sees the Sam's era as a two-year transitional period. Part of the transformation required a literal scrubbing of the old disco-era facade. "We knew we had to change the name, but we didn't want people to come in and see that same sticky, gross purple carpet and the same old stuff they saw when it was Uncle Sam's," McClellan said. "We had to change a lot more before we changed the name. Once we got the Entry opened and the carpet out, we did everything we could to buff up the old

floor. We did all that before we could spend any money. We couldn't spend any money on the place for quite a while. We had all plastic cups for a long time. And the Entry really was a key part of it, because it brought a lot of people to the building that never would've gone to Sam's before."

There wasn't a final blow-out for Sam's or any kind of grand reopening celebration as First Avenue. The new name was officially in place on New Year's Eve, December 31, 1981. So, technically, the first performers to play First Avenue as First Avenue were that night's DJ hosts, Kevin Cole and Roy Freedom. McClellan and his partner, Jack Meyers, did invest in ads in the alt-weekly

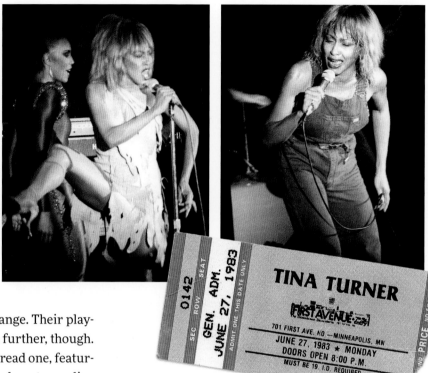

Tina Turner made several appearances at the club between 1982 and 1984. All three of these outfits were worn during her performance on June 27, 1983. *Photos by Michael Reiter; ticket courtesy of Michael Reiter*

papers around the time of the name change. Their playfulness may have just confused people further, though. "Around the corner from Red's Roost," read one, featuring an image of the rather notorious downtown dive (now the Seville Club). Another had a picture of an old urinal and claimed "First Avenue announces indoor plumbing"—especially ironic now, considering the club's restroom fixtures wouldn't be upgraded for three more decades.

Allan Fingerhut claims First Avenue was a name he threw around going back to the opening of the Depot. Muscular doorman Richard Luka recalls "The Purple Cow" also being considered for the marquee at one point, in keeping with Fingerhut's affinity for the color purple. "Think of the implications of that!" Luka wryly noted.

Touring acts that stopped in during the first few weeks of the First Avenue era included: ex-MC5 punk legend Wayne Kramer on January 20, 1982; Nils Lofgren on January 31, four years before his first gig with Bruce Springsteen & the E Street Band at the St. Paul Civic Center; Ohio's art-punk band Human Switchboard on February 7; doo-wop rocker Del Shannon of "Runaway" fame, with Flamingo alum Johnny Rey, on February 8; and surf-rock legends the Ventures on February 15. Then, on February 17, came the first of several returns by Tina Turner. The Rock and Roll Hall of Famer had

been through as much of a transformation as the club since the problematic night in 1971 when she shared the Depot's stage with Ike, whom she divorced in 1978. A *City Pages* review by Randy Anderson recounted several costume changes and a set list clearly meant for rock crowds, including "Honky Tonk Women," "Get Back," and, of course, "Proud Mary." She introduced the last by saying, "The longer I do it, the better it gets."

Within a month of Tina's appearance, the two biggest names born out of the Sam's era, U2 and Prince, returned for their second shows. By the time R.E.M. came back the third time in September 1982, attendance increased more than tenfold from ten months earlier to nearly a thousand people. Things were improving quickly for First Avenue.

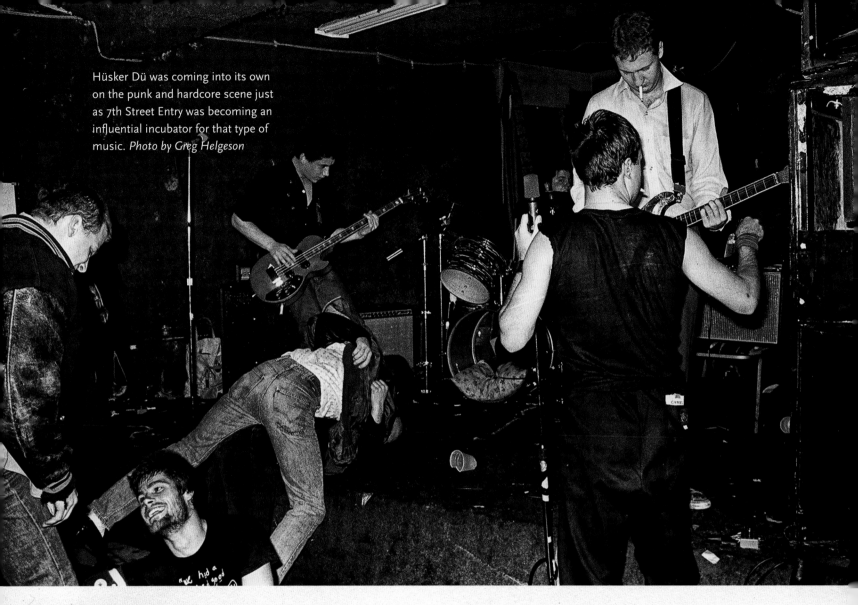

Hüsker Dü was coming into its own on the punk and hardcore scene just as 7th Street Entry was becoming an influential incubator for that type of music. *Photo by Greg Helgeson*

As the Mainroom took on more of an eclectic mix, most of the local bands that would become a big part of First Ave's so-called heyday remained relegated to 7th Street Entry. An audition of sorts for that cross-room transition happened in September 1981, just before the club's name change. Peter Jesperson and his Twin/Tone Records partner, Paul Stark, filmed and recorded nineteen bands over six nights at the Entry for a series they dubbed Soundcheck. "The idea was to make a live version of *Big Hits of Mid-America*," Jesperson remembered, alluding to the compilation LP series that originated in the '60s with Soma Records and had been co-opted by Twin/Tone in 1979. Three to four bands played each night, starting

with the wild-eyed Warheads and Chris Osgood's L7-3 on Tuesday, September 1, and ending with Timbuktu, the Dads, and Wilma & the Wilburs on September 8. Other acts included the Hypstrz, Fine Art, Rusty Jones & the Generals, Things That Fall Down, Mark Olson's pre-Jayhawks band Stagger Lee, and the REMs (with music scribe Jim Walsh, not Michael Stipe).

The Soundcheck performance with the Replacements and Hüsker Dü on September 5 was something of a watershed moment for the club's new identity. It also provided some of the best live video on file for both bands, who would use the Entry as a launching pad to national indie-rock stardom. "That's an amazing documentation of that week," Hüsker Dü singer/guitarist Bob Mould said in 2016. "I've seen the Replacements footage

since then and the Hüskers footage, and it's really just stunning." Mould's band headlined that night, steamrolling through their set with impressive efficiency and frantic energy. A little piss and vinegar went into it, too. After "In a Free Land," Mould yelled, "If you think you live in a fucking free land, you're wrong!" Later he sounds even angrier, chiding the bouncing and moshing crowd: "Whoever it was that knocked over my beer, go get another one."

The hosts of the Soundcheck series, Twin/Tone, had largely been dismissive of the Hüskers during the band's formative years. They weren't alone either; most local music writers also paid them little mind. "I always felt like the first two years they were learning to play on the stage," said *Sweet Potato/City Pages* columnist Martin Keller. Drummer Grant Hart thought it was unfair, though. "Some of the people in the Longhorn scene, even some of the wonderful people there, could be god-awful snobs," he said. "We had come from St. Paul. We were outsiders."

Steve McClellan liked that Hüsker Dü went against the prevailing trends, though, and made them regulars at the Entry, where punk pioneer Chris Osgood also took a shine to them: "I'd never seen a real mosh pit before Hüskers started playing the Entry," the Suicide Commando said. "I'd seen a little of that, but not with so many guys—and, of course, it was almost entirely guys—jumping around and bouncing off each other." By the time the trio headlined the Saturday Soundcheck show, they were finally starting to get respect. "It was nice Twin/Tone included us," Mould recalled. "We were grateful, but I imagine we already had other things on our horizons and were moving ahead without Twin/Tone."

In fact, the band being somewhat ignored in its hometown pushed the guys to seek attention elsewhere. "Thanks to Steve [McClellan], we had made contacts in Chicago, and from Chicago we met bands in Madison and Milwaukee," Hart recalled. Their first major trek, from mid-June to early August, 1981, included long stayovers in Calgary, Edmonton, Seattle, and San Francisco. "We were a different band after that," Hart said. It was abundantly evident in the show they played upon returning

Cover for Hüsker Dü's *Land Speed Record*, recorded live in the Entry on August 15, 1981

to the Entry. The live recording that would be released as *Land Speed Record* was a culmination of that tour, its title referencing both the traveling involved and the rapid-fire musical approach the band had developed on the road.

Longtime Hüskers sound man Terry Katzman said the Entry was the perfect place to capture the band in its element at that point: "The energy of it, being in this confined space with them. Everybody that came here were just huge fans and really dedicated to the band." Among those followers was Lori Barbero, who concurs that the band improved greatly after that summer's long haul. Before that, "the band was not that great musically," she admitted. "I loved them, but the vocals were horrific. They were my friends, so I remember just being uncomfortable sometimes because I felt bad. Then they went on this tour and came back, and I screamed through that whole damn record. It was really, really great." Out west, the band had earned interest from Greg Ginn to record for SST Records, but he was strapped for cash, so Mike Watt agreed to apply some of the profits from his band,

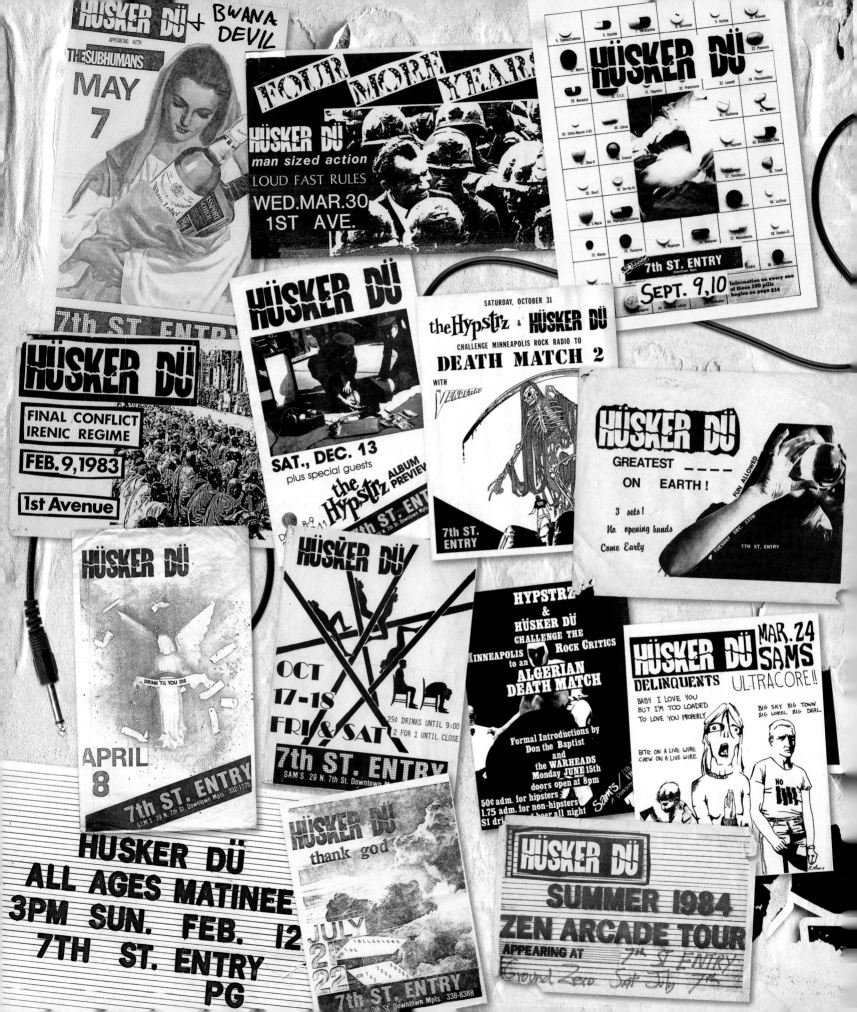

the Minutemen, to put the Hüsker's record out on their own imprint, New Alliance. Ginn would rerelease *Land Speed Record* after Hüsker Dü began recording for SST, starting with the 1983 EP *Metal Circus*.

By 1983, Hüsker Dü was regularly performing in the Mainroom, sometimes early in the week to only a few hundred people and sometimes to many more as an opening act. One of the first big warm-up gigs the trio landed was for Washington, D.C., hardcore punks and African American rock pioneers Bad Brains on October 27, 1982. Mould now acknowledges that made up for losing out on the chance to open for the Ramones three years earlier. "Steve was very good about that over time," he said. "He spread it around pretty good and gave all of us [local bands] each a shot at some of those shows." This particular night turned into something of an unfortunate eye-opener for the Minneapolis trio, though, whose coleaders' sexual identity had largely been a nonissue within the confines of the Entry and other local venues. After the show, Grant Hart offered to put up Bad Brains' members at his home, as he did many bands, paying back the floor-crashing offers that helped his own group make ends meet on the road. Come morning, Hart found that his guests not only stole all his weed but also left "All fags must die" graffiti on the wall. "A great band, but that's some fucked-up shit," Mould said.

After playing the Entry sometimes three or four times a month when they weren't on the road, Hüsker Dü's members became fixtures at First Avenue even when they weren't on the bill. Mould, in particular, would frequently be seen up in the office chatting with McClellan. "Bob's a really smart guy who was *also* into

wrestling, so he and I would talk a lot about just about anything," McClellan said.

More wild-mannered and gregarious, Hart also hung around the office and club a lot in the early days and made an impression on younger musicians, such as Trip Shakespeare's Matt Wilson. "Grant sort of seemed like a social hub at the place," Wilson said. "He was a very big personality for a very young guy. He would just be holding court, talking very fast. When he was around, it was the 'Grant Hart Experience.'"

Hüsker Dü enjoyed a highly charged run in 1984 and 1985, putting out its three best albums—the double-LP *Zen Arcade*, *New Day Rising*, and *Flip Your Wig*—in a fourteen-month span. The trio also crammed in a lot of well-remembered Mainroom gigs, bringing up several younger local bands along the way and helping earn them decent followings, including Man Sized Action, Rifle Sport, and of course, Soul Asylum. "Hüsker Dü would always play the stuff from their new record before it came out, so you would always be a little disappointed," said future Hold Steady frontman Craig Finn, who caught a few of the all-ages shows then. "Then when the record came out, you'd want to hear all those songs you didn't recognize the last time they played."

A terrific snapshot of that era came on August 28, 1985, one of the most widely bootlegged First Ave concerts by someone other than Prince. The band kicked off the show with the three opening cuts from *Flip Your Wig* (which would release a month later), including the title track and "Makes No Sense at All." They also played most of the newly issued *New Day Rising* LP, encored with more *Wig* songs, and threw in the Elvis Presley cover "You're So Square (Baby I Don't Care)" and the Grade-A B-Side "All Work and No Play." The show was recorded for *Spin* magazine's Spin Concert Series and distributed to radio stations. The handwritten contract, signed by "Robert" Mould, includes standard lines guaranteeing the magazine "would not commercially release, sell or distribute" the live recording. After the very-limited-edition vinyl pressings went out to radio stations, though, they were remade into CDs and cassettes that became widely available all over Europe. Sound engineer Terry Katzman

(Opposite) Hüsker Dü flyers from 7th Street Entry and First Avenue's Mainroom, 1980 through 1984. *Courtesy of Mark Freiseis, Mike Madden, Minnesota Historical Society Collections, Dale T. Nelson, and the Museum of Minnesota Music*

(Above) By 1987, the Hüskers had made it to a major label and were filling the Mainroom, but creative differences led to the band's dissolution in early 1988. *Photo by Daniel Corrigan.*
(Right) The Replacements were staples at the Entry during the early '80s. This is one of their tamer moments onstage. *Photo by Daniel Corrigan*

wasn't surprised it became a sought-after recording: "It was easily one of their best nights in that room."

Like Hüsker Dü's Soundcheck set that September night in 1981, the Replacements' footage from the same night is full-speed-ahead in tone. Looking clean-cut, normally dressed, and downright cheerful, the quartet tore through two twelve- to thirteen-song sets in only fifty minutes total. It could have been one of the finer live recordings of their entire career, except for one problem: "They were out of tune for almost the whole show," Jesperson lamented.

By this time, however, the Replacements were 7th Street Entry regulars and honing their craft in ways that are evident on their beloved debut record, *Sorry Ma, Forgot to Take Out the Trash*, which was released less than two weeks before the Soundcheck show. And they hadn't yet begun to sabotage their live shows too frequently. As production manager Fred Darden put it, "Early on, they had to go home to their moms, so they couldn't get too hammered. They got hammered more when they were on the road." Greg Helgeson's cover photo for *Sorry Ma* shows

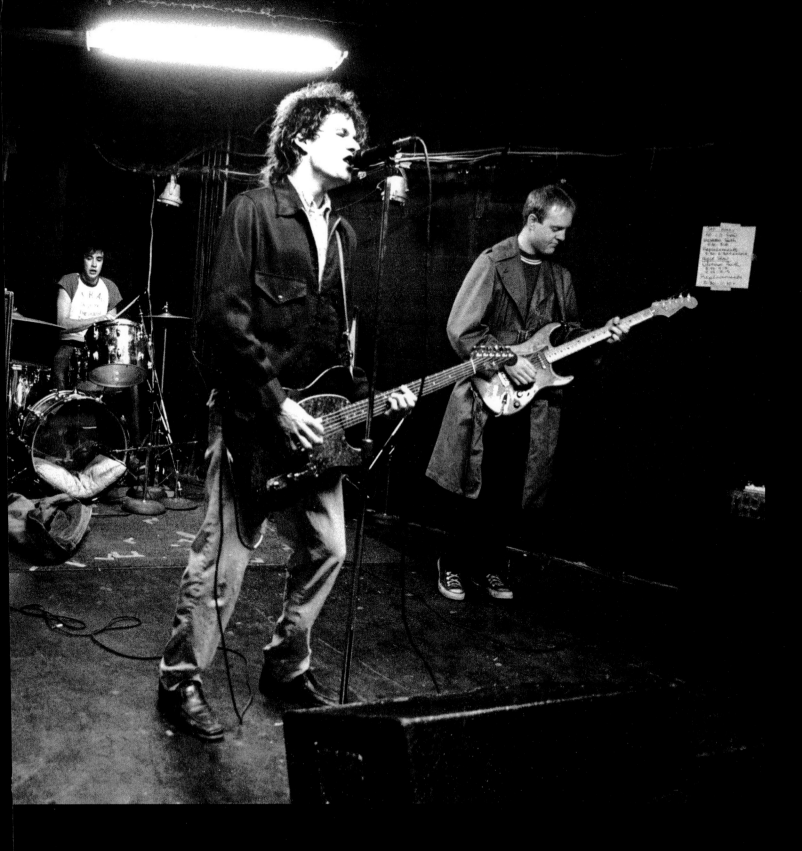

them in full flight one night in the Entry in 1981, with fourteen-year-old Tommy Stinson leaping in the air with his bass while frontman Paul Westerberg leans heavily into his mic.

Jesperson, who was the Replacements' manager by then, disputes Westerberg's contention that McClellan and the First Ave crew were "the guys who supported my band when we still sucked." Said Jesperson, "On the good nights in the Entry, they really were an amazing live band to see in those days. Paul's talent as a songwriter was obvious even then, and Bob [Stinson] could bring down the house."

Bob Stinson quickly became the one to watch in the Entry. He would often take the stage in wild attire, play from inside a trash can, or spit a loogie up onto the club's low-hanging ceiling and wait for it to come down. "I remember one time he dressed up like Chad Everett from [CBS-TV's] *Medical Center*," said Soul Asylum's Dan Murphy. "He'd wear like a London Fog beige trench coat, and he'd be naked underneath. So he'd be playing, and his jacket would open. His little wang would be there." Perhaps the Entry's steadiest customer in those days, Lori Barbero also still marvels over some of Bob's wardrobe choices: "He loved wearing dresses, and he loved wearing the plaid and the pants that were way too small for them," she said. "They all wore polyester. I don't know how they played in that crap, because polyester is plastic and just gross. And I doubt they washed it between shows, and a few of them probably peed themselves." She remembered the band being so scruffy and shameless back then, they would pry cash out of the audience: "They had a little mantra, 'Just throw money!' And people would empty their pockets and throw money, and they would run out and grab as much as they could and shove it in their pockets."

Like the discount drinking nights of the Depot era, Mondays became a designated live music night in the Mainroom after the name change to First Avenue. The Replacements played what was likely their first headlining set in the bigger room on Monday, March 1, 1982. They had earned a few coveted opening slots in the bigger room before that, though, including one with the Ramones on September 28, 1981. But the Entry shows were much more their territory. The more they played in there, the more bonkers things got. Noting the band's penchant for not playing entire songs, Barbero remembered, "If they would finish a song, everyone would look at each other going, 'What just happened?!' I mean, no one knew the endings to any of their songs."

Amid the mayhem, maybe the most daring thing Paul Westerberg did was agree to play a solo acoustic set—in the Mainroom, no less. He may have been half in the bag when he agreed to the gig, shooting pool with Roy Freedom and Peter Jesperson at the CC Club one night. Roy mentioned that the club wanted a solo act to open for Jefferson Airplane/Hot Tuna's Jorma Kaukonen. "You should do it," the DJ said to the singer, who raised his eyebrow and turned to his manager. "What do you think you can get them to pay me?" Westerberg asked Jesperson, who was one of the very few to hear the shy frontman's trove of acoustic home recordings. "Roy and I looked at each other like, 'Holy fuck!'" Jesperson recalled. "I

(Opposite) Replacements flyers from 7th Street Entry and the Mainroom, 1981 through 1987. *Courtesy of Minnesota Historical Society Collections, Dale T. Nelson, and Chrissie Dunlap*

> "[The Entry] is where we started. Bob vomited onstage a few times there. That's where we learned to do what we do."
> —Paul Westerberg, quoted in MTV's *120 Minutes* segment on First Avenue for the club's twentieth anniversary

7th ST. ENTRY
SAM'S 29 N. 7th St. Downtown Mpls. 332-1775

Friday, Jan. 23, 1981

~~QUEEN~~
~~MEAT LOAF~~
~~JOHN DENVER~~
~~and the SEWER BUNNIES~~
~~THE BLURT~~
~~THE MORMAN TABERNACLE CHO~~
~~PORTER WAGONER~~
~~THE BAG OF FOUR~~
~~TRINI LOPEZ~~
~~DONNY AND MARIE~~

The Replacements
Don't ask why

Also appearing:
THE DADS

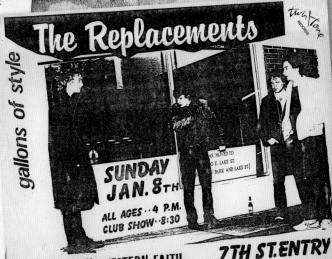

The Replacements
gallons of style

SUNDAY JAN. 8th

ALL AGES · 4 P.M.
CLUB SHOW · 8:30

WITH SPECIAL GUESTS: **WESTERN FAITH** **7TH ST. ENTRY**

THE
REPLACEMENTS
WEDNESDAY
FEBRUARY 25th
7th St. ENTRY
No Pets

7th ST. ENTRY
SAM'S 29 N. 7th St. Downtown Mpls. 332-1775

YOUR GUIDE TO
The Royal Wedding

R EM **R**
 S
Replacements

**TUES
AUG
4
1981** **RSVP**

7th ST. ENTRY
SAM'S 29 N. 7th St. Downtown Mpls. 332-1775

WED. & THUR., SEPT. 17-18
Replacements
Low Class Rock
WED.: 1/2 Price drinks. THURS.: $1.00 Drinks

7th ST. ENTRY
SAM'S 29 N. 7th St. Downtown Mpls. 332-1775

THE REPLACEMENTS

Saturday November 28th

CLASSIC CITY SOUNDS

7th ST. ENTRY
SAM'S 29 N. 7th St. Downtown Mpls. 332-1775

Tuesday
July 28th

the replacements
there's nothing
wrong with them

THE REPLACEMENTS

THE 800th LIFETIME
ALSO MAKING A
SPECIAL APPEARANCE.

WED. DEC. 26th FIRST AVENUE & 7th St.
The Downtown Danceteria

THE REPLACEMENTS

WEDNESDAY, MAY 13TH

FIRST AVENUE & 7th St. entry
The Downtown Danceteria

$9.00 ADV. $11.00 DOOR

told him I could get a hundred dollars, but when I went to McClellan, he said, 'No way. I'll give him twenty-five.' It seems like Steve could've given him a little more for something like this."

Jesperson lied to Westerberg and paid the seventy-five-dollar difference out of his own pocket, just so he'd go through with it. Paul still contemplated bailing right up until he took the stage on October 17, 1982. "If I had half a brain, I'd make a run for it now," he said just before the screen went up. A bootleg of the set captures his nervousness. "Christ, how much time I got?" he asked near the start, then later added, "This isn't quite as bad as I nightmared it to be—of course, I'm lying." He opened with the bluesy "Take Me Down to the Hospital," followed by his only publicly issued acoustic track at that point, "If Only You Were Lonely," and then hard-strumming versions of "Treatment Bound" and "Shutup," and, for a finale, the New Orleans music staple "Lawdy Miss Clawdy." Jesperson sees it as a pivotal moment, even though Westerberg wouldn't go solo again for another decade: "It just scared the daylights out of him. I think that was good for him at the time." McClellan said he recognized pretty early on that "Westerberg never liked performing live. That's why he was always so drunk."

Of all the Replacements, Tommy Stinson seemed to hang out at First Ave and the Entry the most in the early '80s, despite the fact he was still underage. "He was such a brat!" Entry booker Chrissie Dunlap said bluntly. "I of course adore Tommy now, but at the time I took my job somewhat seriously. I'd say, 'Tommy, we can't lose our liquor license. You're only fifteen. Get out of here!' He'd leave and come around the back, and they would hide him down there or in the dressing room." On the plus side, Stinson's mischievous ways did play a role in the 'Mats defecting from the Longhorn bar and becoming 7th Street Entry regulars in 1980. Jesperson said he quit his DJ gig at the Longhorn after the bar's new owner, Hartley Frank, threw a fit over the teen rocker one night. "It was some kind of thing where he insisted Tommy had to stay in the kitchen," recalled the Replacements manager. "It was just really unpleasant."

Eventually, First Ave staffers tried to come up with semi-legitimate ways of getting Tommy into the club. When he wanted to see the British post-punk band Gang of Four in 1982—a concert cited by several musicians as one of their all-time faves at the club—he got in through a working clause: McClellan made the scrawny bassist part of the stage crew. Stinson recently recounted to *City Pages*: "Here I am, fifteen or sixteen years old, trying to push fucking five-hundred-pound speaker bins up and down ramps. Someone actually caught me as I was about to fly backwards on this ramp." He had no complaints, though. "It was such a fucking great show," he said.

A far cry from the recluse he would later become, Westerberg also hung out plenty at First Ave and the Entry on off nights. "Paul would run around a lot back in those days, too," recalled Barbero, who more often hung out with Hüsker Dü and their so-called Veggies crew, which included future members of Man Sized Action and Rifle Sport. She said Westerberg would sometimes fall in with them. "I just never remember them having any kind of rivalry," she said of the Hüskers and 'Mats. "We were all pretty close." Westerberg was also said to have had a rivalry with R.E.M.—especially after they recruited Jesperson as a tour manager during a lull in 'Mats work—but many people remember one debaucherous night in 1984 when the Replacements frontman and R.E.M. guitarist Peter Buck strutted through the club in full glam makeup. Maggie Macpherson said they were even cutting people's hair and "really made a show of it." Buck himself recounted the night to *Magnet* magazine for its "A Tale of the Twin Cities" cover story in 2005. "The day probably started about noon at the CC Club," he said. "Not that any of us wore a huge amount of makeup, but occasionally you get the whole Johnny Thunders thing going. I do remember that night, though, because we got some real looks walking through the neighborhood." Macpherson remembers them stopping at a White Castle after leaving the club and having to wait in line in their full regalia. "People in this line just wanted to kill Peter Buck," she said.

By the end of 1984, after their *Let It Be* became a favorite album of critics and record-store clerks everywhere, the Replacements could undoubtedly pack the

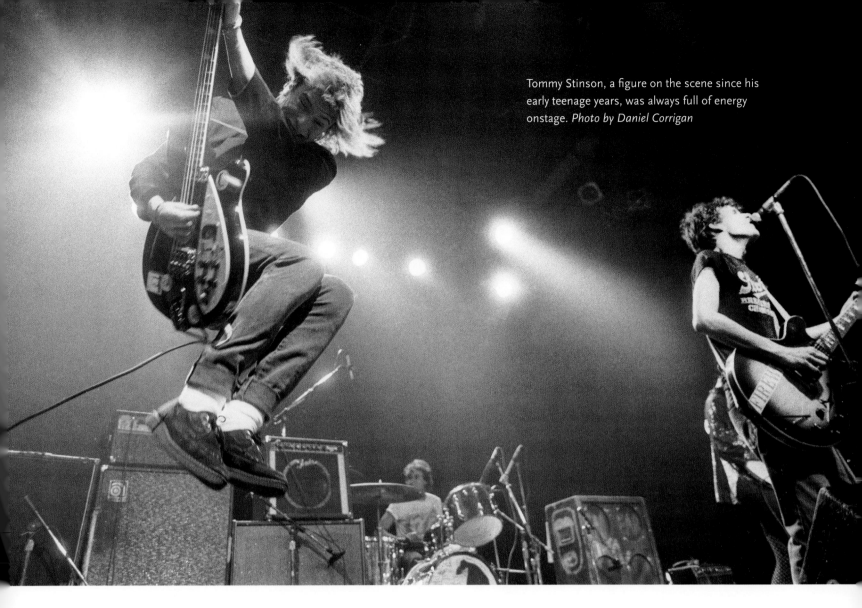

Tommy Stinson, a figure on the scene since his early teenage years, was always full of energy onstage. *Photo by Daniel Corrigan*

Mainroom. So of course they opted to play the Entry when it came time to issue their first major-label record for Sire, *Tim*, in October 1985. They booked the small room for five nights in a row. Most 'Mats diehards cite this five-night run as the crowning moment in the Replacements' tenure at the club. "The excitement around the shows was incredible," Kevin Cole recalled.

Predictably, the Entry run started out strong and semi-focused but got more erratic as the week wore on. The *Minnesota Daily* described the band as "sounding tighter than anyone could remember" in the first all-ages show on Tuesday. Jon Bream's high praise in the *Star Tribune* read, "Tuesday's performance was a test of how far these guys have come since going corporate, [and] they passed with flying colors. They showed enough versatility and cohesiveness to reach a lot of rock fans who don't know them yet." That was certainly the hope of legendary Sire Records founder Seymour Stein, who flew in for the shows, perhaps not expecting his big newcomers to be playing in the small room. In Bob Mehr's definitive Replacements biography, *Trouble Boys*, the band's new sound engineer, Monty Lee Wilkes—who regularly worked at First Ave and later as tour manager for Nirvana—recalled Stein "looking terrified [because] it was packed in there."

Craig Finn attended the two late-afternoon all-ages gigs and remembers it being a lot of fun if a bit perplexing to a high schooler. "It was an early show, so they were ... sober-ish," he said. "They were still pretty crazy. They would stop in the middle of songs and all that.

In May 1985, Paul Westerberg's side project Jefferson's Cock made an appearance with the Magnolias in the Entry. *Courtesy of Dale T. Nelson*

With his outlandish outfits and intense guitar playing, Bob Stinson was an onstage force with the Replacements, but his personal demons eventually led to his dismissal from the band. *Photo by Charles Robinson*

At that point, I hadn't ever seen a show where the band was that unprofessional." Apparently, things got less "sober-ish" and even more unprofessional after that. Cole remembered, "They were pretty intoxicated by the time of the adult show. Bob and Westerberg came out in dresses. Paul pulled Bob's down, and Bob kept doing it to Paul. Thirty seconds into the first song, they got into a full-on fistfight and were just pounding the shit out of each other."

As is now well known, Bob Stinson's wild ways and personal troubles would get out of hand enough for his bandmates to fire him after the *Tim* tour. Their final First Avenue shows with the much-loved guitarist were January 21 and 22, 1986, the Tuesday and Wednesday after their notorious *Saturday Night Live* appearance, when they were banned from the show for behavior that

included a muffled on-air F-bomb and doing lines of coke in the dressing room with that night's host, Harry Dean Stanton. First Ave showed the TV performance in the Mainroom that Sunday night. Two nights later, Westerberg launched the band's early all-ages show with a cocky declaration: "Rock gods that we are, we're going to do a song called 'Takin' a Ride.'" The band was indeed rather godly that night, with Bob Stinson's quick-burst guitar parts cutting through the din like sirens in traffic. Westerberg, however, seemed to be slurring heavily between songs, like when he asked the underage fans, "How many of you skipped school today?" A night later, the band was even more hell-bent on playing fast and furious, but the

frontman again seemed out of sorts, complaining of guitar trouble. "He had this awesome Gibson semi-hollow, and he had taken tape and wrote 'firewood' on the front, kind of like Woody Guthrie's 'This machine kills fascists,' but for our generation," remembered Kevin Bowe, who opened the show with his band Summer of Love and later toured with a solo Westerberg. The guitar trouble, Bowe said, might have stemmed from how Westerberg "'fixes' his guitars at home with screw guns and super glue, and they're way way worse than before he fixes them."

Bob Stinson's final gig with the Replacements devolved into the usual series of mostly ramshackle covers, including Kiss's "Rock and Roll All Nite" and Big Star's "September Gurls." Roy Freedom, who ran the sound board for a lot of the earlier Replacements shows, said simply, "I don't think I'd ever seen them go through a whole set without ever stopping, or *something* happening." Chan Poling of the Suburbs was more blunt: "I never saw a completely sober rock show by them. I wish I had."

The Suburbs were already too big for 7th Street Entry when it opened, so Poling's first time playing the smaller room was with two Replacements (one original and one future) and other friends in what was perhaps the first First Ave supergroup: the short-lived, all-for-fun ensemble Jumbo Shrimp. It featured Poling; his first wife, Terri Paul of the new wave band Fine Art; Suburbs bandmate Hugo Klaers on drums; Chris Osgood of the Suicide Commandos, plus Tommy Stinson and Bob "Slim" Dunlap. "It was kind of like the New Standards concept," Poling said, likening it to his cabaret covers band of the 2000s and 2010s, "but we did the songs straight." Said Osgood, "It was emblematic of how all the bands who played there were cordial with each other. We were all friends, and we had a lot of fun together."

"That was a pretty funny time, being a little kid hanging out with guys that were a good seven years older than me and playing goofy covers," Tommy Stinson later said. He also featured in another Entry-founded all-star cover band, the Alice Cooper–themed Spyder Byte, which

included Westerberg and Replacements drummer Chris Mars with Soul Asylum's Dan Murphy, First Ave sound technician Gerard Boissy, and Bill Sullivan, the Replacements' roadie who would later run the 400 Bar in Minneapolis's West Bank neighborhood. Sullivan played the part of Cooper in full costume.

Off and on part of First Ave's production crew, Sullivan and Chrissie Dunlap also dreamed up the Jammi Awards, a spoof of *Sweet Potato*'s Minnesota Music Awards. "Bill was so hilarious at those, he was perfect for them," said Dunlap. Categories included "Best Dancer on Drugs" (given to Curtiss A one year), "Best Hair," "Best Blue Guitar," "Peter Tosh Legalize It Award," and "The Barbara Flanagan Gee It's Good to See My Name in Print Award," named after the *Star Tribune*'s gossip columnist. In light of all the "best" awards, the club even got the nearby Best Steak House outlet to be a Jammies sponsor. "It was all for fun, but I think they made some decent money, too," Dunlap said.

It was Dunlap, more than McClellan, who can take credit for a third band that the Entry launched to alternative-rock fame later in the decade. The members of Soul Asylum were all frequenting the Entry in its first year or two, as high schoolers. When Murphy turned nineteen, the legal drinking age, he would hand his ID off to Karl Mueller at the door, which became a problem when Mueller used his own ID to get free champagne on his actual nineteenth birthday (he had been a regular for more than a year). But they were there to study up as much as drink: It was hard to pooh-pooh it when they would get compared to the 'Mats and especially Hüsker

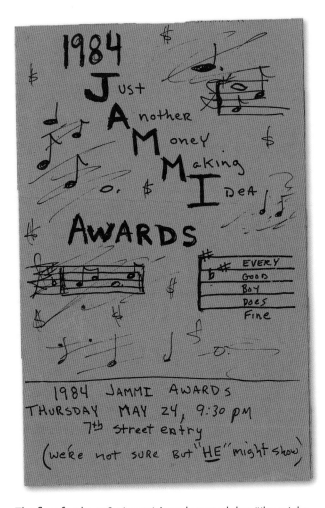

The flyer for the 1984 Jammi Awards teased that "'he might show," and although "he" didn't, among those who did were Grant Hart of Hüsker Dü, Dave Pirner of Soul Asylum, and comedian Lizz Winstead. *Courtesy of Chrissie Dunlap*

Soul Asylum brought its high-energy live performances to 7th Street Entry frequently in the early and mid-'80s prior to making the leap to Mainroom-headlining status. *Photo by Daniel Corrigan*

Dü in the ensuing years. Frontman Dave Pirner told *Magnet* magazine, "I know this sounds kind of corny, but it really was a magical time. A band would play the Entry, and the same twenty people would show up. And they'd all be in bands, too. I got immersed in it and never looked back."

Soul Asylum was not well liked by McClellan back when the band started playing the Entry as Loud Fast Rules. Dan Murphy thinks it's because the club's GM caught him behind the bar pouring himself a beer during a sound check one afternoon. Chrissie Dunlap said McClellan accused her of booking them early on because of their scruffy good looks. "Yeah, Karl Mueller, he was very cute, not a bad thing," Dunlap said. "I got a

lot of shit: 'Why do you keep booking them?' I said, 'They can write good songs. They'll get better as a band.' And they did. They rehearsed five nights a week. There was something about their work ethic, their songwriting, and Dave's voice, which I could hear on the radio. They walked the line between heavy metal and hardcore, so they were kind of an odd fit then."

Mueller wore a kilt for Loud Fast Rules' first Entry show in late 1981. Another night, the bassist showed up with two missing teeth and a bloodied face after a mishap earlier that day where Pirner playfully tackled him (yes, drinking was involved). That kind of persistence kept them coming back month after month, working their way up to Entry headliners and then Mainroom openers. They were still performing as Loud Fast Rules on May 15, 1983, when they made up a flyer with their name at the top over "very special guests" the Ramones. "Steve was really pissed about that," remembered Murphy, who was amazed Joey Ramone fondly recalled their set years later when he met them as Soul Asylum. Even McClellan had come around by the time they issued their Bob Mould–produced Twin/Tone debut, *Say What You Will*, in August 1984. Later that year, the band earned one of its first big breaks by opening for X as Soul Asylum on October

15. "X is why we decided to take it seriously," Murphy said. "They remembered us and called up Frank Riley, who was their booking agent, and wanted to take us out on tour. And we all dropped out of school and did it. . . . We decided to drop out of school and take it seriously. It was the first step."

While the Replacements, Hüsker Dü, and Soul Asylum are seen by many as the quintessential rock bands of First Avenue's '80s heyday, there were two other groups that drew bigger crowds and put on much more refined albeit still adventurous live shows. Attendance records from the club show that, when the 'Mats and Hüskers were drawing three hundred to five hundred or so

people in the Mainroom in 1983, the Suburbs and the Wallets each would draw more than a thousand. "They were dance bands," sound engineer and Hypstrz/Mofos leader Billy Batson said. "They had great grooves, but they were white-bread enough to play colleges and high schools. Those crowds would come down to the club to see them. Hüsker Dü couldn't play a high school! And they had management, too. Somebody saw they had commercial potential."

The Suburbs also had looks and style, which brought a lot more women and girls to their shows than most of the Entry bands. "They certainly looked better than us," quipped Chris Osgood, whose Suicide Commandos proverbially passed the torch to the 'Burbs and who helped make them an original flagship act of Twin/Tone Records. The star of the show visually was the Suburbs' muscular, goggles-wearing singer/guitarist Beej Chaney,

Loud Fast Rules and Soul Asylum flyers from 7th Street Entry and the Mainroom, 1983 through 1987. *Courtesy of Minnesota Historical Society Collections, the Museum of Minnesota Music, and Dale T. Nelson*

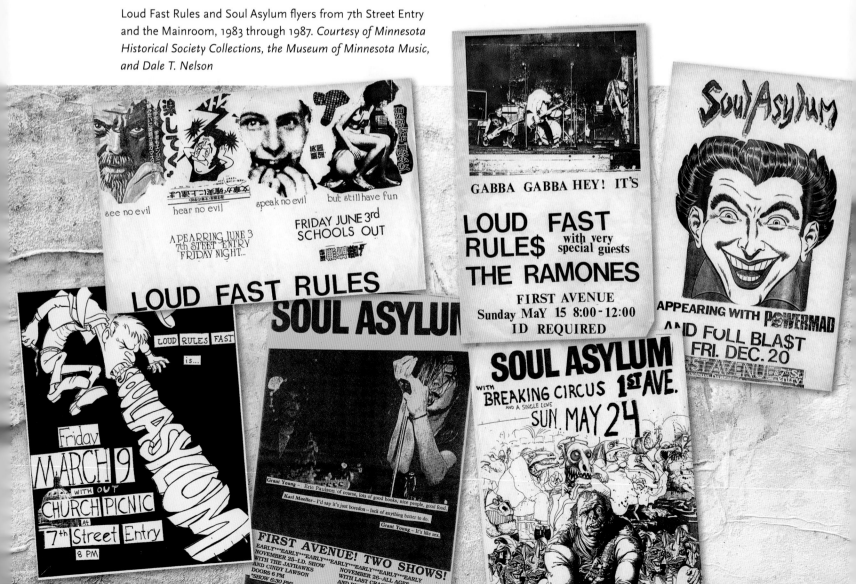

who was known to climb out into the crowd and engage in other unruly stage antics. Gary Sklenar remembered, "I once did stage security for them in 1983, which consisted mainly of pulling girls off Beej and tossing them back into the crowd." But beyond the spectacle and sex appeal was a tight band with a hard-driving groove, especially after their first two Twin/Tone albums *In Combo* (1980) and *Credit in Heaven* (1981). "If you didn't see them in 1982 you truly missed something," said John Munson, who later became Chan Poling's bandmate in the New Standards.

Unable to remember their first Mainroom show, the Suburbs' singer/keyboardist could only recall another kind of thrill there in 1982, when they first pressed copies of their single "Music for Boys." Their manager, Steve Greenberg, followed Prince's lead and lobbied the DJ crew at the club. "He said, 'Let's go down and see if Kevin or Roy will play it in the dance party,'" Poling said. "That was cool."

When the Suburbs stopped playing the Longhorn bar, they were already big enough to be a Mainroom act. They first played the club when it was still called Sam's, and by 1984 they had made at least five headlining appearances. On August 27 of that year, they led a tellingly eclectic local lineup that included Curtiss A, Willie & the Bees, Dave Ray and Tony Glover, and Hüsker Dü for a benefit for local radio personality Billy Golfus, who was left in a wheelchair after a motorcycle accident.

The Suburbs' crossover appeal was made evident by the supporting acts for its March and April shows after its major-label debut, *Love Is the Law*: One had Soul Asylum, and another, local synth-pop newcomers Information Society, who would chart three years later with "What's on Your Mind (Pure Energy)."

The Suburbs' contract with Polygram Records was short-lived, but the group was soon scooped up by another big label, thanks in part to their rabid reception at a 1985 First Ave gig. Unbeknownst to the band, A&M Records executive John S. Carter had flown in to catch them on their home turf. Carter was the cowriter of the Strawberry Alarm Clock's 1967 hit "Incense and Peppermints" and went on to be an A&R ("artist and repertoire") representative for the likes of Bob Seger and the Steve Miller Band. Poling recalled, "He came back to the little

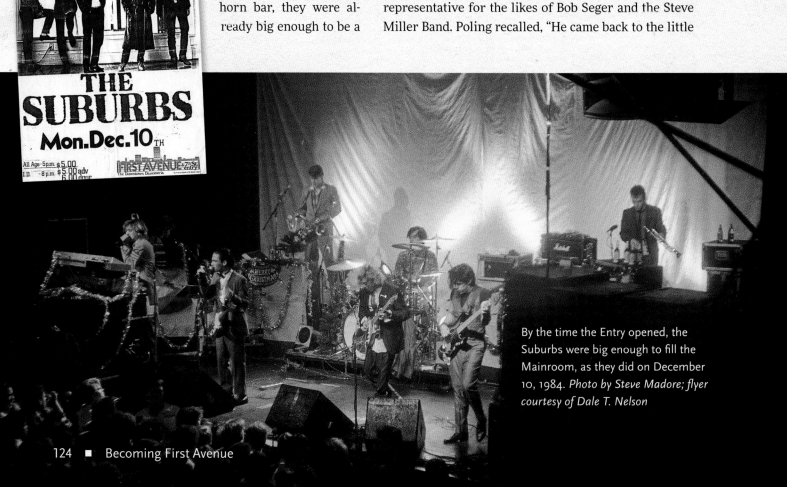

THE SUBURBS
Mon. Dec. 10TH
All Age - 5pm $5.00
I.D. - 8 p.m. $5.00 adv
6.00 door
FIRST AVENUE & 7th St Entry
The Downtown Danceteria

By the time the Entry opened, the Suburbs were big enough to fill the Mainroom, as they did on December 10, 1984. *Photo by Steve Madore; flyer courtesy of Dale T. Nelson*

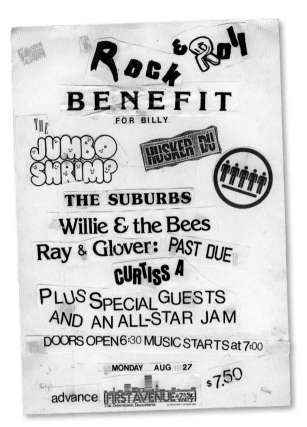

In August 1984 an all-star lineup of bands performed a benefit concert for Billy Golfus, a radio personality who was badly injured in a motorcycle accident. *Courtesy of the Museum of Minnesota Music*

dressing room and said, 'Hey, you guys are great. I'd like to have you join A&M Records,' just like something out of the movies."

Alas, the A&M deal proved to be less than picture-perfect, and the 'Burbs burned out on the music business by the late '80s, though fortunately not for good. In fact, Poling said First Ave felt more like home when the band played a set of reunion shows there in 1993, after a six-year hiatus. "We made this funny video, where we were all in a bar, and our tour manager comes running and says, 'You guys better get onstage!'" Poling warmly recounted. "The camera follows past all the Minneapolis landmarks; we pull up to First Ave and get off the bus and go into this long series of tunnels just like Spinal Tap, with an elevator scene." (For the record: There's no elevator in First Ave.)

With their bright, splattered blend of polka, new wave rock, New Orleans funk, and world beats, the Wallets were probably too quirky to graduate from the local Twin/Tone roster. But their First Ave shows are legendary. Frontman Steve Kramer had soaked up the art scene in New York before suffering a near-fatal fall off a three-story roof and returning to Minneapolis; he usually dreamt up some kind of visual twist for each show, as if the music itself wasn't warped enough. He rode a donkey onto the stage one night. He wore blackface another night, a memory that prompted critic Martin Keller to note that today, "Kramer probably couldn't have gotten away with half the things he did." Said Steve McClellan, "He was a super likable guy. So that helped him get away with all that crazy stuff he did."

A video from July 1983 shows the Wallets performing in the Mainroom with a giant horn section and two go-go dancers behind shadow screens. But the attention nonetheless winds up on Kramer. The singer literally tarred and feathered himself for the show, the gooey feathers flying all over the stage and into the crowd. A mush-coated, loin cloth–wearing Kramer dances at the microphone and plays the keyboards as if it were just another day on the job. Ironically, he remains fully clothed in the innovative, artsy video for their biggest single, "Totally Nude," filmed in the Mainroom in 1986. That was the year New Orleans legend Allen Toussaint produced the Wallets' first LP, *Take It*—their musical peak before Kramer pulled the plug on the group in 1989. Said Keller, "The fact that a totally inventive band like the Wallets could pack a club the size of First Avenue in a city our size, especially in those days, really says something about how progressive and open-minded this city really is."

Another group emblematic of the city's and First Ave's openness, Têtes Noires emerged in the Entry in 1983 and would soon prove popular enough to take over the Mainroom, a surprise even to its members. For one thing, they were one of the first all-female bands to hit the scene. Fronted by former Miss South Dakota Jennifer Holt, they took their name—French for "black

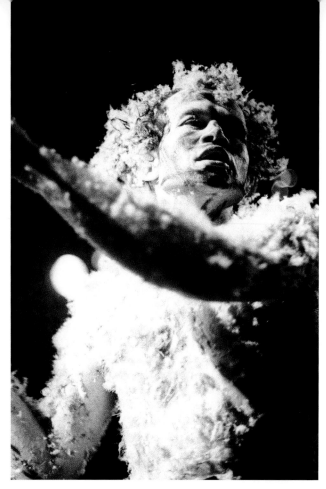

Always an entertaining stage presence with the Wallets, Steve Kramer went to the extreme in July 1983 when he took the stage tarred and feathered. *Photo by Daniel Corrigan*

Têtes Noires—seen here posing in the First Avenue bathroom— was one of the earliest and most influential all-female local bands to play the Mainroom. *Photo by Catherine Settanni*

heads"—from the members' shared hair color. Têtes Noires also stood out musically, with a whimsical, sometimes just plain smart-ass blend of new wave and punk built around five-part harmonies and occasional forays into a cappella.

"We were *so* different," keyboardist/co-vocalist Camille Gage recalled proudly. "We were so much not like the Replacements and other bands in town at all. It made it challenging. It's hard to do a cappella songs in a bar where everybody is drunk. But something about the Entry's size worked well for us. It was more intimate, and people seemed to listen more." Têtes Noires moved into the Mainroom in 1984 to open for the Violent Femmes, whose members would go on to produce the quintet's third album, *Clay Foot Gods*, issued on Rounder Records in 1987. By October 1985, they shared a Mainroom bill with another all-woman band, the Clams, a more

straight-ahead, Stones-y punk band that also frequented the Entry. Members of both groups say they felt an unavoidable amount of sexism around the scene in those days, but not from the folks running the venue.

"It was still such a small music scene in the '80s," said Clams singer/guitarist Cindy Lawson. "There would be some sour grapes from people who thought we were only getting booked because we were a chick band, like it was a novelty. It was still kind of a new thing." That wasn't the case at First Ave because these bands had Chrissie Dunlap up in the office as an ally. Ironically, Gage said, Têtes Noires' members were intimidated by Dunlap "because she was just so cool, and everyone in our band felt uncool. But luckily, she was the nicest person, too." As much as Dunlap helped, though, these two groups also got strong support from Steve McClellan. Gage said she saw "the real Steve" one night at a party, when she found him playing with her seven-year-old daughter instead of mingling with the cool adults. Lawson later married and had two daughters with the club's seemingly gruff general manager.

"I hope it doesn't ruin his reputation, but he was such a sweet man once you got to know him," Gage said. "I felt like he really wanted to give us a shot. And that's what made the Entry so great. It was a place to go to see new bands. It's where so many bands cultivated a

Bob Dylan: One More Night

He was spotted there often in the early '70s and almost played there himself in the 'oos, but Bob Dylan may have snuck into First Avenue a few times unnoticed in the early and mid-1980s. He was spotted at least once, in 7th Street Entry no less, in 1983. At the time, the Minnesota expat and his brother, David, owned the nearby Orpheum Theatre. Bob also frequently spent summers with his kids at a farm he owned along the Crow River, forty minutes west of Minneapolis. Whether by chance or through his Los Angeles music connections, he went to the Entry to catch the punky, L.A. roots-rock band the Alley Cats. "He was wearing a Hawaiian shirt," recalled that night's sound man, Roy Freedom. "He stood in front of me, right in front of the sound-board. He was nice. I mean, he was all right. No one bothered him, either. All night long, people would come into the Entry and just look around the corner." At least one regular did bug him. "I took a photo of him," Lori Barbero sheepishly admitted, "with my flash on my camera because I was like [astonished]. And he freaked! He jerked, and he was looking to see who had that flash camera. I had to quick put it in my pocket." That may have been his last time there. Thanks a lot, Lori. ∎

Lori Barbero, who often came equipped with a disposable camera at shows, surreptitiously snapped this photo of Bob Dylan during a rare sighting in the Entry in 1983. *Photo by Lori Barbero*

relationship with people in this town, the people that really wanted to listen and experience what was going on."

The local bands that haunted First Avenue in the early '80s seemed a galaxy apart from the primped, hair-sprayed, choreographed, eyeliner-coated artists on MTV, the new and flourishing cable TV station. First Ave staffers weren't wary of MTV or its artists, though. The music videos on the big screen in front of the stage became part of the draw on Mainroom dance nights. The club also brought in many of these bands for live shows, too—at least before MTV blew up, and many of the bands it promoted outgrew the old depot.

Since music videos had already long been popular in England, British bands were a big part of that first wave of MTV acts to play First Ave: Culture Club, Duran Duran, the Human League, ABC, Bow Wow Wow, Frankie Goes to Hollywood, the English Beat, Robert Palmer, Thomas Dolby, Howard Jones, Adam Ant, and Billy Idol were among the touring acts to play the Mainroom in 1982 and 1983. Other MTV standouts who played First Ave in those years include Missing Persons, INXS, Big

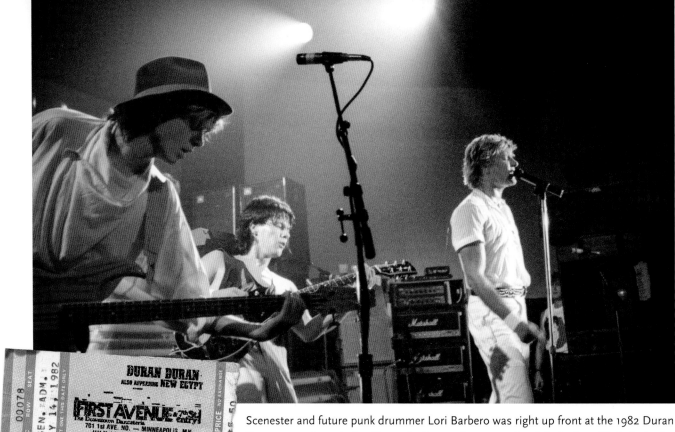

Scenester and future punk drummer Lori Barbero was right up front at the 1982 Duran Duran concert, capturing Simon Le Bon and company in all their glory. *Photo by Lori Barbero; ticket courtesy of Don Hughes*

Country, Men Without Hats, and Danny Elfman's Oingo Boingo.

Often cited as the prototype band of MTV's early years—what with its stylish videos and handsome members—Duran Duran was among the first to ride this wave to a packed First Avenue. Their July 14, 1982, show came midway through their second North American tour, and the band was supporting their breakthrough album *Rio*, but U.S. radio stations wouldn't catch up to the craze around the video for "Hungry Like the Wolf" for several months. "It may not be the coolest band to have as the first band you saw at First Ave," said future Semisonic bassist

John Munson, there for his inaugural Mainroom gig, "but at the time it was a big deal." Looking back on the show, bassist John Taylor said in 2016, "When we came to America for the second time, we were still playing clubs like First Avenue—bigger clubs, ones that were built for live music. I loved that tour. There was an excitement around the band at that time that you would always hope for and you never can replicate. We hadn't even had *Purple Rain* there yet, had we? That's funny now, looking back."

Culture Club's Twin Cities debut, on February 13 and 14, 1983, is cited by many as the most memorable appearance by the British MTV bands. It came early in Boy

> "When we came to America for the second time, we were still playing clubs like First Avenue—bigger clubs, ones that were built for live music. I loved that tour."
>
> —Duran Duran bassist John Taylor

George and company's first U.S. trek and closely followed the rise of "Do You Really Want to Hurt Me?" to No. 2 on the *Billboard* charts. "When Steve booked Culture Club, they could've sold out an arena probably," remembered marketing staffer LeeAnn Weimar. First Ave made a last-minute offer to book a second night upon learning the band had an off night following the scheduled show. "I was on the phone, trying to call the inside lines to radio stations, going, 'We're going to do this again tomorrow!'" Weimar recalled. "It was by the seat of our pants." But in those pre-internet days, word about the added date did not get out fast enough. "The club lost all the money it made on the Sunday when the Monday show failed to even sell half a house," McClellan complained. "I ended up comping the shit out of the Monday show so the audience looked respectable."

Among those who did turn out were a surprising number of the local scene's punkier musicians, including members of Hüsker Dü and Soul Asylum. "Karl was nuts for 'Karma Chameleon,'" Soul Asylum's Dan Murphy said of his late bandmate Karl Mueller, whose widow Mary Beth Mueller confirmed, "The show was amazing. Boy George tore off his pearls, tossed them at the crowd, and then sniped, 'Pearls before swine!' That was before he became the media cartoon and was still a snarly Brit punk." Boy George hung around the club over the course of the two days and made friends with some of the locals. Drummer Tom Cook, whose band Go Great Guns played the Entry one of those nights, said, "He still had the makeup on then [offstage] and looked like a girl, but he was just casual about it." VJ and stage crew member Patrick "Spot" Epstein remembers George walking around barefoot and flirting with him. "I felt like I was standing next to a woman, he was so pretty," Epstein said. "He was trying to get me to go on tour with them, and we hung out on their tour bus, but I came to my senses." Weimar said George playfully kicked her out of the club's upstairs office so he could call a friend. "He's one of the few artists that has called me 'crackers' in my life, and I love that," she said.

Billy Idol was apparently quite crackers (British slang for "crazy") when he hung out at the club after his gig on October 27, 1982, touring behind his first solo

Culture Club's Boy George put on a great show at First Ave in February 1983, just as the band was climbing the *Billboard* charts. *Photo by Daniel Corrigan*

album. A Minneapolis police affidavit is on record from that show due to an after-hours incident in the dressing room, which resulted in one unknown man's injury and a broken wall mirror. Idol piled on the polite British charm in an interview, claiming that the mirror somehow fell off the wall and hit the guy. Fellow MTV-branded pop-punker Adam Ant's appearance a month later—Thanksgiving Day, November 25—is similarly remembered more for a disturbance than for the music. A major fire at the Donaldson's downtown department store—one of the biggest fires in Minneapolis history—was apparently enough of a draw that some fans skipped out on the concert to go watch.

A memorable near-disturbance came the night INXS played, May 1, 1983, a show behind third album *Shaboo*

Scorpios
Try this for sighs
Goody 2 shoes
Crackpot History
Ants Invasion
Killer
Human Beings
S.E.X.
Here comes the Grump.
Dog eat Dog
Antmusic
Rancheros
Desperate not serious
Friend or Foe
Stand + Deliver

Hello I Love You
Kings

Man called Marco—] with
Car Trouble ——— | Marco
Physical ——— |

Adam Ant was an early MTV-boosted British act to reach Minneapolis's First Avenue. He played hits from his *Friend or Foe* solo debut at the Mainroom on November 25, 1982. *Photo by Tommy Smith III; set list courtesy of Dean Vaccaro*

Shaboo. Epstein was unexpectedly assigned to the stage crew after he had had a few drinks—a no-no even back then—and during sound check, he nearly came to blows with the Aussie band's drummer, Jon Farriss. "He just said such mean shit to me, and punched a nerve," Epstein remembered. "Someone called up the office. I've never seen Steve [McClellan] ever walk onto the main stage ever in my life, and he walked up then and goes, 'Spot, go home!' So I went home."

The INXS show may have marked a tipping point, when the MTV stars started to act like rock stars. "Frankie Goes to Hollywood, Thomas Dolby, Cabaret Voltaire, and those kinds of shows were hard," production manager Fred Darden remembered. "The English were always a little more particular about things. Some guys would come in and say, 'We played Wembley in England.' I'd say, 'You're not at Wembley.' For Frankie, we had to build a

whole thrust around the stage and put all these lights on it. It was like building a house, and loading out was hell. It went 'til four AM."

MTV certainly wasn't the only source of overseas bands during the early '80s. From 1982 to 1984 an impressive string of artier, edgier British and Aussie imports also came to the club, favored heavily by DJs Kevin Cole, Roy Freedom, and Paul Spangrud. Among them: New Order, the Cure, Johnny "Rotten" Lydon's Public Image Ltd, the Fall, the Birthday Party with Nick Cave, and Gang of Four. Except for the last's raved-about 1982 concert, though, none of these shows are that fondly remembered, and some were steep disappointments.

The low stage lighting for New Order's sixty-seven-minute set on June 29, 1983—captured on video and later bootlegged—fittingly reflected the band's low investment in the performance. "They were dicks before the show, during the show, and after the show," recalled PD Larson, noting that it was especially insulting that the synth-pop heroes didn't play "Blue Monday," a song the First Ave DJs had helped turn into a local dance-floor staple. The crowd might have forgiven them if the group

"The club is an escape. People want to hear something that's not on the car radio."

—Roy Freedom, quoted in *Time* magazine, July 8, 1983

New Order's performance on June 29, 1983, exemplified the disdain exhibited by many British bands toward their American fans. *Courtesy of the Museum of Minnesota Music*

didn't appear stolid and disinterested throughout much of the set, but "their disdain of the crowd was palpable," Larson remembered. Midway through the show, after the dark number "Truth," singer Bernard Sumner snidely chided the crowd, "If you didn't like that one, you must be Americans."

Predictably, the snidest of the Brit pack was Lydon. "Oh, what a bloody shithole," he proclaimed upon arriving at the club on October 25, 1982, according to First Ave crew member Spot Epstein. A local preview blurb had noted that Lydon looked a tad meatier since fronting the Sex Pistols five years earlier; he thus appeared onstage with a pillow under his shirt and asked, "Do I look fat?" And he never lightened up, spending "much of the night ranting with his back to the audience, clad in a Bellevue Hospital smock," wrote critic Jim Walsh in the *Minnesota Daily*, recounting the '82 show when PiL returned to the club in 1986. At that time, Walsh approached Lydon for an interview but was refused even before he got the question out; the critic described the performer as "a parody of himself" and "uninspiring" following that second performance.

Though Nick Cave would later put on some of the most incendiary performances ever seen at the club, his debut with the Birthday Party on April 6, 1983, was quite a farce. "He was so fucking drunk, he couldn't even stand up," Dan Murphy remembered. "And he had this bass player that wore like a cowboy hat and disco danced. It was the weirdest thing." Strange in another way were Robert Smith and the other members of the Cure. Staff members recall them coming in to rehearse the day before their first-ever Twin Cities show on November 7, 1984. But apparently, rehearsing wasn't their priority.

The California-based Cramps were a unique mix of punk and rockabilly. Led by singer Lux Interior and guitarist Poison Ivy, the Cramps made numerous stops at First Ave during the '80s and '90s. *Photo by Lori Barbero; flyer courtesy of Dale T. Nelson; tickets courtesy of Michael Reiter*

"First thing they did was break out these remote-control cars and start racing them around the dance floor like little kids," recalled Epstein. When they did turn to their instruments, "they played heavy metal all day," Roy Freedom remembered. Come show time, Smith wore a stylish gray suit with a white dress shirt and kept his hair mostly over his eyes instead of up in the air, with only a touch of makeup compared to later years. In the end, Freedom acknowledged, "They were really good."

A band that *never* got its live act together, the Jesus and Mary Chain also went over poorly in their December 15, 1985, debut at the club. The fuzz-rock darlings stopped in for an employee party around the corner at Northern Lights record store, but that did nothing to make the surly Brits more cordial toward the Minneapolitans. "I remember how mad everyone was that they didn't go on until almost closing," recalled Michelle Strauss Ohnstad. Entry sound man and Polara frontman Ed Ackerson recalled, "They were already my favorite band by the time they played here, so I knew what to expect, but much of the rest of the crowd was totally pissed off. The band blitzed through ten songs in about nineteen minutes.

People were screaming and throwing stuff. Eventually, they came back and just restarted the set from the top, playing a couple more songs before storming off."

Beyond the punky locals and the cocky Brits, First Avenue in the early '80s was also the place to see some of rock's greatest pioneers. McClellan had booked Bo Diddley in 1980 during the Sam's era and Tina Turner, as mentioned, at the start of 1982. The response to those shows was encouraging enough for him to bring each back, as well as additional high-caliber acts, including Ray Charles, James Brown, Wilson Pickett, Ronnie Spector, and Sam & Dave. They would be among the first inductees into the Rock and Roll Hall of Fame, but many had been relegated to the Carlton Celebrity Room, a faux-ritzy supper club in suburban Bloomington, during prior tours. Chrissie Dunlap, too, was an advocate for bringing all these favorites from her youth back into a true rock venue. "I mean: why not?" she quipped.

The Ray Charles show on October 17, 1983, lived up to

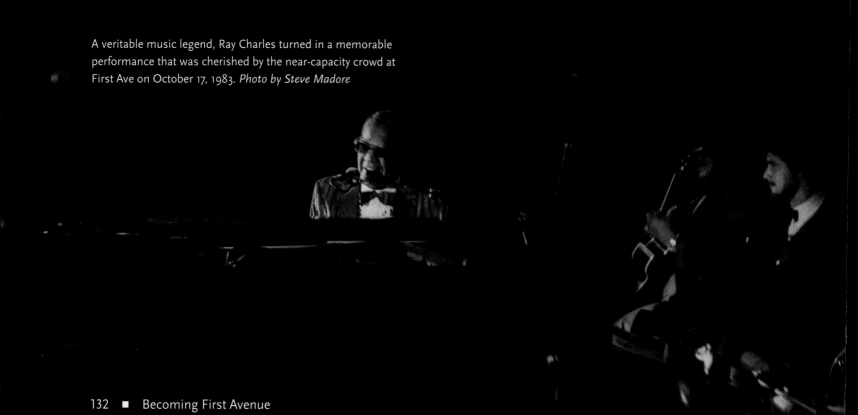

A veritable music legend, Ray Charles turned in a memorable performance that was cherished by the near-capacity crowd at First Ave on October 17, 1983. *Photo by Steve Madore*

RAY CHARLES ENTERPRISES

JOE ADAMS
EXECUTIVE VICE PRESIDENT

October 20, 1983

Mr. Stephen McClellan
First Avenue
P.O. Box 3191 Traffic Station
Minneapolis, MN. 55403

Dear Mr. McClellan:

On October 17, 1983, the RAY CHARLES SHOW
'83, had the pleasure of playing an engage-
ment for you. We hope that in the future
we have the opportunity of working with
your organization again and, that all of
our future engagements are as pleasant as
the past.

On behalf of the Ray Charles Organization,
we thank you for your gracious hospitality
while we visited your city.

Sincerely,

JA/gh

Just like his fans, Ray Charles's management was apprecia-
tive of First Avenue's hospitality, sending a letter of thanks to
Steve McClellan just a few days after the concert. *Courtesy of
Chrissie Dunlap*

the legend. Falling on a Monday night amid a diverse cal-
endar that included the Time, X, Richard Thompson, the
Itals, the Fleshtones, and Jonathan Richman, the Georgia
icon drew almost fourteen hundred people with $12.50
tickets, a steep price for the club at the time. A sure sign
that the venue wasn't used to such a production: The con-
tract on file for the gig specifies three dressing rooms:
one for the Raelettes, Charles's back-up singers, one for
the band, and one for Mr. Charles. "To be figured out lat-
er," someone wrote in the margin of the contract. Soul
Asylum's Dan Murphy surmised that the Hall of Famer
played on rented gear. "They had a little electric piano
for him, and when he was playing, it was like he ran out
of keys," Murphy recalled. "It wasn't really what he was
used to."

While the set was a rather predictable run through
standards such as "Georgia on My Mind" and "Hit the
Road Jack," everyone remembers Charles being very
into it. Three days after what Roy Freedom called "an

unforgettable show," McClellan received a letter from Joe
Adams, executive VP at Ray Charles Enterprises: "On Oct.
17, 1983, the Ray Charles Show '83 had the pleasure of play-
ing an engagement for you. We hope that in the future
we have the opportunity of working with your organiza-
tion again, and that all of our future engagements are as
pleasant as the past." Take that, Carlton Celebrity Room.

Things didn't go so smoothly for James Brown or
Wilson Pickett. The Godfather of Soul arrived on Sep-
tember 10, 1984, when the mania around his pupil,
Prince, was pretty well at its peak. Once again, the club
had to come up with three dressing rooms. His backup
singers got a makeshift space near the pinball machines.
Fred Darden, First Ave's production manager, acciden-
tally walked in on them. "One of the singers was stand-
ing in her bra and panties, and she put her hand over her
head because she didn't have her wig on," Darden said.
"She was more embarrassed to be seen without a wig
than in her underwear." Later, Chrissie Dunlap walked
into the main dressing room, though in that case she was
the one caught off guard.

"That show should've been a highlight for me, but it
wasn't," she said. It was a rare case where McClellan was
out of town, so Dunlap was in charge. When the soul
legend didn't take the stage at show time, she recalled, "I
went back to the dressing room and politely said, 'They're
clapping. You gotta get onstage now.' He said, 'Give me a
thousand dollars, and I'll go on.' I said, 'No, your agent
got the fifty percent deposit, I'll give you the other fifty
percent when you're done, as per your contract.' He said,

> "That show should've been
> a highlight for me, but
> it wasn't."
> —Chrissie Dunlap, booker,
> on James Brown

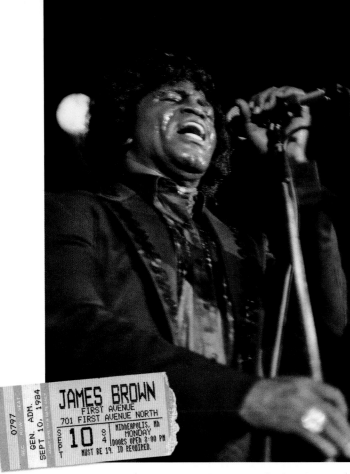

James Brown squeezed the club for extra cash when he played the Mainroom in 1984, but he also squeezed a lot of soul into his performance. *Photo by Tommy Smith III; ticket courtesy of Michael Reiter*

of his deeper cuts, "I Found a Love." After sound check, Almsted sought out the Detroit-bred powerhouse to ask his permission. He found him in a little-used side room at the club "where a lot of secret stuff happened."

"I knocked on the door, and he yelled, 'What you want?!' I opened the door, and there was a rope strung from side to side, with a sheet over the rope and a light on in the back, casting these sort of dramatic shadows. He was smoking a crack pipe and getting a blowjob. When you see the shadow of this, the shadows are bigger than the people. It was like a performance art piece." Almsted says that scene is "indelibly etched" on his brain, but the night wasn't over.

Sometime between sound check and show time, Pickett made his way back to his hotel. There was no sign of him at the 11:00 PM show time, so Dunlap and a friend went to find him. "We went and pounded on his hotel room door," she recounted. "Finally, this woman answered the door, and she and Wilson are in there smoking crack. I said, 'I'm with the club, and we've got a sold-out crowd there waiting. We've got a car and you have to come right now.' It took us a half hour to get him to the car. I was so stressed out. I was the one that had pushed for this show."

Amazingly, Pickett pulled through in the end and delivered a solid performance. "His set was so fucking great, I couldn't believe it," recalled Almsted. Dunlap agreed, but noted, "it's so disappointing to meet your hero in a situation like that." Pickett did manage to conquer his demons before his death in 2006, but not until after he missed his Rock and Roll Hall of Fame induction in 1991 and did a jail stint a few years later.

In contrast to those R&B-infused rock heroes, Tina Turner was enjoying an unparalleled career comeback when she returned to the venue for what would be her last time, on August 1, 1984. Just as her single "What's Love Got to Do With It?" rose to the top of the charts, almost sixteen hundred fans packed the club, and the songs from the *Private Dancer* album sounded as good as they would in arenas a year later. Turner did take the stage late, but unlike in 1971, the delay was certainly excusable. According to staff, the glamorous diva had to

'Give me a thousand dollars cash or I'm not going on. I want ten hundred-dollar bills.'"

She knew better in later years, but with the packed crowd starting to get antsy, Dunlap did as he wished. "As I gave it to him, I said, 'We sold this out. You're going to put on a great show now, and this will be your fucking bonus.' I said, 'I won't call it a shakedown. I'll call it a bonus.' And he did put on a great show. He earned his bonus."

A month later, Dunlap had an even more disheartening experience with another of her heroes, Wilson Pickett. The personal life of the singer of "Mustang Sally" and "In the Midnight Hour" had been in a downward spiral for many years, and he was still far from recovery when he arrived in Minneapolis on October 8, 1984. Curtiss A, also a big fan, jumped at the chance to open the show. He had plans to impress his idol by covering one

use the restroom (and not just to tinkle), but the dressing room still did not have a toilet. She refused to fight her way through the crowd to use the public ladies' room. An ice cream bucket reportedly was procured, and the room cleared for privacy. In what may be the most bizarre bit of lore shared amongst the club's alumni, rumor—and let's pray it's just rumor—has it that the lidded bucket and its contents were taken home by an employee and preserved as a museum piece of sorts.

By the mid-'80s, the black paint that covered First Avenue's walls was also a wardrobe color of choice at many concerts. Metal and hardcore punk shows weren't the easiest to pull off. They usually had to be all-ages, which meant less bar profits, and the crowds sometimes got unruly amid all the moshing and headbanging. However, the tickets usually sold well. Metal shows, in particular, seemed to have a consistently solid audience. While the era's more hair-sprayed, spandex-clad, MTV-oriented metal bands headlined bigger venues, most thrash groups of note that rose up in the '80s made their way to First Ave. Among the metal heroes on the calendars in that span were all of the so-called Big Four—Metallica, Slayer, Anthrax, and Megadeth—plus Motörhead, Samhain, Saxon, Armored Saint, the Plasmatics, Corrosion of Conformity, Metal Church, and Overkill.

Among hardcore and thrashier punk bands, Black Flag, Bad Brains, Fear, the Minutemen, the Misfits, and D.O.A. played the club early on; later in the decade, it was the Descendants, Circle Jerks, G.B.H., Discharge,

Slayer rocked the Mainroom in November 1986 in front of a head-banging crowd that was becoming increasingly present at the venue. *Photo by Daniel Corrigan*

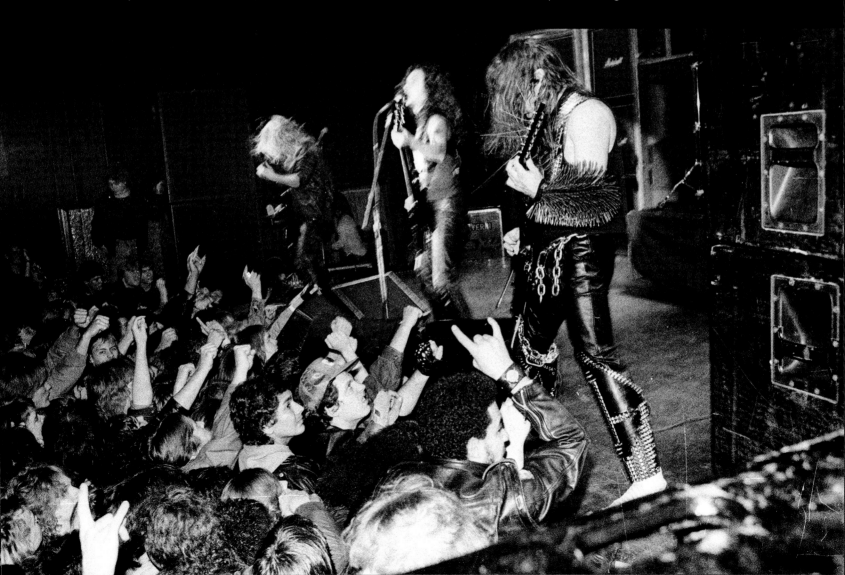

the Cro-Mags, Milwaukee's Die Kreuzen, the Vandals, T.S.O.L., Suicidal Tendencies, D.I., D.R.I., Flipper, the Meatmen, and Fugazi. For many '80s teenagers, the metal shows and especially those hardcore gigs became the gateway drugs that got them hooked on the dark and dingy venue, especially late-afternoon matinee gigs in 7th Street Entry. "Probably the first twenty times I went, if it said doors at four o'clock, I'd get there at three-thirty," said Craig Finn. Arzu Gokcen of the Selby Tigers and Pink Mink said, "It was like scary and thrilling at once when you were that young. And all the bands seemed good." Among local acts, Powermad, Impaler, or Slave Raider often got tapped to open for the touring metal bands; Outcry, Final Conflict, Blind Approach, or the Libido Boyz supported the punk headliners. "I was of the generation that was forced to sit through the Libido Boyz in order to see any national band I liked," MTV news editor Jessica Hopper once told *City Pages*. St. Paul fan John "Spitball" Pierson, later of the poorly named Cribdeath, remembered the Boyz's many appearances more fondly.

Among the international alphabet soup of punk bands to play the Entry in the '80s were the Dutch hardcore punkers B.G.K. *(left)*, the Vancouver-based D.O.A. *(center)*, and the influential British street punks G.B.H. *(right)*. *Photos by Lori Barbero*

"At the time, they were blowing away every band that came through," he said. "That's a band that their recorded output never ever did justice to them."

One of the first of the hardcore Mainroom shows was a March 18, 1982, appearance by Los Angeles's brawny and boneheaded troublemakers Fear, led by future *Flashdance* actor Lee Ving. Martin Keller's review in *City Pages* recounts Ving teasing and "having a ball with a sea of skinheads in Hüsker Dü T-shirts," and later chasing down a guy in the crowd who was recording the show on a portable Sony tape recorder. Ving came at him "with the kind of manic zest only a football coach could love, chased the spud across the rear end of the club, made a diving tackle and ripped the tape outta the deck, slightly cracking the little Sony."

Before those hardcore matinee shows, Black Flag played 7th Street Entry twice in 1981. Though the gigs were just over a month apart, the band changed singers in between. A long-haired Dez Cadena fronted the band on June 26, 1981, their second Twin Cities appearance, after a Longhorn bar show in 1980. "That was the first time we saw full-scale slam-dancing in the Entry—which was always just so stupid in that room, because it's too damn small," remembered Billy Batson, who worked sound that night.

SAT.
FEB. 14

HENRY ROLLINS

7th ST. ENTRY

(Left) At Black Flag's Mainroom show on October 3, 1984, a woman in the front row got a little too up close and personal with Rollins and pulled down his black shorts. Photographer Tommy Smith III captured Rollins fully repantsed. *Photo by Tommy Smith III.* (Above) Black Flag's last appearance in the Twin Cities with Henry Rollins was on June 11, 1986, but Rollins returned to the Entry eight months later for a Valentine's Day spoken-word gig. *Courtesy of the Museum of Minnesota Music*

A couple weeks later, in Washington, D.C., a scrawny twenty-year-old Henry Rollins got onstage with Black Flag and made a lasting impression singing just one song. A few nights later, Rollins joined the band as a roadie and worked his way up to full-time vocalist as Cadena willingly stepped aside to play rhythm guitar behind bandleader Greg Ginn. The band hit the Entry again in late July as it made its way back to California, where they would record the legendary album *Damaged*. When he returned to First Ave in 2003 with the Rollins Band, Rollins claimed that that 1981 Entry gig was only his second show as lead screamer. He remembered Ginn being sick and "vomiting after every song," which he said, "set the tone for the rest of us . . . the show will go on."

Black Flag also played Duffy's and Goofy's Upper Deck locally, and in 1984, they moved up to the First Ave Mainroom during the *Slip It In* tour. During the two sets

on October 3, the show-must-go-on mantra was tested again in a whole other way. By then Rollins had begun the transformation to his signature buff, muscle-bound look, and he took the stage in skimpy black shorts and a bare chest. A young woman who was pressed up against the stage tugged his shorts partially down and got a warning. She persisted, pulling them all the way down a few songs later. "He's standing there with his dick hanging out, and asks her something like, 'Who raised you?'" Batson recalled. Others remember something more suggestive, like "What are you gonna do now?" The club's famed house photographer, Daniel Corrigan, has photos from that 1984 show (shorts on) and later got Rollins to pose for one of his favorite portraits when Black Flag returned one last time to the club on June 11, 1986. After that, the singer regularly came through with the Rollins Band.

Two of the bands that recorded for Greg Ginn's label

SST Records, the Minutemen and Meat Puppets, were on tour together and played the Entry in 1984. Kevin Bowe remembered the Minutemen "came out and were playing really, really well when D. Boon fell down on his butt right in the middle of a song. But he kept right on playing and at the end of the song Mike Watt reached his big arms around him and just pulled him right back up on his feet. Then Watt says into the mic, 'D. Boon! D. Boon takes a tumble,' and it was just the sweetest thing I've ever seen."

Rollins's fellow D.C. hardcore punk pioneers Bad Brains had had a dubious intro at the club with the incident in 1982 at Grant Hart's home, but their handful of subsequent shows have a legendary reputation. Led by Rastafarian howler H.R. (Human Rights), they came back in July 1983 in support of their Ric Ocasek–produced *Rock for Light* album. "That was fucking nuts," remembered Soul Asylum's Dan Murphy, "H.R. was just out of his gourd." By the time Bad Brains returned in October 1986 supporting *I Against I*, reggae was infused more heavily into their fast and furious sound. "They were doing the super fast and wild Bad Brains thing, which just rocked," remembered Mark Dueffert, one of the teenage fans in attendance, "and then all of a sudden they slowed it down and were doing reggae covers of the Rolling Stones' 'She's a Rainbow' and a Beatles song. All these punk rockers going crazy in the mosh pit didn't really know what to do with that."

In a lot of cases, punk and thrash metal fans spilled into the same show, though not always peacefully. When Megadeth first played the club on August 3, 1986, Fred Darden recalled, a bunch of hardcore punk fans turned out for an opening act he couldn't remember. "One kid kept making fun of Dave Mustaine," Darden said, and the bandleader finally broke. "He points to the kid and goes, 'Get him!' We had to pull the kid onstage to save his life." Future Black Keys tour manager Jim Runge recalled "a lot of fights" when his fellow Wisconsin punks Die Kreuzen earned a Mainroom opening slot for Motörhead in December 1985. "It was before metal kind of took up slam-dancing, so they had kids slam-dancing and the metal guys just wanted to head bang."

Bad Brains played First Avenue on multiple occasions during the early and mid-'80s. Hüsker Dü (1982), Soul Asylum (1986), and Blue Hippos (1987) were among the local acts to open for the D.C.–based punk pioneers. *Flyer courtesy of the Museum of Minnesota Music; ticket courtesy of Michael Reiter*

In August 1983, not long after changing its name from Loud Fast Rules, Soul Asylum also landed a warm-up gig for Motörhead, whose famously haggard frontman Lemmy Kilmister was surprisingly nice to the less-than-metallic local kids. "We got to go back and hang with Lemmy," Dan Murphy remembered, laughing at the memory of bandmate Karl Mueller's unusual wardrobe choice that night: bright orange seersucker shorts. "Lemmy was giving him shit: 'Your shorts are fucking blinding me!'"

Hanging out with Lemmy would remain a common occurrence at First Ave in the coming decades. The metal icon usually stuck around the club for the four or five hours between sound check and show time, rather than retreat to a hotel or tour bus. He'd frequently be seen lurching over a pinball machine or seated at a bar stool with a glass of whiskey. On one rare occasion in the late

Motörhead's Lemmy helped to usher in the metal era at First Avenue in the '80s, and the band continued to play the club into the next millennium. They made a somewhat odd pairing with southern-infused rockers Supersuckers and Nashville Pussy in 2000. *Photo by Daniel Corrigan; flyer courtesy of Minnesota Historical Society Collections*

'80s—most likely the triple bill with Slayer and Overkill on November 21, 1988—Lemmy did leave before a gig and couldn't figure out how to get back into the building. The hulking rocker started banging on one of the front doors and accidentally smashed right through the glass. "He was super apologetic about it," Steve Mc-Clellan noted. Working as a production manager in the mid-'80s, Maggie Macpherson no doubt put up with a lot from hyper-masculine metal bands, but she didn't mind it so much when the Motörhead frontman playfully picked her up and planted a full-on kiss. "It was amazing," she gushed, adding with a laugh that her boyfriend at the time, Suburbs drummer Hugo Klaers, also saw it as something to brag about. One thing *everyone* on the production crew remembers about Motörhead shows: The fine art of arranging the band's arsenal of sound gear, which included wrapping large amplifier stacks in a horseshoe configuration behind the band. Said Fred Darden, "They had more PA onstage for monitors than they did for the audience. But Lemmy was such a nice guy, we never complained."

Motörhead set the stage for an underground metal wave that peaked with Metallica on February 6, 1985. The San Francisco quartet had been newly signed by Elektra Records but was technically still an indie act, touring behind its second album, *Ride the Lightning*. The show kicked off same as the record, with "Fight Fire with Fire" and the title track. Interestingly, the band skipped the best-known cut, "Fade to Black," for older songs such as "Seek & Destroy," the encore finale "Motorbreath," and bassist Cliff Burton's showpiece "Anesthesia (Pulling Teeth)."

Lori Barbero was at the show and has fond memories of Burton, who died a year later in a bus accident. "He was just an awesome bassist, but also a lovable guy to watch, really joyful about playing," she recalled. His band topped the bill over the more veteran and showy W.A.S.P., with Armored Saint as the opener. Darden recalled the contrast between the first two bands and the headliner: "Armored Saint had these scary costumes and big stage props, like a heaven's gate kind of thing. And W.A.S.P. had a giant skull onstage and red leather costumes. I thought it was laughable [how] they were trying so hard to be scary, and then Metallica came out in jeans and T-shirts, and I said, 'These guys are actually scarier.' It was a very good show."

That concert stood out for Metallica, too. In 2004, they picked 7th Street Entry as the one place in the country to host a signing for their coffee-table book, *So What! The Good, the Mad & the Ugly*. About a thousand ticket-holding fans lined up starting around midnight,

Metallica guitarist Kirk Hammett hams it up for amateur photographer Lori Barbero, who captured the metal icons from the side of the Mainroom stage in 1985. *Photo by Lori Barbero*

following the band's Xcel Energy Center concert. Lead guitarist Kirk Hammett said after the signing, "It was cool to do it here, somewhere from our past, instead of Barnes & Noble or wherever." In 2016, when the band headlined a concert at the new U.S. Bank Stadium, they made T-shirts that listed all their Minnesota shows, starting with the 1985 gig.

Pressed for memories of that local debut, Lars Ulrich said, "Minneapolis was always kind of isolated—a big distance between here and the East Coast and West Coast—but back then, there were certain pockets in the middle of the country that were more progressive and more ahead of the curve musically, and this was one of the big ones. That venue was a big reason why. Not a lot of venues like it have been around that long with that much history."

As the '80s wore on, many of the local bands who rose in stature along with First Avenue started to wear out. Hüsker Dü began 1987 strong with a three-night stand in the Mainroom, from March 30 to April 1, behind its second album for Warner Bros., the double-LP set *Warehouse: Songs and Stories*. But when the trio returned for two purposefully downsized Entry shows on December 3 and 4, "things were just kind of off," remembered Barbero, who had been to nearly every show the band played in either of the club's rooms. "You could kind of tell it was going to end," she said. The band broke up a month later.

The Replacements went a full year and a half without playing a hometown gig after the firing of Bob Stinson early in 1986. Stinson himself became more of a fixture in the club once he was out of the band, at least for a little while. "My Bob and Bob Stinson essentially traded jobs," noted Chrissie Dunlap, whose husband Bob "Slim" Dunlap had been a First Ave janitor before joining the Replacements on guitar, at the recommendation of Stinson. Chrissie and Steve McClellan gave the troubled ex-Replacement a job as a janitor. However, it proved to be an ill fit for Stinson, who battled alcoholism and drug addiction for many years before he died of organ failure in 1995. "I had to keep my eye on him, because it wasn't really a good idea to put that guy to work at an open bar," Chrissie solemnly recalled. "We tried, but I'd constantly find him behind the main bar upstairs. I'd say, 'What are you doing?' He'd say, 'Cleaning!' We had to fire him. It didn't last long. We tried, though. Bob and I always adored him." She added, "People think there must've been some animosity, but Bob Stinson was never mad at Bob Dunlap. They were very good friends."

Bob Dunlap did get a little mad, however, when the Replacements finally returned to First Ave with him in tow but resorted to their old ways. They played two warm-up shows with the new guitarist in the Mainroom two weeks apart in May 1987, just a few weeks after the release of the *Pleased to Meet Me* album. The first, on May 13, found them well under the table before they took the stage, where they cut many songs short. The second, an

all-ages May 27 show, had them drinking enough to make up for underage fans in attendance and throwing out such random cover songs as "Born in the U.S.A.," "Iron Man," and the Shirelles' "Dedicated to the One I Love." "Bob was really bummed out that those guys chose to get so drunk and fuck it up; he never went along with that," Chrissie Dunlap recalled in 2015, when Westerberg and Tommy Stinson were earning high marks for their reunion shows. "The band that they are now, that's the band he wanted to be in—tight, professional, but very soulful."

Maggie Macpherson, who quit working at the club in 1985, said some of the staff and regulars tried too hard to wave the underground freak flag as the decade wore on: "I remember when everyone started saying Soul Asylum had sold out, or Hüsker Dü. Even the Replacements. It usually was within a year of them signing their first album deal. It was a period of time where people were holding on so strongly to the alternative lifestyle, alternative music. It was really hard for them to let go of it and see people doing well." Before too long, though, the alternative became mainstream, a fact reflected in the club's calendars from 1987 to 1989, which feature such names as Jane's Addiction, the Pixies, Soundgarden, and Nirvana for Entry shows.

Before that wave of alt-rock took hold, Chrissie Dunlap used her position to champion one last Minnesota band that would get a major-label record deal by the end of the decade—though with a sound that eschewed the grungy rock flavor of the day. The Gear Daddies got their start playing main-street bars and VFW halls around southern Minnesota and in their hometown of Austin, Minnesota—also the hometown of Hormel and its iconic canned meat, Spam. The Gear Daddies' traditional country influence and small-town heartland vibe was to Dunlap's liking, as was the fact that they were simply nice guys. "I just thought Martin [Zellar] was a really good songwriter, and they were a very reliable band," Dunlap remembered.

The Daddies were part of what could be pinpointed as the pinnacle of the New Band Night showcases, appearing on a New Year's Eve 1986 lineup that also featured Trip Shakespeare, Run Westy Run, and the Blue

Bob "Slim" Dunlap (right) replaced Bob Stinson as the Replacements' guitarist alongside Paul Westerberg in 1986, just after the band made the leap to a major label. They continued to play the club that helped establish them as local, if nationally underappreciated, indie-rock darlings. *Photo by Daniel Corrigan*

Up? with Ana Voog. "That was a good year," New Band Night host Billy Batson confirmed modestly. The preview blurb in *City Pages* didn't overstate it, either: "This is definitely the place to be for those in the local musical know," it read, noting that Trip Shakespeare also had to play an opening slot with the Suburbs at the Cabooze earlier in the night. "I really genuinely loved all those bands," said Trip bassist John Munson, whose bandmate Dan Wilson remembered, "Run Westy Run blew me away that night, and the Gear Daddies we already knew were great."

After that, the Daddies became a frequent opening band at First Ave for a variety of acts, from bluesman Clarence "Gatemouth" Brown to numerous twang-rock acts such as Rank and File and even a novelty hip-hop act from Brooklyn. "I shit you not, they even had us open for the Fat Boys," Martin Zellar remembered. "We were there so much—and we were relatively easygoing—we just became their go-to band for a while." The singer/songwriter singled out Chrissie Dunlap as "right up there with David Letterman for making things happen for us,"

COMEDY CLUB

Louie Anderson gave his last performance as a Twin Cities resident there. Tom Arnold thinks he did his first line of cocaine there. And Lizz Winstead gave her one and only peep show there. They might be footnotes in the context of all the rock legends that rolled through the club, but those three renowned comics used First Avenue to prop up their stand-up careers.

Anderson was well on his way on the stand-up comedy circuit when he made a few appearances at the club in the early '80s, first at Sam's and then after it became First Avenue. His "Comedy After the Bomb" show on July 28, 1982, was his farewell gig before heading to Los Angeles, where he landed his breakout *Tonight Show* slot within two years.

Around that same time, Tom Arnold moved to Minneapolis from rural Iowa to launch his comedy career. "I would open for Big Country, Hüsker Dü, or whoever, I didn't care," said Arnold. "Even if I got onstage for five minutes and had people booing because they only wanted the music, that was still great by me." Arnold landed those opening slots at the club after he became good friends with several members of the staff, especially Steve McClellan. Said the comic, "I loved being there. I loved going up to Steve's office after a show, maybe for drinking and maybe other things." Some of those "other things" would be chronicled by David Carr in his memoir about addiction, *The Night of the Gun*. The *Twin Cities Reader* editor and future *New York Times* columnist shared Arnold's love for music and for partying. And First Avenue, said the comic, "was the place for both."

(Left) Comedians have been taking the stage at First Avenue for decades. Louie Anderson first performed there when the club was known as Sam's. *Photo by Steven Laboe. (Above)* A flyer for 7th Street Entry's Comedicus Spasticus series, featuring Liz Winstead (back when she spelled her name with just one "z"), Phyllis Wright, Joe Lyon, Tom Arnold, Harmon Leon, and Mike Gandolfi. *Courtesy of the Museum of Minnesota Music*

Arnold eventually partnered with Winstead as co-hosts of a Wednesday-night comedy series in 7th Street Entry billed as Comedicus Spasticus. Both comics cited that series as pivotal to their early careers. "They did a good job, and it went over fairly well," McClellan remembered. Said Arnold, "I remember trying a whole bunch of stuff those nights. I was kind of insane there."

Thirteen years before she helped create *The Daily Show* for Comedy Central, Winstead earned what she thought was her first big break—but she also nearly broke her neck instead, and certainly put a dent in her pride. In 1983, the Minneapolis native landed hosting duties for the finale of the Great Pretenders, First Ave's weirdly and wildly popular weekly lip-synching contest.

On the night she hosted the big event, Winstead hoped to impress the sold-out crowd and especially one of the contest's judges: Prince protégé Vanity. "I wanted to wear something provocative, punk rock, sexy, feminine, glamorous, and lightweight," Winstead

wrote in her 2013 book, *Lizz Free or Die*. "Naturally, I chose a ragged old 1950s wedding dress I found at the local thrift store Ragstock." The air-conditioning in the club had gone out that particular hot August night, however, and so she stripped out of her tights and underwear, hoping the audience couldn't see through her dress in the stage lights. Unfortunately, the audience soon saw a whole lot more when her dress got snagged on the screen at the front of the stage just as it was raised up to make way for the performers. The dress went up over her head, and Winstead herself was lifted a few inches off the ground. As she put it in her book: "I was hanging from the screen, trapped with my vajesus exposed to God and Vanity and everyone in the club." That moment alone should have earned Winstead a star on the club's wall. ∎

(Left) Comedian and writer Lizz Winstead onstage emceeing the 1990 Jammi Awards. *Photo by Jay Smiley. (Above)* Five years before creating the cult-favorite *Mystery Science Theater 3000* television series, Joel Hodgson performed stand-up in the Mainroom on August 1, 1983. *Courtesy of the Museum of Minnesota Music*

Indicative of the eclectic bookings under Chrissie Dunlap's watch, the April 1986 calendar alone included international R&B legend Bo Diddley; the Georgia-based electro-funk SOS Band; heavy-metal icons Anthrax and Ministry; American hardcore punk pioneers Circle Jerks; and the Latin-tinged dance/pop ensemble Kid Creole and the Coconuts. The Entry, meanwhile, showcased the heyday of local bands: the Gear Daddies, the Magnolias, Run Westy Run, the Blue Up?, the Clams, Soul Asylum, and more. The Mainroom also hosted wrestling and a variety of dance nights. *Courtesy of Chrissie Dunlap*

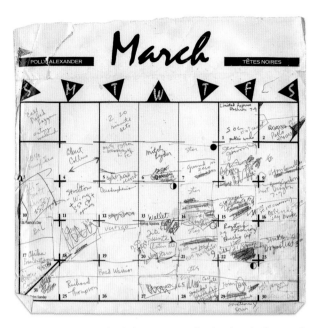

Chrissie Dunlap's scheduling process had a decidedly DIY flavor, but the results cannot be denied. *Courtesy of Chrissie Dunlap*

referring to his 1991 appearance with the late-night TV king. "She was a hero to a lot of bands in those days." Pioneering punker Chris Osgood concurred: "Chrissie deserves a big part of the credit for bringing in a lot of the bands that played there, but more so for being a big part of the chemistry that made that place go. The things she did allowed Steve to do what he did, but at the same time she also kept him on the reservation, as they say."

By 1988, though, Dunlap was not as highly regarded within the club's staff hierarchy. As her husband hit the road with the Replacements, the demands on the home front increased with their three kids, but she said she dealt with it like any working mom. McClellan, meanwhile, brought in a young new talent buyer, Rich Best, who was more clued in than both of his predecessors to the alt-rock bands coming into vogue. Dunlap admitted she had probably bumped heads with McClellan one too many times by then. "Steve essentially forced me to

quit, based on pressure from some of the younger people that resented I had the best job there," she claimed. "I got to choose bands and make the guest list, but then they didn't see me around there at night. Steve said I needed to be there more at night. He told me my new hours were from noon to close. I said, 'Steve you know I'm not going to do that. I have three kids at home.' I said, 'You want to fire me, don't you?'"

Dunlap took solace later, she said, when she found out three people were hired to do her job: "Someone to handle tickets, handle calendars and promo, and handle some of the booking," she said. "People were amazed later on I did all that myself." Two and a half decades later, she looks back proudly on her nine-year run at First Ave. "I don't think there was a better decade to be there, to be honest," she said. "No matter what you think of Steve personally, you can't deny he put that club on the map and made it what it is today. He took so many chances booking acts. And then to see a lot of them, especially the local bands, being recognized nationally at the same time, that was pretty incredible. Those were *our* bands. It was a thrill. And of course, it didn't get any more thrilling than what happened with Prince." ■

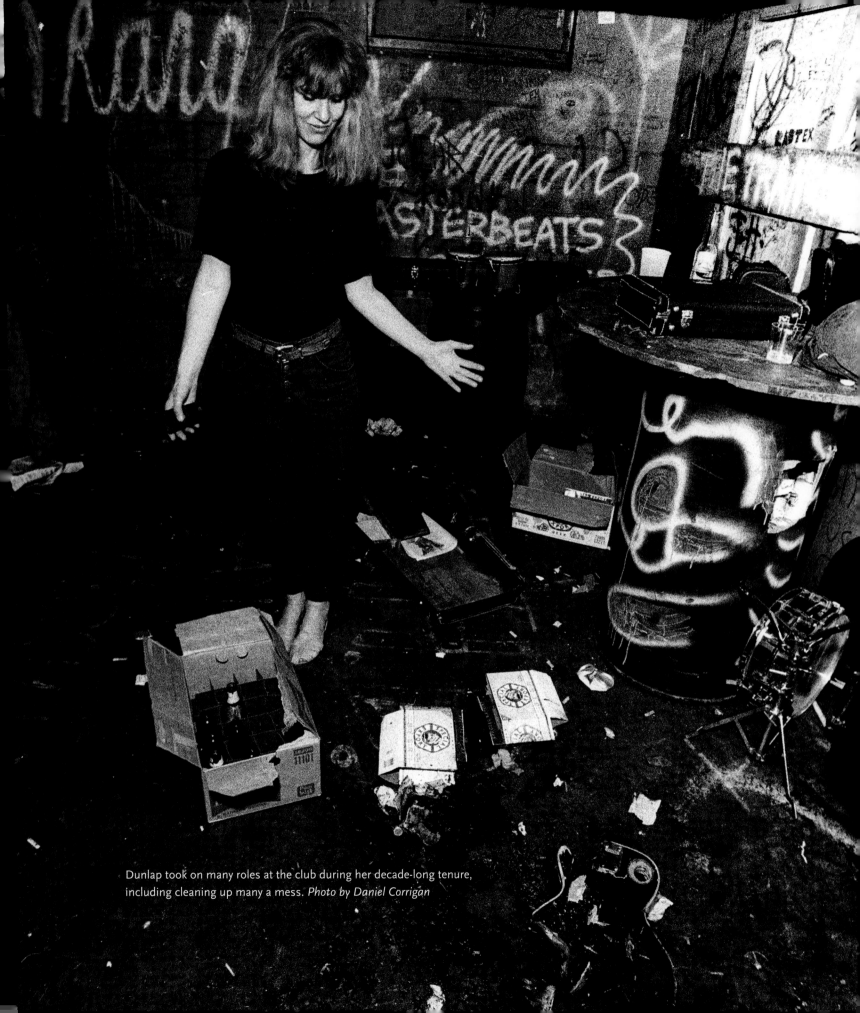

Dunlap took on many roles at the club during her decade-long tenure, including cleaning up many a mess. *Photo by Daniel Corrigan*

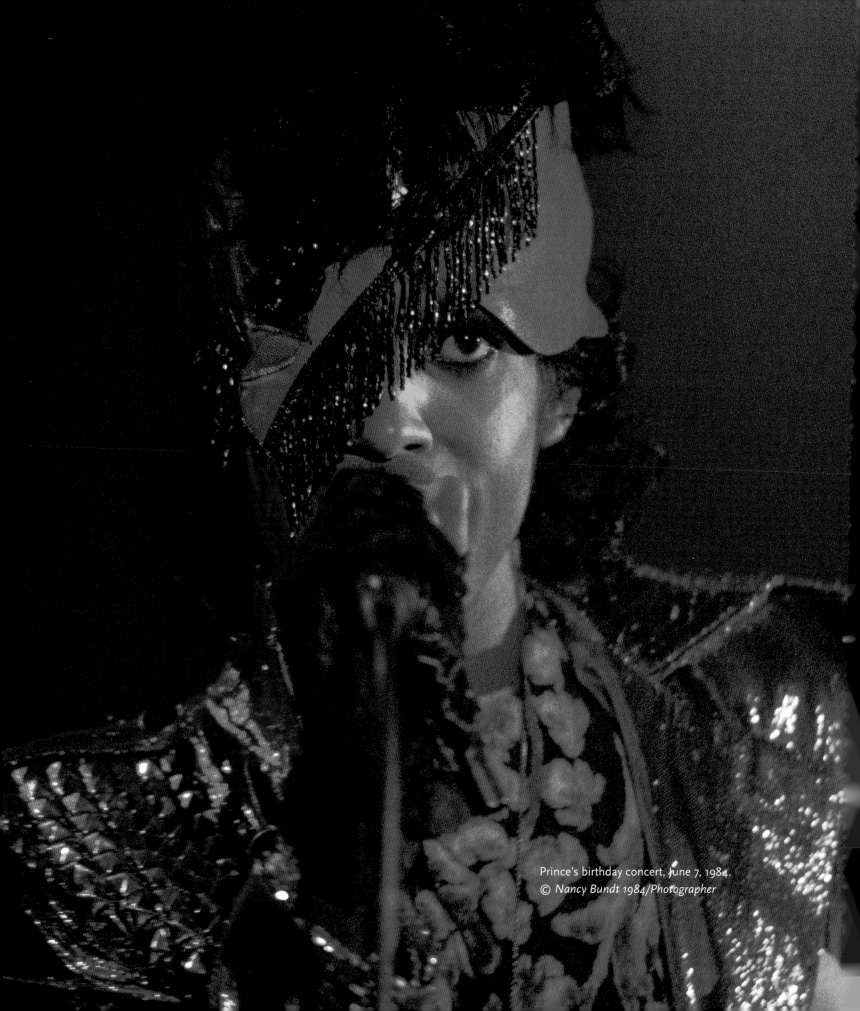

Prince's birthday concert, June 7, 1984.
© Nancy Bundt 1984/Photographer

PRINCE'S REIGN, PART 2

1983–1987

"When the film came out, a lot of tourists started coming to First Avenue. That was kind of weird, to be in the club and get a lot of, 'Oh! There he is!' I'd be in there thinking, 'Wow, this sure is different than it used to be.'"

—PRINCE, *ROLLING STONE*, SEPTEMBER 12, 1985

The letter is dated September 22, 1983, with "Purple Rain" across the top in a font that suggests a superhero movie. Next to the title are the names "Cavallo, Ruffalo & Fargnoli," written out like a law firm's name. Underneath are the address for the Holiday Inn Airport #2 in Bloomington and a phone number for the "production office." Addressed to Stephen T. McClellan and First Avenue, the letter introduces itself as "a standard form location release" and offers a few pleasantries about a "very productive meeting" that happened earlier. Then it gets down to "the main points of our agreement," a list of five bulleted items that includes:

■ Your club would be closed and available to us from Friday morning, November 26, to Tuesday, December 20, for dressing, filming and strike during our filming of "Purple Rain."

■ We agree to pay you, 1st Avenue and 7th Street Entry Club, $100,000 (One Hundred Thousand Dollars) as location fees and rentals, thereby covering standard continuing costs for the club and an estimated loss of profit for the club during that period.

■ We will work in close cooperation with you in regards to the publicity and public relations, showing you and the club to be aiding us in the filming of "Purple Rain" and we will work to aid you in showing that the club is an ongoing operation with great entertainment completely independent of Prince.

"We didn't realize then how great a deal they gave us," said the recipient of that agreement, Steve McClellan. "They built us a bigger stage, which was a big thing. We got new [stage] lights out of it, too." That stage is for the most part the same one used today. And let's hope it always will be.

Of course, the biggest takeaway for letting the *Purple Rain* filmmakers take over the club for a month wasn't the new stage or lighting, or even the $100,000. It was the fact that by the end of the following summer—and well into the next millennium—Prince fans and musicheads around the globe not only would know First Avenue, but many of them would think of it as something of a promised land.

In the months after *Purple Rain* hit movie theaters in July 1984, media outlets regularly flocked to the venue, filing Prince stories on a weekly basis. Fans from around the world kept coming even after the media left—in numbers large enough to make it Minnesota's top tourist destination in the latter half of the decade. For years, the

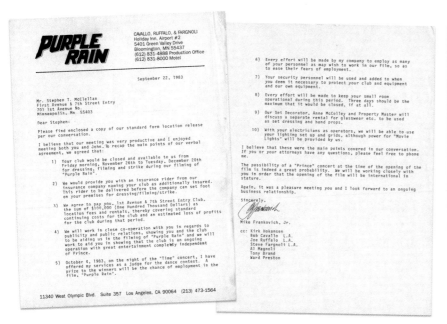
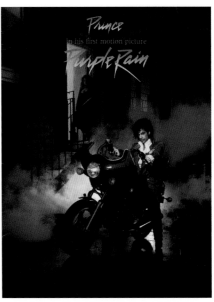

(Above left) Letter, dated September 22, 1983, from the firm of Cavallo, Ruffalo, & Fargnoli to Stephen T. McClellan outlining the agreement to close the club from November 26 to December 20, 1983, for "dressing, filming, and strike during our filming of 'Purple Rain.'" *(Above right)* Brochure promoting the release of *Purple Rain. Minnesota Historical Society Collections*

club's office line would ring or a car would pull up from out of town with someone wanting to get a demo tape to Billy Sparks. "He doesn't work here anymore," was one of the snarkier responses offered by a club staffer. In reality, Sparks is a real guy who worked on Prince's road crew in the '80s, but he never owned or even worked at First Ave, as is portrayed in the movie.

One myth that does hold up: First Avenue likely would not be here today without the influx of revenue that Prince mania brought to the club beginning in 1984. Up until then—four years after the American Events/ Uncle Sam's corporate regime ended—the venue was still struggling to pay its bills. "*Purple Rain* kept us going," confirmed the club's true owner, Allan Fingerhut. "We went from lean to thick quickly after that. Those were the years I handed out bonuses. We were finally doing well."

However, the "*Purple Rain* effect" also had its downside, at least in the eyes of McClellan—yet another example of how it was never about making money for the club's longtime manager. "We lost our innocence in a way," he said. "Before that, nobody really knew who we

were or what First Ave was all about, outside of our little world of misfits and outcasts. We could always kind of do whatever we wanted. After *Purple Rain*, everybody knew about us. We lost control of it then." He also believes that the other music acts at the club suffered a bit by taking a backseat to "His Royal Badness." "The crowds didn't care who was onstage," he continued. "They only cared about whether or not Prince was coming in that night."

Prince apparently never entertained thoughts of filming the performance scenes anywhere but the club. "There was never any doubt that the music [in the movie] would be at First Avenue, as far as I know," said Bobby Z. "The story is about Prince, Apollonia, Morris, *and* First Avenue, you know, by using this club as some sort of mythical land [where] bands became famous. First Avenue was put on the map by Prince telling this fairy tale about this battle of the bands that made the place mythical."

Everyone who was there for the filming in the winter of '83 remembers three things: 1) how cold it was outside; 2) how early the call times were; 3) and how much the lip-synched performances looked like the real thing. That first memory is not an exaggeration: Weather

records show an average daily low temperature of minus three degrees Fahrenheit and not a single day in December above freezing, which is harsh even by Minnesota standards. The low fell to minus twenty-nine degrees on the coldest day of the month, December 19, when filming wrapped.

The early call times weren't exaggerated, either. As Wendy Melvoin told the *Star Tribune* in 1984, "Lisa [Coleman] and I had a condo in Edina. I remember that our call on the set was like four-thirty or five o'clock in the morning." Filming would typically last until ten at night, too. Bobby Z had an especially hard time getting to the club so early and required heavy prodding by Craig Rice, a friend of the band with Hollywood experience who was enlisted as assistant director (and later served as a tour manager for Prince). Said Bobby, "I'll never forget Craig Rice's phone calls at four AM. 'Bobby, it's Craig!' And eventually he'd have to start bribing: 'There's fried egg sandwiches and coffee if you get here.' Anything to get you to get down there. And then you're down there, and you did hair and makeup. The scene of First Avenue was completely laid out different. All of the usable space that goes back by the new bar and the pinball machines that were there in the past was all partitioned off as individual dressing rooms for wardrobe."

"We were there before the sun came up, and then it was a lot of long days of hurry-up-and-wait," keyboardist Matt Fink recalled. Not that all the waiting was a bad thing. "There were a lot of pretty extras also waiting around doing nothing," he added, "and we were young men. So you can imagine." Although he was dating his future wife, Vicki, then, Bobby Z said he didn't mind sitting around for a change, either. "I found the whole process extremely fun [after] the grinding of tours, just to have this kind of release," he said.

The band had been working hard in the months leading up to filming, going from dance workouts to acting classes to regular band rehearsals on a daily basis. Their effort paid off once they got in front of the cameras at First Avenue. Even though they were mostly miming, Fink said, "the performance scenes were essentially the real deal. It felt like we were performing. And that came

The Kid's purple suit is one of many iconic visuals to come out of the *Purple Rain* film. *Minnesota Historical Society Collections*

down to the discipline in the band, and all the work we put in on choreography and different rehearsals. And it came down to Prince's ability to express himself even just as a dancer." The band typically ran through each song three times for the cameras, and that was it. In fact, the filmmakers had planned on the performance scenes at the club taking three weeks to shoot, but things went so smoothly they were done in just ten days. "We were ready for it," Bobby Z said.

Credit should go to Prince's longtime lighting director, Roy Bennett, for making First Ave look so good in the movie. Lighting should have been the biggest challenge to filming at the notoriously dark club, but Bennett—husband of Vanity/Apollonia 6 member Brenda Bennett—used the setting as an advantage. "Roy lit it to look color rich," Bobby recalled. "Whereas the Hollywood guys were like, 'Well, this can't be just a rock 'n' roll–looking lighting set.' There was some argument. But Roy was obviously trying to do one of the greatest lighting [jobs] of all time. He had it down. Especially in 'The Beautiful Ones,' Prince is almost 3-D looking the way it comes out."

Not only did the club star in the movie, so did many of its regular patrons. Today, the extras who worked on the set of *Purple Rain* are littered all over the Twin Cities in many different walks of life. Larry Bogolub, a student at Macalester College at the time and now a kindergarten teacher in Minneapolis, saw an ad for the extras casting in the *Twin Cities Reader* placed by a talent agency. "There was a brief interview, and then they told us we would get paid forty dollars a day but the talent agency would get ten percent of that—which was a pretty good racket, since there were hundreds of us," remembered Bogolub, who worked three days of filming at the club. He said Prince "didn't even show up" one of the days, and another day a member of the film crew spent a long time coaching the crowd on how to do the "I Would Die 4 U" hand gestures. "It wasn't that complex, but they were exhaustive about it," said Bogolub, who's viewable for just a split second but considers it "a really fun memory."

Michael Provence, now a realtor in St. Paul, remembers a lot of the extras being aspiring actors and actresses who came to Minneapolis from all over, "hoping to be discovered" among the hundreds of other extras in the film's club scenes. He called his time on the set a "freaking blast. The best part was seeing and hearing all this new music that was so unlike any of Prince's other stuff. 'Let's Go Crazy'. was insane." Minneapolis singer/songwriter Katy Thomasberg shared a memorable moment from the mass casting call at the Holiday Inn in Bloomington: "The applications for the women asked for their cup size," she said. "I asked the gal who took my application if the men's applications asked for their dick size. She laughed and said I was in." Thomasberg's brother-in-law Kirk Erickson went with her and wound up with a speaking part directed at the star: He's the redhead backstage who says, "Good show, Prince."

A handful of the club's employees got hired for various runner and low-level production jobs. Those who weren't officially hired tried to stay out of it—which apparently wasn't easy. McClellan said, "[Prince's] bodyguard Chick was always running up to the office during the filming: 'Prince needs this, Prince needs that,' and sometimes it was for the smallest little thing. We definitely got to see the perfectionist/control-freak side of him during those weeks." All the more annoying, McClellan remembered, "The offices were inundated with a spastic array of 'very important' filmmakers and accessories."

At least one employee had a memorable on-screen appearance: "Ladies and gentleman . . . the Time," intones an eyelinered Joseph (Jeff) Ferraro from the second-floor DJ booth, where the VJ (video jockey) and stage technician had caught the eye of someone in the film crew—perhaps it was his long, wavy hair. Another full-time VJ, Patrick "Spot" Epstein, had a bigger, offscreen role—or rather, a role that was all about size.

"Prince [was] about half an inch shorter than me," said Epstein, who was hired as Prince's stand-in, dressing as the star and posing in designated spots for lighting tests before each scene. A trained video technician, Epstein had first met Prince a couple years earlier while the singer was hanging out at the club. Part of the then-newfangled VJ job was to splice videos together like a hip-hop DJ mashing up records. Prince apparently took a liking to Spot's skills and, subconsciously or not,

took note of his height. Flash forward to the *Purple Rain* production, a few days in: Word got out that the original Prince stand-in had been talking to press, which was strictly forbidden in Prince's camp. "They fired him," Epstein said, and "Prince personally told his staff, 'You know, hire Spot.'"

He had to arrive early for his new duties. "They had to darken my face up to make my complexion match Prince's complexion. I wore cowboy boots so I was just about the right size as Prince [in his high-heeled boots]. And I would just sit around and fucking wait and wait and wait, until the DPs [directors of photography] would tell me to stand on the A mark, B mark." Epstein served the same role during the filming of 1990's *Graffiti Bridge*; in the interim he went to work for Prince at Paisley Park and served behind the camera as the director of Prince's "Alphabet Street" video.

One local journalist, former *City Pages/Sweet Potato* music editor and columnist Martin Keller, didn't need to enlist extras to tell him about the movie shoot; he got hired as one himself. He showed up at the casting call with a plastic, illuminated purple rose for the casting director, a token of Prince fandom. It worked. His cover story for the *Twin Cities Reader*'s A&E tabloid *Nightbeat* ran in early February 1984 and opened with a description of the movie set:

> The frost was still thick on car windshields and the darkness had barely lifted on Minneapolis, but the crowd inside First Avenue at nine o'clock one cold December morning was at a frenzied pitch. Five hundred well-heeled movie extras who had been waiting since their 7 a.m. call started behaving like it was after

midnight on the dance floor. Technicians fogged up the place with a smelly kerosene concoction. "Smoke it up and react," the floor manager yelled. From the back of the stage, Prince walked forward like Charlie Chaplin in drag, his hair tussled, his made-up eyes searching the cloudy sea before him. The Prince who would be king pointed his finger toward the heavens and proclaimed, "Dearly beloved, we are gathered here today to get through this thing called life."

In the end, the movie effectively depicted the real-life experience of First Avenue. (Aside from the backstage area, which features in the movie as a large corridor lined with spacious rooms, but in reality is just a slim, one-couch room to the side of the stage.) While much of the dramatic storyline filmed outside the club—the family trauma, the love story—was exaggerated and fictionalized, the performances and other scenes at the club hewed close to Prince's own story. André Cymone said he even had a serious case of déjà vu watching the movie for the first time. Long gone from Prince's camp by then, the former bassist said he thought the diversity and overall look of the crowd in the film harked back to that first Prince show in March 1981 at Sam's. "It was funny to see it," he said, "because you could almost take the *Purple Rain* audience and that whole vibe and put it in that performance we did in [1981]. It was almost exactly the same, minus the clothes." Matt Fink believes that filming at the club brought the movie an authenticity lacking in so many other rock 'n' roll flicks. "The inspiration of performing on that stage was very real, and it helped when it came to filming," the keyboardist said. "You can see that on-screen. You wouldn't have gotten that anywhere else."

"The inspiration of performing on that stage was very real, and it helped when it came to filming. You can see that on-screen. You wouldn't have gotten that anywhere else."

—Revolution keyboardist Matt Fink

As production work on the movie and soundtrack progressed, Prince & the Revolution got back to their regular rehearsal regimen—minus the acting and dancing lessons—in the months leading up to the midsummer release of *Purple Rain*. The first single from the soundtrack, "When Doves Cry," quickly went into heavy radio and MTV rotation upon its release on May 16, 1984, and by July it was Prince's first No. 1 hit. All signs pointed to a major breakthrough. Either wanting to dust off the cobwebs or blow off some steam amid the growing anticipation, Prince threw a surprise party for himself that turned into another memorable First Ave gig.

While most of his performances at the club served the purpose of prepping for a tour or previewing new album material, the June 7, 1984, birthday concert was strictly for fun. It was advertised as a "Members First" party for the club-within-the-club, which offered, for a membership fee, special discounts and tickets (in this case, still a hefty twenty dollars). After opening with "17 Days"—the B-side to "When Doves Cry," and widely considered one of his best non-LP tracks—Prince made it clear the "in" crowd wasn't in for a hits-filled set.

"Because it's my birthday, we're just gonna get up here and we're just gonna make a little music for you to party by," he told the audience. His friendly, casual manner belied his attire, a less-than-casual ensemble—purple lamé trench coat, a purple scarf wrapped around his head, black lace covering one eye—worn by his *Purple Rain* character, The Kid. He further advised, "If y'all came here expecting to drive Prince's 'Little Red Corvette,' that's not gonna work. We're just going to play some other numbers. Some of them you'll know, but most of 'em you won't."

The only "known" songs that night were two *1999* deep cuts, "Free" and "Something in the Water (Does Not Compute)," plus the new hit "When Doves Cry," extended to a grinding, eleven-minute jam for the pre-encore finale. Otherwise, the set list was largely

To celebrate his twenty-sixth birthday on June 7, 1984, Prince put on a concert that was all about having fun, and the sold-out crowd got more than they could've asked for. *Photos by David Brewster, Star Tribune*

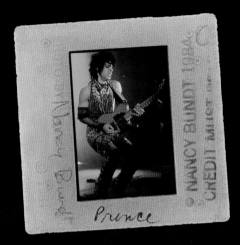

(Above) The 1984 birthday concert is fondly remembered by all who were present, and the recording of it is a coveted bootleg. © *Nancy Bundt 1984/Photographer.* (Right) The "Members Private Birthday Party with Prince" brought in more than $15,000 in admissions from 1,355 total attendees, including 515 on complimentary tickets. Steve McClellan closed his "numbers" memo by noting, "Another smoothly run party with the Prince crew." *Courtesy of Chrissie Dunlap*

devoid of tracks from the upcoming soundtrack, and Prince picked through a grab bag of deep cuts, as if intentionally avoiding the songs he knew he would be playing for the next year and a half while on tour. It included two more B-sides, "Erotic City" and "Irresistible Bitch"; and three tracks never released on record: the hyper-funky "Possessed," the moody, falsetto-filled ballad "Our Destiny," and the midtempo funk bopper "Roadhouse Garden." In addition, he covered two tunes he wrote for protégés whose albums he'd helped produce that winter and spring: the peppy "All Day, All Night" for Jill Jones, followed by the sultry slow jam "Noon Rendezvous," written for a singer in attendance that night, watching from the soundboard. "This song is dedicated to that little dame over there," Prince said as "Rendezvous" kicked in. "That's Sheila E."

A high-quality audio recording of that 1984 show has become a favorite among bootleg traders. If released as-is by Prince's estate handlers, it could become an instant classic, thanks in large part to all the rarities played. His next show, just two months later, would be far more conventional, but things changed dramatically in those months for both the musician and his hometown club. ■

1. 17 DAYS
2. OUR DESTINY
3. ALL DAY/ALL NIGHT
4. FREE
5. EROTIC CITY [NEW SONG MAYBE PIANO]
6. SOMETHING [FAN OFF]
7. WHEN DOVES CRY
8. IRRESISTABLE BITCH
9. POSSESSED
10.

Prince focused on his lesser-known repertoire for his first concert at the club following the filming of *Purple Rain. Courtesy of Chrissie Dunlap*

Even in high-heeled boots, the film's star had a diminutive physical stature. First Ave employee Patrick "Spot" Epstein served as Prince's stand-in during filming at the club, although he wore his own footwear. *Minnesota Historical Society Collections*

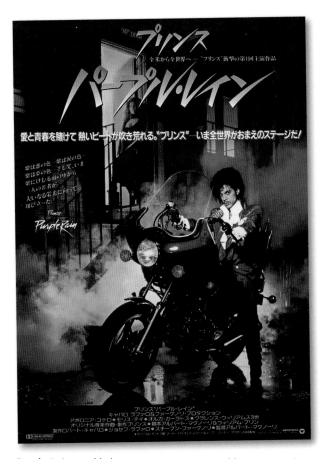

Purple Rain quickly became an international hit, raising the profile not only of Prince but of the club in lands far and wide, as evidenced by this movie poster from Japan.

When *Purple Rain* hit theaters on July 27, 1984, tickets were being scalped for twice their face value at the Skyway Theatre on Hennepin Avenue, but around the corner at First Avenue there was no formal recognition of the occasion. Warner Bros. threw a typical bigwig premier at Grauman's Chinese Theater in Hollywood, where celebrities from Eddie Murphy to Pee-Wee Herman showed up. The hoopla continued for two weeks as the movie overtook the top box-office position from *Ghostbusters*. Crowds swelled at First Ave's weekend dance parties, and TV crews from around the world showed up to get footage at the fabled venue where "The Kid" made his mark. Meanwhile, Prince and his bandmates returned home from Los Angeles to prepare for a worldwide tour unlike any they'd done before. About a week into rehearsals, they opted for something more familiar: another unannounced, last-minute booking at First Ave.

The August 14, 1984, performance was a thank-you to the club. Prince told his management he wanted to do something to counterbalance the events in Hollywood. The concert was free to First Ave members and two of their guests, and just $2.50 for everyone else. Prince did not take home any money from the show. Word spread so fast on this one, the Minneapolis police had to get involved to control the crowds outside the club.

Inside, fans were essentially treated to a test-pattern set for the upcoming *Purple Rain* tour, including the live debut of two songs off the soundtrack that weren't played the prior August, "Darling Nikki" and "The Beautiful Ones." This was an all-business type of show, as the band played at a breakneck pace with no time for playful moments. All the songs off the album—just a month and a half old—were already greeted like hits by the crowd. When he pulled out the *Purple Rain* title track for the

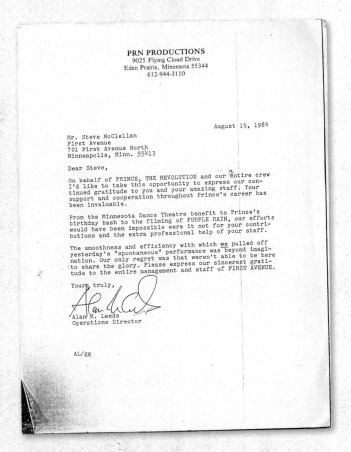

PRN PRODUCTIONS
9025 Flying Cloud Drive
Eden Prairie, Minnesota 55344
612-944-3110

August 15, 1984

Mr. Steve McClellan
First Avenue
701 First Avenue North
Minneapolis, Minn. 55413

Dear Steve,

On behalf of PRINCE, THE REVOLUTION and our entire crew
I'd like to take this opportunity to express our con-
tinued gratitude to you and your amazing staff. Your
support and cooperation throughout Prince's career has
been invaluable.

From the Minnesota Dance Theatre benefit to Prince's
birthday bash to the filming of PURPLE RAIN, our efforts
would have been impossible were it not for your contri-
butions and the extra professional help of your staff.

The smoothness and efficiency with which we pulled off
yesterday's "spontaneous" performance was beyond imagi-
nation. Our only regret was that weren't able to be here
to share the glory. Please express our sincerest grati-
tude to the entire management and staff of FIRST AVENUE.

Yours truly,

Alan M. Leeds
Operations Director

AL/gg

Following Prince's "thank you" concert for the club on August 14, 1984, Steve McClellan received a thank-you note from PRN Productions operations director Alan Leeds, noting that "your support and cooperation throughout Prince's career has been invaluable." To be sure, the value of the relationship was a two-way street. *Courtesy of Chrissie Dunlap*

In his 1984 book, *Prince: Inside the Purple Reign, Star Tribune* critic Jon Bream describes the after party at a sculptor's studio in Minneapolis's warehouse district, which drew old friend André Cymone and members of Prince's family. The all-purple décor complemented a five-tier cake with purple musical notes and piano keys and topped with a seven-inch single of "When Doves Cry." Kevin Cole and Roy Freedom spun for the crowd until five in the morning, and Prince pretty well stuck to the dance floor, "not partial about partners; every lady [got] a turn."

Bream, who also remarkably got backstage access that night, painted this picture of the scene right after the show: "No one had ever seen him smile so much onstage. Afterward, he burst into First Avenue's tiny dressing room. He was beside himself. 'These people,' he blurted out. 'They are the nicest people. They make you want to give and give.'" Despite that display of affection, Prince would not give another full-fledged concert on the First Ave stage for nearly two years.

encore, fans waved their hands over their heads during the climactic finale just like they were extras in the movie (and some, in fact, were). In the audience were members of the Cars and Wang Chung, who rushed to the club following their own concert at the Met Center. Curtiss A remembers watching the show beside a teenage Tommy Stinson near where the Cars' frontman Ric Ocasek was also standing. "We were down by where a cigarette machine used to be at the bottom of the steps. [Ocasek] was tall and lanky; he was hard to miss. He seemed to be pretty mesmerized by Prince. And after one particularly great song, Tommy says to him—like he was in the Bowery Boys or something—'Let's see you top that!'"

More than his major performances, it's Prince's brief, random onstage appearances at First Avenue that stand out in the minds of some club employees and patrons. One of Steve McClellan's favorite memories, for instance, involves Prince showing up at a May 16, 1983, Mainroom gig by Jah Wobble, best known as the bassist in John Lydon's post–Sex Pistols band Public Image Ltd. There's evidence Prince was a PiL fan, though at that point—pre-*Purple Rain*—the appreciation wasn't mutual. "Prince wanted to get onstage, but Jah Wobble didn't even know who he was," McClellan recalled. Nonetheless, Prince worked his way backstage with the Time's Jesse Johnson in tow and asked if they could get up and jam after Wobble's set using his band's gear. According to Princevault.com, Prince picked up Wobble's bass backstage, licked the E string, and said, "Nice and greasy, just the way I like it." They got onstage and did an improvised jam with Wobble's band that included part of what became "Cloreen Baconskin," a rare track issued fifteen

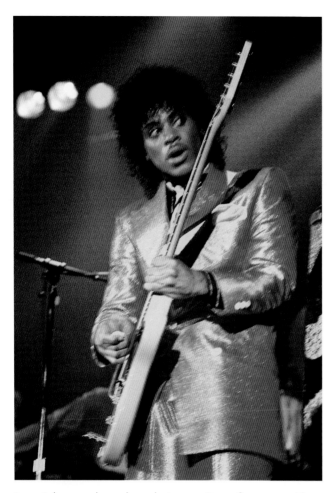

Jesse Johnson, shown here during a 1984 performance with Morris Day & the Time, played an impromptu set with Prince in the Mainroom on May 16, 1983. *Photo by Tommy Smith III*

manager Maggie Macpherson, one of the only First Ave staffers in the club at the time, said a film crew member approached her just before midnight: "We want to do like an impromptu wrap party, and [Prince] would just like to say thanks to everybody," she recalled him saying, even though they still had another week or more of work. Macpherson checked in with Jack Meyers, who told her they would charge for it like they would a private party.

"And so they stayed, and everyone was hanging out," Macpherson recounted. "About an hour or two into this party, Prince comes walking through, walks on the stage, and he sits down on the side of the stage, picks up a guitar, and he starts playing and singing. And it was the coolest thing I've ever seen in my life." Among the other witnesses to the rare solo performance was Replacements manager and Twin/Tone Records cofounder Peter Jesperson, who was in the Entry that night for a show by the Neats, friends of the Replacements from Boston. As he walked the Neats to the office to collect their payment around two in the morning, Jesperson recalled, "We heard a lone guitar playing as we went up the stairs. We looked down to the stage, and there was Prince, all by himself, legs dangling off the edge of the stage playing guitar. It was a truly stunning moment. I remember the looks on the Neats' faces very clearly. They were completely bug-eyed. One of them said something like, 'No one back home is ever going to believe this.'"

Another unsuspecting out-of-town band, the Pedaljets from Lawrence, Kansas, left with an even more impressive Prince story. They headlined the Entry the same night Sheila E. had her first headlining set in the Mainroom, on October 25, 1984. It was her warm-up gig before heading out two weeks later as the opening slot on the *Purple Rain* tour. Prince got onstage with her for one song, "Too Sexy," but otherwise let her keep the spotlight to herself. He still had an itch to scratch, though. After Sheila's set, he wandered next door with his bandmates Bobby Z and Mark Brown. At some point, word got to the Pedaljets that royalty was in the house, and the services of their instruments and gear had been requested. As they wrapped their set, the Kansas rockers advised the modest crowd of less than a hundred people to "stick around for

years later as part of the *Crystal Ball* box set. Apparently, like Wobble, the crowd that night wasn't all that impressed by Prince. "The show was kind of a bomb, maybe three hundred people there," McClellan recalled. "Those three hundred people were all the Sex Pistols/PiL audience. They didn't want to see Prince."

Even smaller groups got to see short, improvised Prince performances at First Avenue during the filming of *Purple Rain* in late 1983 and a year later, when he took over 7th Street Entry after Sheila E. played the Mainroom. Details of the first occasion are sketchy. It came about midway through the three-week shoot, when Prince decided to throw a party for the film crew. Stage

Memories of Prince

Kevin Cole, longtime First Avenue DJ: "He would come down on nights I would spin. I really think he was grooving to what we were playing. I really think what's on 1999 was stuff he heard there and at other rock clubs. Then I would start getting calls: 'Prince is going to come down and wants to bust a new record.' He or his people would come down and let me play something first. It happened with 'Erotic City,' I know. I'm hunched over the turntable, and I feel a tap on my shoulder. It's Prince standing there. He asks, 'Will you play my record?' It was an acetate of 'Erotic City.'

"We had a little VIP area where he could go, up by the office door. He'd hang out up there. I had a line of sight to him from the DJ booth. After he brought me 'Erotic City,' he waited for me to play it. When I worked it into the mix, he ran down to the dance floor and started dancing. The dance floor was packed, too. He would dance to his stuff, or the Time, Vanity 6, or maybe Parliament/Funk or James Brown. But always to his own stuff."

Scott Bogen, longtime patron and thousand-dollar winner for impersonating Prince in one of First Avenue's Great Pretenders lip-synch contests: "It must have been early summer of 1985, and it was a dance night. I was hanging upstairs, near the DJ booth door. There is a bit of a commotion. I see Prince and Madonna ascending the Entry-side staircase. Big Chick [Prince's bodyguard] was behind them. They are smiling, and Prince seems to be pointing things out to her. In true Minnesota fashion everyone is doing their best to ignore them, but at the same time looking at them out of the corner of their eyes. They made no attempt to disguise who they were.

"They reach the top of the stairs, and at that moment the video of 'Like a Virgin' comes on the big screen. Now, this was not the Madonna version. No, this was the Lords of the New Church version.

Madonna went into instant meltdown. Prince appeared to be trying to calm her down, but from my point of view, about ten feet away, she seems to see this as a mean-spirited put-down of her. Another thirty seconds of discussion with Prince, and then the two of them turn around and leave the club. I could see the frustration on Prince's face. Here he is showing off his hometown to Madonna. I would estimate the total time they spent inside was about five minutes, if that."

Richard Luka, aka Dix Steele, longtime doorman and designer of the First Avenue logo: "I was the guy checking IDs, seeing who was on the guest list, throwing out drunks, confronting angry bikers, and of course, letting celebrities in through the side door. People like Prince, Bob Dylan, Kevin McHale, Eleanor Mondale, members of the Vikings, and a slew of pretentious asshole wannabes. On Halloween of 1982, I had the night off and came up with a really cool idea to show up as Conan the Barbarian-as-cross-dresser, complete with red garter belt, red spandex thong, matching fishnets, and '80s leg warmers. I was also one of the top competitive bodybuilders in the state at the time, at six feet four inches and 230 pounds.

"I was a hit that night. Women—and lots of men—couldn't seem to keep their hands off me. At least from what I remember. I drank a lot of beer that night, and smoked *a lot* of weed. Around twelve-thirty, I spot Prince alone over by the cigarette machine near the entrance to the Entry. 'Hey, it's Prince. He knows me. I'll just go talk to him.'

"'Hey, Prince! I'm the doorman! Check *me* out! I look like you, except bigger!' Well, let's just say he tried to get away, but I had him cornered, and I was really chatty. 'Hey . . . I really like your music . . . where ya going? Well . . . okay, go fuck yourself!'

"The next night, after a truly miserable hangover, I got a phone call about ten PM from the managemen

at First Avenue, asking *what* did I say to Prince the night before? He now was coming in with a bodyguard, Chick Huntsberry, a former biker and pro wrestler. I was rather afraid. After that, I apologized to Prince in person at the door one night. He was very gracious about it and always said hi to me after that. So I feel my great contribution to rock 'n' roll might be that I was responsible for Prince realizing he needed more protection from his adoring fans."

Patrick Epstein, club VJ, Prince's *Purple Rain* stand-in, and video director: "Every time Prince came in, Roy Freedom would [say to me], 'Let's put in your recut of 'Sexuality' or '1999!'" I would cut them up, like, 'Now we're gonna party like it's 19 . . . 19 . . . 1999.' I was really getting good at it. I'll never forget the time— because I was a Prince fan—when he walks into the club and it was like, 'Oh my god! Prince is here!' So we put in my video recut. And Prince noticed what I did. He goes, 'What the fuck is that? That's not the original!' And he sent [tour manager] Alan Leeds into the booth. Alan said, 'What's your name? Can I get your phone number? Prince wants to talk to you.' And that was the beginning of a ten-year working relationship with Prince as a young, up-and-coming director." ∎

something special." KFAI-FM DJ Jon Copeland, who had the band on his radio show earlier that day, remembered, "They actually locked the door from the Mainroom so that the crowd there wouldn't rush the Entry."

Prince and his rhythm section launched into a classic blues improvisation for a half hour on their borrowed instruments. "We ain't as good as the band was up here," Prince claimed at the start of the jam, "but we're just going to get loose . . . in a groovy noose." They started with a slow-grooving take on Sly & the Family Stone's "Africa Talks to You (The Asphalt Jungle)," peppered with flashy fills from Prince's especially reverb-heavy guitar. Next came a raw, low-bottomed take on "Erotic City" that morphed into a snippet of "Mutiny," a song he would contribute to the Family's lone album release. "That's right, the shoes match the pants," Prince inexplicably bragged after one especially tasty guitar lick.

It was all improv after that, the most enjoyable chunk of which is a comically old-school cheater's anthem that has since been labeled "First Avenue Blues" by bootleg collectors. Sample lines include, "I took you to First Avenue yesterday, baby / What'd you do? You went on the floor and danced with all them fools," and, "I tried to introduce you to the band, but it seemed like everybody in the band knew your name." As the jamming reached its funkiest peak, Prince sang out to his bandmates,

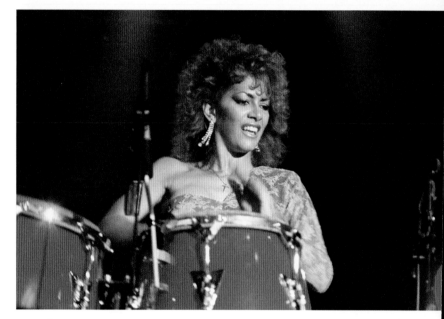

One of Prince's most accomplished protégés, Sheila E. released her debut album, *The Glamorous Life*, in June 1984, just a few months before her first Mainroom gig and before heading on tour with Prince. *Photo by Tommy Smith III*

"Everybody stop on one," and the music came to an abrupt halt. "That's enough!" he said, his smile practically audible in the bootleg recording. And thus ended Prince's first 7th Street Entry performance, a fittingly ragged but adventurous mini-set. Copeland, who hosted

a party with the Pedaljets after the show, remembered, "They couldn't believe what had just happened, and with their instruments. They were still freaking out about it."

Prince pulled a similar stunt in the small room a year later, on July 11, 1985, when he and Sheila E. co-opted the gear of a long-forgotten mid-'80s college-rock band, Ring Theatre. That night's openers, however, the Dead Milkmen, went on to play the Mainroom many times, and co-leader Rodney Anonymous recounted their Princely tale in an online "Dead Milkmen FAQ" years later: "All night, the staff was saying that Prince was in the building. We all thought that they were kidding. During the last song of the night by the headlining band on our show (Ring Theatre, one of the worst bands we've ever played with), Prince and Sheila E. walked into the room and Ring Theatre gave them their drums and bass to play a song with. Sheila E. and the 'Purple One' jammed for a few minutes and then disappeared." They played two songs, "Boys & Girls" and "Holly Rock," trading off on vocals with her on drums and him on bass.

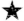

Prince's final onstage appearances at First Avenue in the 1980s were all business: a pair of unadvertised five-dollar shows. The first fell on March 3, 1986, three weeks before the release of the *Parade* album and four months ahead of the premiere of the ill-fated accompanying movie, *Under the Cherry Moon*. Most of the songs from that record and film were played live for the first time that night, though the show opened with the title track of the album that came out the previous year, *Around the World in a Day*. Taking the stage in a white overcoat and a purple, high-shouldered power suit, Prince again advised the crowd the set list would not be full of hits. "We've been rehearsing a week," he said, pointing to a band that included the five core Revolution members and six extras. Among them: saxophonist/flautist Eric Leeds (brother of Prince comanager Alan and a member of the Family), guitarist Miko Weaver (from Sheila E.'s band), and back-up vocalist and dancer Jerome Benton (Morris Day's mirror-holding valet in

Prince triumphantly took the First Avenue stage on March 3, 1986, in his first Mainroom appearance in a year and a half. *Photo by Daniel Corrigan*

the Time). Prince continued, "We're going to try to play everything that we know tonight. Some of it might be rusty. If some of it ain't right, we'll come back and play next week and get it right."

In fact, he and the beefed-up band played nine of *Parade*'s twelve tracks with impressive verve, starting with the album's first three tracks in order. As "Christopher Tracy's Parade" segued into "New Position," Prince cheekily warned a certain audience member, "Jimmy Jam, I don't want to hear this on your new record." That was one of several humorous moments in the otherwise

AROUND THE WORLD
PARADE
NEW POSITION
I WONDER U
PAISLEY PARK
RASPBERRY BERET
~~CONDITION OF THE HEART~~
ALEXA DI PARIS
CONTROVERSY
MUTINY / DO U LIE?
SOFT & WET
I WANNA BE LOVER
HEAD
~~ANOTHER LONELY~~ UNDER THE CHERRY MOON
POP LIFE
GIRLS & BOYS
LIFE CAN BE SO NICE
PURPLE RAIN / ENCORE
~~4 THE TEARS~~
WHOLE LOTTA SHAKIN'
~~AROUND THE WORLD IN A DAY~~ ANOTHER LOVER
MOUNTAINS ~~~~ / LEAVE STAGE
A LOVE BIZARRE
AMERICA
KISS

Prince and company mixed in a few old favorites with songs off the soon-to-be-released *Parade* album. *Courtesy of Chrissie Dunlap*

Prince displayed some nifty dance moves during his March 3 concert, while opening the encore with the Jerry Lee Lewis rockabilly classic "Whole Lotta Shakin' Goin' On." *Photo by Daniel Corrigan*

serious tone of what would be Prince's longest set ever at the club, clocking in at two hours, twenty minutes. He introduced "Under the Cherry Moon" by saying, "This next one is the title track of a movie that we made. It's a real slow one, so if you got a lady, grab her. If you don't, don't do it in here!" The *Parade* material was rounded out by other *Around the World* tracks that were played locally for the first time, including "Paisley Park," "Pop Life," and "Raspberry Beret." He also ran through the way-oldies "Soft and Wet" and "I Wanna Be Your Lover," plus his new hit for Sheila E., "A Love Bizarre," and a thirteen-minute version of "Purple Rain" in which he let Eric Leeds play a lengthy, gorgeous sax solo.

In a rare break where the band didn't charge straight into the next song, a fan yelled a request for "She's Always in My Hair." Prince replied, "You're right, that is a bad one. We forgot to learn that one." Wendy Melvoin interjected, "Lisa and I thought about that song," prompting an annoyed look from Prince, who mockingly repeated her in a teacher's-pet tone. Then he asked, "What is that one people always yell at rock concerts? Right, 'Freebird!' Y'all know some Skynyrd?" Oh, if only. He did throw a rowdy southern classic into the encore, Jerry Lee Lewis's "Whole Lotta Shakin' Goin' On," gyrating his hips a la Elvis-the-Pelvis in tight black matador-style pants. Leading into the finale, Melvoin declared, "I'm in a great mood tonight, and that's all I'm gonna say," after which she and Prince vamped it up in a stretched-out, almost maniacal version of the new radio and MTV hit "Kiss."

Sadly, that was the last time she and the Revolution all performed together with Prince at First Ave. Matt Fink was the only member of the band's *Purple Rain* era still in tow a year later, when Prince returned to the club for his last "secret" show on March 27, 1987. He already

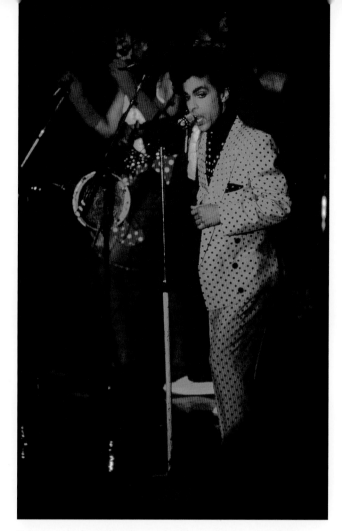

Prince rocked a polka-dot ensemble on March 27, 1987, in what would be his last First Ave concert for two decades. *Photo by Daniel Corrigan*

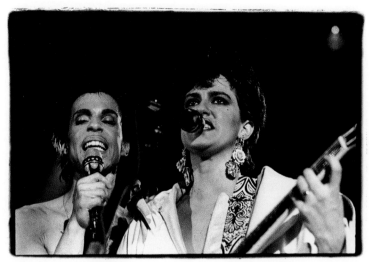

Prince with his longtime guitarist Wendy Melvoin during the March 1987 show. *Photo by Daniel Corrigan*

had another new album to promote—a double-album, in fact, one that many critics and hardcore fans consider his all-time best: *Sign o' the Times*, just ten days from being released. The mighty Levi Seacer Jr. was on bass, Sheila E. handled drums, and her bandmates Miko Weaver and Boni Boyer played guitar and keyboards, respectively, along with a crew of horn players and backup singers/dancers.

Looking remarkably like a *Golden Girls* cast member in a shoulder-padded polka-dot suit, poufy hair, and large-rimmed glasses, the bandleader gave the packed crowd his standard warning at the beginning: "Listen," he said. "We're still in rehearsal. So you are invited to a rehearsal, okay? We're just gonna play some new things and try 'em out on you, and try 'em out ourselves." After

introducing all the band members, he deadpanned, "And in case you're on valium, my name is Prince." Then he suddenly shouted out, "Shut up, already! Damn!," his bandmates' cue to launch into one of his all-time funkiest numbers, "Housequake."

Five more *Sign o' the Times* tunes followed, most of them in the lively, grinding vein of the night's opening tune, including "Hot Thing," "Strange Relationship," and the encore workout "Gonna Be a Beautiful Night." First Ave staffers remember Prince being there the night James Brown played the club, and on this night it was clear he was emulating the Godfather of Soul. He didn't pick up the guitar for most of the night and instead did a lot of J.B.–style maneuvers, including sudden mic-stand tilts and fall-down leg splits. Perhaps because of the physical exuberance, he kept the set to a modest seventy minutes and didn't goof off much, except during "Gonna Be a Beautiful Night" when he and Sheila E. twice traded duties behind the drum kit without missing a beat each time. At show's end, he offered the audience a sweet, genuine-sounding, "Thank you so much for coming," and that was it. He would play some of the biggest shows of his career that year, but he would not come back to the small rock hall he turned into an international landmark for another two decades.

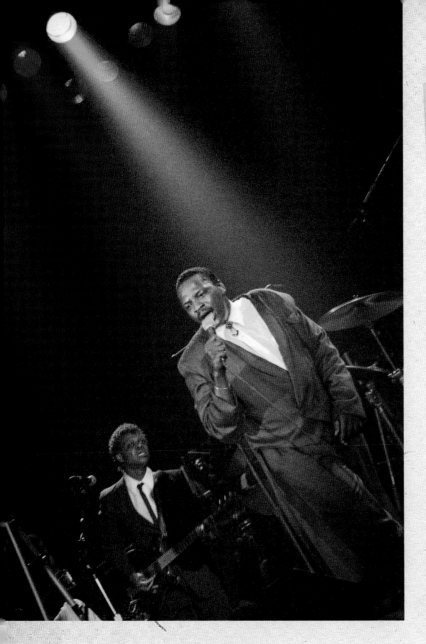

Sunday, Sept.15th

ALEXANDER O'NEAL

With new band

FIRST AVENUE & 7th St entry
The Downtown Danceteria 1st Ave. N. & 7th St., Mpls

Tickets:
$6.50 adv.
$8.00 door

Although Prince played only nine full shows at First Ave, he helped open the doors to more and more R&B artists at the club. One-time Flyte Tyme member Alexander O'Neal broke out with a solo album in 1985 (produced by former Flyte Tyme bandmates Jimmy Jam and Terry Lewis) and played the Mainroom that September. *Photo by Tommy Smith III; flyer courtesy of the Museum of Minnesota Music; ticket courtesy of Errol Joki*

★

A primary reason for the long hiatus from First Avenue is the fact that Prince had already broken ground on Paisley Park by the time of that final funk fest in March of 1987. The 65,000-square-foot suburban studio complex included a performance room with a capacity for 1,850 people and a high-grade audio system. It was up and running by New Year's Eve, 1987, the night of his first public concert there. His house at the time was just a mile from the studio, and in later years the apartment at Paisley became his main residence. Also, he later became a Jehovah's Witness and likely preferred performing in an

alcohol-free venue. But really, what musician wouldn't prefer to play a venue where their gear doesn't have to go anywhere and their living room is just down a couple of hallways?

"He's got his own sandbox to play in," Bobby Z said when the First Ave shows stopped. "I don't know how much he thinks about it, but he's got this beautiful facility, he's having the time of his life, having parties at his own house. You know, I don't know why he'd want to [go] downtown."

Prince himself seemed to acknowledge the coming end of his First Ave heyday in his penultimate 1980s

performance there. He was always unusually personal and open with audiences at the club, but he got a little extra emotional at the end of the *Parade* set in 1986, telling the crowd:

> I want to say something in all seriousness, sometimes when you stand up here—when I'm here—I get all jittery because of this, and it just feels really nice. What it is is love. I need to shake, in all forms of the word. I got a few more things to do, and when I do them, I'm going to come back here and build a big clubhouse so we can do this every day.

Perhaps the club was ready for a break from Prince at that point, too—not that his performances there weren't undeniably special, of course, but there were those other 363 or 364 nights a year when people came in hoping he would be there. Even DJs Kevin Cole and Roy Freedom, who'd been proudly spinning Prince's records since the Sam's days, admitted the relationship had become a little strange. "It got to a point where, after a while, we didn't even play any Prince," Freedom said. "We just avoided it—not right after the movie, but years down the line. Everybody just expected us always to play Prince. Everybody came in expecting something [the club] really wasn't. It was a battle for a while."

Cole related a similar experience. Even a few years after the movie, he said, "there was still an untold number of people coming to the club wearing trench coats with spikes on them, ruffly shirts, and all the things that were portrayed in the movie that weren't really what First Ave was like. For a while, that's what a lot of people thought First Ave was. We had to deal with their disappointment, and we had to keep the club the way we thought it should be." ∎

THE MAINROOM GOES MAINSTREAM, AND HIP-HOP BREAKS THROUGH

THE 1990s

"We had a really, really great run in that time period. It was a who's-who of bands that went on to ginormous stratospheres."

—RICH BEST,
FORMER FIRST AVE BOOKER, 2016

"The industry got a lot more stressful and greedy, artists included. All of a sudden, it seemed a lot more corporate, with no loyalty to the clubs."

—STEVE McCLELLAN,
FORMER FIRST AVE GENERAL MANAGER, 2016

Only a few local record store clerks and radio staffers knew anything about the young group that snuck on the lineup on July 22, 1991. That night's headlining band, Trip Shakespeare, was miffed Steve McClellan let an unknown out-of-town act take the opening slot last minute. Trip bassist John Munson even remembered telling the club's GM, "Fine, but we're not paying 'em! That's coming off your end." He also sheepishly admitted, twenty-five years later: "I was still at home showering during their set." The bandleader of that

night's second opening band, John Eller & the DT's, also didn't bother checking out the newcomers that went on before him. "I thought they were some kind of Trip Shakespeare side project, because [Trip] had a song called, 'Pearl,'" Eller recalled. "But then Steve said, 'It's some fucking Seattle band whose agent pushed hard to get them on the bill. He really thinks they're gonna be a big deal.'"

How quickly the agent's prophecy came true. Pearl Jam packed First Avenue as headliners just seven months after their little-seen opening gig with Trip Shakespeare, and then the future Rock and Roll Hall of Famers got too big for First Ave. That's how things went in the alternative-rock boom: Young bands that likely would've been exiled to 7th Street Entry during much of the 1980s were filling the Mainroom in the early '90s.

(Opposite) Kurt Cobain and Nirvana spearheaded the alt-rock explosion of the 1990s. Their Mainroom show on October 14, 1991, followed two earlier gigs in 7th Street Entry. *Photo by Jay Smiley*

(Above) Flyers and ticket stubs from just a few of the top alternative-rock acts that played the venue in the late '80s and early '90s. *Courtesy of the Museum of Minnesota Music, Dale T. Nelson, and Michael Reiter.* *(Below)* Nirvana's 7th Street Entry concert on April 9, 1990, came at a pivotal turning point in the world of indie rock and in the life of the club. *Courtesy of Dale T. Nelson*

Nirvana, for instance, went from playing the Entry with only a small buzz in 1989 and 1990 to putting on a packed Mainroom show in October of 1991. And they, too, never played First Ave again (although drummer Dave Grohl made several memorable returns with his Foo Fighters). Other acts who played the club once or twice before either exploding or imploding—or both—during the '90s include Jane's Addiction, Soundgarden, Nine Inch Nails, Green Day, Alice in Chains, Smashing Pumpkins, Hole, Tool, Stone Temple Pilots, Rage Against the Machine, Beck, Elastica, Oasis, and Radiohead. Many of them went from playing to fifty to fifteen hundred people at First Ave to facing thirty thousand–plus fans at Lollapalooza tour stops across the country.

First Avenue production manager Conrad Sverkerson related a favorite story from this era: the time the Flaming Lips came through as headliners and were so green they didn't have a rug to put under their drum

kit to keep sound vibrations from moving the drums. He gave them one from the club and told them to keep it. When Sverkerson ran into Lips frontman Wayne Coyne backstage when Lollapalooza hit downtown St. Paul a couple years later, in 1994, Coyne told him, "We still got your rug! We don't have the same drummer, but we've got the same rug."

Unlike the Flaming Lips, the Lollapalooza-bound Pearl Jam never even played 7th Street Entry, although guitarist Stone Gossard and bassist Jeff Ament did in 1989 with Mother Love Bone, their prior group. "I loved Mother Love Bone, and when [MLB singer] Andy Wood died they kind of formed Pearl Jam," recalled Rich Best, First Ave's young go-getter talent booker under McClellan at the time. Best, who's still booking Pearl Jam shows three decades later as the head of Live Nation's Los Angeles concerts, was won over by "Alive" and two more songs on a demo cassette that previewed Pearl Jam's debut, *Ten*, which would not be released for another month.

Best recalled, "Their agent was like, 'Look, I just need a gig. Let's get them on *something*.'" The night before the First Ave show, the Seattle newcomers opened for Soul Asylum and the Jayhawks in singer Eddie Vedder's hometown of Chicago, helping to mark the eighth anniversary of the Metro nightclub. The Metro's bookers must have gotten the same hard sell as First Ave's.

Of course, Pearl Jam made a hard sell in return. Too bad only about forty or fifty people were there to witness it. As a last-minute addition, the quintet had to go on right when doors opened at 6:00 PM. "Who shows up at a club when the doors open?" asked Paul Adams, a local record-store clerk who nonetheless made the show, having also heard the band's advance sampler. Adams said the band played only thirty minutes: "After a couple of songs on the stage, Eddie jumped down to the floor and was singing to each of us who were there," he recalled. "Stone even jumped down to the floor and finished the set in the crowd with Eddie."

Their eagerness to perform on the same level as their "crowd" may not have been just for show. The other three bands on the bill that night already had their gear set up, leaving Pearl Jam with about as much room onstage as it would have gotten in the Entry. New to the production crew at the time, Sverkerson remembers specifically telling Vedder to leave the other bands' gear alone. "Just please don't screw around with the drum kit or whatever is up there," he told the singer. Sverkerson recalled with a laugh that then "they got up, played for a half hour to maybe fifty people, and towards the end of the set, he started fucking around on the drums."

First Avenue was a copromoter on the next Pearl Jam date in town, a now-legendary triple bill at St. Paul's Roy Wilkins Auditorium on November 30, 1991, with the Red Hot Chili Peppers and Smashing Pumpkins. Those other two bands help illustrate the contrast between the pre- and post-Nirvana era at First Avenue. The Chili Peppers predated alt-rock's mainstream crossover by a half decade and put in ample time at First Ave. The Pumpkins, on the other hand, hit the Mainroom once in 1993 before becoming too big for the club. They may have already thought they were too big when they played the Entry twice in the years prior. Like another bloated group of the era—Stone Temple Pilots—would do two years later, the Pumpkins opened for the far less commercially ambitious hometown band Run Westy Run in the Entry at some point in 1990. They also had an Entry show with a better-known band that November.

"I missed the R.E.M. and U2 days, but I saw Smashing Pumpkins open for the Lemonheads in the Entry," was a humble brag from Jim Runge, a First Ave regular in the '90s who later became a tour manager for the likes of the Black Keys and Wilco. Though the Pumpkins were still a year away from issuing their debut LP, *Gish*, Billy Corgan's Chicago-reared prog-grunge band was ready for the big time.

"Billy was such a genuine douche," Entry sound engineer Randy Hawkins offered. The Pumpkins' rider from that Entry opening gig included very specific requests such as three large bottles of Evian, a pot of hot water and tea bags, two six-packs of imported beer, and "one pint of vodka (preferably Stoli)." All the requests were firmly crossed out by a club employee and replaced with a note: "Support act—drink/soda tickets." Apparently, the Pumpkins didn't get a lot of support from the crowd

Nirvana Blows Up

On the night his epochal Seattle trio played the First Avenue Mainroom, October 14, 1991, Krist Novoselic waited until right before the sixth song to point out how far Nirvana had come in such a brief span. "Last time we played here, it was through that little door right there about a year and a half ago," the wise-cracking bassist told the sold-out crowd, recalling his band's Entry show on April 9, 1990. "I lost part of my bass there, though, so if anybody picked it up, throw it up here."

Then, Kurt Cobain kicked into the sixth song of that October '91 set with the scratchy guitar riff that had become ubiquitous on MTV and FM radio—and the crowd went nuts. As soon as Novoselic and drummer Dave Grohl jumped in with their parts, the dance floor looked like a popcorn maker, with bodies jumping and flailing everywhere. "The room just erupted," remembered the club's director of operations, Molly McManus. "It was one of those rare times when the crowd really became one." It was the one and only time Nirvana played "Smells Like Teen Spirit" at First Avenue.

The band had played in Minneapolis three times before—the 1990 Entry show and two gigs at the Uptown Bar in 1989—but it hadn't exactly caught on. Cobain and his cohorts spent the week before the Monday night Entry concert at producer Butch Vig's studio in Madison, Wisconsin, working on what would be the biggest rock record of the 1990s. Then they went back to being an opening band, playing with fellow Sub Pop Records proto-grunge band Tad in the Entry. "I thought Tad totally killed it that night—way better than Nirvana," sound man Randy Hawkins claimed. Lori Barbero, who hung out with Nirvana before the set, recalled, "Kurt didn't really have any cold-weather clothes, so I gave him this sweater with the thumb holes." The sweater later showed up in band photos. "They were just young kids having fun and not really making any money," she added.

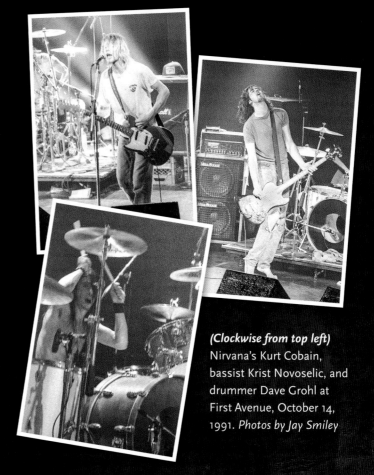

(Clockwise from top left) Nirvana's Kurt Cobain, bassist Krist Novoselic, and drummer Dave Grohl at First Avenue, October 14, 1991. *Photos by Jay Smiley*

Even with the growing hype around them, they were still having fun in October 1991, judging by a bootleg of the stripped-down in-store performance they did at Northern Lights record shop around the corner from First Ave. With Kurt on acoustic guitar, they played the Leadbelly and Vaselines covers later featured on their *MTV Unplugged* special, plus "Dumb," "About a Girl," "Been a Son," "Something in the Way," and "Negative Creep." Looking at the record racks around them, Grohl asked Novoselic through his microphone what he thought of Primal Scream's *Screamadelica*. The bassist replied, "Good record, for being pretty unpronounceable," which led to riffs on neighboring records, including Pearl Jam ("Might as well name themselves Spew or Jism") and Robert Palmer ("Go home, asshole").

Cobain barely said a peep at the store, and he was equally mum later that night onstage. But he was undeniably captivating. Such historic shows tend to get exaggerated in later years; few people who brag about being there are going to say anything bad about it. But a bootleg recording of Nirvana's First Ave appearance

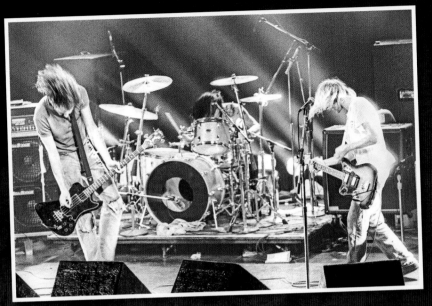

By the time Nirvana played the Mainroom in 1991, the alt-rock boom had arrived, and Twin Cities music fans flocked to see the grunge-rock pioneers. *Photo by Jay Smiley*

confirms that the twenty-one song set truly was a fine-tuned and incendiary performance, one perhaps sharpened by the band's tour manager, Monty Lee Wilkes, and drum tech, Myles Kennedy, both of whom were Minnesotans and had worked the soundboard and stage at First Ave many, many times before. They had signed up with Nirvana a few months earlier, before "Teen Spirit" exploded. "It turned into being one of the things of a lifetime where you get to go on a ride," Kennedy said. "Not many people get to do that, and I had the extreme pleasure of getting to do it with my mentor," referring to Wilkes, who died from cancer in 2016.

The crew had their work cut out for them when they rolled into Minneapolis that October night. Two nights earlier at the Metro in Chicago, the band members destroyed some of their instruments onstage. They ended up borrowing some gear from their opening band, Urge Overkill, at First Ave. Earlier in the day they also made a trek to B-Sharp Music in northeast Minneapolis, a place not so fondly remembered by many local musicians. Novoselic made his contempt for the store known twice during the show, referring to it as "B-Flat Music" and proclaiming, "The place is such a fucking shithole, it deserves a petrol bombing. Never buy equipment from B-Flat, because if you do, you'll *beeee* fucked."

The bassist was duly impressed with First Ave, though. After the crowd enjoyed another fit of pandemonium during "Come as You Are," he said, "This place is really progressive, really utopian. You have people here standing behind the barricades handing out glasses of water to anyone who wants one. That's what it's all about, brothers and sisters."

Nirvana's First Ave concert lives on in band lore for other reasons, too. Cobain's future wife, Courtney Love—who lived in Minneapolis briefly in the late '80s and later played the club as Hole's frontwoman—was in town for the 1991 concert and made her rendezvous with Kurt that night very well known, even though that's not who she came to see. As she told *New York* magazine in 2011, "I'd flown there to fuck Billy Corgan [of Smashing Pumpkins], who still had lots of hair. I didn't even know Nirvana were playing that night. Kurt and I wound up at the Northstar [Omni hotel], and our daughter, Frances, was basically made that night. 'Smells Like Teen Spirit' was on MTV every five fucking minutes." Talk about a defining moment from the 1990s. ■

Nirvana's Mainroom Concert Set List, October 14, 1991

- Jesus Doesn't Want Me for a Sunbeam
- Aneurysm
- Drain You
- School
- Floyd the Barber
- Smells Like Teen Spirit
- Polly
- About a Girl
- Lithium
- Come as You Are
- Breed
- Love Buzz
- Sliver
- Territorial Pissings
- Been a Son
- Negative Creep
- Blew
- On a Plain
- Endless, Nameless

Encore:
- Something in the Way
- Rape Me

Young and mostly tattoo-free, Anthony Kiedis, Flea, and the rest of the Red Hot Chili Peppers rolled into First Avenue on October 21, 1985, promoting the band's second album, *Freaky Styley*. *Photos by Tommy Smith III*

that night, either. Club regular Aaron Egan remembers watching local rockers Galactic Rodeo open the show, "Then everyone left and came back just in time for the Lemonheads." No doubt Corgan & Co. got a lot more of what they asked for when they returned for a sold-out Mainroom show on October 5, 1993, at which they played almost all of their fast-ascending sophomore album *Siamese Dream*.

The Chili Peppers were regulars at First Ave during the early years of the alt-rock wave. "They must've played there nine or ten times," McClellan figured. Tickets for their first Mainroom show, on November 21, 1984—a few months after the release of their eponymous debut—cost just two bucks. It was either that show or the one after that the band went onstage for the encore wearing nothing but tube socks covering their genitalia, which became one of their trademarks. They returned in October 1985, on the *Freaky Styley* tour, and were back a year later, on December 1, 1986, with Los Angeles vets T.S.O.L. for support. After the release of their breakthrough fourth album, *Mother's Milk*, in 1989, the Chili Peppers were big enough—and faithful enough to the club—for a two-night stand in early October.

"Those were really big, exciting shows at the time," said Molly McManus, then the club's operations director. "They knew the club, and the club knew them, so it was really mutual appreciation." A true sign of their love for the place came a decade later, when the Chili Peppers picked First Ave as one of five venues around the country on a quickly arranged tour a month after the Columbine High School shooting in Littleton, Colorado. Tickets to the "Increase the Peace" concert on May 20, 1999, were awarded to Twin Cities high schoolers who wrote essays preaching love and understanding.

After opening for the Chili Peppers at Wilkins Auditorium the previous November, Pearl Jam returned to First Avenue once more, on March 25, 1992. This time, the band was granted the full stage, though Vedder still roamed around the club during the eighty-minute performance, which featured most of the songs off *Ten* plus the Fugazi cover "Suggestion." One fan in the crowd, Tom Steman of St. Cloud—who counts that as his all-time favorite First Ave show—remembered watching the singer "wander around the balcony during the set, and holding onto him while he was hanging over the crowd." At one point, the power to the stage was blown, and it took

a few minutes to sort out. "They took it with a grain of salt," Sverkerson remembered of the Pearl Jam members. "They kind of just busted into an acoustic thing without the mics." Coincidentally or not, the band's well-remembered *MTV Unplugged* appearance occurred right around that time.

The stage manager blamed the power outage on the club's outdated electrical system. For better or worse, the wiring that dated back to the original 1937 bus depot factored heavily into the sound onstage during the guitar-laden 1990s. Amplifiers inevitably picked up the electrical currents running through the place. "We'd get a terrible guitar buzz, which was something we went through for years," Sverkerson said. "We'd go through it with almost every artist. It was a drag. I remember the first time Bob Mould was back in town. He was like, 'Oh yeah! There's that old First Avenue buzz!'"

Molly McManus, shown here in the early 2000s, was a fixture at the club for more than a decade, including during the momentous '90s. *Photo by Daniel Corrigan*

As is true of most eras, many employees who worked at First Avenue in the 1990s swear it was the best time to be there. "We really felt a sense of accomplishment, because all of these bands we supported and believed in were becoming big," said Molly McManus. "A lot of us at the time became really great friends, too."

McManus made her own impressive rise through the ranks, starting at the club in her late teens as a barback in 1986 and working her way up to director of operations in her early twenties. Like Chrissie Dunlap and Maggie Macpherson before her, she overcame the inherent boys-club mentality—more of it from visitors than staff—largely by doing her job well. "I didn't want to be a waitress. I wanted to be involved with running the place," she said, "and First Avenue was a good place to be given that opportunity. I think it helped a lot that I had a very hard work ethic. There were many days I would essentially work from about noon to four AM. But we all did it because we loved the place and believed in what we were doing there."

"It was a super exciting time," concurred Rich Best, hired to help with marketing and promotion in 1988. "I started literally making flyers in the copy room and running tickets around." The future Live Nation exec initially worked under Willie Wisely, another marketing

"There were many days I would essentially work from about noon to four AM. But we all did it because we loved the place and believed in what we were doing there."

—Molly McManus, operations director

In addition to being the lead singer of the Hypstrz and Mighty Mofos, Billy Batson was also one of the best sound men in the business. He spent many hours mixing sound in the Entry booth throughout the '80s. *Photo by Daniel Corrigan*

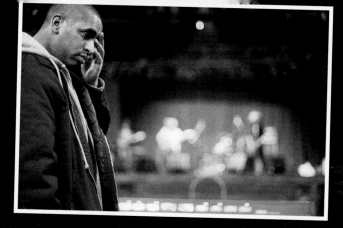

Randy Hawkins started doing sound in the Entry in 1990 and later became a sound engineer and tour manager with Rhymesayers Entertainment. *Photo by Daniel Corrigan*

staffer who was also a regular onstage in the early '90s with his flowery pop/rock band the Willie Wisely Trio (a quartet).

Sound engineer Randy Hawkins—who would later tour with Run Westy Run, Cows, and eventually Atmosphere—started as a janitor in his late teens. He apprenticed with Billy Batson in the sound booth on New Band Nights. When Bob Mould hired Batson to work his *Black Sheets of Rain* tour in 1990, Hawkins began helming the Entry's sound booth on a regular basis. "I was only twenty or twenty-one, so to be given that kind of opportunity was pretty special," said Hawkins, who probably saw more Entry shows than anyone else in the 1990s. "I loved it. It was one of those things I knew I was good at. And the Entry in those days was a lot more Wild West than it is now."

How wild? Hawkins pointed to a 1993 gig when San Diego's experimental punk band Crash Worship started a bonfire in front of the stage. "[Batson] was working as stage manager in the Mainroom and walked in and saw a bunch of naked punkers dancing around a fire," Hawkins recalled. "He was livid."

First Ave's most recognized employee in the '90s— thanks in part to his lengthy dreadlocks—Conrad Sverkerson started out working the door in 1988. By 1990, he was part of the stage production crew and would run the

show for most of the decade. His first concerts as stage manager were a multi-night stand by the local band that played there innumerable times in the '80s and was soon to become another multi-platinum-selling rock band of the '90s.

"Soul Asylum was playing, so it was a big weekend," recalled Sverkerson, who quickly befriended the band. He also became close with other Twin Cities bands who enjoyed major-label success in the '90s, including the Jayhawks, Gear Daddies, Babes in Toyland, and Semisonic. "They were basically all fond memories," he said. "That's something that's great to see. You know, friends of yours that, all of a sudden, you're seeing them do good."

The riches that many bands enjoyed in the early '90s contrasted with First Avenue's own financial situation. With the *Purple Rain* hoopla long since faded and Prince no longer playing there, the club was struggling again. Another factor was the Target Center arena, which opened kitty-corner from the club in time for the Minnesota Timberwolves' 1990 NBA season following two messy years of construction. "The dirt was so high you couldn't see our lights," remembered business manager

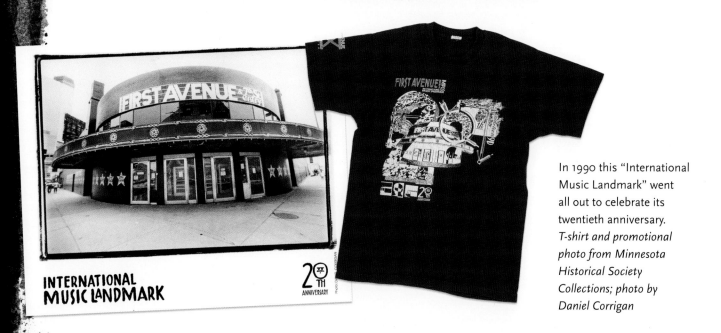

In 1990 this "International Music Landmark" went all out to celebrate its twentieth anniversary. *T-shirt and promotional photo from Minnesota Historical Society Collections; photo by Daniel Corrigan*

Jack Meyers. "It was really bad." Cheap parking options near the club became scarce once the arena opened, too.

Meyers cites the '90s as an especially frustrating time, since it seemed like downtown Minneapolis and the bands who came to play there prospered, but the club got left behind. "A lot of years that should've been good, the bands would wind up playing the State Theatre or somewhere like that," he said. "The bad years, the bands would hold their nose and come here and sell it out."

Hoping to stem their losses and generate more appreciation for the venue, Meyers and McClellan went all out to mark the club's twentieth anniversary in 1990. The official date was April 3—the night of Joe Cocker's inaugural concert in 1970—but they waited until the week after Thanksgiving (when touring died down) to mark the occasion with a five-night concert series. T-shirts were printed up touting a list of performers going back to Cocker. Thick promotional packets were sent out to media outlets. MTV's *120 Minutes* even sent out a film crew to record a segment recognizing the anniversary.

"It's the only place that would have us play," Soul Asylum guitarist Dan Murphy said in the MTV clip, which also featured Bob Mould and the Replacements. Among club staffers, MTV interviewed Steve McClellan and the DJ who helped him shape the vision of the place a decade earlier, Kevin Cole. First Ave eventually lost Cole in the '90s alt-rock explosion as well. He left in 1994 to become

program director at REV-105, an alternative-format rock station that played a key role in breaking many of the new bands that came to First Ave in the latter half of the decade. "In a way, I never really left," Cole said.

Another enjoyable media report from the twentieth anniversary was a seven-minute segment on *Good Company*, a popular afternoon talk show on local ABC affiliate KSTP. The reporter is out of place from the get-go, calling the club "the First Avenue" and observing that it's "a place where you can keep up with fashion." But the clip also shows footage from the biggest night of the anniversary parties: Friday, November 30, 1990, when the Replacements made a surprise appearance before scheduled headliners the Gear Daddies, following sets by Run Westy Run and the Hypstrz and reunions by Man Sized Action and the Whole Lotta Loves, another local act that had been on the scene since the early '80s.

That anniversary show was the Replacements' last at the club; they split up the following year. It was also Paul Westerberg's first performance after sobriety treatment, and their first without drummer Chris Mars. Steve Foley, who would continue playing with Tommy Stinson in Bash & Pop, had been picked as Mars's replacement only a month earlier and would bash his way through a half-hour set, which included "I.O.U.," "Bastards of Young," and the then-unreleased "Merry Go Round." Covering the show for the *Star Tribune*, Jim

CONRAD

Although his distinctive dreadlocks are gone, Conrad Sverkerson has long been a fixture at First Ave. *Photo by Jay Smiley*

He's not the longest-tenured employee. Nor is he in charge, at least not officially. But if you ask musicians from around the world or regular patrons of the club who they know at First Avenue, Conrad is usually the first one named. "One of the big reasons everybody loves playing that place is Conrad," Flaming Lips frontman Wayne Coyne said. When Death Cab for Cutie graduated to Northrop Auditorium in 2006 after a decade of playing First Avenue, singer Ben Gibbard sounded like he missed the man more than the club. "Where's Conrad?" he asked in feigned distress from the stage.

Conrad Sverkerson was a moderate musichead growing up in suburban New Hope in the 1970s, and in his midteens, he went to see Brian Auger's Oblivion Express at the club that would become First Avenue, when it was still Uncle Sam's. In the 1980s he started working at the 400 Bar on Minneapolis's West Bank, where his older brother, Billy, was a manager.

After getting into a dispute with another manager at the 400 Bar one night in 1988, Conrad walked off the job and went straight to First Avenue. "I was just going in to blow off some steam and have a few beers," he recalled. When he got to talking to some staffers, he offhandedly told them, "Hey, you know, I might be interested in working here." He was hired right away, to work the door checking IDs. His first night on the job was for the Duran Duran concert in October 1988. He also pitched in and helped the stage crew here and there. When his predecessor and mentor Ron Anderson (still a big part of the club's crew) started touring with bands in 1990, the club needed a new production manager. Sverkerson learned his fate when he saw the words "Prod Man" next to his name on the schedule one day. "I was like, 'Prod Man?! What's that?'" Although he didn't yet know the technical aspects of the job, he said, "I think the management liked my

people skills. That came from my upbringing, being in a family of ten, dealing with different personalities. That's what makes my job kind of fun and interesting: You don't know the mood of the person you're going to be dealing with."

Other than a few stints when he went on tour with bands—including with Soul Asylum during the *Grave Dancers Union* phenomenon—Sverkerson has been working the stage at the club ever since. Artists ranging from Buckwheat Zydeco to Los Lobos have called him to the stage and thanked him. For many years he was easily recognizable because of his long dreadlocks, which he grew out over twenty years before cutting them off in 2006. Gwar frontman Dave Brockie mourned the loss of the dreadlocked 'do: "I've been trying for years to get him to give me a big chunk of it to use in my costume, probably as a codpiece."

The same year Sverkerson cut his hair, he suffered back trouble that required surgery. The club held a big

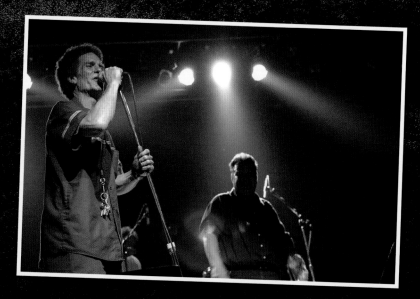

After Conrad needed back surgery in 2006, the club held a benefit show for him on September 6, with a bill featuring the Mighty Mofos, Soul Asylum, and members of Trip Shakespeare, the Jayhawks, and Golden Smog. *Photo by Steven Cohen*

benefit show for him on September 6, 2006, with a bill that included three-quarters of Trip Shakespeare, a mashup of Jayhawks and Golden Smog members, and Soul Asylum with Tommy Stinson on bass. Proceeds from the show were used to form the Twin Cities Music Community Trust, which is still used by the club as a health care fund for other concert professionals.

For the most part, Sverkerson is a welcome sight to the bands who show up at the club. "Conrad is still the first guy you see coming in," said Jim Runge, veteran tour manager for the Black Keys, Wilco, and many others. "The consistency there has always been Conrad." A friend since their days at the 400 Bar, Jayhawks bassist Marc Perlman recalled Conrad getting mad at him only once, when he asked for an extra free-drink ticket—violating what Perlman called Sverkerson's "number one rule." Otherwise, the bassist said, Conrad "understands that touring can be physically and mentally grueling for bands. He brings a comfort level to the club that bands really appreciate. You kind of just have to show up. First Ave obviously doesn't offer much in the way of amenities. There are a lot nicer green rooms than that one. But it still feels comfortable thanks to Conrad, and to the people who work with him."

Sverkerson raves about sharing the overall experience with the musicians when they play Minneapolis's legendary rock venue. "I'm there to try and make sure that the show itself goes off good, and people who bought the tickets have a good time. And the artists themselves have a good time and want to come back," he said. "You know, you could have Emmylou Harris one day and Green Day when they're a bunch of little brats the next day. I try not to treat anybody any different. Once they come back, they are glad to be back, which to me makes a statement."

Production manager Conrad Sverkerson is one of many longtime employees at First Avenue at the time of this book's writing. Here are some of the club's other long-tenured staff members, with the years they were hired:

- Roy Freedom (1978, DJ and calendars)
- Peter Rasmussen (1982, bartender)
- Ron Anderson (1985, sound and stage tech)
- Daniel Corrigan (1985-ish, photographer, stagehand, Special Projects Coordinator)
- Oscar Arredondo (1987, bartender)
- Nathan Anderson (1993, bartender)
- Dan Finn (1998, day manager)
- Sonia Grover (1998, talent buyer)
- Jessica Huntley (1998, box office coordinator)
- Nathan Kranz (1998, general manager)
- Damon Barna (2000, operations manager)
- Sturtevant Stewart (2001, door/bartender)
- James Baker (2002, production coordinator)
- Brad Hertko (2003, facilities manager)

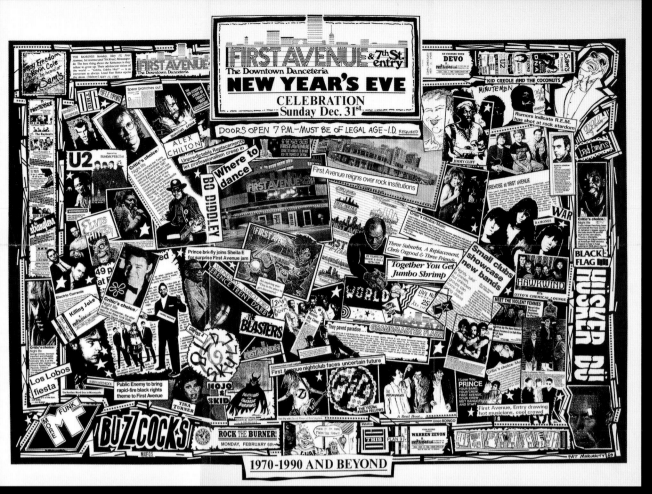

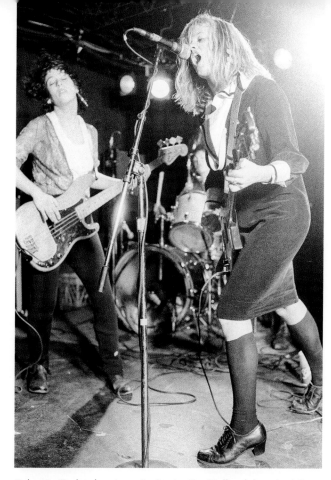

(Opposite, clockwise from top) This anniversary poster depicted clippings, photos, and headlines from two decades of the historic nightclub. Longtime local musicians Chris Osgood of the Suicide Commandos, Billy Batson of the Hypstrz and Mighty Mofos, and Bob Dunlap of Thumbs Up and the Replacements during the anniversary shows. The Replacements joined the anniversary festivities with a Mainroom appearance in late 1990; it would be the last gig for Westerberg and crew as a band. *Poster courtesy of Mark Dueffert; photos by Jay Smiley*

Meyer wrote, "As reaffirming as the Replacements' set was, it was only the tail-end of an evening full of other musical moments celebrating First Avenue's history and its role in making Minneapolis such a fertile musical environment.... Though big stars may have put the club on the map, the many years of service to local musicians and bold musical programming is its true legacy."

One of the boldest hometown bands to frequent First Ave and the Entry throughout the '90s featured the rare punk musician who hung out there during the Uncle Sam's era: Babes in Toyland, with former disco queen/drummer Lori Barbero. The Minneapolis native had been managing local band Run Westy Run at age twenty-five when she started learning drums on an old kit she bought from Westies drummer Bobby Joslyn. A social butterfly, Barbero soon met singer/guitarist Kat Bjelland, newly arrived in Minneapolis from Portland, Oregon, where she had played in a band called Sugar Babydoll with Hole's Courtney Love and L7's Jennifer Finch. Babes in Toyland went through a couple different members when Michelle Leon heard the new band was in need of a bassist and tracked Barbero down one night at—where else?—First Avenue. "Even though I haven't met Kat yet," Leon recounted in *I Live Inside: Memoirs of a Babe in Toyland*, "Lori gives me the address and we schedule our first practice. Sometimes the extraordinary is so ordinary."

Barbero still has the flyer promoting "the exciting debut of Babes in Toyland" at 7th Street Entry on June

Babes in Toyland—singer/guitarist Kat Bjelland, bassist Michelle Leon, and drummer Lori Barbero—rocked the Mainroom and 7th Street Entry many times during the era. This Entry gig in March 1990 was shortly before the release of their debut album, *Spanking Machine*. *Photo by Daniel Corrigan*

19, 1987, opening for the little-remembered bands Fright Wave and Fade to Gray. In true punk spirit, Barbero proudly noted her lack of training as a drummer at that point. "We rehearsed in my basement," she recalled, "and when we had to do the show, I remember I had to carry the drums up the steps, the same way they were set up in the basement, because I didn't know how to break them down, and I didn't know how to reset them up." Barbero couldn't hide her novice skills once she got to the Entry for sound check. Ron Anderson, still on First Ave's production crew thirty years later, put the microphones around her drum kit and went behind the sound board. "I can hear Ron going, 'Okay, Lori, hit the snare,'" she recalled. "And I'm sitting there. He goes, 'Lori, hit the snare!' And I bend over and go, 'Which one is the snare?' Everyone just started laughing."

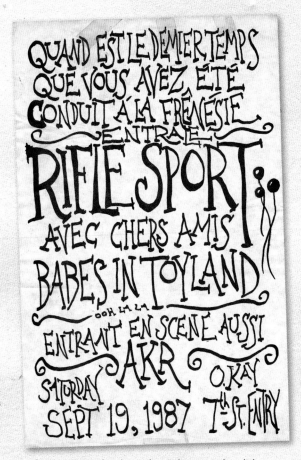

QUAND EST LE DERNIER TEMPS QUE VOUS AVEZ ÉTÉ CONDUIT À LA FRÉNÉSIE ENTRALL

RIFLE SPORT

AVEC CHERS AMIS

BABES IN TOYLAND

OOH LA LA

ENTRANT EN SCÈNE AUSSI

AKR

O.KAY

SATURDAY SEPT 19, 1987

7TH ST. ENTRY

One of Babes in Toyland's earliest shows at the club was opening for Rifle Sport in September 1987. This poster— in French, for some reason—promoted the Entry billing. *Courtesy of the Museum of Minnesota Music*

Thanks to Barbero's outgoing personality and Bjelland's charisma and talent, Babes found ample early support. Among those in their corner was former First Ave production manager Maggie Macpherson. "Everyone knew Lori," Macpherson recalled. "She was just so ingrained in the scene and such a big-hearted woman. So [Babes] were pretty well known from the start, and there always seemed to be a feeling they were going to be big." By the time they recorded their first single, "Dust Cake Boy," in 1989, they were a fixture in the Entry.

The Clams' Cindy Lawson—frontwoman for one of the few all-woman bands to regularly rock First Ave in the '80s—called Babes "a force to be reckoned with. There have been very few bands like them, women or otherwise, where your jaw just drops. Lori is such a powerful drummer, and Kat is really just possessed as a frontwoman."

Their Entry and Mainroom gigs also inspired an army of local women who were already in or about to start their own bands. Psychedelia-tinged guitar-pop band the Blue Up? took on a punkier tone, said frontwoman Ana Voog, after she caught her first Babes set. "I sat down right in the middle of the Entry, my knees were shaking so hard with excitement," she recounted. "It was winter, too, so the floor was all wet and gross. I couldn't help it. When I saw Kat unleash her pent-up aggression, I was like, 'Oh, that's how you do it.'"

Arzu Gocken, later of the Selby Tigers and Pink Mink, caught the Babes at an all-ages Entry matinee show while in high school and refused to go to classes the next day. "I told my mom, 'I've seen it all . . . ,'" Gocken laughingly recalled. "That sound they would make would just hit you so hard, but it was only three of them and it wasn't anything too complex. I thought, 'If they can do that, I can do it, too.'" Renowned rock critic Jessica Hopper was also a regular at the all-ages shows. She got her start in music journalism at age fifteen writing a response to what she thought were demeaning reviews of Babes in *City Pages*. "Music writers in town were mostly writing about them being a caustic, vitriolic punk band, or their amateurism," Hopper said. "To me, they meant so much more. They were life-affirming. They told me I belonged in the music scene as much as anyone."

Babes were also ambassadors of sorts for out-of-town bands at the Entry or Mainroom. Barbero became pals with groups from all over the map, including Nirvana, and would put them up at her house in the Minneapolis Uptown neighborhood. One of her band's first Entry gigs was opening for Dinosaur Jr. in 1988. Babes later joined Dinosaur Jr. on a triple-bill 1992 tour with British whir-rock innovators My Bloody Valentine, including a February 12 date at First Ave that still has ears ringing around town twenty-five years later. In 1990, Babes issued their full-length Twin/Tone debut, *Spanking*

Minnesota Historical Society Collections

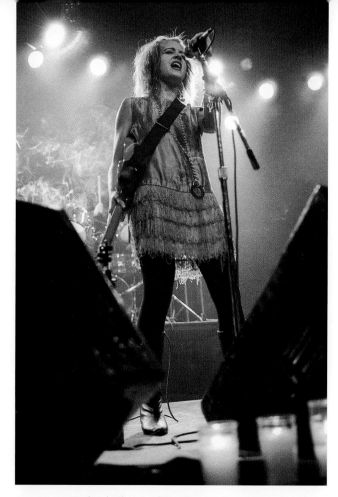

Ana Voog (Rachael Olson) of the Blue Up? was one of many musicians—both male and female—to be inspired by Babes in Toyland. The Blue Up? was a fixture at First Ave and the Entry in the late '80s and early '90s. *Photo by Jay Smiley*

The triple bill of Babes in Toyland, Dinosaur Jr., and My Bloody Valentine in 1992 was a powerhouse lineup of '90s rock. *Minnesota Historical Society Collections*

animated conversation with Tool's guitarist Adam Jones about the fact that she had never eaten a peanut butter and jelly sandwich. Months later, Barbero was midway through a set at First Avenue when an employee ran on-stage with a Fed-Ex package for her. "It was a 'special de-livery' and I'm sitting there in front of everyone opening this package," she recounted. "It was a peanut butter and jelly sandwich from Adam. I took one bite and threw it into the crowd."

Despite the Lollapalooza slot and ample media at-tention, Babes never enjoyed the kind of commercial breakthrough that many of their peers did during the '90s. They played First Ave throughout the decade and even returned to the Entry on occasion. Randy Hawkins pointed to their gig on May 29, 1994, as an indicator of how "the door count was always subjective" in the small-er room. Official capacity in the Entry is 250 people, but he believes they crammed in six hundred that night. "We actually said, 'The people in their crowd are small; we can fit a lot more in,'" Hawkins remembered. A recording of their Mainroom show on November 25, 2000, was fit-tingly used for the live album *Minneapolism*, the band's final release.

"They brought a lot more attention and respect to Minneapolis," said drummer Linda Pitmon, whose own, poppier all-woman trio Zuzu's Petals was another main-stay at the club in the early '90s. "Having the Replace-ments, Hüsker Dü, and Soul Asylum and Prince was cool, of course, but having this really unique, hard-rocking all-female band from there, I think that's what really showed we were a progressive scene."

Babes were also part of a wilder, noisier, more ex-perimental breed of punk bands that made their home at First Ave and especially the Entry, bands that could

Machine, and shot live sequences for their "He's My Thing" video with local filmmaker Phil Harder in the En-try. That summer they went on their first real tour, trav-eling across Europe with Sonic Youth, whom they had befriended during the New York art-punk band's many First Ave shows in that era.

"Once we went to Europe with them, then we final-ly started getting paid to do shows," Barbero recalled. "We came back and played with them in the Mainroom, our first Mainroom show." She thinks it was during that show or one soon thereafter when the raging Bjelland hit a fragile part of the stage and nearly crashed through it. "You know how she stomps and kicks," she said.

One of Barbero's favorite First Ave memories orig-inated in the band's 1993 Lollapalooza tour with fu-ture alt-metal kings Tool. After a show she got into an

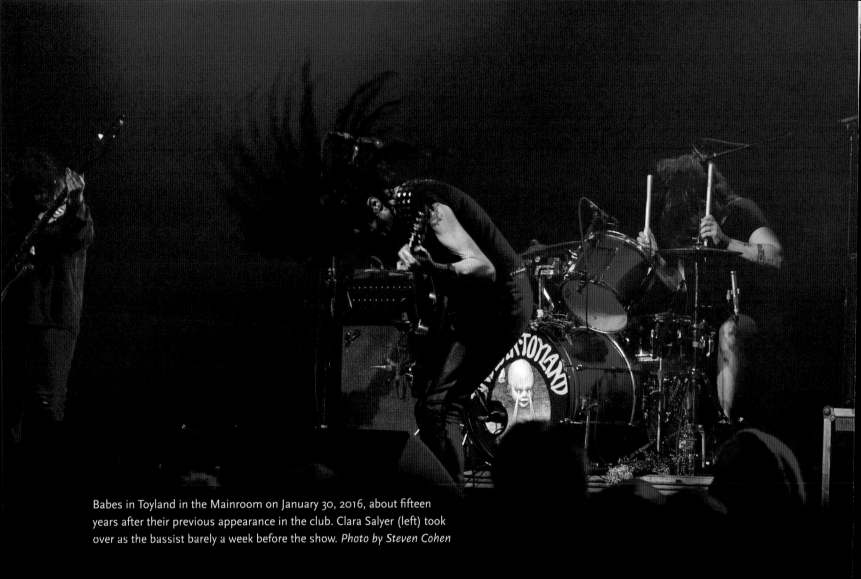

Babes in Toyland in the Mainroom on January 30, 2016, about fifteen years after their previous appearance in the club. Clara Salyer (left) took over as the bassist barely a week before the show. *Photo by Steven Cohen*

not have hoped for much more of a commercial break than a record deal with Minneapolis's noise-rock label, Amphetamine Reptile. Led by Tom Hazelmyer and Pat Dwyer, AmRep built up a roster starting in the late '80s that included Cows, Hammerhead, Halo of Flies, and Janitor Joe, plus such out-of-towners as Unsane, Boss Hog, Helmet, and the Melvins. The AmRep band that made the biggest impression was definitely Cows, led by bugle-blowing, wild-eyed frontman Shannon Selberg.

"We never knew what to expect with them—and were always kind of afraid," Molly McManus said. Hawkins lists off Cows shows like he's reading a *News of the Weird* column. Among the better stunts pulled by the band involved covering the entire Entry in tinfoil before their show. "One of the funniest nights ever in that room," the sound man said. On another occasion somebody kicked

Although they never hit it big nationally, Run Westy Run, led by brothers Kraig, Kirk, and Kyle Johnson, established a rabid local following. They would fill not only the Entry, as seen in this late-'90s shot, but the Mainroom as well. *Photo by Jay Smiley*

Three decades after their heyday, the Westies continued to reunite and entrance fans with their great stage shows. Kirk Johnson got up close and personal at a Mainroom concert in December 2013. *Photo by Steven Cohen*

the urinal off the wall in the Entry bathroom and "the floor of the club was covered in six inches of water." And then there was the time Selberg pulled out a live crab during a show and tossed it into the crowd. "Pretty soon this girl is screaming her head off because the thing has attached itself to her foot," Hawkins recounted.

Run Westy Run may have been mellower and Stonesier musically than the AmRep crowd, but they were equally unpredictable onstage. "If I had to name the band whose shows I loved seeing the most at First Avenue, it would probably be Run Westy Run," said John Munson of Trip Shakespeare and Semisonic. He fondly recalled a gig where they brought in floor lamps: "Those were the only lights in the room," Munson said. "It doesn't sound like anything special, but it was." At another show, they brought out leaf blowers rigged with toilet paper rolls on a wire. Per Munson: "They would hit the button on the leaf blower, and it would just shoot out the paper into the crowd. It was an amazing visual effect. I have so many super-vivid memories of their shows."

Duluth rocker Alan Sparhawk—whose then-fledgling

(Opposite) Cows frontman Shannon Selberg—seen here sporting a cowboy hat for an Entry show in October 1988—could always be counted on to put on a lively performance. *Photo by Daniel Corrigan*

band Low had begun playing the Entry in this era—recalled Run Westy Run starting a fire in a bin onstage during a Mainroom show. "I don't know how they got away with that, but it sticks with me every time I'm up there playing that stage," Sparhawk said. Despite some of the headaches they caused, Conrad Sverkerson also counts Run Westy Run as one of his all-time favorite local bands to work with. "I always thought the Westies should have done better than they did," the stage's guru said. "I mean, they played some *shows.*"

Two Minneapolis bands with relatively long histories at First Ave and the Entry did break through and enjoy the commercial perks of the '90s. First came Soul Asylum, who were on the ropes from 1990 to 1991 once A&M Records dropped them after their album ... *And the Horse They Rode in On* sold poorly. The band found some solace those years playing their usual shows around Thanksgiving or Christmas. "That was a real tradition," guitarist Dan Murphy said. "We'd play that for a lot of years. Even after the record didn't do as much business, we could still rock that club."

Bassist Karl Mueller sold a vintage muscle car to help pay for the demos that would earn Soul Asylum

Soul Asylum continued to book gigs at First Ave even after they made the leap to national acclaim in the '90s. *Photo by Jay Smiley*

attention from Columbia Records, which issued *Grave Dancers Union* in October 1992. The initial singles "Somebody to Shove" and "Black Gold" became modest radio hits, enough to turn their year-end First Ave stand into a packed three-night run that year. Then in June 1993, the video for "Runaway Train" hit MTV, the record went platinum twice over, and the band never looked back. But Soul Asylum did keep coming back to First Ave.

"When the band got big, there were no great venues [larger than First Ave] to play in Minneapolis," Murphy said. "We never really excelled at theater shows. It was super fun to play First Avenue sort of semi-unannounced—just announce it a couple weeks before the show. Those were some outrageous shows, by far the most fun shows. We'd been touring a lot, so to go back and play First Avenue in front of like eighteen hundred people in there, it was crazy."

Semisonic found a similar level of national and even international success at the tail end of the decade, but its members were already packing First Ave in the early '90s, as Trip Shakespeare. After the release of their first album for A&M Records, *Across the Universe*, Trip played

about a half dozen two-night stands in the Mainroom, with the first on June 10–11, 1990.

"Those two-night stands were cool because you weren't traveling on the day of the show," recalled guitarist/co-vocalist Dan Wilson. "It was all set up, and you could come back and learn a new song at sound check. In a sense, there was a heroic feeling about it. Like we had sort of earned this exalted spot that it took a lot of work to get to." Trip Shakespeare would not go much further, though. After its second album, *Lulu*, eschewed the grungy flavor then coming into vogue, the band was also dropped from A&M Records. They played a final two-night stand on April 7–8, 1993, and called it quits soon after.

By the summer of 1993, Dan Wilson and John Munson were back in the Entry fronting a new, more straight-ahead pop/rock band called Pleasure with drummer Jacob Slichter. "In the breakup of Trip Shakespeare, different people took different items from the divorce," Munson recalled. "Matt [Wilson] took the recording equipment, and we took the van. We started touring immediately and learned to play together as a new ensemble." By the beginning of 1995, Pleasure had built up

Trip Shakespeare—bassist John Munson, drummer Elaine Harris, guitarist/singer Matt Wilson, and guitarist Dan Wilson—at a Mainroom show in January 1992. Following the band's breakup the following year, Dan Wilson and Munson went on to further acclaim as Semisonic. *Photo by Daniel Corrigan*

Three-fourths of the original Trip Shakespeare lineup—John Munson, Matt Wilson, and Dan Wilson—took the stage together for a fundraiser for stage manager Conrad Sverkerson in September 2006. *Photo by Steven Cohen*

enough buzz to play a bona-fide showcase for major-label executives on home turf at the not-so-major-sized Entry.

"We had done some shows at the 400 Bar, and then when it came time to show our wares to the record labels, we booked a show at 7th Street Entry, and we packed it," Dan Wilson recalled. He listed representatives from Geffen, Elektra, Capitol, and MCA, plus prospective artist managers, who were in attendance that night. The recording industry bigwigs were even interested enough in the band to brave the Entry's dingy basement green room. "All of them were at this one show and came downstairs afterwards," Wilson continued. "A couple of them didn't dig the show, but a bunch of them did. And that's when the pursuit began of the labels wanting to sign Pleasure." He thinks the setting for the showcase was key to their success, versus "some rehearsal space in Los Angeles." Said Wilson, "John and I had kind of super honed our craft [in the Entry]. Our amps were super loud, and our attitude and sense of ownership of the place was super strong." After an initial deal with Elektra fell through, the band

signed with MCA Records. Along the way, though, they discovered that another band had copyrighted the name Pleasure. Thus, the Entry calendar listing for September 29, 1995, reads "Semisonic (née Pleasure)."

Semisonic would take three more years and a second MCA album before it hit the big time. The trio's 1998 LP, *Feeling Strangely Fine*, went platinum on the strength of the No. 1 modern-rock single "Closing Time." At that point, the group graduated to theaters and other larger venues. As touring wound down for their third record, 2001's *All About Chemistry*—well received by fans and critics, but less of a commercial success—the band convened at First Ave one last time on June 20, 2002, another farewell show of sorts recorded for a live album, *One Night at First Avenue*. Semisonic never formally split up, though. The band still reunites regularly and every four or five years returns to First Ave.

After cowriting Grammy-winning mega-hits for Adele and the Dixie Chicks, Dan Wilson in 2010 relocated to Los Angeles, where he works with musicians

from all over. "I'll mention that I grew up in Minneapolis, and they say, 'Ah, that's like one of the best cities for me,'" he said. Usually, First Avenue is mentioned as a major reason why. "Probably because of First Avenue, but other reasons, too—Minneapolis is a very welcoming music town. A lot of musicians I know who do kind of left-of-center music will cite Minneapolis as one of their best early places to play. There's a kind of openness, and a kind of artsy-ness, but they're not snobbish. First Avenue becomes like the welcoming grounds for that vibe."

The Gear Daddies and the Jayhawks helped make First Avenue a hub for another '90s "alternative" genre: alt-country. The Gear Daddies were the more popular of the two local twang-rock acts in the late '80s, drawing large, rowdy crowds. "We eventually made that club a lot of money, but probably gave 'em a lot of headaches, too," said Daddies leader Martin Zellar, referring to high sales at the bar during their shows. In 1992, though, after a memorable appearance on *Late Night with David Letterman*, Zellar's crew went on hiatus—right about the time the Jayhawks finally crossed over to become a Mainroom act.

"It seemed like we played there a ton, but I don't ever remember feeling like we had made much of an impression there until 1991," recalled Jayhawks bassist Marc Perlman. The Americana band, led by singer/songwriters Mark Olson and Gary Louris, was more a fixture at the 400 Bar in the late '80s, when it also began touring regularly. First Ave frequently called on the Jayhawks to open for other touring rootsy acts, including the Bo-Deans, Long Ryders, and Beat Rodeo. Then in 1991, the Minneapolis twangers landed a deal with American Recordings, a new rock label from Def Jam Records founder and mega-producer Rick Rubin, which was already red hot thanks to the Black Crowes.

Their acclaimed debut on that label, *Hollywood Town Hall*, came out in September 1992, and the Jayhawks packed First Ave as headliners for the first time that December, with the newly solo Slim Dunlap opening.

Perlman was struck by the full room. "We were touring and kind of lost touch with things while we were gone," he recalled. "It was the first time I got up there, looked out at the crowd, and said, 'Wow, we're doing all right.' And my mom was there, too. It was just an unforgettably great feeling." After that, the Jayhawks became one of the Mainroom's most ingrained local headliners. They played many multiple-night stands, including some memorable ones in 1997 after Olson's departure. "That was like the acceptance we needed," Perlman said.

During their extensive early-1990s touring, the Jayhawks befriended a younger alt-country band at the Blue Note in Columbia, Missouri, whose members would soon become alt-country torchbearers and First Ave regulars. "They put us up at their house, and they kind of struck us as these Americana geeks wanting to talk up the Flying Burrito Brothers and whatnot," Perlman remembered. A year later, the Jayhawks returned to the area and shared a bill with those geeks. "We went out and saw their set, and I said to Gary, 'We should've been nicer to these guys.' They just had it."

The band in question was Uncle Tupelo, whose co-leaders Jay Farrar and Jeff Tweedy went on to front Son Volt and Wilco, respectively, by the middle of the decade. With Uncle Tupelo, they started playing the Entry in 1991, first opening for Royal Crescent Mob and then on a bill with the Mighty Mofos, featuring the room's veteran sound man Billy Batson. "[McClellan] came to me about a week before the show and asked if they could play that night, the only night that would work for them—and they wanted to go on last," Batson recalled. "I said, 'Fine, good luck following us.'" Batson contends

(Opposite top) Mark Olson and Gary Louris fronted the Jayhawks during their rise to prominence in the late 1980s, playing many gigs in the Entry and the Mainroom. Five years after this 1990 Entry show, Olson left the band. *Photo by Daniel Corrigan.*
(Opposite bottom) The Minneapolis supergroup Golden Smog at 7th Street Entry in July 1990: (left to right) Marc Perlman of the Jayhawks, Dan Murphy of Soul Asylum, Gary Louris of the Jayhawks, Kraig Johnson of Run Westy Run, and Soul Asylum's Dave Pirner on drums. *Photo by Daniel Corrigan*

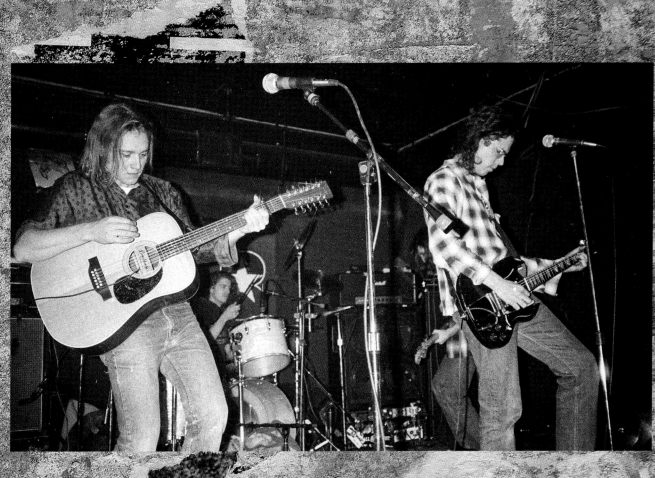

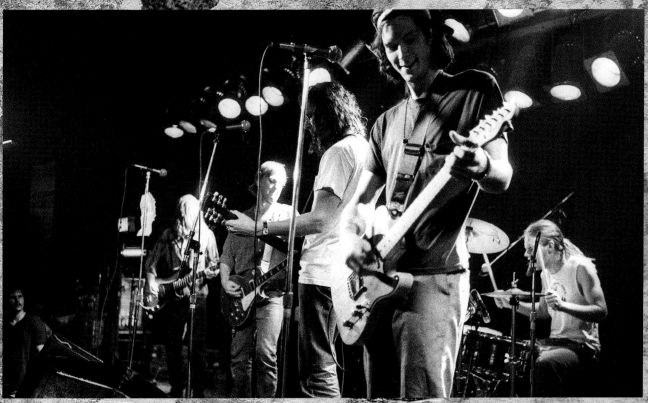

that the Mofos "out-rocked" Uncle Tupelo, who were also "out-countried" by the third band on that night's curious lineup, a true old-school country band called Stetson that normally played VFW halls. Stetson's leader Nate Dungan—later the frontman of Trailer Trash—was more favorable in his assessment of the night. "The guys from Uncle Tupelo stood by the stage, watching our set," Dungan said. "I guess they liked it because they said they wanted to get a VFW band to open for them wherever they played. It was one of those nights where the mood was like, 'Why the hell not?!' It worked, and it was a blast."

Uncle Tupelo quickly developed a Twin Cities following, and by 1994—after the release of their final album, *Anodyne*—the trio held down a two-night stand with an expanded six-man lineup in the Mainroom, on March 19 and 20. The opening act both nights was Michigan-bred songwriter Joe Henry, who spent ample time in Minneapolis recording with the Jayhawks as his backing band on a pair of excellent early-1990s alt-country albums. Not surprisingly, Gary Louris of the Jayhawks joined Uncle Tupelo onstage during the encore on the second night.

The branches on the Jayhawks/Uncle Tupelo/Joe Henry family tree get pretty twisted from there. Jeff Tweedy soon was singing on the First Ave stage in the all-star band Golden Smog with Louris and Perlman (plus Soul Asylum's Dan Murphy and Run Westy Run's Kraig Johnson); Henry's band for the March shows featured Twin Cities bassist Jim Boquist, who would soon join Farrar in Son Volt, and drummer/co-vocalist Tim O'Reagan, who would soon join the Jayhawks.

"We had a lot of fun playing the club in those days, because it always felt like coming home, there would be so many friends to see there," Wilco bassist John Stirratt said two decades later. Stirratt joined Uncle Tupelo on tour in 1994 and then continued on with Tweedy. He said "it was no coincidence" the first show Wilco played outside its home base of Chicago was at 7th Street Entry, on November 21, 1994. "It was kind of like being called down to Triple-A, but it didn't feel like a demotion, it was pretty exciting," Stirratt said. The band opened with "Box Full of Letters" and tore through the rest of the songs from its debut album, *A.M.*, which would arrive the following

March. Also on the set list that night were "Outta Site (Outta Mind)," three of Tweedy's Uncle Tupelo cuts, several songs that were never issued, and "Pecan Pie," which would appear on Golden Smog's 1995 LP, *Down by the Old Mainstream.*

Wilco's next visit was part of still another well-remembered triple bill, sandwiched between Aussie instrumentalists the Dirty Three and headliners Pavement on March 26, 1995. After that, Tweedy's band became headliners themselves and hit the club at least once a year for the next five years, including several two-night stands. "All the way back to Uncle Tupelo, this town has made us feel good, made us feel like we could do this," Tweedy said when he returned to First Ave in 2015 with his son Spencer in their namesake band. "It's an oasis for every rock band in the world."

One particularly memorable Wilco night was April 2, 1997. The band happened to be booked opposite the No Depression tour in the Entry, sponsored by the alt-country magazine named after a Carter Family song revived by Uncle Tupelo. The musicians on that tour would also become First Ave mainstays, including Dallas-reared headliners the Old '97s and a North Carolina group called Whiskeytown, led by twenty-two-year-old singer/songwriter Ryan Adams.

Apparently, Adams's image as a cocky and precocious rock-star-in-the-making was already well known by then. Bootlegs of Wilco's Mainroom set from that night capture Tweedy making a few mocking comments about Adams from the other side of the Entry door. "I remember really feeling that was incredibly rude," Stirratt later confided. "I don't think there was really any reason for it other than maybe whatever reputation Ryan had at that point. We had met him a time or two before that, and he was nothing but nice to us, so I don't really think it was merited."

After Wilco's out-of-town debut in the Entry, Son Volt followed with its own on June 16–17, 1995. Farrar and Uncle Tupelo drummer Mike Heidorn had been regularly coming to Minnesota to rehearse and record with an all–Twin Cities crew that included bassist Jim Boquist, his multi-instrumentalist brother Dave Boquist,

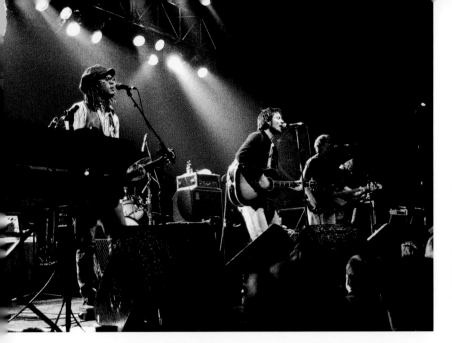

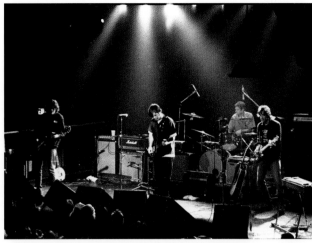

Jeff Tweedy (middle) has been playing First Ave's Mainroom stage since his days with Uncle Tupelo. He was a regular there with Wilco beginning in the latter half of the '90s, including this show from 1999. *Photo by Steven Cohen*

Uncle Tupelo's other offshoot band, Son Volt, also headlined the Mainroom in the '90s. Jay Farrar (center) and drummer Mike Heidorn were joined by Minneapolis brothers Dave and Jim Boquist to form Son Volt in late 1994. *Photo by Steven Cohen*

pedal-steel wiz Eric Heywood, and producer Brian Paulson. All were involved in the making of *Trace*, Son Volt's classic first album, issued that September. *No Depression* founder Peter Blackstock drove sixteen hundred miles from Seattle to the Entry to put the band on the cover of his magazine's first issue. "It's an auspicious live debut," Blackstock writes in the liner notes for *Trace*'s expanded twentieth-anniversary edition. "The band revisits some of Farrar's material from the Uncle Tupelo days for part of the set, pleasing longtime fans who call out for old favorites. 'But it's the new songs I'm digging most,' I write in the cover story for the first issue. Soon enough, the rest of the world will get to hear them."

Son Volt also quickly became a Mainroom headliner once that album arrived. Wilco eventually became the more commercially successful band, but early on many First Ave staffers considered Son Volt the pinnacle of the alt-country wave. "Those first shows in the Entry were so wonderful," said LeeAnn Weimar, who noted that the timing of Son Volt's debut in 1995 coincided with the end of the Olson/Louris-era Jayhawks. "We used to do this annual holiday-time [year-end] show with the Jayhawks, two nights in the Mainroom," she recalled. "And we thought, 'What are we gonna do?' I said, 'Well, how about

Son Volt?' And it worked!" The Jayhawks really should have been nicer to those Americana geeks.

While First Avenue was part of the vanguard both boosting and benefitting from grunge, alt-rock, and alt-country, it was late to the party when it came to the other booming genre of the time. Rap and hip-hop came to the forefront of the pop music world in the 1990s, but it was still conspicuously scarce at the club early in the decade. And when it did make it to First Ave, there were a few high-profile cases where things went greatly awry.

"The club was very much anti-rap back then," said sound man Randy Hawkins. "There was definitely an undertone of racism to it, but rap was also just becoming big and was still pretty new. And they had a couple really bad nights, too, through no fault of the club's."

Steve McClellan did get a jump on the genre in one prominent early booking: Rap's first mainstream crossover act, Run-D.M.C., arrived at First Ave three days after Christmas in 1983. The trio had only one single to its name, "It's Like That/Sucker MCs," and was still three months from issuing its debut album. What the New

New York's Run-D.M.C. was one of the first rap artists to cross over to mainstream airplay, and they were one of the first to play First Avenue when they came in 1983. They returned five years later, following the release of their fourth studio album, *Tougher Than Leather*. *Courtesy of Steve Decker*

Hip-hop pioneers Grandmaster Flash and the Furious Five were scheduled for a Mainroom show in March 1984, but the concert was canceled. They never returned to the venue. *Courtesy of the Museum of Minnesota Music*

Yorkers were doing in Middle America over the holidays is a mystery, but the production notes and contract rider were as concise and clear as could be: They asked for a table (for the turntables), two setups for microphones, and very little else. They earned $1,100 off about 220 ticket sales, with about a hundred additional curiosity-seekers taking advantage of the many comp tickets handed out.

"It was still such a new thing, it wasn't even called hip-hop then, it was only called rap," McClellan recalled. "People didn't quite know what to make of it." The GM also proudly remembers booking Gil Scott-Heron a couple of times in the '80s. The street poet who had a minor hit with "The Revolution Will Not Be Televised" in 1970 was being newly heralded as a forefather to rap. "We did about a thousand people, and I thought it was just a great show on all fronts," McClellan said, singling out Jamaican dub poet Linton Kwesi Johnson in the opening slot. "He had this soft voice, and it was hard to hear him, but the crowd listened intently. It was one of the quietest times I remember the club getting when it was packed."

First Ave went from that hushed audience to "Bring the Noise" with Public Enemy on December 12, 1988, a few months after the band dropped its groundbreaking and bombastic second album, *It Takes a Nation of Millions to Hold Us Back*. Stage manager Conrad Sverkerson remembers a surprisingly relaxed vibe backstage when the group—led by stern, radical rapper Chuck D and his wonkier, clock-attired sidekick Flavor Flav—returned to the club in 1990.

"It was always one of the more professional, well-run venues, and just had a great vibe in the room. Our shows were always strong there."

—Chuck D of Public Enemy

Influential poet and musician Gil Scott-Heron was a particular favorite of Steve McClellan. *Courtesy of the Museum of Minnesota Music*

Rappers Flavor Flav and Chuck D were back in the Mainroom with Public Enemy on October 3, 1999. Rising local hip-hop act Atmosphere was one of the openers. *Photo by Steven Cohen*

"We were doing two shows in one day, so we had to get the first show done by 8:30 and turn the crowd," Sverkerson recounted. "I was pretty young, and really not that experienced at my job. And I went up to—it wasn't even their tour manager, it might have been [DJ] Terminator X or somebody—and I said, 'I gotta get you guys onstage.' And he was like, 'Well, go wake Chuck up.' I was like, 'I don't even know Chuck.' I look, and he's sleeping on the couch in the dressing room. And I go up to him: 'Chuck! Chuck!' And he's not budging, so I just gently grabbed him. 'You gotta get up!' He popped up and goes, 'Where's my mic?' I went and grabbed him his mic, and they went out and they did an hour and forty-five minutes."

After the first set, though, Flavor Flav got worked up and started shouting, "Where's the promoter? This stinks! It's toast, man!" The wooden stage wasn't sturdy enough, and he wanted it fixed before the second set. He and Chuck were jumping around a lot, as they always did, and as a result the records on the turntables kept skipping. Sverkerson kept a cool head: "Between now

and an hour from now, the stage isn't going to change. So I guess we're gonna just have to deal with it," he recalled telling them. "But I mean, they were great." Apparently the fondness was mutual, at least with Chuck D: "It was always one of the more professional, well-run venues, and just had a great vibe in the room," he said in an interview before PE came back to First Ave in 2012. "Our shows were always strong there."

One-hit wonders Technotronic ("Pump Up the Jam") opened those PE shows in 1990, which resulted in another funny story from Sverkerson: When he asked the Belgian duo how long their warm-up set would be, the response was a precise "twelve minutes." He asked if they could stretch it to about twenty minutes to fill in more of their allotted time. They replied, "We find after twelve minutes we kind of start to lose the crowd." And that wasn't Technotronic's only gig at the club in 1990, either. On March 12 they also opened for DJ Jazzy Jeff & the Fresh Prince, who were out building hype for their second album two years after their novelty hit, "Parents Just Don't Understand." Despite the fact that the Fresh Prince would turn into one of the biggest celebrities to ever take the First Ave stage after he became Oscar-nominated actor Will Smith, little is remembered about this appearance.

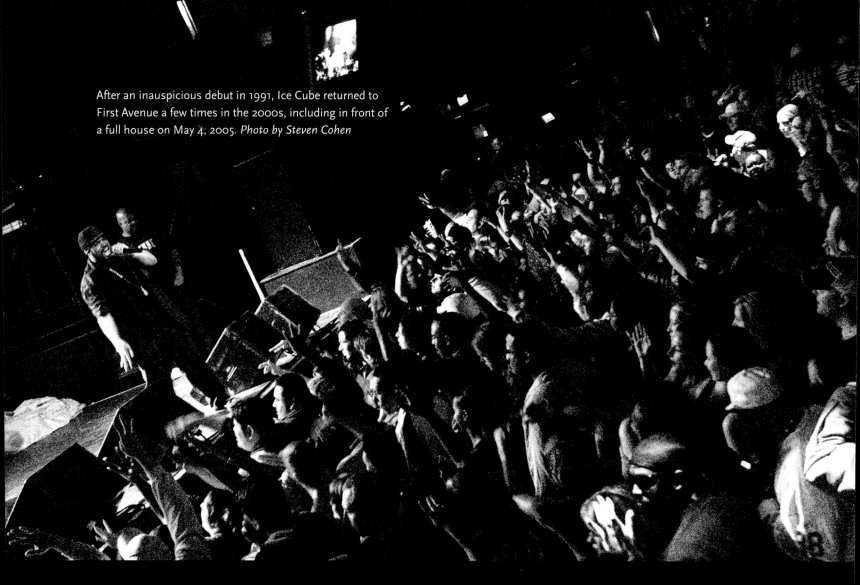

After an inauspicious debut in 1991, Ice Cube returned to First Avenue a few times in the 2000s, including in front of a full house on May 4, 2005. *Photo by Steven Cohen*

In 1991, Ice Cube stood at the other end of the rap spectrum from the amiable Fresh Prince, even though he, too, would go on to become a PG-rated Hollywood actor. He also booked two sets on one date, March 4, now one of the most notorious nights in First Ave history. Cube (O'Shea Jackson) was two years removed from his stint in N.W.A. but kept up the gritty portraits of Los Angeles street life on his 1990 solo debut, *AmeriKKKa's Most Wanted*. Quite simply, his music was unlike anything First Ave had hosted before. During the second, more alcohol-tainted show that night, several fights broke out that turned into a brawl and then an all-out riot, with some of First Ave's own staff injured in the melee.

A similar incident had erupted a year before, during the fifth anniversary of the More Funk Thursday dance night. The weekly party where Prince and Jimmy Jam used to test their latest jams, More Funk had seen sporadic trouble in 1990 that boiled over at the anniversary. DJ Roy Freedom said it was more symptomatic of a citywide problem with gang members from Chicago coming to Minnesota. "At the end of the night, when the lights came on," he said, "all of a sudden like twenty guys just went through the crowd and just went crazy. And they went after basically all of our security people." Freedom got on the microphone and started yelling that the police were on their way. "It cleared out really quick," he said.

The ruckus at Ice Cube's show proved harder to diffuse, though. Tension started during the all-ages show when a bottle was tossed from the balcony, and some guys on the floor went looking for who did it. For the second show, it was there as soon as the doors opened. Stationed on the floor for the second show, Molly McManus

remembers the spinning siren lights on the ceiling—a signal to staff a fight has broken out—"pretty much going off all night."

The staff tried fruitlessly to stymie all the conflicts. Booker Rich Best and stage manager Sverkerson both said it was their scariest experience while working at the club. "I remember saying to McClellan, 'I don't know how you could put your employees through something like this,'" Sverkerson said. At some point, even the front-of-house sound man was punched out, which marked the end of the concert. Said McManus, "We had some violence at some of the hardcore punk shows, too, so it wasn't just rap, and we weren't all that inexperienced with it. But this was just a whole other level of it. I just remember desperately trying to get people out of there safely. There were like twenty-five of us trying to handle a crowd of fifteen hundred. A lot of us seriously had post-traumatic stress after that one."

Ice Cube's concert also had a lingering effect. "The cops basically said, 'It's your problem if it's a rap show,'" McClellan recalled of the aftermath. "And a lot of customers got scared to come down after that, whether it was a rap show or not. So we had to be a lot more choosy [with bookings]." He still contends, though, that the problems at both the More Funk night and the Cube concert were classic cases of a few bad apples. "It was less than ten percent shitheads," he said, "but ten percent in a crowd of fifteen hundred is 150 shitheads. That's a lot—enough to give the club and the music a bad reputation."

A sign of how much things eventually changed, Ice Cube was welcomed back to First Avenue on subsequent visits. The rapper spoke highly of both the club and the Twin Cities music scene in a 2013 interview, without any memory of the 1991 debacle: "To me, Minneapolis has always been a live town," Cube said. "My first time coming in to play First Avenue was a big deal. I saw [*Purple Rain*] when it came out in 1984. I had been a big Prince fan from day one. I've always been intrigued by the scene there because of him. I loved the Time back in the day, too. So for there to be a good hip-hop scene there now is not a surprise."

Although it scaled way back, First Ave still brought

By the time the Beastie Boys came to First Ave in 1992, they had evolved their musical talents to include playing their own instruments. They shared a bill with punk pioneer Mike Watt's post-Minutemen band, Firehose. *Courtesy of the Museum of Minnesota Music*

in a few major hip-hop acts after Ice Cube. The Beastie Boys finally played there May 12, 1992, at the start of their "Skills That Pay the Bills" tour behind their third album, *Check Your Head*, on which they played many of the instruments themselves. The trio spent the week before the show rehearsing at Prince's Paisley Park, essentially learning how to perform as a live band rather than a rap trio. "It is possible to play (instruments) and rap at the same time, but we haven't perfected it yet," Beastie Adam "MCA" Yauch admitted to the *Star Tribune*'s Jon Bream while at Prince's complex, where they were scolded for skateboarding on the curved sound-stage walls. "They've been getting really uptight with us, but it's like so much fun to skate on it," Yauch said.

Another act dubiously deemed "safe" to book during this era, "Jump Around" hitmakers House of Pain brought trouble with them on April 5, 1993. Minneapolis police officers arrived around sound check to ask about an incident the night before in Chicago: One of the blokes

De La Soul first performed the Mainroom with A Tribe Called Quest in 1993 and have been back several times since. Here rappers Posdnuos, Maseo, and Dave perform on August 27, 2009. *Photo by Steven Cohen; ticket courtesy of Daniel A. Leary*

Ms. Lauryn Hill returned to First Avenue on January 18, 2011, and sold out the room after largely staying out of the public eye for the better part of the previous decade. *Photo by Steven Cohen*

in Boston's Irish American hip-hop group or their crew had allegedly pulled a gun on someone. Randy Hawkins (filling in as First Ave production manager while Conrad Sverkerson toured with Soul Asylum) saw more signs of trouble all over the group's rented Ryder truck, which had been "covered with spray paint from top to bottom," and which they were using to haul "about a $25,000 lighting rig," he said. The paint apparently wasn't reserved for the truck, either. "They were all huffing paint in the dressing room before the show," Hawkins marveled.

Even firing on all cylinders, House of Pain would have had a hard time outshining their opening act on that tour: Rage Against the Machine, who by all accounts stole the show. "That was a big mistake," said booker Rich Best. The Los Angeles rap-rock pioneers were originally booked to open for Stone Temple Pilots a few months earlier in the Entry, he remembered, but that show got cancelled (perhaps STP realized the act they had to follow). So Rage played to a packed Mainroom its first time in town. "I had never seen a singer have that much command over a crowd," Best said of rapper Zack de la Rocha.

Attending his very first show at the club that night, future *City Pages* writer Pat O'Brien remembers de la Rocha speaking out about white oppression and the American Indian Movement (AIM), headquartered in Minneapolis, and being wowed by Tom Morello's innovative guitar work, too. "Fifteen-year-old me was, of course, immediately taken by them," he said. "I watched House of Pain play an absolutely terrible, sloppy, too-short set and then literally never thought about them again."

Two acts that brought a more sophisticated, jazzy, Afrocentric tone into hip-hop, De La Soul and A Tribe Called Quest played First Ave together on December 10, 1993. While that double bill would later assume greater status, maybe the most stacked hip-hop lineup in the club's history came in November 1996, when the Fugees, the Roots, and Goodie Mob performed together. Led by Wyclef Jean and twenty-one-year-old standout Lauryn Hill, the Fugees had just hit the charts with their "Killing Me Softly" remake and would last only another year as a group. The Roots didn't let the middle-band slot keep them from doing their usual improv jam session, during which frontman Black Thought freestyled through impressions of each Wu-Tang Clan member. Atlanta duo Goodie Mob—with singer Cee-Lo—also made a lasting impression, according to Lars Larson, who ranked the show No. 8 on *City Pages*' list of the top twenty First Ave concerts. "People who were in attendance knew this was a special night, and knew something like this would never happen again," he wrote.

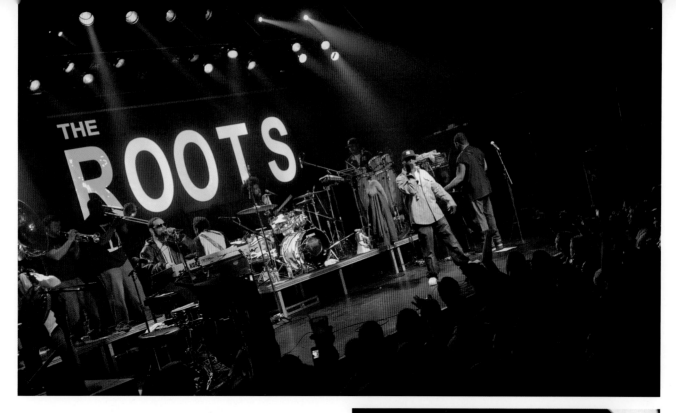

Both the Roots and Lauryn Hill made it back to the club many times on their own. The most memorable Roots date came in 2009, during a July 4 break from their first season as the *Late Night with Jimmy Fallon* house band. They went from playing thirty-second snippets on TV to a nonstop two hours onstage, one song bleeding into the next. Drummer Questlove—a renowned Prince fanatic—has returned many times on his own, too, DJing at some of Bobby Z's fundraiser concerts and other Prince-related events. Questlove also backed D'Angelo when the reclusive R&B genius picked First Ave as one of the first venues he played in 2013, following a decade-long hiatus.

Hill similarly chose the club in 2011 as she came off a nine-year hiatus. The January 18 show started about two hours late but proved worth the wait. Upon her return in 2016, five months after Prince's death, her tardiness shrank to about forty-five minutes and her band grew to an almost-unwieldy enormity. Hill ended her set with a moving speech about what First Ave's patron saint meant to her—and probably the most devastating version of "Nothing Compares 2 U" ever heard in that building.

The Roots at First Avenue, March 20, 2007. Drummer Questlove showed his respect for the Minneapolis music scene by donning a Morris Day sweatshirt during the concert. *Photos by Steven Cohen*

By the early 2000s, First Avenue's calendar was regularly loaded with hip-hop acts each month, including names from the Twin Cities' own booming community. The roots of local hip-hop were almost singlehandedly planted by a ragtag group of Minneapolis rappers and DJs who began booking monthly Entry showcases in 1997.

"I think we reopened the doors to hip-hop at the club, because at the time it had sort of gone away there," said Brent "Siddiq" Sayers, president of Rhymesayers Entertainment. Billed as the "Rhyme Sayers Collective" early on, the informal union of friends and friendly competitors grew into Minnesota's biggest record label and one of the top independent labels in all of hip-hop by the mid-'00s. Rhymesayers has its own prosperous record store, Fifth Element, in Minneapolis's Uptown district. It also puts on a massive music festival, Soundset, which took its name from a popular dance night started in First Ave's Mainroom.

In 1997, however, Rhymesayers only had flyers and word of mouth, which was still enough to make their first Entry showcases a success. Foremost on those early lineups were Beyond and Atmosphere. Later known by the rapper name Musab, Beyond issued the first full-length album on Rhymesayers, 1996's *Comparison*. And Atmosphere would become the flagship act not only for the label but for all of Minnesota hip-hop. Other names on the Entry bills in 1997 and '98 included the Native Ones (later Los Nativos), Kanser, Gene Poole, Phull Surkle, Extream, the Fam, Mudkids, J-Live, DJ Stage One, DJ X-Caliber, and later Sixth Sense, which featured two wily high schoolers from St. Paul known as Eyedea and DJ Abilities.

"We started out trying to do our own parties, kind of following what the rave promoters were doing," recalled Atmosphere rapper Sean "Slug" Daley, who also became Siddiq's chief partner in Rhymesayers. "But those parties wound up being too much of a mess, with too many young kids on drugs and technical problems. So that's when we kind of went to [the Entry], where people knew what they were doing. And that's when we got Randy Hawkins in our corner."

Although he was more of a punk-rock kid and had played bass in the band Charlie Don't Surf, Hawkins recognized the talent as well as the positive side of the upstart hip-hop crew. "Kids were having fun at their shows, and they were pretty mixed racially," the Entry sound man remembered. "There were never any problems at their shows." Sometime in 1998, Hawkins pushed the Rhymesayers crew on McClellan, suggesting he let the fledgling collective put together its own night in the Mainroom "and see what happens," he recalled. What happened was the biggest opening night ever for a dance party at First Ave. It was also one of the shortest-lived dance nights in the club's history.

"Initially it was just going to be in the Entry, but summer was coming, so kids were going to be out of school," Slug recalled of the first Soundset night, held in June 1998. "They took a chance on us and gave us Wednesday nights in the Mainroom, and we fucking blew the roof off it. It would pack First Ave every Wednesday." Siddiq added: "It was totally a unique, new thing for the club. I don't think anybody else in town was doing anything else like it."

While it was more a traditional dance night than the series of live sets of today's Soundset festival, Atmosphere, Musab, and guests such as Kanser would still pop up for cameo appearances. Slug contends that the

> "They took a chance on us and gave us Wednesday nights in the Mainroom, and we fucking blew the roof off it. It would pack First Ave every Wednesday."
> —Sean "Slug" Daley of Atmosphere, on Soundset nights

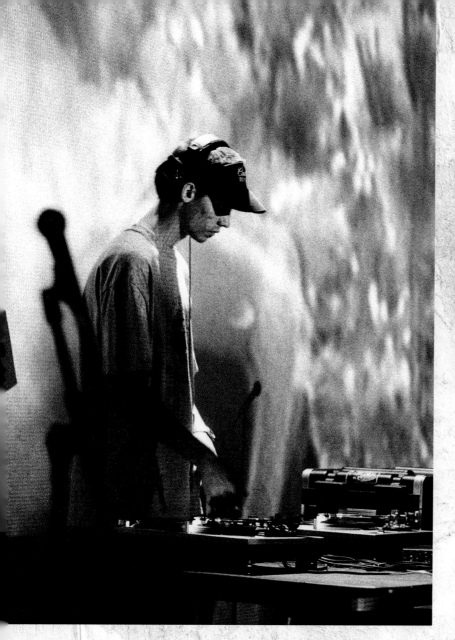

(Left) Seen here DJing in the Mainroom in 1997, Sean "Slug" Daley of Atmosphere helped to put Twin Cities hip-hop on the map. He and his Rhymesayers cohort found a home at First Avenue and 7th Street Entry. *Photo by Daniel Corrigan.* (Above) Brother Ali joined Rhymesayers Entertainment in the late '90s and released his first album on the label in 2000. By the end of the decade, he was one of the Twin Cities' biggest hip-hop acts. *Photo by Steven Cohen*

immediate success of Soundset proves First Avenue was missing a big boat by not booking more hip-hop nights. "The kids coming didn't give a fuck who Rhymesayers were," he said. "They just wanted *something* like that to do, an all-night hip-hop dance party at the end of the night. So it gave [Rhymesayers] a built-in audience, and we just pushed our music down their throats. What it did was take a whole bunch of kids who didn't even know there was a local hip-hop scene and introduced them to the fact that there was a scene—and introduced them to us, obviously."

It was too much of a crash course for First Ave management, though. The Soundset parties lasted just a few months, despite their popularity. McClellan said the crowds were young and unruly if not violent, and thus the sales at the bar did not do enough to offset the workload. Siddiq believes it was lingering prejudice against hip-hop. "First Ave wasn't ready to deal with its success," he said. "People were still a little sketchy on hip-hop."

Hired at First Ave that summer as a ticket runner, future general manager Nate Kranz remembered "everybody in management talking about how Soundset got too busy too fast, which is why they had to cancel it—they couldn't handle it," he said. "There were a few fights and stuff like that, but it wasn't like gang fights, just pretty general stuff. Now, we would try to figure out a way to make it work *because* it was successful, but back then they just didn't want to deal with it."

Within a few years, though, the club welcomed Rhymesayers and especially Atmosphere with open arms. The hip-hop crew started using a business model

akin to the DIY methods employed by the punk and college-rock bands First Ave was accustomed to. After the Soundset nights were cancelled, Slug said, "we started to focus on the label. And once the label got going, that's when we hit the road." Atmosphere earned college radio play and a smattering of record-store sales around the country for its 1997 single "Scapegoat" and the subsequent album, *Overcast!* The group leveraged that attention to get in a van and tour 7th Street Entry–type clubs around the country, including a lot of college towns and Middle America cities.

"Prior to us, rap tours would come to town if you could book an auditorium or arena," Slug said. "We had no expectations. We were at the very beginning of rappers touring like rock bands. We had a rock booking agent to book us in rock rooms, and we weren't asshole rap stars to deal with, asking for a pound of weed before the show and the royal treatment. We were just like, 'Man, give us water, twelve-pack of Bud, we're good.' That opened so many doorways for us. Rappers had to tone down their self-entitlement because of us."

Atmosphere's bond with First Ave was sealed during this period, and the stage was finally set for Twin Cities hip-hop to take over the club entering the new decade. By 2000, when the group put out its *Ford One* and *Ford Two* EPs, it toured to both coasts and then did a homecoming show at the club. "That's the tour where we were suddenly doing five hundred people in San Francisco, and we could even afford to get a hotel room after a lot of the shows," Slug recalled. "And that's when we came home it was the first time we sold out First Avenue in advance just as Atmosphere. That's the moment I said, 'Okay, I can actually pay my bills off of rap.'"

Paying the bills at First Ave remained a challenge through the '90s. Amid the vast commercialization of alt-rock during the decade, McClellan's preferences for touring shows veered more and more toward truly alternative options. In 1990 alone he booked an unusually wide and quite admirable array of world music and roots acts that included Sun Ra, Fela Kuti, Jimmy Cliff, Yellowman, Burning Spear, Youssou N'Dour, Pato Baton, Jo-El Sonnier, Doug Sahm's Texas Tornados, and Jerry Jeff Walker. One of McClellan's earliest favorites, King Sunny Adé, played the club four times from 1983 to 1988 and returned in 1992. At least one of those shows is remembered by Prince producer David Z: "For a rock club to book that [act] in those days was pretty adventurous, very daring," he said.

"We would do African acts [whose members had] never seen snow," marveled former marketing staffer LeeAnn Weimar. "Their bus would break down in Iowa. They'd get out in eighteen inches of snow. Can you imagine?" Toward the end of the decade, the First Ave calendar was littered with names of African and Caribbean acts not likely seen on the marquees of other rock clubs around the country, performers including Black Uhuru, the Mbetani Twins (with Minnesota's own Congolese transplant Siama Matuzungidi), Baaba Mal, Ibrahim Ferrer, Lucky Dube, and Salif Keita.

McClellan is rightfully proud of booking such a deep and diverse roster, but he admits it was almost always a losing proposition financially. Many of the shows were expensive to put on, because the bands often arrived via airplane instead of bus, so a lot of their musical gear had to be rented locally. Ticket sales were usually modest, at best. McClellan often resorted to giving away hundreds of free tickets to draw crowds to these gigs. On top of all that, some of the performers were difficult to deal with. "Fela [Kuti] was the worst; he was such a whiner," McClellan remembered of the Afrobeat legend, later the subject of a hit Broadway musical. "He did three dates at the club. One, he was cobilled with Jimmy Cliff, and even that one didn't sell out."

"I could never figure out how bands like Burning Spear could sell out like the Greek Theater in California or Red Rocks in Colorado, but not do well here," McClellan continued. "The hippies and Deadheads would go see them out there, but the Minneapolis jam-band fans would never come to see the African bands. I mean, if you want to see a 'jam band': Sunny Adé, the first time here, he played five hours and had an entourage of forty people.

BURNING SPEAR
& BURNIN' BAND
WITH SPECIAL GUESTS:
MOJA NYA

SUNDAY, FEBRUARY 22ND

FIRST AVENUE & 7th St entry
The Downtown Danceteria 1st Avenue North & 7th Street, Mpls

$7.50 ADV.
$9.00 DOOR

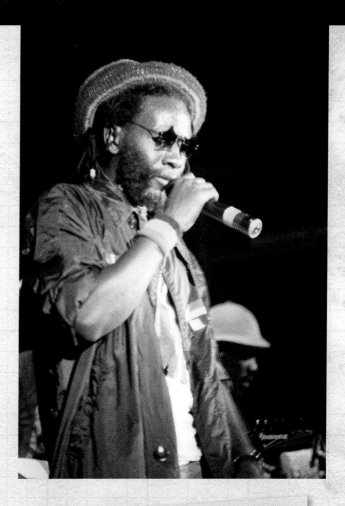

(Above and right) Since the 1980s, Steve McClellan had been booking reggae and other world music acts as an alternative to the club's increasingly indie-rock and punk vibe. Burning Spear (Winston Rodney) landed in Minnesota in late February 1987. *Photo by Tommy Smith III; flyer courtesy of the Museum of Minnesota Music.* (Lower right) Congolese musician and singer Sam Mangwana played First Avenue's Mainroom in October 2000. Mangwana began his music career in the early 1960s and performed as recently as November 2016. *Minnesota Historical Society Collections*

He didn't understand curfews. I'd put any of those shows up against any Deadhead show for jams."

The rest of the staff describes McClellan's affinity for those acts with equal parts admiration and beguilement. "He was so ahead of the curve on that stuff," Nate Kranz assessed, "but it maybe always belonged at the Cedar [Cultural Center]." "I learned so much from Steve," said Molly McManus, who worked at First Avenue until 2002, "but he had some pretty ambitious ideas about the club. Jack [Meyers] really had to work hard to make his ideas work financially. All of us really had to work hard to make those ideas work. But we did it, because we all loved the guy and still believed in him." ∎

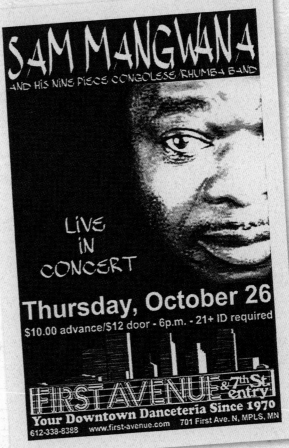

SAM MANGWANA
AND HIS NINE PIECE CONGOLESE RHUMBA BAND

LIVE IN CONCERT

Thursday, October 26
$10.00 advance/$12 door - 6p.m. - 21+ ID required

FIRST AVENUE & 7th St entry
Your Downtown Danceteria Since 1970
612-338-8388 www.first-avenue.com 701 First Ave. N, MPLS, MN

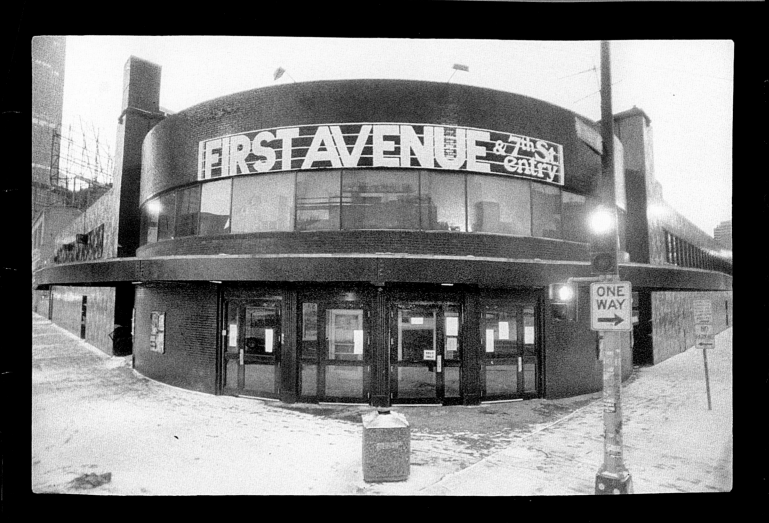

TO THE BRINK

2000–2004

"There was a time in the 1980s when First Avenue made a noise big enough to shake the whole country. As radio conglomerated and curdled, and live music became a dicey, increasingly competitive business, people stopped going to clubs three or four times a week. Empty nights at First Avenue became desperate ones, and Mr. Fingerhut was behind on insurance, taxes and the rent. . . . Mr. Fingerhut took the club into bankruptcy on November 2."

—DAVID CARR, "FIRST AVENUE IS DEAD (LONG LIVE FIRST AVENUE!)," *NEW YORK TIMES*, NOVEMBER 12, 2004

When he wasn't wearing his oversized monster costume and decapitating members of his crew, David Brockie was a surprisingly normal-looking and friendly guy. The late frontman for the sci-fi gore-metal band Gwar—better known by his stage name Oderus Urungus—even showed off a tender, concerned side as he stood in First Avenue's green room the afternoon of November 19, 2004. He was dressed in a sweatshirt and jeans and no metal codpiece, discussing the club where he had spilled blood so many times before. "I was breathless waiting to find out," he said. "It's been the most consistent rock venue in North America."

Dozens of touring bands around the country, along with everyone in Minnesota who hoped to set foot in First Ave again, had been kept in suspense as Minneapolis's resilient nightclub sat empty and shuttered for three weeks that November. Allan Fingerhut, who opened the venue at age twenty-six, put First Ave into Chapter 7 bankruptcy protection after three years of fighting with his accountant, Byron Frank. The partners used to play pinball side by side in the old Greyhound bus depot, and now they were trying to kick each other out of the same building. In the interim, no one outside of the court's bankruptcy administrators could get inside the club. The locks were even changed.

While they knew the basic ins and outs of his fight with Frank, First Ave's staffers were blindsided by Fingerhut's maneuver. Nate Kranz had bought his first house just a few days before he was suddenly put out of work. Not that he ever stopped working. Overseeing the talent booking since Fingerhut fired general manager Steve McClellan five months earlier—another big surprise—Kranz and the club's other up-and-coming booker, Sonia Grover, quickly set up shop in the living room of Kranz's apartment. They didn't know when—or if—the club would open again. They weren't getting paid in the interim. But they wanted to do what they could to salvage their shows and First Ave's reputation in the meantime.

(Opposite) This booklet was produced for the venue's thirtieth anniversary in 2000. It wasn't long before serious doubts emerged about whether First Avenue would make it to thirty-five. *Courtesy of the Museum of Minnesota Music*

Nate Kranz and Sonia Grover, seen here in 2010, were put to the test in 2004, shortly after taking over the talent booking and managing duties at First Avenue. *Photo by Daniel Corrigan*

They called agents. They called other clubs. They found new homes for many of the scheduled concerts: Jonathan Richman moved to the Cedar Cultural Center, Matthew Sweet to the Cabooze, Jon Spencer's Blues Explosion landed at the 400 Bar, and (the least lucky of the bunch) Kathleen Hannah's Le Tigre went to the Ascot Room at Quest, a rival venue run by Los Angeles–based entertainment conglomerate Clear Channel.

Rhymesayers rapper Brother Ali, set for a hard-earned debut as a First Ave headliner, also had to move to Quest, whose operators wouldn't even let Kranz hang around for Ali's show after he brought them all the pre-sale ticket money. "I wasn't on the list," Kranz recalled being told. Brother Ali, however, showed his thanks and devotion. "I think a lot of what makes Minneapolis unique and special is wrapped up in that club," he said as First Ave sat in limbo. "Losing it would be catastrophic to this city."

Gwar's agent got a call, too. Kranz and Grover were hopeful the club could reopen by the time the band's bloodmobile pulled into town. Luckily, they were right. "I knew things were okay when we rolled up and Conrad was there to greet us," Brockie/Urungus said after Gwar's sound check on reopening day. For his part, First Ave's well-known stage manager Conrad Sverkerson

looked at the bright side of his unexpected nineteen-day break: "My house has never been cleaner, and I've got all my rock 'n' roll T-shirts washed and folded." He went on to sing the praises of the local music community: "I couldn't go anywhere without hearing, 'Is the club okay?' It was very heartening that people were so concerned." Sverkerson also found some amusement in the media coverage. While his pals in Gwar did make the TV news that night, Conrad was nervous about the possibility of mentioning the opening band on camera. "I can't say, 'Dying Fetus is on the bill,'" he recalled himself thinking years later. "How am I gonna explain that to my mom if she sees me on TV?"

Gwar was perfect—even poetic—as the headliner for a crucial night in First Avenue history: the changeover from pre- to post-bankruptcy eras. All the blood that had been figuratively spilled in a three-year battle over ownership—the axes that had been ground, the heads that had rolled—seemed to be encapsulated in Gwar's macabre stage show. And in general, the value of blowing off steam at a good, thrashing metal show seemed fitting.

Perhaps the only person who didn't welcome the news of Gwar being the first post-bankruptcy headliner was Minneapolis mayor R. T. Rybak. Not only had the mayor pitched in city resources and cut a bunch of red tape to help the club get up and running again quickly, he had also pledged to do a stage dive on reopening night to drum up attention. Rybak wisely put that off for a few nights, until Chicago alt-rockers Urge Overkill came to town. "I think he was afraid Gwar would kill him," Sonia Grover conceded.

Steve McClellan and Jack Meyers, however, did show up. Five months after they'd been fired from the club they ran for twenty-five years, McClellan and Meyers were back in their old roles at the reopened club. Working the room almost like figureheads, they greeted well-wishers and talked optimistically about the venue's future. They gave a speech onstage before Gwar's set, thanking attendees for their support. Offstage, though, McClellan sounded pessimistic, fearing both the corporatization of the concert industry and the gentrification of downtown Minneapolis. "It doesn't help that our competition is

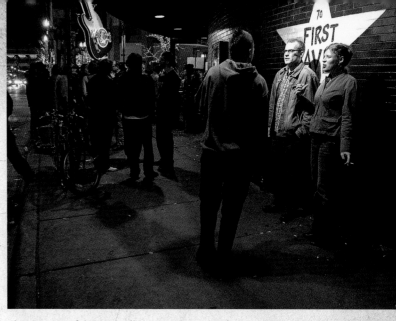

Steve McClellan greeted the crowd with a smile at the re-opened club after a tense couple of weeks in 2004. *Photo by Jeff Wheeler, Star Tribune*

The specter of the giant illuminated guitar of the Hard Rock Café on Block E, across Seventh Street from First Avenue, presented both a stark contrast to the older club and a challenge to its existence in the mid-2000s. *Photo by Steven Cohen*

filling their February and March calendars, and we still have December to fill up," he said.

Many fans interviewed the night of the reopening carried an us-versus-them mentality against the club's new neighbor, Block E, a ridiculously envisioned suburban-style mall across the street from First Ave. The city had coughed up $40 million for a place to bring an Applebee's and a Hard Rock Café to downtown Minneapolis. And there sat downtown's greatest cultural landmark, deep in the red. First Ave paid $109,000 in Hennepin County property taxes in 2003, compared to only $5,200 paid by Block E's developer. McClellan stewed over that, and wondered if there was still a place for First Ave in the modern downtown. "We're the difference between the mainstream and the alternative," he said, "between a sold-out show at the Target Center and the first time Los Lobos comes to town to play the Entry. Hopefully, there's still value for that in this city."

The guy most responsible for First Avenue becoming a local institution, McClellan would not last at the club another year. Before he departed—or, in his view, was fired—he could finally take satisfaction knowing the city did, in fact, value what a difference he made.

Four years earlier, the new millennium started out on a deceptively positive note as the club celebrated its thirtieth anniversary. One of the acts that had played the Depot, Texas blues hero Johnny Winter, returned in January 2000 to help kick off the year. But the anniversary wasn't the only reason for hope. Behind the scenes, Byron Frank had begun negotiating with Ted Mann's Hollywood Theatre Co. to buy the building that housed First Avenue. For the first time in the club's history, its operators would actually own the place and could thus be certain about its future. Or so they thought. The $2.5 million transaction that was supposed to guarantee First Ave's longevity instead became the centerpiece of its upheaval in the early '00s.

Perhaps more than the increase in downtown property values amid the (short-lived, as it happened) Block E boom, the timing of the building's sale also stemmed from the Mann family's desire to unload some properties. Ted Mann himself had been long retired and would die in 2001 at age eighty-five. The timing was not opportune for Allan Fingerhut, who had spent the past decade living in California wine country. First Ave's owner had invested much of his money in art galleries and an art publishing business, and while the publishing side had grown to include rights to the visual estate of Theodore Seuss Geisel, aka Dr. Seuss, both businesses were

struggling. Fingerhut didn't have anywhere near $2.5 million to invest in the old depot building back in Minneapolis. Buying the property still made good sense to him, though, as it did to his accountant, Frank, who had stored up a sizable nest egg for his own retirement.

The way Frank describes it, he was simply trying to do his friend a favor. "Allan couldn't afford to let the club go because he was getting $60,000 a year from the club," Frank claimed. That money came from the other businesses on the property. In 2000, the First Ave real estate included a large attached garage (then used for contract parking) and the storefront that housed the UnBank check-cashing company (now the Depot Tavern). "When I told Allan that I would invest $200,000 so he could afford to buy the building, he put his arms around me and thanked me," Frank asserted.

Of course, the loan came with some stipulations. "I told Allan, 'Okay, I'll invest with the understanding I'll oversee it,' because at that time this club wasn't doing well," Frank said. He set up a new company to buy the building, which in turn leased the property to Fingerhut's Committee, Inc., the company that had owned the First Ave brand and its assets since 1970. Frank and Fingerhut each retained a forty percent stake in the new company that owned the building. The other twenty percent went to McClellan and Meyers. Frank arranged it so the managers who had been running the club largely on fumes since 1979 each got a ten percent share in the building, even though they did not put up any money for it.

"I had so much respect for those guys because I knew how much hard work they put into the place for so many years," Frank said, but added, "My goal really was just to make the business work." Not only would the longtime managers' stake in the property guarantee the oversight that Frank wanted; they would have the deciding vote should a dispute over the building's ownership ever erupt between Fingerhut and Frank.

Probably the greatest publicity stunt in First Avenue history happened on April Fools' Day, 2000, and by coin-

Best known for his *Drinking with Ian* TV show, Ian Rans had his most notorious moment in the sun when he concocted an April Fools' prank in 2000 that hit a little too close to home. *Photo by Steven Cohen*

cidence it presaged the purchase of the building. One of the reasons the practical joke worked so well is because everybody knew the club wasn't prospering. "It was a constant rumor: 'Did you hear First Avenue is closing?' or, 'First Avenue is losing its lease,'" remembered the man behind the stunt, Ian Rans, a local scenester who later hosted the cable access TV show *Drinking with Ian*. In 2000, Rans was publishing a local fanzine called *Toast*, which meant he had both media contacts and materials printed on First Ave letterhead.

Rans spent the morning of April 1 copying the club's letterhead and concocting a press release, which he faxed to nearly every media outlet in town. First Avenue staff had no idea what he was up to. The bogus announcement claimed the club was finally throwing in the towel on downtown and would soon relocate to Blaine. Yes, Blaine: a mostly affluent and conservative suburb twenty miles north of downtown Minneapolis. A former SuperValu grocery store there would house the club, Rans wrote. As if all that didn't seem far-fetched enough, he threw in some lines about the addition of a café offering

"a whole variety of soups." Said Rans, "I thought, if nothing else, the soups thing would give it away."

McClellan loved the April Fools' joke and thought it was "so hilarious, that there was no way anyone would actually believe it," said the club manager. But the laughter was over by the end of the day, when at least one major TV outlet, CBS affiliate WCCO, took the press release at face value and ran with the story. "I genuinely felt bad, because I heard some people got fired over it," Rans said. "I didn't expect anyone to really buy it."

There was some positive payoff, though. For starters, New Jersey indie-pop darlings Yo La Tengo packed the club for the first time a night or two later. Years of critical acclaim didn't do it, but rumors of First Ave moving to Blaine did. "People came out to the show because they thought the place was gonna close," McClellan remembered. The stunt also highlighted the club's plight in the media. McClellan told reporters who called that there was indeed a very real possibility the venue could lose its lease. With Ted Mann no longer helming his company and the Block E development enveloping the property, First Ave had been put on a month-to-month lease. "It's hard to book shows six months out when you don't know if you'll be there in three months," McClellan said. Three months later, the building was sold.

The ringleader in the real-estate deal, Byron Frank was reportedly so impressed with the hoopla generated by the practical joke that he suggested McClellan hire the joker behind it. "I went from very seriously being afraid I would get sued by First Avenue to getting hired," said Rans, who worked in marketing and promotion at the club through the early 2000s. He said the outlook turned unusually optimistic when he started, in part because of the building purchase. Rans remembers many of the club's full-time employees were sent on vacations to Mexico and Jamaica over the winter of 2000–2001 to celebrate the club's fruitful, hopeful year. "Byron was starting to throw his weight around, and maybe get people lined up on his side," Rans theorized.

Another way Byron Frank's influence was felt: "Things got a lot more rigid and businesslike," Rans said, pointing in particular to the change in the after-hours scene at the club. "We'd hear stories of all-night binges and McClellan getting into fistfights. In our era, the floor managers would come around at one fifteen and pick up everybody's drinks."

While things were looking up behind the scenes at the start of the '00s, the momentum onstage was up and down. The calendar in early 2000 was filled with holdovers from the '90s alt-rock era that didn't graduate to the bigger venues. The Flaming Lips, Peter Murphy, and Matthew Sweet all played a busy week in mid-March. Sleater-Kinney, Modest Mouse, and Ween also all performed days apart in May. The Sleater-Kinney date kicked off the trio's tour behind *All Hands on the Bad One*, and it culminated in a second three-song encore not offered at many subsequent dates. Another indie hero from Portland, Oregon, Elliott Smith arrived with a full band on May 27, opening his twenty-one-song set list with "Son of Sam" and "Junk Bond Trader" from the new album *Figure 8*, the last before his 2003 death.

A slow summer in 2000 gave way to a busier fall as Weezer played two shows in one day on September 6, a big deal since frontman Rivers Cuomo had been away attending Harvard through the late '90s. Wilco stopped in for a two-night stand November 17–18, the first show of which started with a montage of songs from its two *Mermaid Avenue* albums, collaborations with Billy Bragg of songs based on Woody Guthrie lyrics. The second night ended with a rarely played cover of the Who's "Won't Get Fooled Again."

> "It's hard to book shows six months out when you don't know if you'll be there in three months."
> —Steve McClellan

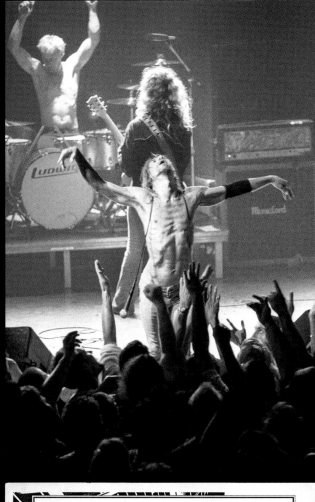

(Above) Former Talking Heads frontman David Byrne made a rare appearance at the club on May 22, 2001. *Photo by Steven Cohen. (Right)* Iggy Pop's show at First Ave on May 16, 2001, was nearly thirty years to the day after he first appeared in the venue, then known as the Depot, with the Stooges on May 9, 1971. He played both Stooges classics and recent hits for this 2001 concert. *Photo by Daniel Corrigan. (Lower right)* Between his 1971 debut and his 2001 show, Iggy Pop played the club twice in the '90s, including this concert on October 11, 1990. *Flyer courtesy of the Museum of Minnesota Music; ticket courtesy of Michael Reiter*

November 2000 would see two unforeseen farewell shows: Babes in Toyland played its last headlining show on the twenty-fifth before a fourteen-year hiatus, and Warren Zevon made his final appearance on the twenty-first. After turning in ten gigs at the club through the '90s, Zevon had become a personal favorite of Conrad Sverkerson. "He had such a dry sense of humor, it always made it fun working with him," the stage manager said. Zevon always joked with Sverkerson that First Ave would be his favorite venue "if only they had a toilet in the dressing room." When the club did finally install a bathroom backstage, Zevon "couldn't shut up about it," Sverkerson reminisced on the day after Zevon's death from lung cancer in 2003.

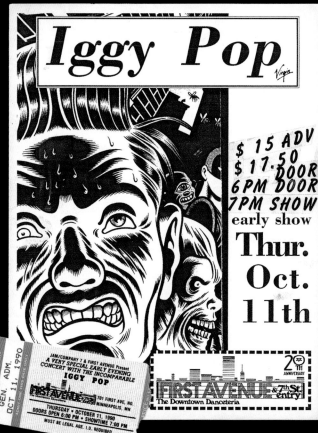

The first half of 2001 was highlighted by some pioneering heroes of the indie/alt-rock music world, including Robyn Hitchcock with the reunited Soft Boys on March 31, who played their song "Mr. Kennedy" with its subject, First Ave sound man Myles Kennedy, behind the board; Pixies frontman Frank Black with his new band the Catholics on April 27; and Gary Numan on April 29, who dared to play "Cars" five songs into his set. On May 16 one of the legends from the earliest days of the club, Iggy Pop, returned, proudly revisiting his Stooges days on his *Beat 'Em Up* tour. He dropped in "I Wanna Be Your Dog," "No Fun," "1969," and five more Stooges songs alongside solo tunes including "Lust for Life" and "The Passenger."

Fugazi played its final show at the venue on June 27, a year before the D.C. hardcore vets went on indefinite hiatus. The big alt-rock money-grab of the 1990s apparently didn't affect DIY guru Ian MacKaye; his band raised its ticket price from five dollars going back to 1989 to a mere six dollars in 2001 and again insisted on an all-ages crowd, with local punk act the Selby Tigers opening. A decade later, Fugazi would be selling that night's twenty-seven-song set as a download on its live recording archive. Asking price: five dollars.

Wilco returned for another two-night stand on June 29–30, 2001, during a pivotal time in the band's career. Behind the scenes, the alt-twangers were in a dispute with their record label, Warner Bros., which balked at releasing that year's album, *Yankee Hotel Foxtrot*. Jeff Tweedy & Co. previewed some of the songs off the shelved record, including "War on War" and "Jesus, Etc." There was tumult within the band, too, captured by a film crew for the 2002 documentary *I Am Trying to Break Your Heart*. The Minneapolis footage is jovial, though, and includes a backstage reunion with several of Tweedy's Golden Smog pals, including Dave Pirner, who's caught on camera scarfing down some of Wilco's pizza.

"It was kind of a weird time for the band, and having a film crew there made it weirder," Wilco bassist John Stirratt remembered in 2016. Although Tweedy would play subsequent solo gigs at the club and First Ave would copromote their local concerts at other venues, Wilco got too big to play the Mainroom after 2001. Stirratt

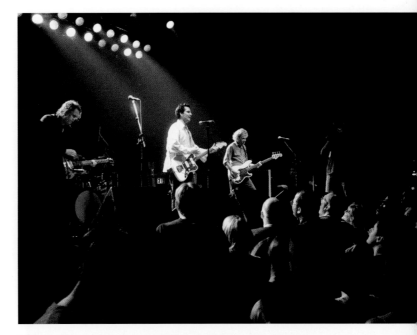

Jeff Tweedy and Wilco were back on the Mainroom stage in 2001, this time with a camera crew in tow for the documentary *I Am Trying to Break Your Heart. Photo by Steven Cohen*

still counts it as one of their favorite places to perform, though. "It's cool it's in the old bus station and feels like a historic part of Minneapolis," he said, "but more than anything it's the people who run it and people in Minneapolis in general who always made it great to be there. It reflects back to a time when clubs were not just rooms. There would be a whole subculture built around a club, and they had their own identity and personalities—Conrad [Sverkerson] being at the forefront of those personalities in this case."

The guy who played opposite Wilco in the Entry four years earlier with Whiskeytown, Ryan Adams played what was perhaps his all-time best Mainroom show on December 5, 2001—two years before his unequivocally worst show there. The 2001 date found him in a good mood, at one point singing Bob Dylan's "Mississippi" with a spot-on imitation of the Minnesota legend's nasal voice. He also delivered a strong batch of new material off his *Gold* record before a lengthy, rowdy encore that closed with a cover of Elton John's "Rocket Man."

Adams's December 14, 2003, gig was one he wouldn't

First Avenue Ghost Stories

They've seen the overhead lights inexplicably switch on and off for thirty minutes straight. They've heard glasses crashing to the floor but couldn't find any broken glass. They've had people call their names when no one is around. They've felt unseen forces poke them hard in the shoulder or back. They've blamed a ghost nicknamed "Flippy" for flipping bar stools onto the floor. And at least a few of them have reported seeing the same young woman—long blonde hair, wearing an army-green jacket and bell-bottom pants with no shoes—appear and disappear without a trace.

These are among the most-often-told of many haunting experiences that former First Avenue staffers have compiled from late nights and other random hours at the club. Ghost hunters have visited and claimed they captured EVPs (electronic voice phenomena). There's even a Facebook group page, First Avenue Ghost Stories, dedicated to the paranormal activity at the club. "There was nothing creepier than being alone in that big black box," wrote '90s staffer Tanya Kennedy on the page.

Since the building served as a Greyhound bus depot for three decades, the belief is that at least a few of the hundreds of thousands of people who passed through—including transients and other desperate folks—lingered there in the afterlife. The reported hauntings even predate the buses. Ghostly animal noises are attributed to reports that the club sits on land that was a holding pen for livestock to be slaughtered in the earliest days of the city. Frazer Gardiner claimed he heard sheep baa-ing in distress so loudly one night in the ultra-creepy basement when he was bar-backing, he said, "I ran upstairs thinking it was something Roy [Freedom] had on the turntable."

Molly McManus, operations manager in the 1990s, has some of the most vivid stories. Late one night, as she was counting money in the office, the stereo went dead. When she moved to turn it back on, she said, the stereo console "went flying across the room. It didn't just drop. It flew." As a postscript, she noted, "I was listening to Black Sabbath." She also shared a more somber experience that's similar to other reported encounters in the women's restroom, often cited as the hub of the club's paranormal activity. One night in 1991 she was on "drool patrol," doing a final walkthrough before closing to make sure no one had passed out in a bathroom stall or dark corner. When she pushed open the door to the now-fabled fifth stall in the women's restroom, she saw a figure she believes was the young woman in the army-green jacket. "I saw a body there, someone who looked like they had hung themselves. I truly thought someone had committed suicide that night, and I was thinking, 'Oh my god, what do I do?'" Just like that, though, the body was gone.

According to legend, a woman waiting at the depot for her fiancé to return home from World War II hanged herself in that fifth restroom stall when she found out he had been killed. This could be the woman sometimes seen wandering the club. There's also talk of a woman, either that same one or another, linked to a bizarre, secret portion of the former VIP Room and Record Room, next to that same women's restroom. The story is that this twelve-foot section was hidden behind walls until the early '90s: "We tore the wall out and had no idea what it was there for, and inside there was this booth," recalled longtime business manager Jack Meyers. "The story was she died on that booth, and they walled it up."

For whatever reason, the numbers of ghostly encounters have lessened in recent decades, to the point that today's staffers don't have any new tales to share. The scarcity has prompted a few jokes about the ghosts being "caught up in assets" tied to the bankruptcy battle of 2004, or half-jokes that vices surrounding the club have changed a lot from the prior decades. Production manager Conrad Sverkerson, who's there at all odd hours, said, "I don't discount the stories, but I've never seen or heard anything myself." General manager Nate Kranz theorized, "Maybe the ghosts moved out sometime after I started"—but conceded: "I also don't spend much time in the ladies' room." ∎

live down, even after he became a consistently strong live performer a decade later. It was the last stop on that year's tour, but the bigger culprit was his hard feelings over a Paul Westerberg quote published some months earlier. When asked what he thought of Adams, the Replacements frontman said, "I think he needs to get his teeth kicked in." Adams took it up with Westerberg's hometown crowd. "You don't trash the people you inspired," he shot back from the stage, where his demeanor turned from snide to goofy to depressed. He played a heavy-metal version of one song and a barbershop-quartet interpretation of another, then cut off three other tunes midsong. Toward the end of the night, he smashed a cocktail glass onstage. At the very end, after more than half the crowd had left, he drunkenly mumbled into the microphone, "All I want to do is go home for Christmas." *Rolling Stone* had hired Twin Cities writer Molly Priesmeyer to review the show. Upon reading the *Star Tribune*'s coverage, though, Adams's publicists pulled some strings and got the magazine to nix its review. Merry Christmas, Ryan.

The latter half of 2002 saw some '60s legends come in, starting with psychedelic rock hero Arthur Lee and his reformed lineup of Love on July 31. They revisited "Alone Again Or," "7 and 7 Is," and other early staples a year after Lee was released from a five-year prison sentence, and three years before he died from leukemia. A stronger flashback occurred on September 9 when Bob Weir played the club for the first and last time with his post–Grateful Dead band RatDog. Their two-set performance included such Dead classics as "Friend of the Devil," "Standing on the Moon," "West L.A. Fadeaway," and "China Cat Sunflower," plus Jerry Garcia's "Bird Song" and, for the finale, "I Know You Rider" and "Gloria."

Two red-hot bands that did have a history at First Ave, Coldplay and Foo Fighters, each stopped in during 2002 for "underplay" gigs—a music-biz term for shows in smaller-than-normal venues, typically booked to generate hype for a new album. Coldplay's August 14 date was part of a short promotional tour two weeks before the release of their second LP, *A Rush of Blood to the Head*. They saved the key new tracks, "The Scientist" and "Clocks," for

the pre-encore finale and encore kick-off, respectively. They also dropped in covers of Bruce Springsteen's "Hungry Heart" and Echo & the Bunnymen's "Lips Like Sugar."

On the verge of becoming arena headliners, Foo Fighters started the roll-out for their *One by One* album in the Mainroom on October 18. Dave Grohl announced the show on the airwaves of local hard-rock outlet 93X that morning, where he recounted his history in 7th Street Entry with both Nirvana and his earlier band, Scream. That night in the Mainroom, he roamed offstage and worked his way to the top of the stage-right stairs with guitar in hand, without stopping the music. The show also featured one of the many times Grohl paid homage to Hüsker Dü when in Minneapolis, in this case with a cover of "Never Talking to You Again" and Grant Hart joining him onstage.

What would have been First Ave's ultimate underplay concert—and perhaps one of the most momentous in Minnesota music history—came so close to happening in March 2004 that the club printed up fifty-dollar tickets for it. Bob Dylan was on a short kick playing smaller venues, including the Riviera and Park West in Chicago, the Eagles Ballroom in Milwaukee, and the 9:30 Club in D.C. It's doubtful the North Country native had hung out at those clubs in the past like he had First Ave. For whatever reason, though, he decided against the Minneapolis location and instead added a Vic Theatre gig in Chicago that night; in Minnesota, his only "underplay" show was at St. Paul's comparatively cavernous Roy Wilkins Auditorium, with its forty-five-hundred-person capacity.

"I can't really say why it didn't happen, just that it was booked—and then it wasn't," said Nate Kranz. He was especially crushed, given that he's a Dylanophile, but he now admits his fandom might have played a role in the cancelation: "We were really supposed to keep the lid on the show until it was announced, but *somebody* had a hard time with that." Enough word got out on the secret date that people were mailing cash to the club's staff to try to secure a ticket. Kranz could only offer them worthless paper (which might be collectors' items now). "I have a whole box of Bob Dylan tickets sitting at my home that say First Avenue on them," he lamented.

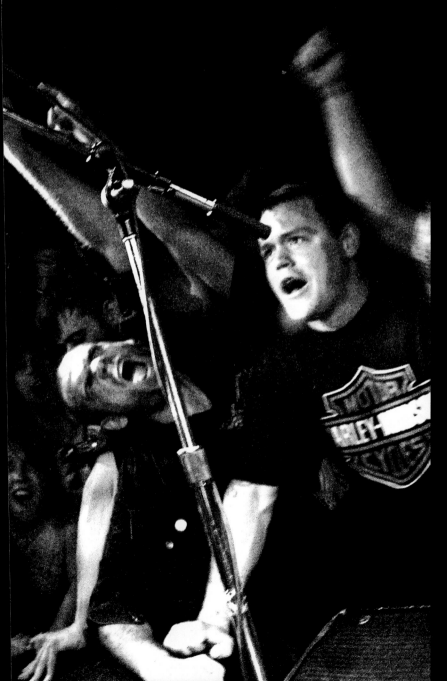

Seen here at a 2009 gig, Dillinger Four began riling up crowds at 7th Street Entry in the early 2000s.
Photo by Steven Cohen

More so than the Mainroom, 7th Street Entry saw new and exciting names in the early '00s that would make lasting impressions, including some of the biggest Minnesota bands of the era. One of the most frequent headliners was Minneapolis's wild-eyed punk quartet Dillinger Four, whose release party for its classic album *Versus God* on June 25, 2000, also featured two other Entry staples in those days, Lifter Puller and the Selby Tigers. Other up-and-coming locals to play the room were industrial metal band American Head Charge, whom Rick Rubin signed in 2000; the fun indie-rock band Sean Na Na, whose leader, Sean Tillmann, had started playing there as a teen with Calvin Krime and by 2000 was also performing as Har Mar Superstar; and such memorable regulars as Mark Mallman, Heiruspecs, Astronaut Wife, the Midnight Evils, Kid Dakota, Song of Zarathustra, and later the Soviettes, Fog, Sweet J.A.P., and Kentucky Gag Order.

This was also an exciting time for touring shows in the Entry, which saw many acts that would, with the help of online streaming and music blogs, become some of the decade's biggest underground/indie/alternative rock stars. Among them were the White Stripes, the Strokes, the Black Keys, Neko Case, Spoon, the Shins, the National, the Gossip, Andrew Bird, Of Montreal, Black Rebel Motorcycle Club, and the Libertines.

Perhaps the most legendary of these shows—one of those nights when the venue couldn't have held half the number of people who now claim to have been there—were the Strokes' pair of sold-out gigs on October 6, 2001. The band released its debut album, *Is This It*, three days later. Its U.S. release had been delayed after the September 11 terrorist attacks to scratch the song "New York City Cops," which offered a less-than-flattering assessment of the NYPD. The new CDs weren't available for sale at the Entry, but the Strokes breezed through it almost verbatim, including "NYC Cops" in order to stretch out the sets to about forty-five minutes. The band exhibited little personality crammed onto the small, low-lit stage, but it proved tight and focused—which remained the case even

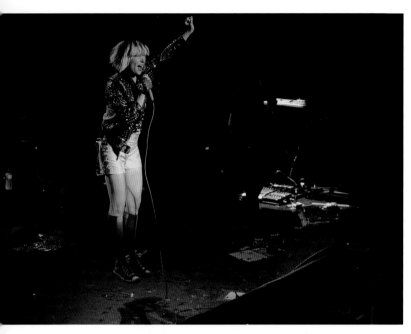

The energetic Karen O of the Yeah Yeah Yeahs lit up First Avenue even after the band hit it big, such as for this 2013 Mainroom appearance. *Photo by Daniel Corrigan*

as they loosened up more in a sold-out Mainroom show a year later.

The White Stripes earned scant notice for their Minnesota debut in the Entry on June 12, 2000. Bandmates Jack and Meg White were in the midst of a divorce that year but soldiered on in support of their second album, *De Stijl*, playing songs such as "Hello Operator" and "You're Pretty Good Looking (For a Girl)" alongside covers of Son House's "Death Letter" and Dolly Parton's "Jolene." By the time they made it to the Mainroom just over two years later, on July 13, 2002, the White Stripes were red hot from the success of their *White Blood Cells* album. Seemingly put off by the hoopla surrounding the band, Jack and Meg skipped their big hit "Fell in Love a Girl" and instead tore through punkier older songs and emphasized their bluesy side, with covers of Blind Willie McTell's "Lord, Send Me an Angel," Leadbelly's "Boll Weevil," and Bob Dylan's "Love Sick." Jack's attitude had a feisty edge to it, making for a thrilling moment at the club.

Arguably the most impressive buzz band to take over the Mainroom in the early '00s, though, was New York's minimalist punk trio the Yeah Yeah Yeahs, who made their Minnesota debut there on November 20, 2003. In an interview before the show, Karen O talked about her bursting onstage presence being a reaction to all the stiff, too-cool rockers she saw after moving to New York. "All the bands I was going to see then were boring live performers," she said. She was anything but, leaping and grinding all over the stage that night in a bright, ornate, tattered outfit. Her wild demeanor was put on hold, though, for a sweet moment when her local pal Sean Tillmann—who had opened some YYYs shows as Har Mar Superstar—walked onstage with a lit cake, marking her twenty-fifth birthday. The Yeah Yeah Yeahs stayed faithful to First Ave, playing the club twice more over the next decade, long after they were filling bigger venues.

No matter who was running the place or who owned the building, two factors in the early 2000s affected First Avenue in ways beyond the control of anyone working there: the September 11 terrorist attacks, and the rise in competition from Clear Channel, the conglomerate whose local bookings were at that point overseen by McClellan's former protégé, Rich Best.

As part of the economic fallout from the 9/11 attacks, bands scaled back their tours. The groups that did often drew smaller crowds. "People were afraid to go out," McClellan remembered. But the brunt, the GM recalled, was that "insurance went through the roof. Nobody even wanted to give us insurance." Allan Fingerhut took a hit as owner, too. "It wasn't like a corporation where there was a lot of money in the bank," he said. "A little bit of hurt hurt a lot."

Some emotional damage came along with the financial pain when Clear Channel (later Live Nation) settled in for a long battle with First Avenue. McClellan had taken Rich Best under his wing in the late '80s only to watch him become his primary competitor a decade later. Best originally left First Ave in 1997 to work for an independent promotions company called Compass, which also employed Sue McClean, a fixture in the Twin Cities

The Suburbs played four nights at First Ave between September 30 and October 4, 2002, while the club struggled to make a profit. *Photo by Steven Cohen; flyer and set list from Minnesota Historical Society Collections*

DUE TO POPULAR DEMAND

Fourth Concert Added For The Fourth

FRIDAY, OCTOBER 4TH, 2002

FIRST AVENUE MAINROOM

THE SUBURBS

$20.00 advance/$20.00 doors
6:00pm Doors
Must Be 21+; Legal ID Required

FIRST AVENUE

MUSIC FOR BOYS
WAITING
TAPE YOUR WIFE
CIG MACHINE
GOGGLES ON
CREDIT IN HEAVEN
GIRLACHE
AILERONS ARE OK
GIRLFRIEND
SPRING CAME
TIRED OF MY PLANS
IDIOT VOODOO
MONSTER MAN
LIFE IS LIKE
FRIDAY NIGHT
TINY PEOPLE
RATTLE MY BONES
LOVE IS THE LAW
ANGEL

BABY HEARTBEAT
PERFECT COMMUNIST
BLACK LEATHER STICK
COWS
BEST IS OVER

???????????????

music industry. Then Clear Channel bought up Compass along with dozens of other smaller promoters around the country. While McClean chose to start her own company, Best went to work for the big conglomerate.

"I owe my career to Steve McClellan; he was my first mentor," Best said in 2016, but justified his decision to "fly the nest" as a smart career move. "Being on the ground floor of some of these up-and-coming artists, I had developed aspirations to continue growing with their careers. You started seeing some of the bands we were working with go and play theaters, arenas, and festivals. That growth stopped [working at the club], and that's something that I aspired to."

Best said he had McClellan's blessing at first, but that disappeared by the time Clear Channel started booking concerts in direct competition with First Ave, at the Quest nightclub. Located just two blocks away on Fifth Street, the Quest replaced Prince's short-lived Glam Slam, a two-story venue with a large wraparound balcony. It left much to be desired in both acoustics and

sightlines, but its sixteen-hundred-person capacity was a wee bit bigger than First Ave's.

Bands that previously had played First Ave and went on to play the Quest in the early '00s included My Morning Jacket, Les Claypool of Primus, Dinosaur Jr., Slayer, the Tragically Hip, the Melvins, Danzig, Echo & the Bunnymen, Audioslave, and even more altruistic punk bands such as Superchunk, Social Distortion, and Bad Religion. McClellan said when he called up the agent for Bad Religion and several similar groups to complain of disloyalty, he was told, "Steve, you don't know how many bands are threatening to leave me if I can't get them the money they want."

First Ave was getting outbid by its well-financed corporate competitor. Age limits were another factor: McClellan still insisted that most shows be twenty-one-plus, while the Quest would often host eighteen-and-up or all-ages concerts. Nearly every significant metal or Warped Tour–type band of that era—acts that relied heavily on teen crowds—chose the Quest over First Ave. An additional deterrent was First Ave's late-night dance parties on Thursdays, Fridays, and Saturdays, which meant concerts on those nights had to end by about ten.

"It's one thing to lose a show because you've been outbid," Sonia Grover recalled with a wince, "but it's another to lose it because at our place the band has to end at ten o'clock on a Friday night, or because we can only do a twenty-one-plus show. As if we weren't already at a major disadvantage working against Clear Channel's very deep pockets. And it was extra frustrating because everyone knew we had the better room."

In hindsight, the fact that the Quest was disliked as a music venue may have been First Ave's saving grace. Even Rich Best doesn't argue the point: "The fact that we were—and I say this respectfully—kicking the shit out of them in a subpar room shouldn't have happened," he said. Had Clear Channel found a better venue, things could have turned even more desperate at First Ave. And they were plenty desperate.

McClellan said at the time that 2002 was the club's worst year on record financially. A court-mandated appraisal that April listed the club's debts at about $75,000, with assets around $547,000 and liabilities at $621,000. Things got serious enough that a series of benefit concerts came together that September and October, featuring bands such as the Jayhawks, the Suburbs, and House of Large Sizes.

To compound matters, the club's primary owners/investors were starting to go at each other. After forty-five years of friendship, Allan Fingerhut and Byron Frank were engaged in a legal battle over other business matters. Their first court date fell in the same week as the Jayhawks' benefit show. In a front-page *Star Tribune* article on September 13, 2003, titled "Hard times, bitter battle play on at First Avenue," McClellan did not blame

the club's dire financial straits on the owners' growing legal dispute. However, he dryly noted, "The timing is impeccable."

June 22, 2004, was a day Steve McClellan had been looking forward to going to work; little did he know it would end with him getting fired from First Avenue. Patti Smith, one of his personal heroes, was due back at the club that night. During her prior appearance, Smith assessed the place perfectly: "You have a great club here with a great sound system. You just need a little more ventilation." On this night, her show had been organized in conjunction with the Developing Arts & Music Foundation (DAMF), a nonprofit organization McClellan set up with Frank's accounting know-how in order to promote up-and-coming and left-of-center artists without worrying too much about profits.

While Frank worked with McClellan on DAMF, his relationship with Fingerhut had deteriorated into a string of lawsuits in 2002 and 2003. Fingerhut had taken a major financial hit after 9/11, and his art publishing

It's surely a night to remember any time Patti Smith is onstage at First Ave, and especially when joined by Twin Cities blues legend Tony Glover. But this date, June 22, 2004, would be memorable for other reasons, as longtime manager Steve McClellan would be laid off before the night was done. *Photo by Daniel Corrigan*

business went under. He accused his childhood friend of misleading him on the art businesses, and the two wrangled over a buy/sell agreement on Fingerhut's struggling galleries. "Allan was very upset, and he sued me for claiming we had a contract that he didn't agree to," Frank recounted. Eventually, the fight spilled over into First Ave's ownership. That's when the arrangements made at the time of the building purchase came into play.

Fingerhut accused Frank of forging his signature on the 2000 contract that gave the accountant oversight of the club. When he received the lawsuit charging him with forgery, Frank said, "I honest to god fell on the floor laughing. After three years, this guy claims I forged a document. After another year and a half and a lot of legal fees, though, it wasn't very funny." Coincidentally or not, Fingerhut's original partner for the Depot opening in 1970, Danny Stevens, has also claimed his signature was forged on a document pertaining to the liquor license, which he believes should still be in his name. As Nate Kranz put it with amused skepticism, "You never hear of people claiming forgery in serious business transactions, and First Avenue actually has *two* cases of people claiming forgery in its history."

Kranz had worked at the club for six years without meeting Fingerhut when, out of the blue, the absentee owner called him up late on the night of February 8, 2004. Fingerhut was upset over a War Ain't Right People (WARP) benefit concert that took place that night, with comedian David Cross and radical Bay Area hip-hop group the Coup. Fingerhut's brother, Ronnie, had happened by the club and seen some pro-Palestinian literature distributed at the show by Minneapolis DJ K-Salaam.

"I remember sitting up in the office with Boots Riley from the Coup when he was getting paid, and I was clearly getting screamed at by Allan over this antiwar benefit, trying to tell him I didn't think it was a big deal," Kranz said. "Then the next time I came into the office, Steve was on the phone getting yelled at by Allan. And the next time, Jack [Meyers] was getting yelled at. In my mind, that was the beginning of the end, because before that Allan wasn't present at all."

McClellan believes Fingerhut felt slighted by Meyers and Frank, the two financially savvy partners in the property ownership. "I think Jack showed favoritism to Byron early on, and Allan understandably wasn't happy about that," McClellan theorized. Once Frank had control of the property, he added, "then Jack didn't care what Allan thought." Meyers said he simply didn't trust Fingerhut's management of the club without his longtime accountant: "Allan needed Byron more than he ever knew." Once Frank started feuding with Fingerhut and stopped working for him, Fingerhut's Committee, Inc. (which ran the club) went deep into the red again. In addition to unpaid taxes and other bills, it fell behind on the modest rent due to the Frank-helmed partnership that owned the building.

A decade later, Fingerhut downplayed the legal scuffle with Frank. "Steve did a great job and did so much, but it was just not the venue I wanted," he said, citing his dislike for some of the "pure noise" (punk and metal bands) that McClellan brought in. "I'm an R&B man. I like to dance. They were bringing in really different acts. I thought it was hard on the club." Amid the "disagreements and arguments," he said, "I felt like I lost control. I was told what we were going to do, and what we were not going to do, and I finally got to a point where I felt I had to gain control again. The club was my baby."

From California, Fingerhut had his lawyer write a letter to McClellan and Meyers telling them they were

Steve McClellan in the office at First Avenue, June 22, 2004. *Photo by Daniel Corrigan*

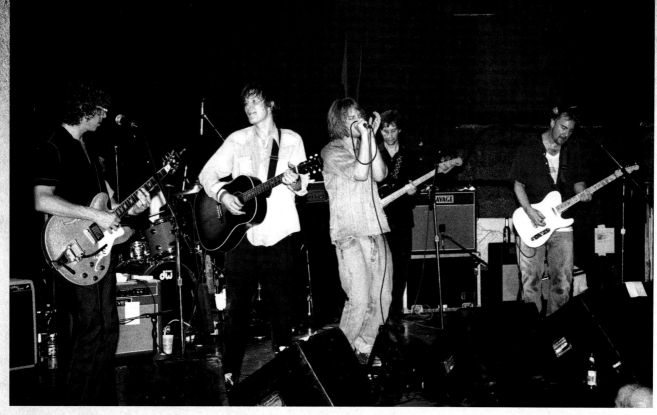

As the First Avenue management was embroiled in bitter infighting, the Minnesota Democratic-Farmer-Labor Party brought people together for a fundraiser, "Rock for Democracy," on July 18, 2004. The bill featured an all-star lineup in both rooms of the club. Among the performers was a version of Golden Smog, including Gary Louris of the Jayhawks, Kraig Johnson of Run Westy Run, Dave Pirner of Soul Asylum, Marc Perlman of the Jayhawks, and Dan Murphy of Soul Asylum. *Photo by Steven Cohen*

being fired for "disloyalty." This is how music scribe Jim Walsh, writing for *City Pages*, described the scene in the office that night of the Patti Smith show: "Steve was folded up against his cramped desk in front of his computer. 'Shit, I'm gonna cry,' he said, and then he did, in a burst. Just as quickly, he shook it off, got it together, and talked about how relieved he is to be getting off the merry-go-round that has been his life for 31 years."

And just like that, the guy who ran the place since 1979 was gone. Drew Miller from Boiled in Lead, an Irish band McClellan adored, had a van and helped him pack up his belongings from the office. Looking back on that night twelve years later, McClellan said, "Hey, at least I got to see Patti Smith on my way out." Meyers, too, remembers trying to see the positive side of getting fired. "I was relieved," he claimed, "because I was getting all these calls [about] money overdue, and there just wasn't a damn thing I could do about it. The hole was too big by then."

The sting of being fired was also softened by discussions that Frank, McClellan, and Meyers had had about taking over the club. Using their majority ownership of the building, the trio worked up a plan to evict Fingerhut from the property over unpaid rent and taxes. It was far from just a tactical ploy—court documents before the first eviction hearing cited $160,000 in back taxes owed by Fingerhut's Committee, Inc.—but it raised two potential scenarios that, in hindsight, seem unthinkable: One could have Fingerhut open First Avenue in another location, which he mentioned at the time as a possibility; the other could have McClellan and Meyers take over the old depot space under a different name, which they also pondered.

With the eviction hearing not scheduled until mid-October, Fingerhut was left to run the place through the summer and fall of 2004. Kranz sums up those months as "absolutely bonkers." Fingerhut flew back to Minneapolis from California the day after firing McClellan and Meyers. He put a new manager in charge of day-to-day operations, Chris Olson, who would later manage two other clubs in town, the Triple Rock and Mill City

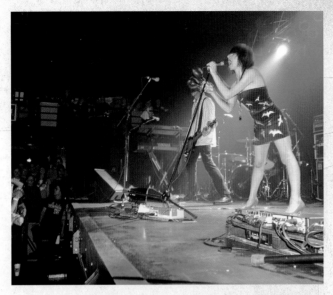

PJ Harvey was a notable booking in the final weeks before First Avenue closed its doors following Allan Fingerhut's bankruptcy filing. An October 1, 2004, concert was her first appearance at the club in several years. *Photo by Daniel Corrigan*

Nights. But for the first time since he shuttered the Depot in 1971, Fingerhut was more or less the hands-on boss, who brought in many ideas—but not many fresh ones—on how to right the ship.

"For weeks, we sat and listened to Allan's ideas about how to program the club, and it was just crazy shit," Kranz remembered. "It was air-guitar kind of stuff, but also his mentality was, 'Why are we paying DJs?' He talked to somebody who said all we needed to do was bring in a computer that would play Top 40 for us. He thought the [talent] money should instead be going to advertising. He spent like $10,000 on advertising, which at that time was unheard of for us. It was like an 'all in' kind of thing. It went to places like [pop station] KDWB to push our dance nights, for people to come down and hear a computer play Top 40." In short, Kranz said, Fingerhut seemed to believe that "the way First Ave works is you just open the doors, and people come in because it's First Ave."

Kranz and Grover had already confirmed a decent lineup of non-computerized talent over those months before Fingerhut got involved. In fact, it turned into a pretty great run. Some of the acts to play the Mainroom during this span were the "Float On"–riding Modest Mouse on July 28; the Black Keys touting their *Rubber Factory* release on September 21; and the rarely-seen-in-Minnesota PJ Harvey on October 1. October overall, just before the bankruptcy filing, was an especially solid month, with the Drive-By Truckers, Interpol, Flogging Molly, Cake, and longtime club favorites the Old 97's and Camper Van Beethoven.

Meanwhile, Frank, McClellan, and Meyers—along with their lawyers—worked to rein in Fingerhut. Claiming his only goal always was to see the club live on, Frank denies Fingerhut's accusations that all along he wanted to swoop in and take over ownership. "I retired in 1999," Frank pointed out. "I was living on [Sanibel] Island in Florida, where the sun shines every day. My wardrobe consisted of mostly T-shirts and shorts. The last thing I wanted was to be involved in the club business back in Minnesota, and especially in the liquor business." Frank led the charge to evict Fingerhut, though, and enjoyed a victory at the end of October. It would prove only temporary.

When the club's employees awoke on Thursday, October 28, 2004, following a nearly three-hour set from the Drive-By Truckers that had gone until practically two in the morning, they found out they were about to get new bosses—same as the old bosses. That morning, Fingerhut had been officially evicted in a Hennepin County court. McClellan and Meyers would take back the reins of the club the following week, based on a court settlement worked out between lawyers. Fingerhut had one week to clear out. No mention of bankruptcy was made.

"This [case] is not about wanting to take back the club," Frank's attorney, Sean Shiff, said after the hearing. "It's about dealing with Allan's defaults." The two sides agreed to meet early the following week, after the club (still under Fingerhut's watch) got through a busy Halloween weekend. The meeting would include negotiations on the right to the First Avenue name and transfer of other assets. A report in the *Star Tribune* the following day proved fittingly ominous: "Conceivably, Fingerhut

could negotiate a plan to continue operating the club, but the other business partners would have to agree. Thursday's settlement suggested he would not do so."

As expected, it was a bustling weekend. The club's Halloween dance party and costume contest had been a popular draw going back to the Uncle Sam's disco days. "There was a lot of money in those tills," Nate Kranz remembered of the bar sales. But that money was all gone by Tuesday afternoon. After a day off Monday, many of the club's employees showed up Tuesday to work, collect their pay, or both. They got rather stern and unexpected instructions from Fingerhut, via Chris Olson: Go cash your checks right away. "I was told specifically to take my check to U.S. Bank and cash it immediately," Kranz recalled. "So I went over there, stood in line with other First Ave people."

At 1:30 PM on Tuesday, November 2, 2004, Allan Fingerhut officially filed for Chapter 7 bankruptcy protection for the Committee, Inc., the company he established in the spring of 1970 to run the Depot. Employees who didn't cash their paychecks before 1:30 PM were left with rubber checks, as were some of the bands—Flogging Molly and Interpol among them—who had just played the club and took a check with them.

Twelve years later, Fingerhut initially tried to avoid questions about the bankruptcy. "I just don't like talking about things that were within the company," he said. Eventually, though, he explained that his attorneys talked him into filing Chapter 7 as a way to prevent further lawsuits against him. Fingerhut conspicuously avoided the name of his former friend. "I was forced into it," he said. "A bunch of lawsuits came to me. It had everything to do with control and ownership of First Avenue. And they tripled the rent. I'm not using names, but ownership moved to somebody, and they tripled the rent because they wanted to own it themselves, and there was nothing I could do. It was barely making it at the time."

Frank strongly disputes Fingerhut's claims his rent was raised, pointing out that his old friend *earned* about $60,000 more annually than he paid in rent—revenue from the property's other businesses. "Allan knew exactly what he was doing," said Meyers, the club's longtime

The First Avenue green room—spruced up and looking nice in this photo from 2010—sat empty for a tense seventeen days in November 2004. *Photo by Daniel Corrigan*

business manager. "He went and cleaned the account out the day of the payroll. He cashed his paycheck, and then cleaned it out. He tried to tell me that once, too—that he did the bankruptcy so people could get paid. I think he tried to believe that. Everybody knows what he did. He took the money and ran, and screwed over a lot of people."

A small crowd of people, including many who typically didn't leave the house before noon, filed out of a federal courtroom in downtown Minneapolis just after 10:00 AM on November 12, 2004. It was a bright and sunny morning—literally and figuratively. Their smiles were tempered by a deer-in-the-headlights daze that comes with most legal proceedings. The biggest among them both physically and vocally, Steve McClellan was the first to wipe away his grin outside the courtroom and ask perhaps the most direct and welcome question heard during the three frenzied, fearful weeks that the Midwest's most

famous rock club had been out of commission: "Did we get the keys yet?"

Earlier, in the courtroom, McClellan, Meyers, and Frank sat before bankruptcy judge Robert Kressel. Fingerhut's lawyer, Gregory Weyandt, sat across the aisle, his client already back in California. "I gather there is some urgency about this," the judge said from his podium. Kressel's ruling was thus swift: In lieu of the rent money owed them, the majority owners of the building (Frank, McClellan, and Meyers) would be given all of the Committee, Inc.'s assets, including, most notably, the name First Avenue.

Things kept moving quickly from there. Just hours after leaving the courtroom, McClellan, Meyers, and Frank went to the office of Mayor R. T. Rybak, who had already pledged his support of their efforts. They asked for help securing a new liquor license (which would otherwise take months) and a low-interest loan from the city to offset reopening costs. They got the license but not the loan. They also got a public-relations boost from the media-savvy mayor, a former journalist who made sure the *Star Tribune* was in on the meeting. "It's time for the community to step up to the plate," Rybak told the newspaper. "Everyone was in mourning last week when First Avenue closed, but now they should be thinking about going in there and spending money to support it." That's when the mayor promised his stage dive. Thanks to his involvement and the know-how of the new/old managers and staff, it took only a week for the club to be a place to dive in again.

Permanently sidelined by Judge Kressel's ruling, Allan Fingerhut has not set foot in First Avenue since he put it in bankruptcy. The club's original owner continued living north of San Francisco and working in the art business up until the early 2010s, when he closed the last of his galleries. After a few health scares, he settled into a retirement routine that includes daily viewings of *Wheel of Fortune* with his wife, Rose, whom he married in a ceremony at the club in 1985.

In 2015, Fingerhut looked back with pride and nostalgia on most of his thirty-four-year run at the club. Whatever is said of his involvement throughout that

Childhood friends Jack Meyers and Steve McClellan had a long and often-tumultuous tenure after taking over the club in 1979. *Photo by Daniel Corrigan*

time, it's an undeniably long tenure for a rock-club owner. He bristled at the suggestion that he padded his personal fortune off of First Ave all those years. "It may have been break-even in the long run, but nothing more," he said, then offered this misty-eyed assessment: "It was a wonderful journey. I can't complain. It really was incredible. It was the same thing with my galleries and publishing companies: I didn't make money, didn't lose much, but it was a wonderful experience having them. And now it's all over. I miss most of it. I'm glad I went through it, and I made out okay. Everybody that worked there felt it was the greatest thing in their life, and making money off of it wasn't more important than that. Steve [McClellan] always said that, too: Money wasn't what was most important. I'm so proud the club is still there. So proud. It was like losing one of my children when I lost the club."

When asked if he would offer any well-wishes or encouragement after all these years to the current owners of First Avenue—Byron Frank and his family—Fingerhut clammed up. "I'd rather not answer that," he said simply. ∎

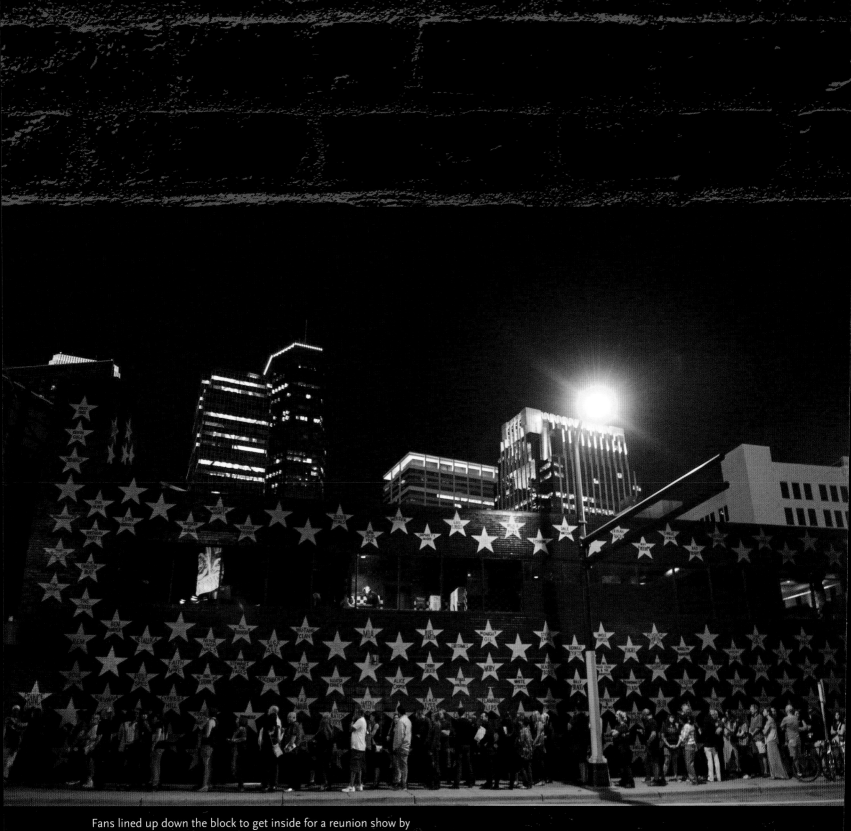

Fans lined up down the block to get inside for a reunion show by
the Revolution on September 1, 2016. *Photo by Steven Cohen*

THE REAL HEYDAY

2005 TO TODAY

"Today's fans still love the no-frills vibe and killer acoustics, even if waiting in line during a Minnesota winter can be a bummer."

—"The Best Music Venues in America: #3," *Rolling Stone*, April 2013

Craig Finn had trouble keeping his emotions in check. His new band, the Hold Steady, was loading in for its first headlining performance at First Avenue on June 6, 2005, and after living in New York City for five years, coming home was naturally bittersweet. First Ave, in particular, was its own kind of homecoming. It had been only seven months since Finn was closely monitoring the news from Minneapolis while everyone else was glued to news out of Washington, D.C. "The day the club closed [from bankruptcy] was also the day George W. Bush was reelected," he grimly recalled. "I remember thinking, 'This has not been a good day.'"

The Hold Steady frontman had been hitting First Ave since the summer before his freshman year at the Breck School in suburban Golden Valley. His mom, Barbara, dropped him off for his first show, the Violent Femmes, on June 17, 1985. "It was right after they put out their second record," he said with a hint of lament, as if the Milwaukee punk strummers were already past their prime. "I just kept going there after that," Finn continued. "A lot of the all-ages hardcore shows; a lot of the local bands." He saw the Replacements, Hüsker Dü, and plenty of Soul Asylum. He was there the night the Descendents recorded their *Liveage!* album in the Mainroom ("That's

impressed a lot of people over the years," he said). He got to see Aerosmith's members crash Cheap Trick's show, when the former was in town filming its video for "I Don't Want to Miss a Thing" at the Minneapolis Armory. He got to see Courtney Love crash the stage on some random band in the Entry and start yelling expletives at the crowd.

Finn also got to take over the 7th Street Entry stage, many times. As a high schooler, his group, No Pun Intended, earned a slot on New Band Night in 1988. The only good that came of that, he said, was advice they got from sound man Ed Ackerson: "Stop playing Peavey amps." By 1996, Finn was playing the Entry on a regular basis with his post-college band, Lifter Puller. The snarly-yet-literary punk quartet got to open for Sebadoh and Built to Spill in there. They shared bills with local pals like Dillinger Four, the Selby Tigers, and Atmosphere. One of their last Entry bookings before calling it a day was opening for Sleater-Kinney with D4 and the Murder City Devils in March 1999, but S-K cancelled when Carrie Brownstein suffered a back injury. "We still got like six hundred people in there, which I think proved we belonged in the Mainroom," Finn recalled proudly. Alas, his shot at the big stage would have to wait.

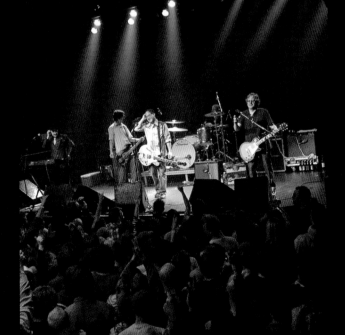

(Above) Craig Finn and Lifter Puller in the 7th Street Entry, June 1998. *Photo by Daniel Corrigan. (Right)* Craig Finn and the Hold Steady in the Mainroom, October 2006. *Photo by Steven Cohen*

When that headlining gig in the Mainroom finally came in the summer of 2005—a month after the arrival of the Hold Steady's second album, *Separation Sunday*—Finn's excitement doubled when he found out the show had sold out. "That was a really big deal," he said. "Especially since it was so soon after it almost shut down, it was kind of overwhelming. I was happy just to set foot in there again, and here I was stepping on the stage where I'd seen so many amazing bands. It was like a temple to me. And it's sold out. There were so many forces at play to make that happen."

Some of those same forces would work in First Avenue's favor in the coming years, too. The club started to flourish again almost immediately in the months after

the great bankruptcy scare. As the internet became an increasingly important avenue for discovering and consuming music in the mid-'00s, a new groundswell of indie and underground music developed. Bands like the Hold Steady were getting exposure from blogs and websites outside corporate music channels, and they no longer had to hope for radio play on the narrow-format, Clear Channel–owned Twin Cities stations, such as the Hootie & the Blowfish–spewing Cities 97. (First Ave's chief competitor, the Quest, also could no longer rely on its corporate ties to Clear Channel, and it finally shut down for good in late 2016.)

One radio station did play a vital role, however, in the rebirth of First Avenue and the rise of bands like the Hold Steady. And its timing couldn't have been better: 89.3 the Current debuted on January 24, 2005, two months after the club reopened. The so-called "anti-format" station was billed as radio for the digital generation. Its operator, Minnesota Public Radio, was a powerhouse in the nonprofit radio business thanks to Garrison Keillor and his syndicated radio show, *A Prairie Home Companion*. Ol' Man Keillor wasn't bringing in many Gen-X listeners or younger supporters as sustaining members, however. MPR followed the lead of other nonprofit stations around the country such as KEXP in Seattle—where longtime First Ave DJ Kevin Cole wound up—and created a hipster-baiting rock station with a playlist akin to the eclectic mix available on an iPod or a music blog.

In fact, the Current's inaugural song was an indication that it would be in cahoots with First Ave's aesthetic: "Say Shh . . . ," an ode to Minnesota by Atmosphere, one of the club's homegrown headliners. The Minneapolis hip-hop duo was one of many local acts that had been ignored by the corporate stations in town ever since the demise of Rev-105 in 1997. Thanks in large part to the Current and the always-supportive local music press, First Ave would see more Minnesota acts rise to Mainroom headliner status in the coming years than in its 1980s indie heyday.

Proof came just a few weeks later in the form of Duluth's slow-burning trio, Low. Despite being a favorite of legendary BBC DJ John Peel and an opener on

On December 9, 2005, Alan Sparhawk (left) and Low shared a stage with fellow Duluthians Trampled by Turtles. Both bands were buoyed by exposure on the new local radio station, 89.3 the Current, during the mid-2000s. *Photo by Steven Cohen*

Radiohead's *Hail to the Thief* tour, Low was still essentially a 7th Street Entry–level act in the early 2000s. But in 2005, the band's first record for Seattle's venerable Sub Pop label, *The Great Destroyer*, arrived with a strong critical buzz—and by chance, a release date one day after the Current debuted. It immediately went to steady rotation, in part because the station's infant catalog did not yet have a lot of other new CDs to spin on air. To the surprise of many, Low's February 12 album release party in the Mainroom sold out. "That's about twice the business that Low had ever done here before," said booker Nate Kranz, crediting the Current. Low's frontman Alan Sparhawk also made light of the obvious profile boost onstage that night: "It's an honor to be here in this club, with a room full of people who actually want to see us," he said.

First Ave would see the so-called "Current effect" ramp up in the months that followed, and not just with local acts. Bands that would've been marginal choices as Mainroom headliners a year earlier were packing the club, thanks to steady airplay on 89.3. Among the acts to play full or near-full Mainroom shows in 2005 were

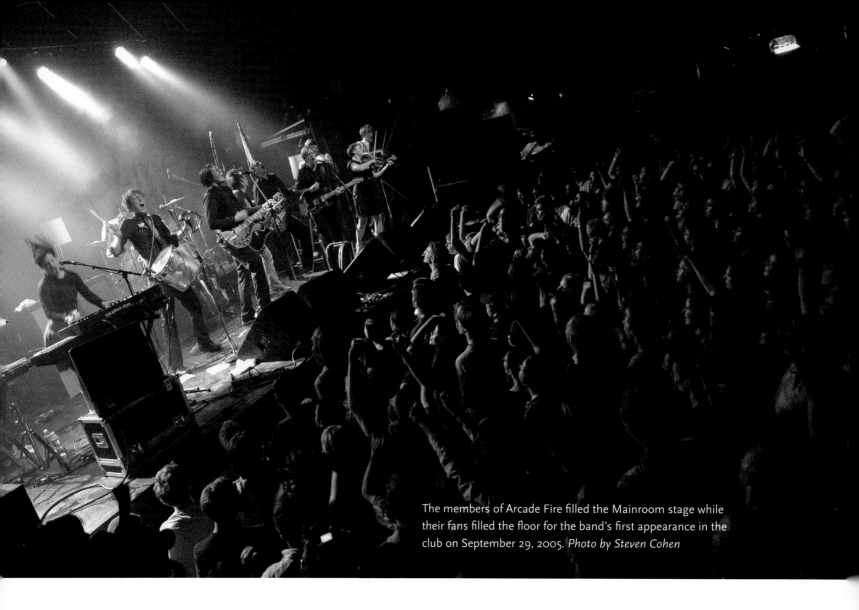

The members of Arcade Fire filled the Mainroom stage while their fans filled the floor for the band's first appearance in the club on September 29, 2005. *Photo by Steven Cohen*

Arcade Fire, Spoon, Kings of Leon, the Decemberists, LCD Soundsystem, the Shins, New Pornographers, Iron & Wine, Rilo Kiley, the Kills, and the aforementioned Hold Steady. Several other Current-buoyed acts moved up to two-night stands that year, including Modest Mouse, Bright Eyes, and Atmosphere. Nate Kranz later recounted to *City Pages*, "It didn't take long for us to start working with the Current a lot, and actually taking into account when we were booking shows what we could do, knowing that we were going to have a radio partner on a station that actually had good listenership and a good range."

Maybe the biggest show for the Current audience in this vital stretch was Arcade Fire's riveting performance on September 29, 2005. That gig certainly meant a lot to Kranz and his fellow talent buyer, Sonia Grover. The

club's young booking duo got in early on the Canadian rockers and had lined them up to play 7th Street Entry the prior November. It would have been interesting to see how the seven-member, hyperactive troupe would have functioned on the Entry's puny stage. Alas, Arcade Fire was one of the bands that had to be relocated to another club during First Avenue's three-week bankruptcy closure. They wound up at the 400 Bar, whose operators insisted Arcade Fire's reps cut First Ave out of the promotion. "It was their 'fuck you' to us, just like the Quest did, while every other club in town was cool to us when we were down," Kranz said. Arcade Fire's agent rewarded First Ave in the end, though. The band still partnered with the club as a copromoter as late as 2014, when Arcade Fire performed across the street at Target Center.

During the 2005 gig—another widely bootlegged First Ave concert—Arcade Fire already exhibited the dramatic flair of an arena-rock act. The set featured all of the band's debut album, *Funeral*, and a crescendoing cover of "Five Years," whose originator David Bowie had performed with the band three weeks earlier in New York. "By the time openers Wolf Parade came out to join the band for a euphoric version of 'Wake Up' that closed out the show," *City Pages* writer Erik Thompson enthused, "the Canadian collective had alerted each and every one of us that a new day was indeed dawning in rock 'n' roll."

Interpol also returned in 2005: The March 12 date for the Joy Division–channeling New York rockers was less than six months after their paycheck from an October 2004 gig bounced, when Allan Fingerhut put the club in bankruptcy. Their return so soon afterward, on March 12, was a show of confidence in the revived Minneapolis club. They weren't just being nice, either. Right after the club reopened, Kranz said he convinced new boss Byron Frank to pay those bands that had gotten stuck with bounced checks. "Byron thought—and rightfully so—that those checks were on Allan," he recalled. "But we had to do it for the club's reputation. It wasn't just about paying back those specific bands. We had to get those bands' agencies and all the other agents back on board with us."

Kranz and Grover would have to convince the new owner of many other things in 2005. But with 89.3 the Current and other technology-driven factors boosting a new wave of independent music fandom in the Twin Cities, First Ave's new guard had a lot of outside help in resuscitating the old club. In the end, the venue's thirty-fifth year of business would be the beginning of a prosperous era that continues to this day.

As 2005 came to an end, so did Steve McClellan's tenure at First Avenue. It was a quiet farewell from a guy for whom the word "quiet" never applied, although the club's longtime general manager did enjoy a noisy-as-hell last hurrah. The venue belatedly celebrated its thirty-fifth

After three decades and three name changes, Steve McClellan's run at the club he helped build came to an end in 2005. During the thirty-fifth anniversary concert and fundraiser for McClellan's DEMO that December, the longtime manager shared a moment with another longtime employee, production manager Conrad Sverkerson. *Photo by Steven Cohen*

anniversary on December 14 with an all-star, two-room concert that doubled as a fundraiser for McClellan's nonprofit, which had evolved and been renamed the Diverse Emerging Music Organization (DEMO). Many of McClellan's pals were on the lineup, including the Jayhawks; a piecemeal version of Golden Smog; the X-Boys, featuring members of the Suburbs, Suicide Commandos, and the Wallets; a Rifle Sport reunion; the Mighty Mofos; Ed Ackerson's Polara; and Curtiss A, who regaled an amused crowd with the story of that time he spit on Allan Fingerhut in the club office and flatly proclaimed "I created punk rock." The Hold Steady also played, and Craig Finn talked about the club being "a cradle" under McClellan's watch.

Another McClellan favorite flew in for the party: California punk icon Mike Watt, who had been moonlighting as the bassist for Iggy & the Stooges that year, hammered through a rowdy set of Stooges tunes with the Jayhawks/Golden Smog contingent as backers. Watt

Among the all-star cast at the thirty-fifth anniversary celebration was Mike Watt, former Minutemen and Firehose bassist, as well as locals Ed Ackerson, Gary Louris, and Kraig Johnson. *Photo by Steven Cohen*

One of Mike Watt's more memorable appearances at the club was on his 1995 *Ball-Hog or Tugboat* tour with Eddie Vedder and Dave Grohl's Foo Fighters. *Courtesy of Dale T. Nelson*

had been coming to the club since 1985, when the Minutemen played a legendary Entry set shortly before singer-guitarist D. Boon's death. His many visits since then included the even more legendary 1995 Entry show on his *Ball-Hog or Tugboat* tour, with a backing band featuring Pearl Jam singer Eddie Vedder on guitar and Dave Grohl and Pat Smear of the then-fledgling Foo Fighters. At the anniversary party in 2005, the bassist sang McClellan's praises and signed off with an emphatic call to action that suited DEMO's mission: "Start your own band!" he yelled.

According to many staff, McClellan had stepped back from his duties as talent buyer and day-to-day manager once Byron Frank became the primary owner at the

end of 2004. "I think Steve's heart had kind of moved on by then," said Kranz. McClellan's high-school mate Jack Meyers—who returned to his duties as business manager through 2009—said, "Steve had a lot going on at the time." Besides overseeing DEMO and teaching part-time at McNally Smith College of Music, he also went through a divorce and other personal upheaval. Marketing director LeeAnn Weimar—who had helped see the venue through the turmoil of 2004 but was gone shortly thereafter following a financial dispute with Frank—felt that McClellan was not treated well at all near the end. "It just was … icky. I can't even define it. It just was like there was a time that was over now. It was sad, and it was hard."

Byron Frank insisted he wanted McClellan around, just as he had brought Meyers back into the fold full-time. The new club owner had already given each of them a cut of the building's ownership in 2000, and once Fingerhut was out, Frank also shared ownership of the company running the club with McClellan and Meyers. They had forty-nine percent to his fifty-one percent. "I had so much respect for those guys, because I knew how much hard work they put into the place for so many years," Frank said. "I had set it up initially so Steve and Jack would run it, and I didn't have to do anything. So I gave them forty-nine percent of the club. I told them, 'You got it. It's yours. I'm staying in Florida.'"

As it turned out, he didn't stay away long from the business in which he now had invested hundreds of thousands of dollars. As Frank got more involved, he

said McClellan became less and less involved. "I said to Steve, 'I know you're going through a tough time. All you have to do is be here. Greet people here. You have no responsibility beyond that.' He said, 'You know what? I think I should just go out and do my own thing.' I said, 'It's up to you.'"

While Meyers corroborated Frank's account, saying that McClellan left on his own volition, McClellan still contended that "Byron wanted the club, so he got Allan out of the way, and then me." The ex-GM doesn't deny he had burned out on the job, though. "Getting forced out the way I did, I realized I glamorized a career that didn't really deserve it," McClellan said a decade later. "I did what every other midmanager at Holiday gas station or Super America does: Squeeze the shit out of your part-time employees, don't hire anybody full-time, buy low and sell high. Buy vodka on sale at this price, sell it high." But, he added with a proud huff, "I didn't do that to bands. I overpaid a lot of bands and wasn't cutthroat to them, which Byron knew all along."

McClellan was still tied in as a partial owner of First Avenue, and DEMO still presented events there, so his departure was not abrupt. Frank eventually bought out his and Meyers's stakes, about $280,000 apiece. The guy who had run the club for a quarter century never found a solid foothold in the music business again. He continued working with DEMO but bounced from teaching jobs to booking in smaller bars to bartending to pay the bills.

"After five years, it dawned on me nobody wanted to hire somebody over fifty-five," he said. "I've had students I taught get hired for jobs I applied for. And it's probably the smart move: If you want somebody to find talent, get a

For decades Steve McClellan was a fixture behind the desk at First Avenue. *Photo by Daniel Corrigan*

kid that's out every night. I don't drink anymore, so that's a deterrent in this business." Only rarely does McClellan return to First Avenue. "I don't want to be like Danny Stevens was back in our day: a guy from the club's past always coming around trying to get on the guest list," he said. In 2014, when Bob Mould returned to 7th Street Entry for a surprise gig, McClellan had to track down the former Hüsker Dü coleader himself to get in the door. "Nobody knows who I am there anymore," he claimed.

"If it wasn't for Steve [McClellan], there would not be a First Avenue here today. He built this place. He brought all the talent in. He's as important as anyone to the legacy of First Avenue."

–Byron Frank

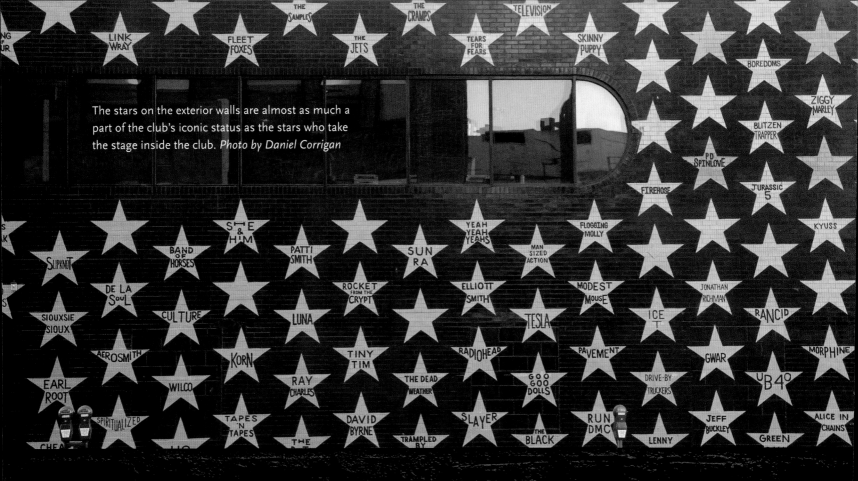

The stars on the exterior walls are almost as much a part of the club's iconic status as the stars who take the stage inside the club. *Photo by Daniel Corrigan*

THE WALL OF STARS

t's the only place where Prince, U2, Metallica, Tina Turner, GG Allin, and the Replacements have all hung out together—or where their names hang side by side, anyway. First Avenue's wall of stars, which wraps around the front exterior of the club, boasts the names of more than four hundred prominent acts that have played the venue since 1970. The monikers are painted in black type on silver stars, except for Prince's gold star, which further boosted the wall of fame's iconic status as fans piled memorials underneath it in the days after his death. However, the stars had not yet been painted on the building when the club became famous on-screen in *Purple Rain*. They came a year or two later, once Prince and many other performers who landed at the club over the years had graduated to bigger venues.

"People would say things like, 'Wow, U2, too bad you couldn't have them play here,'" recalled the club's longtime business manager Jack Meyers, who first brainstormed the stars with other staffers as a marketing idea. "I'd say, 'U2 did play here!' And when Target Center was built [in 1990], you would have bands like the Red Hot Chili Peppers playing right across the street, and a lot of their fans would walk right past First Avenue and not know anything about us or how many times that band played here."

The stars disappeared without much fanfare under a full blanket of black paint for several years in the late '90s as a cost-saving measure, but they were brought back after the club's operators bought the building in 2000. A decade later, it was clear just how big a deal the stars had become when they suddenly disappeared again for about a week, this time for a once-per-decade repainting—and the fans expressed outrage at the apparent removal of the stars. "We had people call, email, blog, post, corner us if we were sitting down for

★ **Total number of stars: 530.**

★ **Total number with names in them:** About 450 as of 2017. The rest are blank to leave room for newcomers.

★ **Number of stars inside the club:** 2, one to commemorate the April 3, 1970, opening date with Joe Cocker and another for *Purple Rain* and the date the film hit theaters, July 27, 1984. Both appear at the top of the main staircases.

★ **A star is lost:** Adele's star had to be removed after her one and only scheduled gig there was twice cancelled due to laryngitis; the star had been painted on before the shows as a surprise to her.

★ **Most questionable star:** Aerosmith, whose members joined Cheap Trick onstage in 1998 but never played their own show.

a beer, you name it," general manager Nate Kranz said at the time of the repainting in 2010.

Perhaps no one attaches more importance to the stars than the Minnesota acts whose names appear on the side of the local institution—everyone from the obvious Hüsker Dü, Soul Asylum, and Atmosphere to hometown favorites like the Gear Daddies, Tina & the B-Sides, Koerner, Ray & Glover, Ipso Facto, the Magnolias, and Cows, as well as more recent breakout acts such as Trampled by Turtles, Har Mar Superstar, and Motion City Soundtrack, to such curiosities as the Jets and adopted Minneapolitan Tiny Tim. "A lot of clubs in America don't sport their hometown pride," piano rocker Mark Mallman said proudly when his star earned better real estate in the 2010 repainting. "It's rare, actually, which is what makes First Ave so fantastic." ∎

Of course, that's not true. McClellan's top-dog status among First Avenue's MVP alumni is recognized by everyone involved with running the venue today. Byron Frank himself put McClellan and Meyers first on the list of names to get a star on the walls outside the club when they were repainted in 2010. "If it wasn't for Steve, there would not be a First Avenue here today," Frank said recently. "He built this place. He brought all the talent in. He's as important as anyone to the legacy of First Avenue." McClellan's eventual replacement, Nate Kranz, said of his exit, "We all loved the guy. It was hard to think of First Ave without thinking of Steve. I was scared, to be honest. He was the heart and soul of this place."

Musicians also spoke highly of McClellan's contributions, not just to the club, but to their careers. Bob Mould claimed he learned most of what he needed to know about the music business from McClellan: "Steve really taught me a lot of things I still use to this day." The Jayhawks' Marc Perlman said, "He was just a very real, honest guy in a business that doesn't have enough of those." Dan Wilson humorously credited McClellan's gruff demeanor and high standards for toughening up Minnesota's sensitive rock auteurs, including himself: "When Trip Shakespeare was trying to play First Avenue, and then Semisonic, I always permanently picture Steve kind of glaring, his eyes bulging at you with a very skeptical glare," he said. "That's probably kind of great, to have someone on the scene who's like, 'Ehhh!' It makes you prove yourself."

Among First Ave staffers past and present, Pete Rasmussen, a bartender for more than thirty years, said, "We all started out being intimidated by Steve, but once you stood up to him about something, you realized he's a teddy bear underneath." Former crew member Maggie Macpherson, who became a competitor as booker for the Uptown Bar, said McClellan gave a clear message to his staff that they were doing noble work. "Steve sort of made us all feel like such an important part, a big cog in the wheel." LeeAnn Weimar, who went on to work for the Orpheum and State theaters, believed she butted heads with McClellan more than anyone on staff—a bold

In 1993, the *Twin Cities Reader* alt-weekly proclaimed McClellan the "crabbiest man in Minneapolis." That didn't stop him from building the club into a world-renowned music venue, earning him praise from many employees and musicians who walked through its doors during his long tenure. *Courtesy of Michael Reiter*

claim—but she continued to hold him up as one of the great unsung cultural heroes of the Twin Cities.

"Mary Tyler Moore [was] probably a really wonderful person," Weimar said of the actress/TV character immortalized in bronze on Nicollet Mall, "but there should be a statue of Stephen McClellan somewhere. I seriously think that he has been underestimated. He was a visionary. He changed the face of music, not just in this market but in the country. He wasn't a guy who said, 'Okay, one Rolling Stones show, I'm a millionaire, and I'm out.' No. The word is 'develop.' He developed the relationships, the

artists, the kids that can do it. Developed the music. He does it to this day."

As McClellan's role at the club grew more tenuous, Byron Frank considered something that now seems unthinkable: having a giant corporate promoter like Live Nation (then still Clear Channel) book First Avenue. As Kranz explained it, "Byron became hands-on about everything in the club—when the wait staff clocks in or whatever. But he has always steered clear of the concert business. He's a fan. He tells us what he likes, and he comes out and enjoys a lot of the shows. But he just doesn't want anything to do with the business and promoter side of it. So from his standpoint, it just made sense to let Clear Channel or AEG"—a global sports and entertainment conglomerate—"handle that part of the business."

Much like McClellan visiting Allan Fingerhut's mansion in 1979 to pitch his idea for a post-disco Uncle Sam's, Kranz had to sell Frank on the idea that he and Grover could turn First Ave into a profitable venue in 2005. The two talent buyers each turned thirty years old around that time—rather young for Frank to entrust them with the future of the club. They already had a long history together, though, working side by side at Cheapo Discs in Uptown before being hired at First Ave just a few months apart in 1998.

A Long Lake native and Orono High School grad who frequented the club long before he worked there, Kranz started as a "ticket runner," dropping off tickets and picking up money at record stores. Grover was brought in to help manage the booking contracts. Originally from suburban Maryland, she moved to the Twin Cities in large part out of her love for the Replacements, but also

> "There should be a statue of Stephen McClellan somewhere. I seriously think that he has been underestimated. He was a visionary. He changed the face of music, not just in this market but in the country."
>
> —LeeAnn Weimar, marketing director

Nate Kranz was in his early twenties when he started at First Avenue, and by the time he was thirty he was helping put the place on the path to profitability as general manager. *Photo by Daniel Corrigan*

to attend Macalester College. "Back then, if you wanted to book bands at the club, there was a feeling of 'go for it,'" Grover recalled. "It wasn't cutthroat. Usually, it was just about us wanting to bring in the bands we liked ourselves." When she contacted agents for Belle & Sebastian and the Promise Ring—popular college radio bands at the time—"they were stoked they finally had a contact here. They wanted to play here as much as we wanted them here."

As Frank sought to streamline operating costs, there was talk of Grover and Kranz being let go as staff and operating as independent promoters outside the club. "It probably would've worked," Grover said, "but we wanted to work for First Avenue." Then came the talk of Clear Channel or another corporation handling the booking. That's when Kranz made his hard sell to the new boss. "I told Byron, 'If you let Sonia and me book shows, you're gonna do good,'" Kranz remembered, admitting he may have been a tad cocky about it. "But we definitely had a certain amount of confidence in what we were doing."

For his part, Frank was less impressed by Kranz's chutzpah than by the dedication he and Grover showed months earlier during the bankruptcy battle. He admired their quick actions to relocate gigs during the

November 2004 closure, and their outreach to agents. "They went to great strides to help those bands and help maintain this club's reputation, when they really didn't even know if they would still have a job," Frank recalled. After the reopening, he continued, "Nate said, 'Give us a chance. I think we can make money at the door.' Remember: This was a notion that was contrary to the history of the club. First Avenue almost never made money on the door. Nate said, 'Give us six months. We'll prove it.'"

As of this book's writing, First Avenue has turned a profit every year since Kranz promised that six-month turnaround in 2005. The turnaround was swift, obvious, and inarguable. Anyone who hung out there throughout the decade can tell you how there were more shows during its second half, and far more that sold out, than during the first half. The Current's ascent and the Quest nightclub's fade certainly helped the cause, and Kranz and Grover also worked with a strong internal team. A lot of the management staff and other employees who rose through the ranks during the club's 2005–06 rebound are still leading the place into the late 2010s, including operations director Damon Barna and production coordinator James Baker, often seen roaming the venue talking on their headsets.

After that impressive run of 2005 acts, the club's shows in 2006 included the Black Keys, Gnarls Barkley, Mastodon, Gogol Bordello, Eagles of Death Metal, Clap Your Hands Say Yeah, Wu-Tang Clan, 30 Seconds to Mars, Pink, the Yeah Yeah Yeahs, Animal Collective, and some bigwigs from First Ave's past, such as Frank Black, Ice Cube, Yo La Tengo, and Anthrax. The Hold Steady's sold-out 2005 gig expanded to a two-night stand a year later, October 24–25. Perhaps the year's biggest show was the return of Jack White of the White Stripes with his new band, the Raconteurs, on August 3. "People are watching us learn," White said in an interview before the show, one of their first on tour. "We don't have the luxury of playing in small bars where only ten people showed up. But I love it." The crowd of fifteen hundred loved it, too.

The calendar steamrolled into 2007 with gigs by Neko Case, Arctic Monkeys, TV on the Radio, Queens of

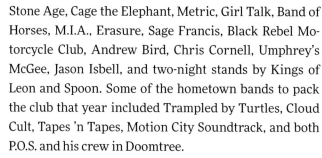

Stone Age, Cage the Elephant, Metric, Girl Talk, Band of Horses, M.I.A., Erasure, Sage Francis, Black Rebel Motorcycle Club, Andrew Bird, Chris Cornell, Umphrey's McGee, Jason Isbell, and two-night stands by Kings of Leon and Spoon. Some of the hometown bands to pack the club that year included Trampled by Turtles, Cloud Cult, Tapes 'n Tapes, Motion City Soundtrack, and both P.O.S. and his crew in Doomtree.

Trampled by Turtles frontman Dave Simonett remembered his all-acoustic string band wanting to play the Mainroom so bad, they drove thirty-plus hours straight from the West Coast so they could serve as a (somewhat groggy) warm-up act for the Ike Reilly Assassination's annual Thanksgiving Eve show in 2006. "We were thrilled just to get the opening gig," Simonett recalled. "And it was less than a year later we headlined

Many major national and international acts came through First Avenue's Mainroom in 2006. Gnarls Barkley *(top left)* entertained a full house on August 2. Ray Davies *(left)*, playing First Ave more than thirty years after he played the Depot with the Kinks, endeared himself to the local crowd by donning a Minnesota Wild sweatshirt and signing autographs following his concert on April 4, 2006. *Photos by Steven Cohen* *(Below)* While the Mainroom drew an impressive lineup of national touring acts in the mid-2000s, the club, especially the Entry, continued to provide a venue for up-and-coming local bands. Ashtray Hearts, part of the "Best New Bands" showcase in 2001, are seen here in February 2006. *Photo by Steven Cohen; ticket courtesy of Michael Reiter*

and filled it ourselves. We really couldn't have been more thrilled. It still had all the mystique. And it still does."

While the number of hometown headliners continued to rise, nothing could match the excitement generated by the 2007 return of two prodigal sons—local boys who helped forge the club's mystique in the 1980s. Neither Prince nor Paul Westerberg had played there in more than a decade.

(Right) The Ike Reilly Assassination began the annual night-before-Thanksgiving concert at First Avenue in the early 2000s. Reilly opened the 2007 show from the stairs above the main floor. *(Below)* Soul and funk singer Sharon Jones brought her band the Dap Kings to First Ave in November 2007. *Photos by Steven Cohen*

In September 2007, Paul Westerberg returned to the Main-room for a conversation with Warren Zanes for an online interview series called *The Craft. Photo by Steven Cohen*

Their performances meant the world to the staff: a sign that even these two hard-to-please dudes—not known for their sentimentality or gratuitous hometown boost-erism—appreciated what the new regime was doing to revive the place. Their shows came to take on even more meaning, because Prince never performed there again, and as of this book's writing the Replacements' frontman has since only played there in private.

Westerberg opened up like he never had for his September 23, 2007, appearance. Seated on a couch and at times sounding like a psychiatry patient, he was interviewed by his fellow '80s indie-rock hustler Warren

Zanes of the Del Fuegos in front of an audience for an episode in the Rock and Roll Hall of Fame's new online interview series, *The Craft* (which tragically was never aired). He played ten songs solo over the course of the episode, starting with the gems "Let the Bad Times Roll" and "It's a Wonderful Lie." With Zanes billing himself more as a fan than a peer of the Replacements—"We got it that this was a band that was gonna be remembered for fifty years," he said—the discussion delved into a lot of insider 'Mats lore, including how producer Jim Dickin-son overdubbed strings and the bass drum on *Pleased to Meet Me* without the band's knowledge. That led to West-erberg ending the show with that album's "Skyway" and "Can't Hardly Wait."

Zanes also asked about Westerberg's growing re-clusiveness, comparing him to author J. D. Salinger. "I'm the catcher in the slump," Paul dryly shot back. In truth, the hiatus—then three years in the making—was partly brought on by a hand injury, which noticeably stymied his guitar playing that night. But it also had to do with raising his son, Johnny, then nine. "I liked it more than I contemplated," Westerberg said of becoming a dad. "I found it so fulfilling that I found it hard to strap on an electric guitar." It would be another seven years before he plugged in again for a formal gig.

Prince's return to First Ave on July 7, 2007, was even longer in the making, but also—predictably—an im-promptu affair. He had already booked two other perfor-mances that day: a full-scale Target Center arena show, preceded by an afternoon gig at Macy's department store in downtown Minneapolis to promote his new fragrance line, 3121. As if to prove he was still a badass despite selling perfume, the forty-nine-year-old legend added a late-night jam at the club at the last minute, just like the old days.

It had been twenty years since his previous perfor-mance, but First Ave was still prepared for just such a phone call. "Whenever we get a new receptionist here," Sonia Grover said, "we tell them, 'If somebody calls and says they're with Prince, they probably really are.' No one lies about that." The call in this case came July 2 or 3. Prince formally confirmed July 5. Tickets went on sale

July 6 and were gone in minutes. The show would have gone off without a hitch, except for the fact that it didn't start on July 7, but nearly three hours into July 8 instead. At the Target Center, where he didn't go on until ten, Prince advised the sold-out crowd about halfway into the two-plus-hour show: "Call your babysitter. We'll be here all night. And I'm still going to go to church in the morning."

Aaron Caswell, a First Ave alum working for Paisley Park at the time, said Prince's crew made a quick transition between the venues. The plan was for him to go straight to the club from the arena, but that didn't happen. "There wasn't any reason for it that I knew of, but that's how it goes," Caswell said. Fans in the elbow-to-elbow club waited around patiently and eagerly for more than two hours, and only got a little antsy once the 2:00 AM bar cut-off came and went. Finally, around 2:45 AM, the screen in front of the stage came up and out strutted the Purple One, with a big band behind him including longtime New Power Generation keyboardist Morris Hayes, backup singer Shelby J., and a three-man horn section. They all—including Prince himself—looked thrilled to be playing the hallowed club.

"I'm up in here tonight!" he yelled after opening with a funk jam, adding prophetically, "I'm gonna stay 'til they kick me out." He followed up with an almost giddy level of enthusiasm and an equally uncommon affinity for oldies. As the crowd ecstatically sang out the chorus in "Girls & Boys" ("I love you baby / I love you so much"), he yelled, "I love you back! First Avenue rocks!" Before "I Feel for You," he slyly purred, "Aw, this is gonna be so much fun." And then came "Controversy," another one he

didn't often play live at that point. "We're at First Ave," he said. "We gotta do it."

The playfulness continued as he kicked out "Beggin' Woman Blues," a jam that harked back to his impromptu 1984 set in 7th Street Entry with Mark Brown and Bobby Z (the latter was waiting in the wings this night). After Shelby J. sang a cover of Amy Winehouse's "Love Is a Losing Game," out came Rock and Roll Hall of Fame bassist Larry Graham, a close spiritual and musical cohort of Prince's. Graham had been booked to play the club thirty-six years earlier in the Depot days with Sly & the Family Stone, but the show was cancelled. He and Prince made up for it with a medley that included "Thank You (Falettinme Be Mice Elf Again)" and "Everyday People." Somewhere in there, though, Prince got the signal: The police were shutting it down. There would be no royal treatment tonight.

"The law is the law for anybody," said Minneapolis police sergeant E. T. Nelson (no relation), who made the call from outside the club. Pointing to some of the twenty officers working overtime—they had blocked off the streets surrounding First Ave and Target Center—Nelson added, "I think it's very arrogant of him to think he can hold us here like this." Years later, Nate Kranz agreed that the little man's big head was part of the problem. "I really think Prince wanted to test the waters," Kranz said. "He knew what the rules were, and he wondered if they applied to him. However, I honestly think if the cop in charge that night had been just a little cooler, nothing would've happened."

Prince broke it to the crowd: "Thank you all so much, from the bottom of my heart. You know if I could I'd stay

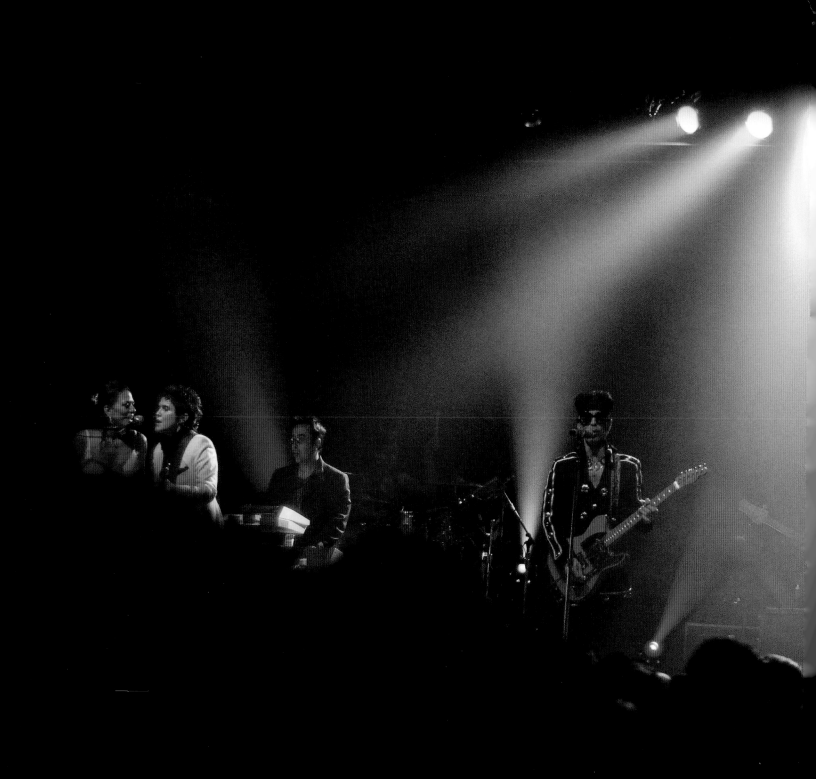

Scheduled for 7/7/07, Prince's final concert at First Ave actually didn't begin until July 8, but the late start didn't dampen the enthusiasm of the crowd—or of the performers. *Photos by Steven Cohen*

here all night, but the authorities say we gotta stop, and we're all subject to the authorities." Sheila E. and the Revolution's Wendy Melvoin and Lisa Coleman—all of whom had appeared with him at Target Center—came out for a finale spin through "Alphabet Street." As the house lights came on, Prince repeatedly asked, "Is this my hometown?" It's hard to say if he meant that positively toward the crowd or negatively toward "the authorities." There were nine more songs on the set list that did not get played, including "Anotherloverholenyohead," "The Question of U," "Black Sweat," and "Kiss." Prince's last words before exiting the stage were, "I'll be back, I promise."

Working on Prince's production crew that night, Caswell left behind a prescient and permanent tribute to the performance: Using a Sharpie, he drew a fanciful rendering of Prince's glyph symbol on the stage door leading to the garage, where the performer's limo swept him away. Next to it he wrote, "Prince walked thru here! 7/7/07." Musicians entering the club today often marvel over the artwork without knowing its exact origin. Even production manager Conrad Sverkerson was unaware

Formed in 2010, the local supergroup Gayngs took on various lineups, here featuring vocalists Channy Leaneagh of Poliça, Katy Morley, and Dessa of Doomtree. It nearly turned into a super-duper-group on March 6, 2011, when Prince approached the stage, guitar in hand, but never joined the show. *Photo by Daniel Corrigan*

Prince's band the Revolution reunited in the Mainroom for a 2012 fundraiser, but the "Purple One" himself didn't make an appearance. The band nevertheless played an assortment of greatest hits, from early classics like "Uptown" and "Controversy" to "Purple Rain" and "Let's Go Crazy." *Photo by Steven Cohen*

Caswell did it. "I at least knew it wasn't Prince," Sverkerson wryly noted. "It's too high off the ground."

Prince did come close to returning to the First Ave stage a few times after that. In 2009, he randomly turned up for a performance by Philadelphia's scrappy blues rockers G. Love & Special Sauce. Mid-show, he sent word he wanted to join in during the encore. As Sonia Grover recalled it, "G. Love is onstage, and his tour manager tells him Prince wants to get up. He was of course like, 'Awesome!' G. Love went up there solo, purposefully so Prince would get up and play with him. But in the meantime, Prince had split and didn't say a word to anyone. Poor G. Love stood up there for a long time thinking Prince was going to come out."

An even closer call happened in 2011, when the rock icon crashed the "Last Prom" concert by R&B-flavored indie-rock all-star group Gayngs. Featuring a couple dozen, mostly homegrown musicians twenty to thirty years his junior—including Justin "Bon Iver" Vernon, Har Mar Superstar, and members of Doomtree and Poliça—the

Gayngs crew flipped out when Prince sauntered up to the side of stage, strapped on a guitar, and stood there for a minute or two. In a flash, though, the guitar came off and Prince disappeared out the back door. He hadn't even climbed a single step up to the stage, and never offered an explanation for his sudden change of heart.

A year later, his bandmates in the Revolution set up a guitar and amp in hopes he would join them toward the end of Bobby Z's My Purple Heart concert. The *Purple Rain*-era lineup reunited in 2012 to raise money for the American Heart Association after the drummer survived a heart attack. In that case, Prince didn't even show up. He did send a sizable check to support the cause, though. "We knew the deal," Bobby Z said, unfazed. He theorized their old boss didn't want to steal his ex-bandmates' thunder. Sadly, the next time the Revolution's members all got together to perform at the club would be after Prince had passed away.

Over the last decade of his life, Prince sporadically stopped into the club as a fan, including a final visit two months before his death to watch the R&B/synth-pop trio King. Sometimes he didn't even know who was playing, like the time his limo pulled up as Florida indie-rock band Surfer Blood was loading out after their Entry show in

Mayors Chris Coleman of St. Paul (left) and R. T. Rybak of Minneapolis addressed the crowd during the Current's fifth anniversary celebration. Somewhere in the shadows above the crowd, Prince watched the festivities from the owner's box, but once again failed to appear onstage. *Photo by Daniel Corrigan*

Revered southern twang rocker Lucinda Williams did many shows at First Ave, in both the Mainroom and the Entry, going back to 1989. Her biggest gig at the club, though, was the night of September 18, 2009, when she and Minneapolis native Tom Overby tied the knot on the Mainroom stage. *Photo by Tom Wallace, Star Tribune*

2010. Prince walked into the Mainroom, then the Entry, then walked back out, apparently unaware it was 2:00 AM and the music was over. "That's what we do when bands are really good," Kranz joked with the Surfer Blood kids. "We call up Prince and tell him to make an appearance."

A lot more intent and meaning was attached to Prince's appearance on January 29, 2010. Jim McGuinn said he could "hear the collective eye roll" when he alerted First Ave staff that Prince planned to attend the fifth anniversary party for the Current. He was new enough in town to believe Prince's word was reliable, having come from Philadelphia a year earlier to be the program director for the influential but still-improving public radio station. "Just tell 'em he's coming, and they'll know what to do," Prince's handler told the radio programmer, whose crew had put together a cool birthday lineup with P.O.S., Mason Jennings, the Twilight Hours, and synth-rock headliners Solid Gold—all popular local acts, but none really in Prince's wheelhouse. Lo and behold, Kranz watched as Prince slid into the club's "owner's booth" (an area of the DJ platform directly across from the stage, consisting of a few bar stools and a little

standing room) and started playing air guitar while Jennings performed.

McGuinn was standing next to the stage with the mayors of Minneapolis and St. Paul, who'd made a joint "Current Day" proclamation, but ditched them when he got the text message from Prince's handler: "We're here up in the booth," it read. He and a few other Current staffers got to say hello. Prince said he had been listening to the station and liked the concept. Both McGuinn and First Ave staff saw that night as a pivotal moment. Said the Current's new boss, "It really felt like he gave us all his blessing. Like: 'Carry on.'"

Despite its financial rebound, First Avenue's future was cast in doubt again around the start of the 2010s, though not many people knew it. The issue this time was Byron Frank's health. The club owner had come out of retirement in 2005 to oversee First Ave's rebirth firsthand, but he was forced to take it easy again after he suffered a minor stroke at age sixty-five in 2009. "I believe to own

a business like this, you have to be here to help run it, or it's never going to work," Frank explained a few years later. "And I couldn't be here to run it anymore."

The younger of Byron's two daughters, Dayna Frank, had carved out a sweet life for herself after she left her native Golden Valley to attend New York University in the early 2000s. She wound up in Los Angeles working in TV and film for the Creative Arts Agency and then VH1. She met her wife in the industry, too: Ember Truesdell, a copresident of Drew Barrymore's production company, Flower Films. So it was a hard tug in two directions when Byron gave Dayna and her sister, Marti, an ultimatum over First Avenue after his stroke. "One of you needs to take this over, or I'm going to have to sell it to Live Nation or AEG."

Luckily for the club, Dayna had spent a lot of time there in her youth. As a teenager, she could either get her parents' approval and get on the guest list for a show, or go downtown without them knowing and pay for a ticket like everybody else. She usually chose the latter. "I'd always be afraid I'd be seen by someone who knew my dad," she recalled. "It was pretty much in the thick of the '90s grunge and DIY scene, which was such a great scene there." So it was not surprising that Dayna reacted with emotion when her dad laid the future of First Avenue on her shoulders. "I think for anyone who was there then," she said, "the idea that the club could wind up in the hands of a company that's not responsible to Minneapolis/St. Paul and doesn't inherently understand the beauty of this market—that was unfathomable to me."

By the summer of 2010, after months of flying back and forth from L.A., Dayna had quit her VH1 job. By then, the property had been more or less turned over to her and her sister, and she was fully ensconced as the managing co-owner of the club. Nate Kranz had been named general manager a year earlier, when Jack Meyers retired. Sonia Grover became the club's lead talent buyer. All in their midthirties at that point, Dayna, Nate, and Sonia made quite a power trio as the club's second-generation wave. It was more than just Dayna's family connection. They all grew up with the club and the bands it fostered. They shared similar tastes in music

Dayna Frank with her parents, Byron and Shirley, shortly after taking over management of the club for her father in 2010. *Photo by Daniel Corrigan*

(Nate's affinity for the Grateful Dead and Ween aside). They believed in keeping First Ave autonomous and supportive of independent bands, but also being aggressive on the business front. In fact, the venue that could barely stay above water throughout most of its first forty years rose into something of a small empire in the 2010s based on that aggressive approach.

Dayna Frank arrived in time to oversee the opening of the Depot Tavern in June 2010. The restaurant and bar went into the long, slim space adjoining 7th Street Entry that once housed the UnBank check-cashing service, and originally served as a bus entrance into the garage. The new Depot's purpose was twofold: take advantage of foot traffic to and from the Minnesota Twins' new ballpark, Target Field, two blocks away, as well as serve concertgoers before a show. Both worked out well from the start. The tavern opened during an especially busy week of concerts, with George Clinton's P-Funk, Edward Sharpe & the Magnetic Zeroes, and an instantly sold-out two-nighter with the Black Keys, whose members got into town a couple days early and came down to the club all those nights. "We were like the guinea pigs for the restaurant to see what food was good," the Keys' ex-Minneapolitan tour manager Jim Runge remembered. "They fed us at that restaurant every night. By the last night, we were like: 'Please, no more!'"

(Clockwise from top left) For the official grand opening of the Depot Tavern in June 2010, First Ave owner Dayna Frank and general manager Nate Kranz were given a hand at the ribbon cutting by hometown musicians Mark Mallman, Sean Tillmann (Har Mar Superstar), and Craig Finn. Conrad Sverkerson wields the shears. *Photo by Daniel Corrigan.* The Depot Tavern has become a popular eatery since it opened in 2010, further expanding the club's presence on the corner of First Avenue and Seventh Street in Minneapolis. *Photo by Daniel Corrigan.* The Depot Tavern's debut wasn't the only major occasion at the club in June 2010. Any time George Clinton and his P-Funk All-Stars are in town, it's a big event. *Photo by Steven Cohen.* The Ohio-based Black Keys were just hitting it big when they played a two-night stand in the Mainroom on June 9 and 10, 2010, less than a month after the release of their breakthrough album, *Brothers. Photo by Steven Cohen*

Though the new First Ave regime would soon have a lot more on its plate, its next move to expand was a bit of a misstep. Plans were announced for the First Avenue Music Festival in 2012, a two-day outdoor bash to be held in mid-July at Parade Athletic Fields near Walker Art Center. But with competing festivals on the rise all around the country, the club failed to land "the perfect lineup" two years in a row and dropped the idea. As Kranz put it, "We're not going to beat our heads against the wall to make this work." That legwork, however, led to a deal with the Minneapolis Park and Recreation Board to promote concerts on Hall's Island along the Mississippi River near downtown Minneapolis, where First Ave booked Alabama Shakes and Wilco to play before capacity crowds of eight thousand in 2015 and 2016, respectively. The First Ave team also partnered with Minnesota's breakout acoustic pickers Trampled by Turtles and copromoter Rose Presents on the smaller-scale Festival Palomino from 2014 to 2016. They expanded indoors, too. The First Ave brand was applied to concerts at bigger venues such as the nearby State or Orpheum theaters (often with Chicago partner Jam Presents) as well as smaller gigs at the Fine Line Music Café, Cedar Cultural Center, and Triple Rock in Minneapolis, and at a beloved old St. Paul watering hole, the Turf Club.

In October 2013, First Avenue officially became a two-city enterprise when it announced a plan to buy the Turf Club. With its 350-person capacity, the size of the 1940s-era venue fit in nicely between the Entry and Mainroom. Plus, it had already played host to many First Ave bookings. Owner Tom Scanlon wanted to ensure that its live music tradition would have a future. "I had other offers . . . [but] I'm confident the future of the Turf Club is absolutely safe in their hands," Scanlon said at the time. Turf Club devotees weren't so sure, though, as First Ave closed the venue over the summer of 2014 and invested almost $1 million in upgrades. They breathed easy at an August 28 reopening concert with Dave Simonett's Dead Man Winter, Frankie Lee, and Erik Koskinen. "It's kind of embarrassing, because people are like, 'Well, what the hell have you been doing for the past three months?'" Kranz said. The venue's vintage façade and charm,

In 2010 Mark Olson returned to the Jayhawks, and the band rehearsed in the Entry before a series of three concerts in the Mainroom that June. The reunion lasted only a few years, however, before Olson again went his own way. *Photo by Steven Cohen*

including its beloved basement bar the Clown Lounge, were largely unchanged. Most of the money went into adding a kitchen, a new ceiling and sprinkler system, and remodeled restrooms.

Dealings over the Turf Club with the city of St. Paul and its musichead mayor, Chris Coleman, helped facilitate First Ave's third major expansion of the 2010s. Coleman had been trying for a decade to fund renovations of the 1916-era Palace Theatre in downtown St. Paul. In 2013, funding was finally approved by the city council, for a final price tag over $15 million. The city then signed up First Ave and its Chicago partner, Jam Productions, to manage the Palace, which, with a capacity of twenty-eight hundred, marked the next size up from the Mainroom. In addition to a seated balcony, the venue offers an open, general-admission main floor that makes it more desirable than other theaters in town for rock shows. "It's a perfect fit all around," Jam Productions cofounder Jerry Mickelson said, talking about both the layout and First Ave's trusted brand. The Palace's grand opening concerts on March 10 and 11, 2017, featured two cornerstone First Ave acts: Atmosphere, followed by one of the few acts to play the club even more often, the Jayhawks. Subsequent

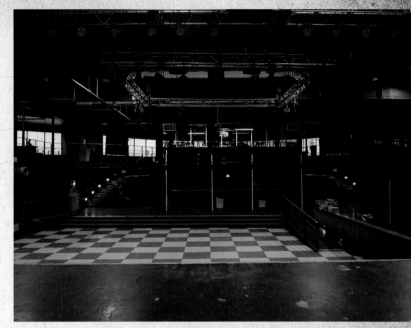

The grand Palace Theatre in downtown St. Paul was reopened by First Ave in 2017 with an eclectic one-two punch of Atmosphere on March 10 and the Jayhawks (seen here) on March 11. *Photo by Steven Cohen*

More than eighty years old, the one-time bus depot underwent major improvements to make it an even better musical experience for musicians and audience members alike. *Photo by Steven Cohen*

nights the opening month featured touring acts that had graduated from playing sold-out one-nighters in the Mainroom, including Phantogram, Regina Spektor, the XX, and String Cheese Incident.

First Avenue wasn't just audacious on the business front in the 2010s. It got political, too. When marriage equality became a hot-button issue in Minnesota—first with a state amendment to ban same-sex marriage in 2012 (which lost) and then legislation to legalize it in 2013 (which won)—Dayna and Byron Frank and their staff put up the club's good name in support of gay rights via ads, social media, and even billboards. "Don't limit the freedom to marry," read a billboard near Target Field with the First Ave logo on it when the amendment to ban was in play. Richard Carlbom, former campaign manager of Minnesotans United for All Families and advocate for same-sex marriage, saw First Ave's lobbying as vital to the cause. "[It] showed countless Minnesotans that a cherished and historic institution in our state supported all families," Carlbom said.

Even as it expanded into new locations, the First Ave team did not lose sight of its (ahem) main room. Despite four distinct incarnations in its first four decades, the original venue had not changed a whole lot physically; there was never any surplus money to invest in improvements. That changed in the late '00s and early '10s. The restrooms, air conditioning, and sound and lighting systems all got upgrades. No more rust stains on men's jeans from the urinal trough; no more sweating off five pounds during a sold-out show in July. More conspicuous changes came in 2012: The two staircases linking the dance floor and balcony were ripped out and rebuilt in less obtrusive locations, making for better sightlines and traffic flow; and a large bar was built in the back corner that used to be the game-room area.

Subtle musical changes also came to the Mainroom. The biggest difference was the waning of the regular dance nights. Long the bread and butter of First Ave—the

DANCE

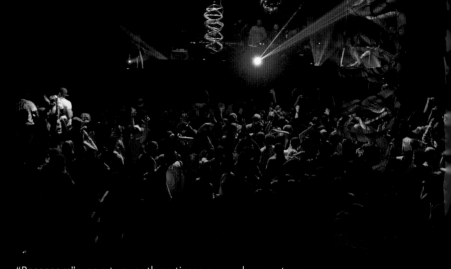

Long after the demise of disco, dance nights remained a staple at Minneapolis's self-proclaimed "Downtown Danceteria." Even as alternative rock exploded in the '90s, five out of seven nights in the Mainroom were given over to DJ-led dance nights—"Sunday Night Dance Party," "Club 241" (Tuesdays), "More Funk" (Thursdays), and the long-standing Friday and Saturday night "Danceteria." Revered DJs from Kevin Cole, Roy Freedom, and Paul Spangrud to DJ ESP and Dean Vaccaro to Jake Rudh, SovietPanda, and DJ Shannon Blowtorch have hosted dance parties in the Mainroom and, for a period, in the VIP Room/Lounge. While live music reasserted its dominance on the calendar in the mid-2000s, the popular Transmission and Flip Phone nights keep the beats coming as the venue approaches its fiftieth year. ∎

"Bassgasm" was a two- or three-times-a-year dance extravaganza held from 2010 to 2014. Hosted by Genius of Fun and DJ ESP (Woody McBride), Bassgasm featured DJs set up at multiple stations throughout the club. *Photo by Daniel Corrigan*

Alexander East spinning at a Beatopia house-music night in the VIP Room in May 2003. Next to him is Elliott Knight, who also played that night. *Photo courtesy of Alan Freed*

DJ Jake Rudh playing tunes from the DJ booth at a typically jam-packed Transmission dance night in September 2015. *Photo by Daniel Corrigan*

Flyers and ticket stubs courtesy of the Museum of Minnesota Music, Michael Reiter, Mark Dueffert, and Alan Freed

club probably would not have survived without the weekend Danceteria crowds in the early '80s or themed nights like System 33 and More Funk later on—dance nights became less profitable and more of a distraction as increasing numbers of bands could pack the Mainroom any night of the week. Part of the decline also had to do with changing tastes of the dance crowds, who wanted swankier, lounge-type venues with VIP table service. "There was a time when we were spending more time and energy trying to keep the dance nights going than we were putting toward concerts, and it got to be too much work," Kranz recalled. Grover remembered finally pulling the plug on Thursday's long-running Latin dance party in 2012 after it cut short a sold-out Alabama Shakes gig. "When you have to end a sold-out show at ten o'clock to bring in maybe four hundred people to dance, is it really worth it?" she said.

The last weekly dance night was Saturdays' techno/ house-oriented Too Much Love parties with SovietPanda (Peter Lansky), which were moved in 2013 into the refurbished Record Room—the space in the southwest corner of the second floor that opened as the VIP Room in the 1990s and had been a storage and part-time dressing room before that—but then the Record Room itself was shuttered in 2016. Another fixture in the Record Room, the Get Cryphy hip-hop dance nights with DJs Plain Ole Bill, Jimmy2Times, Fundo, and Last Word, had become more erratic occasions as its hosts were recruited to tour with Atmosphere, Prof, P.O.S., and others. Nowadays, the Get Cryphy parties happen sporadically in the Mainroom, as do other dance nights such as DJ Jake Rudh's new-wave/Anglophile Transmission and the GLBT-celebratory Flip Phone parties.

Some of the club's veterans lament the demise of the dance nights as a deviation from the original First Avenue brand. "We used to get a thousand people in there every Friday and Saturday night," Roy Freedom (Roy Freid) fondly recalled. "I'm sorry they're not interested in dance nights anymore. To me, being a DJ, that floor is the best dance floor in the whole city." More Funk cospinner Alan Freed said, "I always felt like the dance nights at First Ave never got the credit they deserved. Back [in the

Paul Spangrud, Roy Freedom, and Kevin Cole were the Fab Three among the club's DJs for many years—and in many of those years, it was their dance nights that kept the lights on at the venue. *Courtesy of Kevin Cole*

'80s], dance music was more tied to R&B. The rock always got more attention. It was frustrating. Especially when Prince broke out, I was like, 'This is R&B guys!' Props to Roy Freedom, Kevin Cole, and Paul Spangrud, because those dance nights did persevere, and they did a great job with them."

On the other hand, the spirit and sounds of those dance nights live on in many of the bands who play the Mainroom nowadays. The divide between rock and dance acts has blurred as many indie-rockers incorporate electronic beats, laptops, and other DJ gear into their live sets—occasionally making the performances seem less than live. Conrad Sverkerson, for one, isn't impressed. "I'm not technically advanced," the club's production manager said, "but it seems like if I could program my computer right I could do that. It doesn't seem like there's as much spontaneity in shows as there used to be. You can say to a band, 'How long's your set?' If they say forty-five minutes, they mean forty-five minutes!"

One of the most vocal critics of the Ice Cube debacle in 1991, Sverkerson did grow fond of the independent hip-hop acts that became a big part of the club's stable

DOOMTREE BLOWOUT VII

ONE WHOLE FU☾K-ING WEEK

DOOMTREE BLOWOUT VII
5 NIGHTS IN THE 7TH STREET ENTRY, EACH CURATED BY A RAPPER.
2 NIGHTS IN THE MAINROOM, WITH ALL 7 MEMBERS OF THE CREW.

DECEMBER

SUNDAY	MONDAY	TUESDAY	WEDNESDAY	THURSDAY	FRIDAY	SATURDAY
4	5	6	7	8	9	10
SIMS	MIKE MICTLAN	DESSA	P.O.S	CECIL OTTER	DOOMTREE	DOOMTREE
ENTRY 18+ $7 / $10	ENTRY 18+ $7 / $10	ENTRY 18+ $7 / $10	ENTRY 18+ $7 / $10	ENTRY 18+ $7 / $10	MAINROOM 21+ $15	MAINROOM AA $15

DOOMTREE 89.3 the current

(Top and right) The Doomtree collective—rappers P.O.S., Cecil Otter, Dessa, Sims, and Mike Mictlan and DJs Paper Tiger and Lazerbeak—became a premier home-grown hip-hop act in the 2000s. Their annual Blowouts were always a major event; Blowout VII was a weeklong happening in December 2011, with five nights in the Entry and two in the Mainroom. *Photo by Daniel Corrigan; postcard courtesy of Michael Reiter.* *(Above)* Atmosphere and Brother Ali—sharing the stage at the Soundset after party in May 2014—continued to represent the ever-expanding Rhymesayers Entertainment as the label entered its second decade. *Photo by Daniel Corrigan*

The Scottish synth-pop band Chvrches put on an electric performance at First Ave in June 2014. *Photo by Steven Cohen*

Indie rockers TV on the Radio were frequent performers in the Mainroom during the 2010s, including this set from 2011. *Photo by Daniel Corrigan*

over the past decade. With Atmosphere leading the way, the club began hosting packed shows by the likes of Aesop Rock, Murs, and a lot of artists that played Atmosphere's local festival, Soundset, including Macklemore & Ryan Lewis, Mac Miller, Run the Jewels, and Chance the Rapper. The number of hometown hip-hop acts headlining the club especially boomed. Atmosphere's Rhymesayers labelmates Brother Ali and Eyedea & Abilities became regulars—the latter last played in 2010 before Micheal "Eyedea" Larsen's untimely death at twenty-eight that October—soon followed by Doomtree and its members' solo shows (Dessa, P.O.S., Sims), plus Prof, Sean Anonymous, Unknown Prophets, and the scene's biggest breakout act of the mid-2010s, Lizzo.

Doomtree, in particular, became an integral part of the club when it hosted its early-December Blowout concerts there for nine years starting in 2005. The final eight-night marathon in 2014 started in the Entry and culminated in three sold-out Mainroom shows. "It turned into a hybrid of a pep rally, an after party, a family reunion, and hockey practice," Dessa said of the Blowout years, consistently some of the rowdiest and most

ecstatic nights in the club's modern era. "At the end of every Blowout, I come home really banged-up and hung over—and excited about my scene."

Multiple-night stands like Doomtree's became commonplace in the 2010s even among touring acts, a sure sign of the Mainroom's reputation far beyond Minnesota. Headliners that could have shortened their tour itinerary or made more money playing a single show in a bigger venue (or both) instead chose to settle in for two or more nights at First Ave. These included the aforementioned Black Keys, Neko Case, TV on the Radio, the National, Dr. Dog, Umphrey's McGee, Beach House, Lucinda Williams, Conor Oberst, Dawes, Courtney Barnett, Chvrches, Alt-J, St. Paul & the Broken Bones, Tycho, and two locally rooted favorites, the Hold Steady and Bob Mould. Talking before his two-nighter in 2016, Mould noted that it's a pleasure to keep coming back: "The club has survived all the many changes in downtown Minneapolis and in the music industry, which is rare in both cases," he proudly remarked. "It's now a worldwide landmark among musicians and fans."

Even the Replacements—Paul Westerberg and Tom-

Although the Replacements haven't played First Ave in front of a crowd since 1990, the regular tribute show, held in both rooms at the club on the day after Thanksgiving beginning in 2007, has become a cherished tradition among local rockers and fans. *Photo by Steven Cohen*

my Stinson with their remade lineup—booked three dates in the Mainroom to warm up for their first three reunion dates at Riot Fests in Toronto, Chicago, and Denver. Alas, those First Ave performances were seen by only a handful of people, including the talent buyer who more or less moved to Minneapolis out of her love for the band. "People would say to me, 'You should try to get a Replacements show,'" Sonia Grover recalled with a grimace. "No shit! I'm always trying to get a Replacements show!" And that's no exaggeration, either. Nate Kranz said, "Since Sonia has worked here, for fifteen years or so, every year there would be a standing offer for the Replacements to play here. It was like, 'Let's try an offer for five nights, $200,000, and see if that'll get Paul interested.'"

Grover extended the offer again around the Riot Fest shows. All she got, though, was the chance to host three days of rehearsals. "We were hoping those three days would at least turn into one [public] show, but they didn't," she said. "But I really was just glad they were together." She and Kranz kept a tight lid on the fact that one of the most legendary bands born out of the club was there working again. They told staff that Oklahoma hard-rockers Hinder—"a band we knew nobody on our staff would get excited about"—had booked those days for rehearsals, and even made up Hinder laminated passes to further the ruse. When they finally had to let the daytime staff know the truth, they made them sign confidentiality agreements.

As the first day arrived and the band set up shop, Grover camped out upstairs in the alcove by the office, out of sight from the band members. "Everyone was in good spirits," she said. "Westerberg was especially in good spirits. It was great. And they basically played the same set they played at Riot Fest—it was like the real

The ceiling collapse in August 2015 was a scary moment in the club's history and led to its closure for more than two weeks.
Photo by Elisa Martinez, Star Tribune

thing." Tommy Stinson later said of the chance to play the club, if only while rehearsing, "It wasn't lost on us. It meant a lot." After two days relishing the rehearsals by herself, Grover got some company: Kranz cut short his honeymoon in Paris to catch the last rehearsal, and Dayna Frank came in from Los Angeles.

They did get to work with the Replacements the following year on a real performance—a stellar show, in fact—when First Ave served as promoter for the band's long-awaited hometown love fest at St. Paul's soon-to-be-demolished minor-league ballpark, Midway Stadium, on September 13, 2014. But there was no comparison to those rehearsals in the room that was so much a part of the band's lore; the three power brokers turned into giddy '90s teenagers again. "I mean, that's why you work here," Grover said simply.

It wasn't all smooth sailing in the 2010s. First Avenue's new managers faced two major tests eight months apart. The first came on August 12, 2015, during a show by Vancouver-area metal band Theory of a Deadman. "We were really feeling it, having a great time," bassist Dean Back recalled. "We had friends at the show, too, so

it was supposed to be a celebratory night for us. It didn't work out that way, though."

Four songs in, their sound engineer yelled into the band's monitors: "Guys, get the hell offstage right now." Concurrently out in the crowd, people screamed and ran as large chunks of ceiling plaster came crashing onto the dance floor near the back bar. About a half minute later, another big chunk fell, creating about a thirty-by-thirty-foot hole in total. The debris took out some sprinkler pipes on its way down, sending water streaming onto the floor and adding to the pandemonium. Later, it was determined that the ceiling plaster and lath dated back to the original 1937 construction of the bus depot. The club had passed a city safety inspection just a few weeks earlier when it installed a new lighting rig, but, Kranz said of the plaster damage, "It was the kind of thing you can't really see," because it was between the ceiling and the roof.

Three audience members were hospitalized with noncritical injuries; one had to stay a couple days. Everyone agrees, though: It could have been a lot worse, and First Ave floor staff did a Grade-A job in quickly

evacuating the building. Attendance was around a thousand, so people were able to get out of the way; a packed club could have resulted in a more riotous scene. "It seemed completely random," Mersadees Sten, of Gilbert, Minnesota, told the *Star Tribune*. "People were yelling to get the hell out." Theory of a Deadman's members went to their bus and waited. "It was pretty somber," Back said. "As soon as you hear that fans of your band have been injured at a show, however badly, you take that pretty seriously." The band came back three months later for a show with ten-dollar discounted tickets.

The Mainroom was closed for sixteen days for repairs. Rather than repair the plaster and lath, that entire layer was removed, increasing the room's height and exposing the metal trusses under the roof. Grover and Kranz once again acted quickly to relocate scheduled concerts, just as they had during the 2004 bankruptcy closure. The two biggest shows—R&B singer Miguel and a double bill with '80s alterna-faves Psychedelic Furs and the Church—bounced to the nearby State Theatre. In a nod to his band's 1981 debut there, Psychedelic Furs frontman Richard Butler told the theater crowd, "We were happy to be booked at First Avenue again. We love that place."

Although it was hardly the kind of press you go looking for, media coverage of the ceiling collapse affirmed the club's worldwide reputation. "First Avenue is perhaps not on the top tier of internationally known rock clubs," noted the *Washington Post*, listing the Fillmore and the long-gone CBGB as being in that class, "[but] it is an American institution nonetheless." NBC and other television news reports cited First Ave's recent top-three rank among "Best Big Rooms in America" in *Rolling Stone*'s music venue guide (behind the Fillmore and Washington, D.C.'s 9:30 Club). Every story on the ceiling collapse brought up You Know Who. "Terrifying moment at legendary club where Prince filmed 'Purple Rain,'" read the headline in London's *Daily Mail*.

Eight months later, First Avenue and Prince were tied at the hip again in the international news cycle, the coverage this time unlike anything the Twin Cities has ever seen. Images of the club featured in a majority of the news reports filed on April 21, 2016, and the hard days that followed. Near the entrance, flowers and mementos on the sidewalk beneath Prince's star flowed out into the street, where barricades were set up.

The night that followed Prince's death was an unforgettable one in both First Avenue and Minneapolis history. Within hours of hearing the news, staff from the club and the Current got together with city representatives, and plans were quickly in place for a street party at the intersection of Seventh Street and First Avenue. There was a certain spectacle to the logistical feat of blocking off the streets and putting up a stage and sound system on a few hours' notice—and a very Princely one, too, given his thing for impromptu events.

The music that followed came off with equally impressive aplomb, from PaviElle French's window-rattling "I Would Die 4 U" to Chastity Brown's heaving "When Doves Cry" and Shannon Blowtorch sparking smiles as DJ. Some of the musicians, such as St. Paul rapper Dem Atlas, were not even alive when Prince filmed *Purple Rain* inside the adjoining building. Lizzo flew in from Los Angeles just in time to make it, pushing her way through the crowd to get to the stage. One of her comments that night only resonates more strongly with time. "Prince always spoke how he felt," she told the crowd. "It's our duty as artists to keep that spirit alive in the Twin Cities."

Prince's spirit permeated shows at First Avenue through the rest of 2016. On the three nights following the street party, fans filled the club to dance to his music until seven in the morning, thanks to the so-called Prince Permit issued by the city after his abbreviated 7/7/07 gig. People were openly weeping, but the events had a party vibe, too, as Prince would've wanted it. Bob Mould, scheduled for shows on the latter two nights, brought up his mentors the Suicide Commandos in the encores to tear through "When You Were Mine."

The pinnacle of the tributes was three sold-out reunion shows on September 1–3 by the Revolution, including Prince's pre–*Purple Rain* bandmates Dez Dickerson and André Cymone. Prince's number-one fan, Questlove, also flew in to spin DJ sets before and after the final two concerts. The band members had to fight back

Lizzo was one of several artists to perform for the throngs who came out to remember Prince on April 21, 2016, outside of the club he was so closely connected with. *Photo by Steven Cohen*

tears, especially the first night, but they genuinely raised the spirits of still-grieving fans. The performances were, in a word, loving. Guitarist Wendy Melvoin, who made her debut with Prince at the club at age nineteen, did most of the talking. "Take every one of these songs and make them your own," she urged the crowd each night.

The night after the Revolution shows, Lauryn Hill, whose family Prince had helped out when she was jailed for tax evasion, ended her September 4 concert with a soaring rendition of "Nothing Compares 2 U." Her intro was as beautiful as the song: "I know this city is still mourning, as we all are, and celebrating his life, like we are. Thank you for sharing him with us, because we know you guys loved him first. And First Avenue loved him first." A fellow star from MTV's '80s heyday, Billy Idol paid his respects with, appropriately enough, "Controversy." Even hot-shot country traditionalist Sturgill Simpson backhandedly showed reverence in a way Prince himself would've appreciated: "I'm going to honor Prince tonight by not playing one of his songs," he said.

Comic Dave Chappelle—whose "shirts vs. blouses"

send-up of Prince on *Chappelle's Show* was loved even by the Purple One himself—also set up shop at First Avenue for an eight-show, four-night run in late May, seemingly to pay his respects to his hero. "You guys really gave the world a juggernaut," Chappelle told the crowd in a rare somber moment. "It says a lot about your city he stayed here." The most memorable tribute besides the Revolution's, however, came when Morris Day & the Time played a late-night party after a big all-star tribute to Prince at St. Paul's Xcel Energy Center in October 2016. Playing the club for the first time in twenty years, Day kept his emotions close to the vest, but attendees nonetheless absorbed the visceral healing power of "D.M.S.R." that night—including Stevie Wonder dancing in the balcony (believed to be his first time at the club).

First Avenue's first generation—the guys who brought the club to life—watched the coverage of Prince's death with a mix of sadness and pride. As his impact on the world was celebrated, they liked to think they had a hand in his efforts, too. From California, Allan Fingerhut somberly recounted, "Everybody thought he

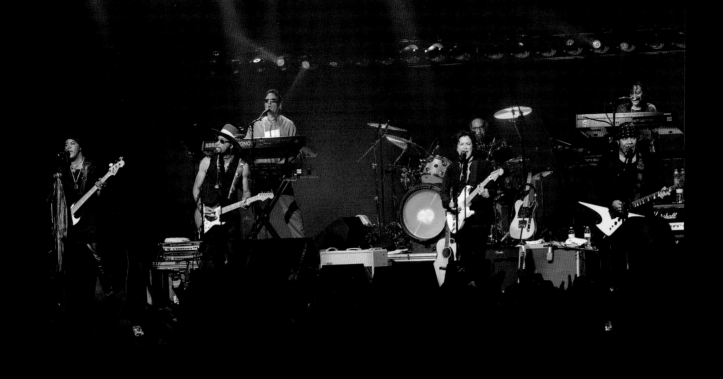

(Clockwise from top) The Revolution on the last of three sold-out tributes to their former leader, Prince. *Photo by Steven Cohen.* It was an emotional night for Wendy Melvoin and the rest of the Revolution when the band reunited for what would be a three-night stand in the Mainroom in September 2016. *Photo by Steven Cohen.* The pioneering Minnesota punk band the Suicide Commandos joined another local guitar legend, Bob Mould, onstage for a tribute to the Purple One during their concerts in April 2016, just days after Prince's death. *Photo by Daniel Corrigan*

owned the club. And I was okay with that. He was just so great." Danny Stevens, whose liquor license and rock-biz connections enabled Fingerhut to open the club in 1970, made the far-fetched claim he planted the idea of filming *Purple Rain* at First Ave in Prince's head. But he also said, "He was an amazing performer. What he did for our club and our city will never be forgotten."

Steve McClellan, who first booked Prince at Sam's in 1981 and then handed him the keys for the filming of *Purple Rain* in 1983—said he didn't want to see the utopian sense of diversity the star brought to the club die with him. "It was so exciting in the early '80s to see Prince mix the audiences," the former GM said. "I had never seen that before to that level. And I don't see that as much today. That was a big part of *Purple Rain*."

As for the accountant who saved the club in 2004, Byron Frank marveled over the whirlwind eight months First Avenue had endured, between the ceiling collapse in August 2015 and Prince's death the following April. He was finally content to watch from the sidelines, it seemed. He was ready to let his daughter, Dayna, and the crew he entrusted with the venue take it from there. "After the way they got this place back in business," Frank said, "I'm one hundred percent confident that First Avenue is in good hands and should be here for the next forty to fifty years."

Let's hold them to that. ∎

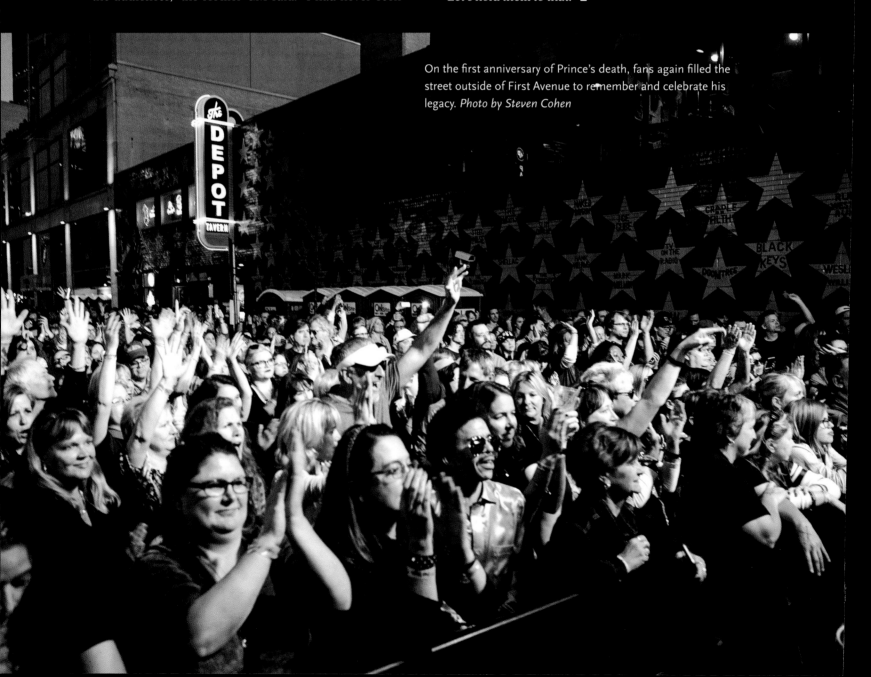

On the first anniversary of Prince's death, fans again filled the street outside of First Avenue to remember and celebrate his legacy. *Photo by Steven Cohen*

∎NDEX

Page numbers in *italic type* indicate illustrations.

Navigating through a crowded dance floor with a tray full of cocktails is just one of the special skills required of a server at First Avenue. *Photo by Steven Cohen*

Backstage with the Jayhawks after a 2010 concert, when Mark Olson reunited with the band. *Photo by Steven Cohen*

Tommy Stinson serenaded the crowd from behind the bar at the rear of the room during the Current's tenth anniversary concert in January 2016. *Photo by Steven Cohen*

ACKNOWLEDGMENTS

It's said a dozen different ways in these pages, but I'll say it again: First Avenue would not exist without the dedicated staff past and present who've worked there for reasons other than financial gain. They all played a role in this book, but I am especially grateful to Steve McClellan, Jack Meyers, Sonia Grover, Nate Kranz, Conrad Sverkerson, Chrissie Dunlap, Kevin Cole, Roy Freedom, Randy Hawkins, Molly McManus, and Dan Corrigan. Thanks also go to Byron Frank and Allan Fingerhut and their families—who differ on many things but share ownership rights to a big piece of Minnesota history—and to Dayna Frank for creating new history.

A good music critic doesn't worry about musicians liking him, so it's lucky for me that so many musicians love First Ave. Their quotes and stories are culled from sixteen years of interviews, but an extra effort was put forth here by Curtiss A, Bob Mould, Lori Barbero, Craig Finn, John Munson, Dan Wilson, Chan Poling, Camille Gage, Jiggs Lee, Chris Osgood, Dan Murphy, Marc Perlman, Wayne Coyne, and Danny Stevens. Prince's cohorts Bobby Z, Matt Fink, André Cymone, and David Z all talked with me before his passing, already recognizing what First Ave meant to his story. More valuable help came from Purple family members Heidi Vader, Frank J. Morris III, Jon Copeland, Patrick Epstein, and Alan Freed.

I knew the Minnesota Historical Society Press would be a good fit for a book on one of the state's greatest landmarks, but I didn't know how great it would be to work with Josh Leventhal, Daniel Leary, Pam McClanahan, Alison Aten, Shannon Pennefeather, and freelance designer Ryan Scheife. A very special thanks to volunteer Mary Benner for the excellent transcription work.

The photos and ephemera that illustrate this book and the story of First Avenue were provided by numerous photographers, both amateur and professional, and by collectors (don't call them hoarders) of calendars, flyers, tickets, and other memorabilia from nearly fifty years. For their excellent photography, I wish to thank Lori Barbero, Darrell Brand, Dan Corrigan, Steven Cohen, Steven Laboe, Steve Madore, Michael Reiter, Jay Smiley, Tommy Smith III, and others whose work is represented in these pages. Dick Champ, Mark Dueffert, Chrissie Dunlap, Robb Henry, Dale T. Nelson, Michael Reiter, and Dean Vaccaro were especially helpful and generous in sharing their personal archives of memorabilia. The contributions of John Kass and Steve McClellan from the burgeoning collection of the Museum of Minnesota Music were simply invaluable.

My fellow music scribes Jon Bream, Martin Keller, Jim Walsh, and PD Larson all could've written this book themselves but instead helped me out immensely. Thanks also to the *Star Tribune* for standing by my thick local music coverage through the thin years and allowing me time and resources to work on this book.

Lastly, a special nod to my wife, Michelle LeBlanc, and especially to Lila and Louisa, who hopefully will understand one day why their dad spent two years writing about that weird old black building.

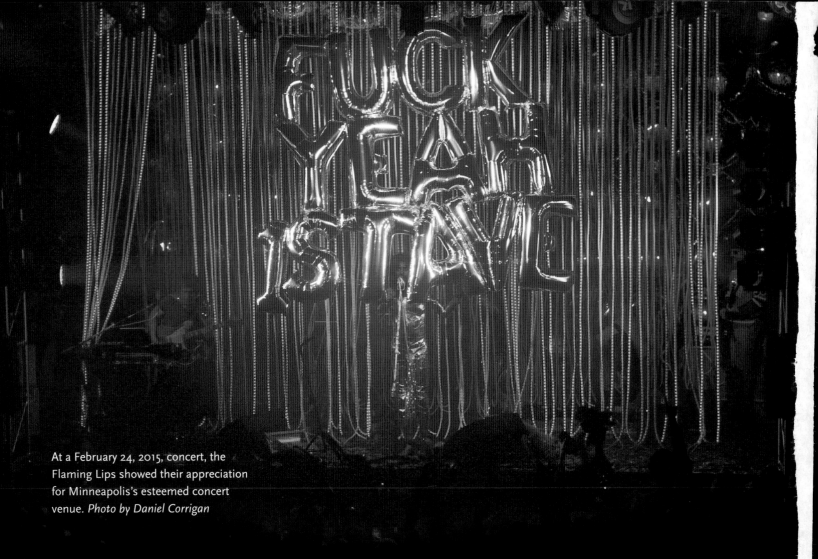

At a February 24, 2015, concert, the
Flaming Lips showed their appreciation
for Minneapolis's esteemed concert
venue. *Photo by Daniel Corrigan*

www.mnhspress.org

The Minnesota Historical Society Press is a member of the
Association of American University Presses.

Manufactured in China

10 9 8 7 6 5 4 3 2 1

Back cover photos: top and bottom left by Steven Cohen;
middle left by David Brewster, *Star Tribune*; middle right by
Michael Reiter.

Frontispiece and contents page photos by Daniel Corrigan;
title page photo by Jordan Abhold, Minnesota Historical
Society Collections.

∞ The paper used in this publication meets the minimum
requirements of the American National Standard for Infor-
mation Sciences—Permanence for Printed Library Materi-
als, ANSI Z39.48-1984.

International Standard Book Number

ISBN: 978-1-68134-044-9 (hardcover)

Library of Congress Cataloging-in-Publication Data
available upon request.